Digital Sports Photography: Take Winning Shots Every Time

Serge Timacheff and David Karlins

WILEY

Wiley Publishing, Inc.

Digital Sports Photography: Take Winning Shots Every Time

Published by
Wiley Publishing, Inc.
111 River Street
Hoboken, N.J. 07030
www.wiley.com

Copyright © 2005 by Wiley Publishing, Inc., Indianapolis, Indiana

Published simultaneously in Canada

Library of Congress Control Number: 2005924625

ISBN-10: 0-7645-9607-1

ISBN-13: 978-0-7645-9607-0

Manufactured in the United States of America

10 9 8 7 6 5 4 3 2 1

IK/RS/QY/QV/IN

For general information on our other products and services or to obtain technical support, please contact our Customer Care Department within the U.S. at (800) 762-2974, outside the U.S. at (317) 572-3993 or fax (317) 572-4002.

Wiley also publishes its books in a variety of electronic formats. Some content that appears in print may not be available in electronic books.

About the Authors

Serge Timacheff is a professional photographer and writer. He is the official photographer for the International Fencing Federation and has photographed numerous world championships and the Olympic Games. He also shoots for Corbis and is the founding partner of Tiger Mountain Photo and FencingPhotos.com. His work appears worldwide, and he gives frequent workshops and lectures on photography. When home, he lives in the Pacific Northwest.

David Karlins teaches and writes about graphic and interactive design, and digital printing. His recent books include *Build Your Own Web Site*, *How to Do Everything with Adobe Illustrator CS*, and *The PC Magazine Guide to Printing Great Digital Photos*. Visit David's Web site at www.davidkarlins.com.

About the Cover Photos

The seven images on the cover were provided by a few of the many outstanding photographers who so generously contributed to this book. They are: Joy Absalon (baseball player, runner, and field hockey players), Amber Palmer (bicyclists), David Esquire (roller blader), Amy Alden Timacheff (equestrian), and Neal Thatcher (snowboarder).

Credits

Acquisitions Editor
Michael Roney

Project Editor
Cricket Krengel

Technical Editor
Ron Rockwell

Copy Editors
Gwenette Gaddis Goshert
Kim Heusel

Editorial Manager
Robyn Siesky

Vice President & Publisher
Barry Pruett

Vice President & Group Executive Publisher
Richard Swadley

Project Coordinator
Maridee Ennis

Graphic and Layout Technicians
Jonelle Burns
Lauren Goddard
Denny Hager
Jennifer Heleine
Heather Ryan

Quality Control Technician
John Greenough
Joe Niesen
Brian H. Walls

Proofreading and Indexing
TECHBOOKS Production Services

Cover Design
Anthony Bunyan

Preface

My friend Martin has a teenaged son who fences competitively. Last year he spent some time with me at the U.S. National Fencing Championship held in Charlotte, North Carolina, while his son competed at his first really big tournament. Martin had purchased a new point-and-shoot camera with lots of bells and whistles, and he had lots of questions for me as he tried his hand at shooting some fencing in the huge convention center venue.

Martin quickly found that the shutter lag, lighting, and fast action of the hall was more than he had anticipated for his camera, which he was learning on-the-fly. He got an occasional good shot mostly due to the fact that he has a pretty good eye for composition and he anticipated the action, but he became frustrated trying to get good images with good exposure taken at the right moment.

So I worked with Martin and explained how to set his camera at least on a partial manual setting optimized for the environment. When he understood a little more about what the light was like, the settings required for the shots, and how to position himself, he found that he was taking very nice shots — better than he had expected to accomplish.

It became clear to me at that point, that the world at-large struggles with technology — whether it's how to burn a disk, how to download photos to their computer, or just how to deal with shutter lag. In addition, the fundamental concepts and principles of photography, which still apply in full force with digital as with film, aren't necessarily obvious to the average weekend photo enthusiast.

The emphasis of this book is to provide consumers, enthusiasts, and even semi-pros that love sports and who are adapting to a digital photography world a means to create and produce better photographs, more efficiently, easily, and with higher quality that will be appreciated more deeply by a wider audience. I've tried to do this in plain, simple language with both visual and written examples that can be applied to nearly any type of sports photography.

By far, I've taken more photos of fencing than of any other sport. But I also realize that fencing isn't what most sports-minded photographers are out to shoot, and especially not in the far-reaching corners of the Earth I tend to frequent. Hopefully you will find, as I have, that fencing — even if you've never seen anyone do it and you know nothing about the sport — will offer itself as a good metaphor for other types of sports photography.

In addition, I've invited some other photographers to lend their images and experiences in this book to ensure it has a comprehensive perspective on sports photography. Some, like Terrell Lloyd, are professionals who shoot for a living; others are amateurs relating their experiences and how they overcame various challenges you might chance to encounter as well. Their insight to sports photography is an integral and important aspect of this book.

In our book published last year, *Total Digital Photography: The Shoot to Print Workflow Handbook,* Dave Karlins and I focused on concepts of digital photography workflow and oriented our messages to more of a working photography audience. In this book, we strive to apply many of the same principles, but to a broader audience. Nonetheless, this book addresses many of the same photography and technology issues while delivering a workflow methodology and advice for shooting sports with digital cameras.

We hope you enjoy this book and that it helps you take great digital photos to last a lifetime, whether it's of your kids, your favorite team, or for a keepsake of wonderful moments in your life. Your thoughts and feedback are always welcome and interesting to us; you can contact me directly through www.fencingphotos.com.

Good luck with your digital sports photography!

Serge Timacheff

Seattle, Washington

Acknowledgments

As always, many friends, family members, and associates have helped make this book possible. Deepest thanks to them all:

- ✦ Jochen Faerber, press chief, and Nathalie Rodriguez, administrative director, and the entire staff of the International Fencing Federation

- ✦ The United States Fencing Association

- ✦ My family: Amy, Alexander, and Tatyana Timacheff

- ✦ Evan Ranes, for supporting my fencing photography at Duel in the Desert

- ✦ Carl Borack, filmmaker and Olympic fencer, for his support and friendship

- ✦ Cody Mattern, member of the U.S. Olympic Fencing Team

- ✦ Kevin Mar and Josephine Rorberg: Business partners, fencers, and friends

- ✦ My friends throughout the global fencing community, and especially those at Salle Auriol Seattle, Rain City Fencing, Northwest Fencing Center, and the Washington Fencing Academy

- ✦ Cathy Zagunis and her daughter, Olympic Gold Medalist Mariel Zagunis, for their ongoing support of my work

- ✦ David Fugate, literary agent for Waterside Productions

- ✦ Cricket Krengel, Mike Roney, Gwenette Gaddis Goshert, Ron Rockwell, and Kim Heusel for their editorial input and guidance.

- ✦ The many excellent photographers who contributed to this book, and Bob Ruddick, a passionate sports and photography enthusiast, for helping us find them.

Contents at a Glance

Preface .vii
Acknowledgments .ix
Introduction . xix

Part I: Understanding Digital Sports Photography . 1
Chapter 1: The Wide World of Sports Photography . 3
Chapter 2: From Shoot to Print: Workflow . 23
Chapter 3: Equipment and Techniques for Digital Sports Photography 51

Part II: Shooting Sports on Location . 81
Chapter 4: Outdoor Field and Court Sports . 83
Chapter 5: Outdoor Recreation and Competition, On and Off the Water 117
Chapter 6: Indoor Competition Sports . 155
Chapter 7: Extreme and Adventure Sports . 187
Chapter 8: Specialized Sports . 205

Part III: Working with Sports Images in the Digital Studio 227
Chapter 9: Creating a Digital Studio . 229
Chapter 10: Working in a Digital Studio . 241

Part IV: The Ins and Outs of Presenting Your Digital Sports Photos 281
Chapter 11: Output: Getting Sports Photos Online, In Print, and On Display 283
Chapter 12: Going Pro or Covering Costs: Selling Sports Photos 309
Chapter 13: Legal Issues: Taking, Displaying, and Distributing Sports Photos 325

Appendix A: Photography Resources . 337
Appendix B: Contributing Photographers . 339
Glossary . 341

Index .347

Contents

Preface . vii

Acknowledgments . ix

Introduction . xix

Part I: Understanding Digital Sports Photography 1

Chapter 1: The Wide World of Sports Photography 3

Capturing Sports . 4
Athletes and Digital Photography . 5
Trials and Tribulations of Shooting Sports . 6
 Anticipation . 7
 Adapting to the action . 8
The Reality of Equipment . 10
 Great cameras aren't cheap . 10
 Optimizing the point-and-shoot camera . 12
Sports from the Photographer's View . 13
 Adapting to your environment . 13
 Understanding your subjects . 15
 Planning a shoot . 17
 Outdoor field and court sports . 17
 Outdoor recreation and competition . 18
 Indoor competition . 18
 Extreme and adventure sports . 19
 Special cases in sports photography . 20
 Summary . 21

Chapter 2: From Shoot to Print: Workflow 23

What is the Digital Photography Workflow? . 24
 What to do with captured images . 25
Creating a Digital Photography Studio . 26
Choosing a Camera . 26
 SLR: The best option for sports photography 27
 Available SLRs for the sports photography enthusiast 29
Preparing for a Digital Sports Photo Shoot . 30
A Digital Sports Photo Shoot Checklist . 32
 Fast glass, big glass, big bucks . 33
 Packing up . 33
 Choosing a file format . 36

At the Shoot . 37
 Setting up . 37
 Having your camera ready . 38
Avoiding (or Dealing with) Disaster . 41
 Better safe than . 41
 Recovering from disaster . 42
The Post-Pixel Stage: Working with the Digital Image 43
CCD versus CMOS: Which is Better? . 44
Getting Images *into* Your Digital Studio . 45
 Portable hard drives . 45
 Using a flash card reader with a PC . 46
 Image transfer: The software factor . 48
Summary . 49

Chapter 3: Equipment and Techniques for Digital Sports Photography **51**
Nothing Beats a Great Photo . 53
 If in doubt, shoot dark . 53
 Cheat sheets . 56
Zoom, Telephoto, Portrait, and Wide-Angle Lenses 58
 Original equipment versus aftermarket lenses 62
 Optimal optics: Making the most of point-and-shoot 62
Composition, Angles, Exposure, and More . 64
 Composing a good sports photograph . 65
 The rule of thirds . 68
 Taking great digital action shots . 69
 Capturing key moments . 70
 Getting a good angle . 70
 Telling a story . 73
 Developing a style . 73
 Getting proper exposure . 75
 Posing . 75
Choosing a Digital Format . 77
Shutter Speed, Aperture, and ISO . 78
Summary . 79

Part II: Shooting Sports on Location **81**

Chapter 4: Outdoor Field and Court Sports **83**
General Positioning . 84
 Professional sporting events . 84
 Local and amateur sporting events . 86
Equipment . 87
 Venue size . 87
 Field or court access . 87
 Weather . 89
Baseball and Softball . 89
 Positioning . 89
 Settings and getting the shots . 91

Football . 95
 Positioning . 95
 Settings and getting the shots . 99
Soccer . 101
 Positioning . 102
 Settings and getting the shots . 103
Other Outdoor Court and Field Sports 105
 Track and field . 107
 Lacrosse and field hockey . 111
 Volleyball . 114
 Tennis . 114
Summary . 116

Chapter 5: Outdoor Recreation and Competition, On and Off the Water **117**
Equipment . 121
 Considerations on the water . 122
 Protecting your gear . 122
 Choosing the right equipment 123
 Considerations on land . 126
Specific Sports . 127
 Boating . 127
 Positioning . 128
 Settings and getting the shots 129
 Water skiing, wakeboarding, and jet skiing 130
 Positioning . 130
 Settings and getting the shots 131
 Car and motorcycle racing . 133
 Positioning . 133
 Specialized equipment considerations 135
 Settings and getting the shots 136
 Cycling and human-powered wheeling 138
 Positioning . 138
 Specialized equipment considerations 143
 Settings and getting the shots 145
 Skiing and snowboarding (and snowmobiling, too . . .) 147
 Positioning . 147
 Settings and getting the shots 149
 Specialized equipment considerations 152
 Summary . 154

Chapter 6: Indoor Competition Sports . **155**
Lighting . 156
Equipment . 158
Settings . 160
 Telephoto considerations . 160
 Using a flash . 161
 Red-eye reduction . 161
 White-balance . 162

Basketball . 164
 Positioning . 165
 Settings and getting the shots . 166
Martial Arts . 171
 Positioning . 172
 Settings and getting the shots . 173
Ice Hockey . 174
 Positioning . 174
 Settings and getting the shots . 175
Wrestling . 177
 Positioning . 177
 Settings and getting the shots . 178
Gymnastics . 179
 Positioning . 179
 Settings and getting the shots . 181
Fencing . 182
 Positioning . 182
 Settings and getting the shots . 184
Summary . 185

Chapter 7: Extreme and Adventure Sports . **187**
Equipment . 188
Hang Gliding and Paragliding . 190
 Positioning . 190
 Settings and getting the shots . 194
Skydiving and Parasailing . 196
 Positioning . 197
 Settings and getting the shots . 197
Climbing . 199
 Positioning . 200
 Settings and getting the shots . 201
Summary . 204

Chapter 8: Specialized Sports . **205**
Equestrian Photography . 206
 Positioning . 207
 Settings and getting the shots . 208
Golf . 210
 Positioning . 210
 Settings and getting the shots . 212
Ocean Sports . 212
 Offshore Sailing . 213
 Scuba diving . 213
 Surfing, wind surfing, kayaking, and boogie-boarding 216
Swimming . 223
Summary . 226

Part III: Working with Sports Images in the Digital Studio 227

Chapter 9: Creating a Digital Studio . **229**

 Visualizing Your Digital Studio . 230
 Digital photography studio hardware 233
 Computer considerations 233
 Preparing sufficient hard drive capacity 233
 CD/DVD burners . 234
 The best monitor for digital photo work 234
 Color-calibration devices 234
 Networks . 235
 Printers . 235
 Deciding about film and slide scanners 236
 Digital photography software 236
 Photoshop . 236
 Photoshop Elements 236
 ACCSee . 237
 Paint Shop Pro . 237
 Slide show software 237
 Creative/artistic treatment packages 237
 Image management tools 238
 Web Services . 238
 Using Removable Storage Media . 238
 Choosing flash cards . 239
 Storing photo files on CD-R/RW and DVD discs 239
 Summary . 240

Chapter 10: Working in a Digital Studio **241**

 Deleting and Transferring Images 243
 Deleting photos safely . 243
 Transferring images safely 244
 Moving sports photos from field to computer 244
 File transfer tools and tricks 245
 Processing Digital Sports Photos 245
 Sorting and choosing . 245
 Prioritizing . 248
 Checking file sizes . 248
 Renaming . 249
 Storing and Archiving Digital Sports Photos 252
 Editing Digital Sports Photos . 256
 A typical editing scenario 256
 Photo sizing . 258
 Correcting images . 261
 Backlighting . 265
 Fill flash . 266
 Cropping . 266
 Photo Touchup . 268

Redeye tool . 268
Clone Stamp tool . 268
Sharpen tool and Unsharp Mask . 269
Other useful tools . 270
Rotation . 271
Layers . 271
Achieving Artistic Sports Photo Effects 272
Going black and white . 272
Adding text . 275
Frames . 276
Filters . 276
Summary . 279

Part IV: The Ins and Outs of Presenting Your Digital Sports Photos 281

Chapter 11: Output: Getting Sports Photos Online, In Print, and On Display 283

Printing Options . 284
Printing sports photos at home . 284
Preparing photos for printing . 285
Inkjet photos . 286
Other home photo-printing options 287
Using lab services . 287
Walk-in labs . 288
Online lab services . 288
Online Photos for Sharing and Profit 290
Creating your own Web site . 290
Using online photo galleries . 291
Displaying and Distributing Sports Photos 299
Creating a virtual contact sheet . 300
LCD projection . 302
Slideshows . 303
Software considerations . 303
iView MediaPro . 304
Summary . 307

Chapter 12: Going Pro or Covering Costs: Selling Sports Photos 309

Establishing Yourself with Team and Player Photos 311
Stock Sports Photography . 317
Understanding stock photography no-nos 318
Knowing what stock agencies want . 319
Assignment Photography . 320
Sports Photojournalism . 321
Breaking into digital sports photojournalism 322
Freelancing . 322
Joining Pro Sports Photography Organizations 323
Summary . 323

Chapter 13: Legal Issues: Taking, Displaying, and Distributing Sports Photos 325

Understanding the Legal Issues in Sports Photography . 326
Following the rules, even when you think they're dumb 326
Avoiding potential legal pitfalls . 327
Legal issues and youth sports . 328
Legal issues and adult sports . 330
Model Releases . 330
Sports Organizations and Photographers . 332
Protecting Digital Photography . 333
Summary . 336

Appendix A: Photography Resources . **337**

Appendix B: Contributing Photographers **339**

Glossary . **341**

Index. 347

Introduction

Country-by-country, thousands of athletes paraded into the massive Greek stadium in Athens, Greece, for the 2004 Olympic Games opening ceremonies, to the cheering delight of the 70,000 fans from every corner of the earth in the stadium and millions more observing on television. One of the most photographed events ever, camera flashes popped constantly throughout the six-hour performance, a harbinger of the days to come where dozens of sports would be observed through camera lenses almost as much as through human eyes.

The athletes, garbed in their homeland uniforms, cheered back at the crowd, but also mimicked it in another way: Many of them carried their own camcorders and digital cameras, snapping shots of the venue, crowd, and each other and documenting the beginning of the world's largest sporting event from the inside out. Figure FM-1 shows the athletes looking back at the world.

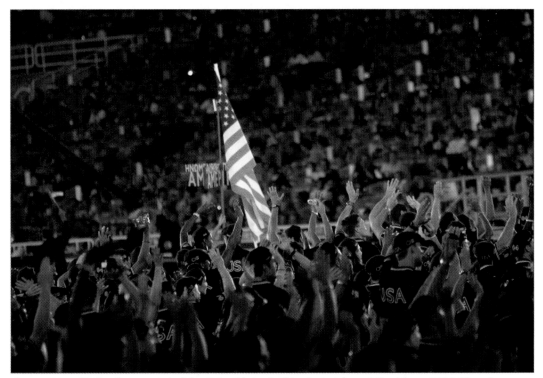

Figure FM-1: Notice that several of the U.S. athletes in this photo taken at the Athens 2004 Olympic Games opening ceremonies were carrying digital cameras and camcorders, recording the event from their perspective.

Kodak, a major sponsor of the Olympics, was pervasively visible throughout the many sports halls and facilities, provided roving personnel able to sell film and digital Flash cards on the spot, and featured a large facility at the main Olympic site where attendees and athletes could process film as well as digital images on the spot. And, while the photography company still provided much for the film photographer, it was clear that the company is firmly committed to the digital format.

In fact, the Athens Olympic Games were the first time in history that film photographers were in the minority. From point-and-shoot to high-end SLR, amateur to pro, digital was experiencing its own form of Olympic victory as the format of choice.

So, welcome to the world of sports photography, where you get to experience, up close and personally, what may be the sport of your dreams, the athletes you idolize, or maybe just your 10-year-old engaged in an early and memorable moment of athletic drama. Digital photography provides a way (and even sometimes an excuse!) to be close to the action, to remember and share the moments, and maybe even to make a living at the same time!

The Breathtaking World of Digital Sports Photography

As a professional and official photographer at the Olympic Games, I was there to shoot for the International Fencing Federation. I also was there on behalf of Corbis (the global leader in stock and assignment photography images), the United States Fencing Association, and numerous publications and fencing federations around the world. My assignment was to capture all the fencing action for nine days of competition, plus the events surrounding the sport, including the opening ceremonies. Everything I photographed was digital, and by the end of eleven days in Athens, I had more than 13,000 photos stored on multiple DVDs and several hard drives. Even before I left Athens, many of these images had been posted online on my own Web site (www.FencingPhotos.com), on Corbis, on various fencing federation Web sites, and on news services.

Among the other pro photographers shooting fencing, digital photography was virtually the only format used. On occasion, I noticed a film camera in use, but by far film was in the minority. Several photographers, shown in Figure FM-2, anxious to get photos of gold medal matches and ceremonies uploaded as fast as possible, sat at the fencing finals taking photographs with a wirelessly connected laptop beside them. In some cases, the athletes had barely left the podium with their medals by the time their images had been posted on the Web for the connected world to view.

At the same time, the crowds watching various sports also captured their favorite athletes and competition with their own digital cameras and, in many cases, were able to e-mail or post images home from Internet connections in their hotel rooms. Others simply took their flash cards to the Kodak center for processing, walking away with CDs and prints of their images.

For many amateur and hobbyist photographers, this may have been their first time shooting high-level sport. At the Olympics, with so many venues, environments, lighting situations, types of seating/positioning (both good and bad), and types of action, these same enthusiastic shutterbugs inevitably found that taking a good shot of sports action wasn't necessarily easy, even if their shiny new digital cameras were packed with features and options making them seem almost capable of capturing shots by itself.

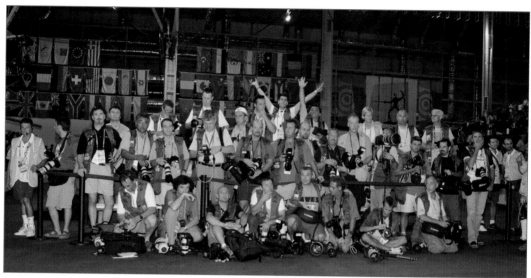

© "Panos," member of the Greek Olympic media support staff.

Figure FM-2: Virtually digital: Athens 2004 Olympic photographers after a gold-medal fencing final and awards ceremony. The author is third from the left.

Challenges for digital sports photographers

Arguably, the two most frustrating aspects of digital sports photography for the consumer armed with a point-and-shoot digital camera are how to manage lighting and dealing with *shutter lag*, which is that pesky tendency of less-expensive equipment to respond less than instantly when the shutter release is depressed. Although the camera may be perfect at taking a good image of a still subject that is lit well, a moving athlete in tricky lighting — which is often the case in sports — makes for a challenge to even the most feature-rich point-and-shoot device.

In some cases, these same cameras can take surprisingly high-quality photographs of sports action. It may be that their automatic settings are directed just right, or the photographer may have intervened and used as many manual settings as possible after testing images beforehand. Whatever the case, when these cameras work well, they work very well and produce images suitable for printing and framing that rival some of the best work by a seasoned pro. But you need to know what you are doing to get consistent results.

Secrets of the pros

The factor that differentiates pro photographers from consumers — other than equipment — is the ability to *replicate* photographs of great sports action over and over again. Nearly anyone can catch a lucky shot on occasion, but to catch a spectacular moment intentionally takes practice, knowledge of lighting and composition, command of equipment, and positioning. Knowing ahead of time how to take the photograph, even if it's of something unexpected, requires some preparation and training. Furthermore, it takes a bit of knowledge of the sport to understand when something remarkable might happen and to be as ready for it as possible.

The photo in Figure FM-3 was just such an occurrence. It shows United States foil fencer Jonathan Tiomkin leaping into the air above Russia's Renal Ganeev in a bronze-medal team battle in Athens. I've shot more than 150,000 fencing photos of high-level fencers, and I had never seen anything like this move. It was completely unexpected and literally came out of nowhere. Fortunately, I had begun shooting my camera, a Canon 1D Mark II, which is capable of shooting more than eight frames per second with no shutter lag, as Jonathan quickly advanced against his opponent. He was moving fast, and I diligently recorded nearly every action in semi-finals and above, ready for a moment just such as this.

After Jonathan landed and the touch had been scored (ironically, his opponent won the encounter), I held my breath and looked into my LCD to see whether the image was focused, centered, and exposed well. My camera had been set properly for the action, and I knew I had captured at least some of it, but even pro photographers have their moments of doubt when something truly remarkable happens. After all, I don't see some of the best shots until they are actually displayed digitally because, if I'm doing my job correctly, the mirror in my camera is up when the shutter opens and closes, so I can't actually see through the viewfinder at that moment of truth.

Does every shot a pro takes turn out perfectly? Absolutely not. I would hate to chronicle the number of incredible images I've missed. However, as a pro, I'm always trying to do whatever possible to hedge my bets, prepare, practice, and improve my percentages. From one shoot to the next, even if I get ten good shots instead of nine out of every hundred, that additional image may be the one photo that takes me to the next level of my career.

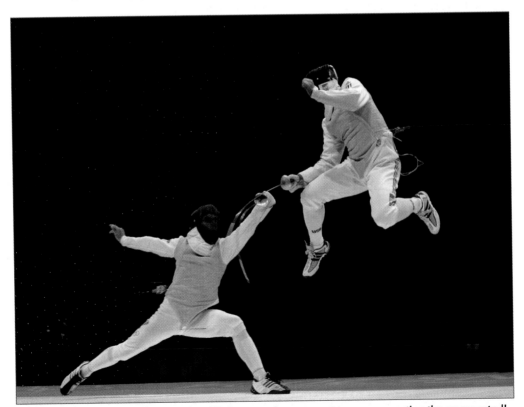

Figure FM-3: Being ready for once-in-a-lifetime sporting moments means expecting the unexpected!

In the case of Figure FM-3, preparation, training, and having shot so many fencing images paid off. Furthermore, being a competitive fencer myself and intimately knowledgeable of the sport helped tremendously. The image turned out to be a phenomenal, almost unbelievable shot of one of the rarest moves anyone has seen in the sport. My camera settings and focus were dead-on, my positioning alongside the fencing strip was good, and the composition was symmetrical with the athletes centered in the viewfinder. It was a shot that only a tremendous amount of preparation and a little luck was capable of capturing.

This isn't to say that amateur photographers are doomed with the equipment they have or the limited time they get behind the viewfinder. The good news is that plenty of camera equipment — even the point-and-shoot type — is perfectly able to capture lots of action well if used properly and with some understanding of how to put together a good photo. And, with the right instruction and practice, anyone with a digital camera and an interest can take some fantastic photographs.

Who Is This Book For?

Digital photography today is seeing huge growth around the world, and photographers of all types — from those who have never taken anything but a snapshot to *Sports Illustrated* pros — have made or are making the switch from film to digital. Most sports pros have already made the switch, and for them this book will be just the basics. However, I've asked several of them to contribute photos along with some tips and tricks, which benefit you because you learn from the best.

This book, then, is specifically for the following types of photographers:

+ Photography enthusiasts, semi-pros, hobbyists, and amateurs

+ Photographers interested in learning more about how to shoot sports

+ Parents and spouses who want to have something really creative, memorable, fun, and active to do while watching and supporting children and other family members as they compete in various sports

+ Sports photographers making the transition from film to digital

A Note about the Sport of Fencing

Arguably, fencing isn't the most all-American sport; however, it is featured throughout this book in a number of places both in the text as well as in photographs. Statistically, it is one of the fastest-growing sports in the U.S., and at the Athens 2004 Olympic Games, the U.S. won its first gold medal in 100 years. Mariel Zagunis of Portland, Oregon, took the gold in women's saber, with Sada Jacobson wining a bronze medal — which has increased fencing's interest, especially among young people.

As a fencing photographer for much of my work, I have more fencing photos than any other sport — in fact, I have more than 500,000 fencing images. As a result, many of my best shots are featured in this book. But it's not only because fencing is what I shoot: I believe the sport is a good model for learning lots about sports photography in general. You have to learn to shoot lightning-fast action in low-light conditions, and you cannot use a flash. These factors alone make it a tough sport to photograph at all, much less creatively.

You may not be interested in fencing per se, but that shouldn't prevent you from appreciating the application of fencing sport photography to a wide variety of sports, whether they are team, individual, outdoor, indoor, or extreme. You'll find elements of all these in one way or another when shooting fencing, so I hope the metaphor of this international and historical sport will help you in anything you may endeavor to capture.

So, although the book isn't for everyone, many of you out there are shooting sports digitally and want to know better how to do it. And some of you may even be interested in making, at the very least, a modest part-time career of it — and that's a very viable pursuit with all the products, tools, and resources available today, in terms of equipment, software, and online services.

What Does This Book Cover?

Digital Sports Photography will help you be ready to take the best possible images you can with the equipment you have. In the predecessor to this book, *Total Digital Photography*, we looked at digital photography workflow, which is how to manage the creation of a good digital photograph from conceptual beginning to final presentation. And, although workflow is an essential element of sports photography as well, other factors that relate specifically to how to best shoot athletic action and drama with a digital camera must be considered.

In this book, you will examine a variety of sports and what it takes to shoot them digitally, including the right equipment, sports-specific factors, how to process images once in the digital studio, and what to do with them when they're ready for printing, display, and distribution. Whether you simply want to share family photos of your children playing soccer or competing at a gymnastics event, or you're thinking of going pro and selling your work, this book is a foundational primer for getting you where you want to be when it comes to digital sports photography. Sometimes it is personal and professional, as in Figure FM-4 of my son, Alexander, at one of his first national fencing tournaments. It's as important to me as any professional shot I've taken!

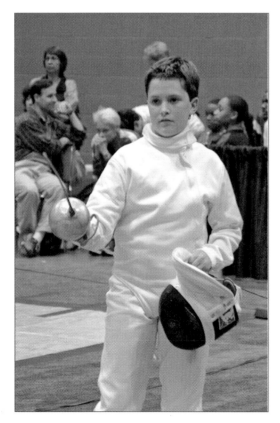

Figure FM-4: Even if you're only taking snapshots of family members pursuing their sport, it's important to know what you can expect out of your camera, what shots you're most likely to be able to take best in various situations and conditions, and how to compose a nice shot — and then what to do with it back in your digital studio.

Without putting yourself in harm's way as a photographer, such as shooting in a war zone, for example, you'd be hard-pressed to be able to shoot as much human drama as you find in sports. It can be one of the most exhilarating experiences you have as a photographer and as a spectator, no matter whether you play the specific sport or know one of the competitors. It's just a wonderful way to exercise your skills as a photographic artist and to build your technical abilities with a camera. When you're truly immersed in photographing sports, you become in tune with the camera, and nothing else, for that time, seems to exist. Being in control of your environment and equipment, understanding what's happening, and being ready for the unexpected allow you to concentrate on creativity and visual storytelling to a degree that you may not have thought possible or so rewarding. Furthermore, getting the shot may mean finding the best spot where you can safely have the perfect vantage point for a dramatic image.

Whether you're on a basketball court's sidelines, balanced on a snowboard, sailing five-foot waves, or simply shooting your kids playing football in the backyard, you should be keenly aware of the limitations and challenges that present themselves. And, in the end, getting to the top of the digital sports photography game itself can give you a personal or even a public victory that rivals winning even the most coveted of sports medals.

Contributions from Other Photographers

As a professional photographer, I've shot around the world in a wide variety of locations and venues. Much of my work has been all about sports, and especially fencing. I photograph all the International Fencing Federation Grand Prix events and World Championships, including the Olympic Games. In the last two years, this work has taken me to sports/fencing shoots above the Arctic Circle in Finland, Bulgaria, Cuba, Greece, New York, Las Vegas, Japan, Austria, Qatar, France, Algeria, and Germany — and that's in addition to my other commercial work, workshops I've taught, and what I've done to write this and my previous photography books. I've shot half a million digital images, just since 2001. Yet every time I meet and talk with other photographers of any skill level, I find that I learn new things I didn't know or that I could do better.

Photography, like most sports, is something you can keep improving and learning, whether you're working on major issues or fine points of detail. You can only benefit from seeing images others have (see Figure FM-5) produced and hearing how they approached the problem of getting certain shots.

However, what I have realized in developing the concept for *Total Digital Sports Photography* is that although I have a variety of sports shots, I still needed to have more images from a variety of other sports. So, by including information from the pros and enthusiasts alike, who are shooting a broad variety of sports, including skiing, boxing, baseball, football, and many more, I'm able to share with you the tips and tricks from a variety of pros out there, and I also have a chance to share some of their fantastic photos from equally exotic and exciting sports shoots.

Although some of the guest photographers are professionals, such as Terrell Lloyd, official photographer for the San Francisco 49ers, not all are doing it for a full-time living. Because I'm including tips and information from many different photographers, you get a cross section of what all types of digital photographers are doing, and how they are getting it done.

So, in advance, thanks to the photography contributors to this book — it's very much appreciated by us all! And, most of all, good luck to you in capturing the best images of the sports you love!

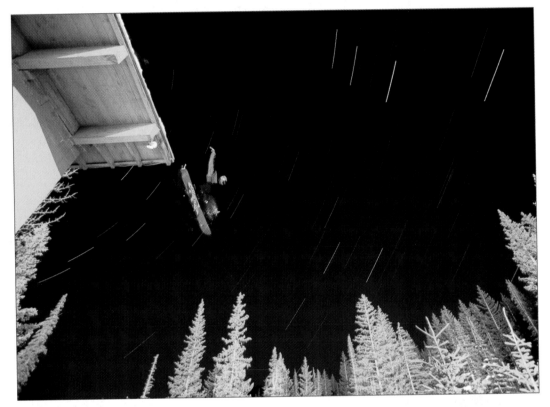

© Will Wissman

Figure FM-5: This spectacular winter image by Will Wissman features multiple elements of photographic difficulty and creativity.

Understanding Digital Sports Photography

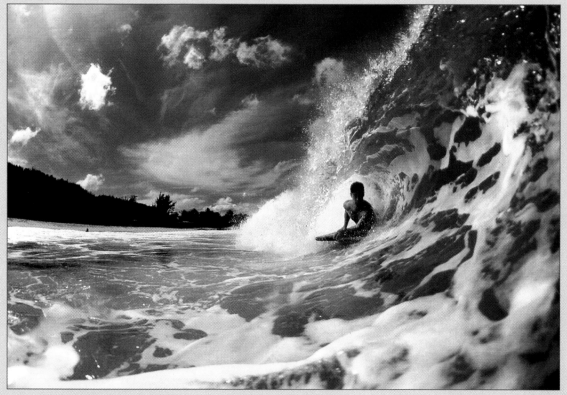

© Neal Thatcher

Chapter 1
The Wide World of Sports Photography

Chapter 2
From Shoot to Print: Workflow

Chapter 3
Equipment and Techniques for Digital Sports Photography

1

The Wide World of Sports Photography

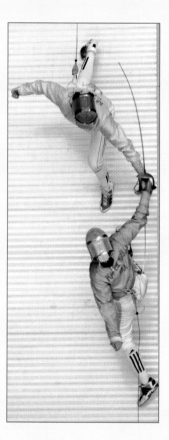

Sports fans and photographers are, individually, two of the most passionate groups of people you'll ever find. Combine these two, and you've got a recipe for obsession — a lifetime of getting close to the action, capturing life at its most dramatic, and sharing it with the world.

For a sports photographer focused on shooting an event, there's nothing else in the world that matters more than what he or she is seeing and experiencing at that moment. For the professional photographer, sometimes it means shooting a sport you don't necessarily know well. For example, professional photographers at the Olympic Games often get assigned to two or three different sports every day and must

quickly learn the key things to see and shoot, whether it's kayaking, equestrian jumping, javelin throwing, or ski jumping. However, while these photographers may not have a driving passion for some of the individual sports they shoot, they typically became sports photographers because of their passion for sports overall.

Let's look at digital sports photography overall: what it means to shoot sports events, how sports photographers (whether amateur or pro) integrate with an event, and the importance of knowing the sport you're documenting. In addition, this chapter looks at the types of equipment you may be using or will need to use for best results, and it reviews the various sports categories from a photographer's perspective.

Capturing Sports

If you're an amateur enthusiast or semi-pro, you're probably intent upon shooting a sport you love or one that someone you love loves (such as your spouse or child). And the dramatic moments of victory or defeat are all the more sweet or bitter as a result. Being able to document those moments for posterity in the form of a well-shot photograph is valuable far beyond its ability to create revenue or be published because it will be cherished by those who love not only the sport, but the player.

Even when you know you have taken a nice shot, it may have impact you don't realize, such as when a Swiss fencer won a gold medal that turned out to be the *only* one won by his country at the Athens 2004 Olympics, as shown in Figure 1-1.

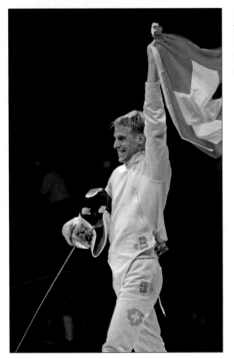

Figure 1-1: Shooting athletes' moments after a big victory often requires quickly changing a camera from an action setting to one that's optimized more for portraiture — or using an alternate camera set appropriately.

Nonetheless, some digital camera–packing photographers become so involved with the gadgetry of today's technological marvels that they fail to see the action they're intent upon capturing. Then, when they go to edit their images, they hardly remember the sequence of action, often have poorly composed images, and often have missed key moments in the event.

Just like with photographing in the studio, at a wedding, or on location at a news event, photographers capturing sports — professional and amateur alike — must be in tune with their subject matter and involved with what's happening. While the athletes may be (and often are) nearly unaware of the photographers' presence, there is still at least an implied relationship between the player and the shooter.

Athletes and Digital Photography

Often the biggest customers of sports photography are the players who want to be able to see themselves performing on the field of play. And, although they may not be thinking of the photographer during the intensity of competition or athletic endeavor, they undoubtedly know at some level of consciousness that they are being watched. This, in turn, affects how they perform, heightens their adrenaline at least a little, and gives them a bit more of the home court advantage knowing there's an interested audience.

Some athletes may take the opposite tack, shunning publicity or being watched on- or off-camera. For some, participating in a sport, in spite of its inherent public performance factor, is a very private thing, and these athletes find themselves easily distracted by anyone observing them. Yet as a photographer, you may still want or need to get shots of these reluctant subjects engaging in their sport, which adds a further bit of challenge to the effort.

Capturing the moment in Figure 1-2 required being discreet while shooting in a weight training facility so as not to disturb athletes while they were training.

The relationship between observer and performer, player and photographer, athlete and spectator is intertwined permanently. And you, the photographer, must understand and engage in this relationship in order to create the best images of the player and the event. To do so means understanding how to shoot the event, how to best use the equipment you have, and what to do best with the images you capture.

You Still Have to Get the Shot . . .

It's not unknown for photographers to be blamed for a competitor who misses a shot or loses a match! I had exactly this happen at a fencing tournament. A parent hired my company to photograph her teenager fencing. The teen then lost an important bout. I was blamed for "being a distraction" to the fencer, who happened to be very shy and didn't want his photo taken. The parent had asked that we try to be discreet about taking the photos, which we were. However, often it's impossible to hide completely and still get a good photo, so it was a calculated risk.

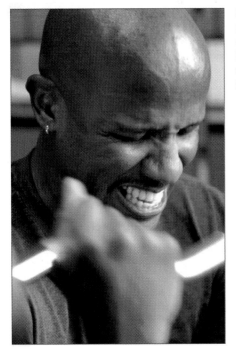

Figure 1-2: Shooting quietly and without distraction requires limiting use of the flash, or not using it all, and often using a longer lens when getting close-ups. This image was shot from about halfway across the room with a 70-200mm, 2.8 lens at ISO 400 at 1/250 second to give it a narrow depth-of-field look.

Trials and Tribulations of Shooting Sports

For most sports, photographers have little, if any, control over their environment. Unlike a studio shoot, or even taking a snapshot of friends, the lighting cannot be controlled, the players cannot be posed, and finding a good spot from which to shoot may be tough. At the most exciting moment of the event, the action you want to shoot may be on the other side of the field, the player may be facing away from you, a zealous fan may jump in front of your lens, or another photographer may suddenly obstruct your view or bump into you.

The photo in Figure 1-3, taken at the Athens 2004 Olympic Games, shows the difficulty that even pro photographers sometimes have in getting a good vantage point to do their work.

Pro photographers often have to fight for the best positions at sporting events. At the Olympics, official photographers are given key positions, and hierarchies exist among the ranks. Photographers receive official vests for identification, and a special vest is given to each photography/media organization, allowing those individuals premium positions in front of other photographers.

Still, photographers often have to elbow and wedge their way into a good slot to be able to see athletes receive medals or top performers doing their thing on the field or court. Add to that the language barriers and variety of cultures at an event like the Olympic Games, and you suddenly have a group of pros that can become hostile at a moment's notice if they aren't getting the shots they want or need.

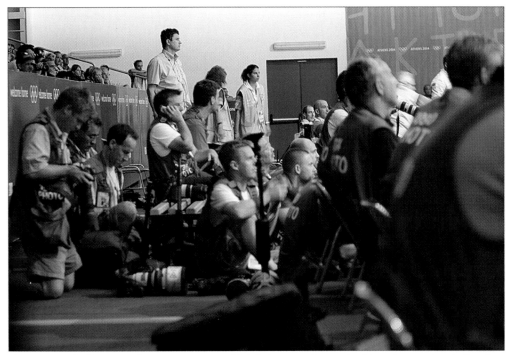

Figure 1-3: Finding a good spot, even as an official photographer at the Olympics, can be challenging; comfort often becomes secondary.

Anticipation

One distinguishing characteristic of how pro versus amateur sports photographers shoot is how they anticipate the action. Amateurs typically shoot as things happen — usually with only one camera — and wait for the best moment to try to take a great shot. Pro photographers are ready for anything and shoot almost all the action — even the boring parts. They know they can simply delete or edit out the useless images later. Furthermore, they *anticipate* the action.

In Figure 1-4, for example, I had taken a quick sequence of shots where these Olympic foil fencers were actually trying to keep each other away; however, in the process, the image ended up appearing much more like a malicious act where one was kicking the other in the chest. However, because of the action that preceded this move, I had been able to anticipate that the fencers would execute an action that would be interesting.

If a gold medal is about to be won, pro photographers have an alternate camera ready to go that's been preset for the lighting changes when the team rushes onto the field to celebrate the win; often the settings and lenses needed for capturing celebration shots are different than what might have been needed for the final scoring action.

Of course, you may not be shooting the Olympic Games, and you might not be out on the field with two or three cameras. Nonetheless, the concept of anticipation and the principles of sports photography apply to successfully capture great photos, whether you have a fixed-lens, point-and-shoot camera or a high-end SLR (single-lens reflex) camera — meaning it uses detachable, interchangeable lenses and, when

you look through the viewfinder, you are looking through the lens. When you're anticipating action, it depends on the capabilities of your camera as to how you can shoot an athletic sequence. If your camera can take bursts of shots in rapid succession, you can anticipate when action is just about to take place, hit the button, and let it go (assuming you have your settings, focus, etc. correctly adjusted). If your camera is a bit slower, or the number of shots it can buffer in a burst is low, then you may be better off pressing the shutter release one shot at a time. The slower the camera, the more you'll need to hone your anticipatory skills — and you'll also want to know the sport well. So anticipating and getting good shots involves knowing the capabilities and limitations of your equipment, understanding the sport, and composing the shot well. Anticipation is all about being prepared to position yourself to take different types of shots as the phases of sports action and ultimate victory (or defeat) take place.

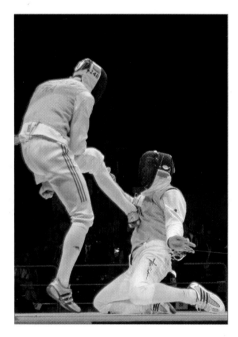

Figure 1-4: Anticipating action involves being ready with the camera and knowing the sport.

Adapting to the action

As a photo enthusiast, you may find yourself limited to being able to shoot from only one seat in the stands, or being very limited in terms of where you can go to take a good photo. This is where equipment can help, at least to a degree, in allowing you to have a closer view with a longer lens, a camera able to shoot good photos in limited light if a flash isn't an option, or the ability to take multiple frames per second to ensure that you catch the action as it takes place.

The photo in Figure 1-5 required me to shoot at a distance, in low light. For this type of shooting, you'll need an SLR with a detachable lens that supports a wide aperture (such as f/2.8) and a high ISO rating. The newer, high-end SLRs allow you to take photos at a high ISO (like 1600 or higher) with a surprisingly small amount of digital noise in the image.

Most often, these options mean buying cameras and accessories that cost more and are more bulky than the simple point-and-shoot models, but if you're truly intent upon getting good photos, you'll have to consider spending the extra money and toting the extra weight.

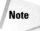

Note　I return to special issues involved in shooting action shots in the course of addressing specific challenges of different sports in Part II of this book.

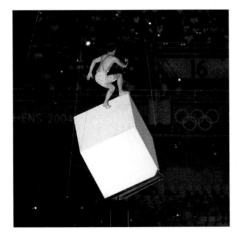

Figure 1-5: Photographing this very athletic performer at the Olympic Games opening ceremonies demanded that I use a fast telephoto lens. I shot at an f-stop of 2.8 at all focal lengths in order to get a crisp shot from a long distance.

Obviously, some sports place more demands on your ability to capture high-speed action than others, but these are some basic principles involved in capturing action shots:

✦ **Know the sport.** Even photographers with only moderately fast cameras can often get good shots if they know what's happening, they make educated guesses as to what might come next in a key competition, and they find the best or most creative vantage points.

✦ **Know what your equipment can and can't do.** For some action in certain lighting conditions, only an expensive, high-speed SLR with a fast lens (meaning that it can shoot at any focal length at a constant, wide aperture setting such as f/2.8) will suffice; in other instances, you may be able to use a point-and-shoot and get good results. In any event, practice with your equipment before having to shoot a "moment of truth."

✦ **Get as close as possible to where pro photographers locate themselves.** Sometimes being close to referees and coaches — as long as you don't get in their way — can provide a great place from which to shoot action shots. I've even shot from the platform of a TV camera before, using a long lens.

✦ **Know the shots you need to get, and study them ahead of time.** Read major sports magazines, such as *Sports Illustrated*, and look at the Web for various images. Use Google or Yahoo! to search for images instead of text; the Web is a great resource.

✦ **Take more shots than you think you'll need.** You can always delete images, but you can't add them!

✦ **If you need your camera to catch more stop-action and you can't get the right exposure, shoot a little darker than you normally would.** This allows you to increase your shutter speed. You can lighten images in your image-editing package relatively easily.

✦ **Don't be afraid to shoot tight, meaning that some parts of the athletes are cut off.** This adds drama to your action composition and makes the person seeing the image really feel close to the action.

The Reality of Equipment

Ever wonder how the pro sports photographers in *Sports Illustrated* and other publications get those great shots that you just can't seem to get, even when you're just as close to the action as they are? In part, the answer lies in techniques that I'll be illustrating for you throughout this book. But the other factor behind those spectacular photos involves the equipment those pros are using.

There's no substitute for a high-quality camera to capture the essence of an athlete, and this can be true both in action as well as personal portraits, such as the image in Figure 1-6.

Here, and throughout this book, I'll be sharing insights into the type of equipment that I and other professional sports photographers use to capture those insanely hard-to-grab sports moments to which we all aspire. Don't despair if your personal equipment isn't professional quality — this doesn't mean that you can't get professional-quality photographs with some practice. You'll find the behind-the-lens insights shared throughout this book are helpful no matter what kind of digital equipment you currently use. And the range of equipment options available is enormous.

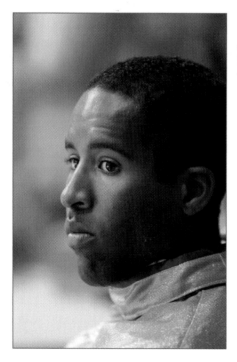

Figure 1-6: U.S. Olympic saber fencing champion Keeth Smart, in a thoughtful moment at the Olympic Games. The Canon 1D Mark II is excellent for capturing high-end sports images, whether they're still, such as this one, or high-speed action.

Great cameras aren't cheap

The camera that I use for shooting fencing and other sports is a Canon 1D Mark II, a top-of-the-line sports and photojournalism camera. It is capable of shooting more than eight frames per second at 8.2 megapixels, up to 40 frames without stopping or slowing down. Dozens, if not hundreds, of lenses are available for the camera, and it can shoot at 1/8000 second at up to 3200 ISO. If it can be seen, this camera can see it. High-end cameras, such as the ones I use, are protected by multiple seals and magnesium bodies that prevent moisture, dust, sand, and other elements from affecting the cameras' performance.

Note

Canon is not the only company making high-quality digital SLRs. Nikon also has a line of these professional-grade cameras.

The photo of the French Olympic saber team, shown in Figure 1-7, was taken with a Canon 1D Mark II. I used the camera's ability to shoot more than eight frames per second to capture the team jumping in the air all together, something I couldn't have pulled off as easily with a camera that had shutter-lag. With a point-and-shoot or camera that's not quite as fast, getting images like this will result from really knowing how to anticipate the action or by getting lucky when you hit the shutter release. However, by placing any camera on manual instead of automatic settings, your speed will be optimized, and, consequently, your likelihood of getting spontaneous action shots.

Cross-Reference

More detailed settings for various cameras and sports are covered in the chapters located in Part II of this book.

Fast, professional cameras are prohibitively expensive for the average amateur and enthusiast photographer; however, we want to address how you can optimize your camera to get the best shots possible, even if they aren't Olympic images. Within the scope of consumer cameras, there is still a large difference between products that will produce decent photos of fast action and ones that won't. And, for many consumer cameras, they've been geared for totally automatic shots taken by someone who really has very little interest in knowing how to set the camera in an optimal way. Yet, many of these cameras are capable of quite a bit more than you might expect if you go to the trouble of understanding how to operate them manually. But this also means knowing how to set the camera for the type of action, light, and sport you're shooting.

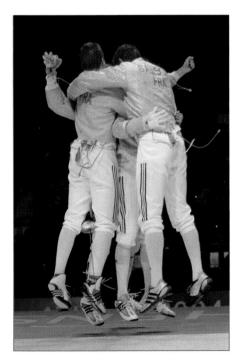

Figure 1-7: The French Olympic men's saber team celebrates with a group jump after winning a gold medal in Athens — the only event in fencing in which the French had not yet won a gold medal until this moment.

About That Digital Zoom

Digital zoom does not mean using a zoom lens with a digital camera. Instead, it refers to a process that allows digital cameras to zoom in on a subject without (or beyond the capacity of) a zoom lens. Normal, optical zooming is accomplished with lenses that capture more data. In extending the enlargement of an image beyond the capacity of the lens, digital zooming captures less data, resulting in blurrier or grainier images. There is *no* good reason to use digital zooming features if they are included with your digital camera. You can achieve better, more controlled results using cropping techniques in your digital darkroom, as discussed in Chapter 10.

Optimizing the point-and-shoot camera

For sports, you might think that a point-and-shoot digital camera is often very impractical, and for the high-end professional photographer, it is. However, many consumer photographers — from amateur to avid enthusiast — are finding them very practical for a wide variety of photography. In addition to my high-end SLR equipment, for example, I also carry a Canon point-and-shoot for photo opportunities where it's a pain to drag-out all of my big equipment.

First, the limitations: For shooting fast sports, the biggest problem is that point-and-shoot cameras usually have the greatest degree of shutter-lag, which means that they have that pesky tendency to respond slowly when the shutter release is pressed, making shooting any action sport very difficult. Also, a simple digital camera often does not zoom in very well. With a point-and-shoot camera, you cannot interchange lenses, and you usually cannot add a flash. Simple digitals can take a long time to record a single image onto the flash card, and they are limited when it comes to sensitivity (often with an ISO limited to 400).

This doesn't mean that you're doomed if a point-and-shoot is what you have; it just means you'll have a harder job getting the shots you want, you need to hone your anticipation skills, and you need to learn to understand the limitations of your particular camera. And don't be fooled. Just because the camera has a reasonably high mega-pixel count, such as 5.0 or higher, it doesn't mean the image quality will be great if you still have to use a digital zoom or other technological innovations. Generally, a digital zoom ends up producing poorer quality images.

If you're going to shoot sports, having an SLR camera is desirable. And, if you are using an SLR, the following features are important:

✦ The ability to interchange lenses of various types: wide angle, zoom, telephoto, portrait, and so on

✦ A shooting speed rating of at least four frames per second

✦ A minimum sensitivity rating of ISO 800 or higher

✦ A shutter capable of shooting photos at 1/500 second or faster

✦ For some sports, having a tracking auto-focus is helpful. A tracking auto-focus changes the focus on a moving object without your having to do anything except keep your finger on the focus button (called "AI Servo" in Canon cameras).

✦ A buffer of at least 15 images, meaning that the camera shoots at its maximum speed up to this many shots before it has to stall to download images.

✦ Image stabilization, especially on telephoto lenses (it's less useful on shorter focal lengths); this is an ability in the camera or lens to electronically "steady" itself to capture a clear, non-blurry image even at a slower speed and when the camera is moving or shaking.

If you do have a point-and-shoot camera or are considering buying one, there are some key features to look for if you're going to be shooting sports:

✦ Higher ISO capability (ISO 400 or higher)

✦ A fast shutter speed (at the very least, 1/250 second)

✦ The ability to manually set the ISO, shutter speed, and aperture (f-stop)

✦ The ability to disable the flash

✦ As little shutter-lag as possible (to really determine this, your best bet is to go to a camera store and try out the various cameras)

✦ As broad an optical zoom range as possible

Sports from the Photographer's View

For virtually every sport on the planet, there are great photo opportunities and a nearly infinite number of ways to shoot the game, the action, the players, the spectators, the environment, the officials, the losers, and the winners. No matter what your level of expertise, if you have a desire to photograph sports, there's an open invitation waiting to capture it like no one ever has.

That said, almost nothing is photographed more than sports. And the digital revolution has had as great an impact on sports as (and probably more than) any other realm of photography. When *Sports Illustrated* went completely digital to shoot (and store!) over a half *million* images at the 2004 Olympics, that decision indicated the dominance of digital photography in sports.

To completely understand digital sports photography, you need to consider where you are going to be working and the impact location has on how you work. You also must try to understand your subjects and their sports, and to determine how you want to capture the action.

Adapting to your environment

Sports are unforgiving to the photographer. You must adapt to your environment; it's not going to adapt to you. You must be ready to deal with whatever lighting exists, possibly harsh outdoor conditions, and people moving about quickly — not necessarily in the direction or facing the way you want them to. It means that even if you're a professional, you won't always get the shot you want, and you may miss something you really need. You'll swear that you'd be rich if you had a dollar for every great shot you missed, and you'll cherish the times when you actually get the great shots.

You'll shoot far more photos than you'll ever need, which means you'll also need to be prepared for postproduction digital photography workflow: Processing, archiving, prioritizing, and presenting images efficiently and effectively will be key to your ability to consistently and successfully execute photo shoots of sports events and figures. The photo in Figure 1-8, for example, is a posed photo. However, the subject, a third-level black belt, was very sensitive to being sure he was positioned and posed correctly to capture the essence of his achievement in martial arts.

It is, then, incumbent upon the photographer to understand what it takes to shoot a specific sport, what various environmental factors will affect the photos, what is important and meaningful in a given sport, what kind of access you'll have to athletes and competition, what the capabilities and limitations are of the equipment available, and what the intended purpose is of the images to ensure the best possible workflow.

Ask yourself these general questions before shooting any sport:

✦ What do I know about this sport and how can I use that knowledge?

✦ What do I need to know in order to understand it well enough to take interesting photos?

✦ Will I be in any danger shooting the sport, such as hanging out of a moving or flying vehicle? What should I do to ensure my safety?

Here are some location-related questions to consider:

✦ Where should I position myself to take the best shots, and how accessible is that spot? What alternative or other positions should I also consider?

✦ Should I avoid some people or places, such as standing in an end zone or getting in the way of a coach or referee?

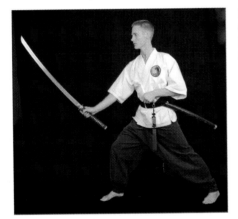

Figure 1-8: Even a posed shot can require learning about a sport and working with the athlete to understand what is required to capture the real feeling of the sport and represent it properly.

Consider what you need to know about the athletes and officials:

✦ Do I need any special permission to take photos, or am I prohibited in some way from taking photos?

✦ Will I have access to players before, during, or after the event in order to take some personal photos?

✦ If necessary, will I be able to identify players after the event by looking at photos (especially important for images that will be published or sold)? Do I need to observe or capture any key players?

Consider what you need to know about the location:

✦ Is the activity going to be indoors or outside?

✦ What will the lighting be, and how will that affect my photos?

✦ In this venue, how close can I get to the action?

✦ How physically fit do I need to be to get the best shots (will I be in the water, skiing the back country, or jumping out of a plane)?

✦ Based on the sport and how I plan to get the shots, what limitations are placed on my ability to access equipment, change lenses and flash cards, etc.?

✦ Do I need to consider environmental factors, such as salt water, cold weather, rain, or even crowds of pushy people?

What equipment you need varies depending on the situation, so consider these points when packing your gear:

✦ Do I need to be able to enlarge the photos? How much? Will they go online or be printed?

✦ What size JPEG files or other formats should I use to optimize my flash card usage but still have images that are large enough for what I need?

✦ Will I be able to use a flash?

✦ Do I know how far I will be from the action?

Understanding your subjects

Obviously, some sports are photographed more than others, and some pro sports are photographed almost exclusively by pro photographers due to limitations placed on photography by professional sports organizations. For example, the International Olympic Committee requires significant documentation and application procedures to become an official photographer, and the credentials are stringent and very limited in their availability. Applications must be submitted many months before the games. Sports publications and organizations commission all of their photos from pro photographers dedicated to providing a comprehensive service of photographs for the event. These photographers receive privileged access to shoot the events. But amateurs and enthusiasts sitting in the stands or on the sidelines at events can still get great photos, even if they aren't going to end up in *Sports Illustrated*. In fact, the average amateur photographer today has many more opportunities to get their images seen thanks to being able to put images online.

Most pro and big-venue sports events provide comprehensive services for working photographers to be able to review and process images and get them to news agencies and organizations virtually immediately, as seen in Figure 1-9.

However, whether you have an interest in getting on the sidelines of a basketball game in a sports arena, shooting your son's snowboarding competition in harsh winter conditions, or hanging on the side of a mountain rock face to catch your buddy in mid-rappel, you need to consider each sport individually in terms of what it demands of photography.

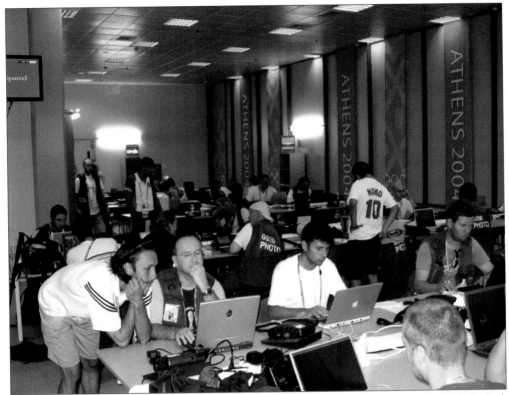

Figure 1-9: Olympic photographers working in the main media facility, where access is strictly limited to working, credentialed photographers

Consider the general parameters of the sport:

✦ What is the nature of the sport? That is, how is it played, where is it played, and who plays it?

✦ Is it fast or slow?

✦ Is it performed in a big or a small space?

✦ Is it indoors or outdoors?

✦ What particular environmental factors need to be considered, both for taking photos as well as for protecting equipment?

✦ What lighting are you likely to encounter?

✦ How will the light affect your exposure settings and white balance?

✦ Can you use a flash?

✦ How have others shot the sport—both amateurs and professionals? Is it a sport that is photographed all the time, or is it less common? Is it going to be logistically, bureaucratically, or environmentally challenging to shoot?

✦ What are you trying to capture? Action? Faces and personalities? Drama?

✦ Are you just shooting for fun, or for a purpose?

✦ How important is it for you to be able to specifically identify each player?

✦ Will other people need to be able to access that information (for example, to be able to find themselves in an online photo database)?

✦ What permission or credentials do you need to shoot the event?

✦ Do you need model releases?

This may sound like lots to think about if your plan is to simply take snapshots of a 10-year-old's soccer game, and for that, it probably is. However, depending on what sport you plan to shoot and what you intend to do with the photos, at least some, if not all, of these points are worth taking into consideration.

In this book sports are divided broadly into five categories: outdoor field and court sports; outdoor recreation and competition; indoor competition; extreme/adventure sports; and specialized sports. While there may be some overlap among these—meaning, for example, that a given sport could fit into more than one category—this breakdown is logically tied not only by the type of sport and where it's pursued, but also how it's photographed.

Planning a shoot

Paid photographers may have better equipment and often get premium positioning, but something that they do that you can also employ in sports shoots is *planning*. The kinds of factors touched on in the previous sections all must be considered ahead of time. Preparing your shoot and equipment before the event will ensure a much higher percentage of good photos than if you go into the event cold and attempt to "shoot from the hip." Years ago, when I was a scuba instructor in the crystal-clear waters of the Gulf of Mexico, I always taught students that you "plan your dive and dive your plan" to ensure safety and success in each dive. Likewise, for sports photo shoots, always remember: Plan your shoot, and shoot your plan.

Although this planning sounds as if it may limit your ability to capture candid moments in sports, it actually has the opposite effect. Because you are more confident about the basic shots you're going to get, capturing the unexpected ones is that much easier.

I want to briefly tell you about some specific areas of sports photography. Later in the book I cover them more deeply and specifically to help you shoot them creatively and professionally. Although it's impractical to cover every sport, those included are grouped into five categories that, for photography purposes, have general application.

Outdoor field and court sports

This category includes baseball, soccer, football, lacrosse, rugby, tennis, track and field, and field hockey.

Outdoor field and court sports are characterized by bigger crowds, changing weather and light, and the challenge of shooting action that may be taking place across a large distance. Photographers who shoot these kinds of sports professionally often use very long (and expensive!) telephoto lenses along with high-speed cameras. Of course, if you're shooting an amateur and/or kids' event, you may be able to get close to the action for some great shots, such as the one in Figure 1-10.

Figure 1-10: This photo by photographer Adam Hardtke captures the drama and action of Little League baseball. Shot at 1/2000 second, a digital SLR is essential in catching stop-action images.

You may even need to be shooting in rain or snow, which means that your equipment needs to be weather-proofed or protected. Professional events for outdoor field and court sports are often highly controlled by officials and sports organizers, so gaining access as a photographer may be difficult and daunting, requiring press credentials from a qualified news organization.

Outdoor recreation and competition

This category includes auto and motorcycle racing, golf, cycling, sailing, water skiing, boat racing, jet skiing, snow skiing and snowboarding, canoeing and kayaking, skateboarding, and rollerblading.

Outdoor recreation and competition are some of the most exciting sports and events to photograph, but they can be the most challenging and equipment-intensive due to the often rough and/or harsh conditions, such as water, cold, heat, and snow. Inclement weather is also a factor; however, you're probably more likely to shoot a football game in a rainstorm than you are water skiing, sailing, jet skiing, or skateboarding. But you still need to be sure that your gear is protected anytime you're close to water, even if you're far from the action shown in Figure 1-11.

These types of sports sometimes require you to be quite far from the action, such as with water skiing or sailing events. This affects the kind of equipment you use. Also, for very high-speed sports, such as motor racing, you must consider positioning as well as the equipment able to capture the action in a loud, often crowded, and potentially hazardous setting.

Indoor competition

This category includes basketball, ice hockey, gymnastics, martial arts, racquetball, fencing, table tennis, figure skating, and weightlifting and bodybuilding

As much as weather is a factor in outdoor sports and recreation, lighting is the biggest challenge when it comes to indoor sports. Rarely are sports halls or arenas lit adequately or evenly, and inconsistent lighting can wreak havoc with a camera's white balance. And don't count on being able to use a flash, because they're rarely permitted when you're close enough for them to be useful.

Figure 1-11: Jet skiing can be spectacular to shoot late in the day during sunny weather. I shot this image directly into the sunlight on Lake Sammamish near Seattle at a shutter speed of 1/8000 second to create a silhouette effect with water spray.

Crowds and positioning also get more critical indoors when you have to move around in a sports facility, navigating referees, scoreboards, equipment, players, and bleachers. These challenges, however, are somewhat offset by being able to shoot where weather isn't a factor and lighting is usually more consistent.

Extreme and adventure sports

This category includes hang gliding, sky diving, parasailing, snowmobiling, rock and mountain climbing, drag racing, and back-country skiing.

Although you may be happy to carry a small point-and-shoot camera for extreme sports because it's so light and portable, these are some of the most challenging activities to shoot with even the most advanced equipment. Cameras must be protected from the elements and rough terrain or conditions, yet accessible with minimal hassle. You may not be able to change flash cards or back up images easily (Change a CompactFlash card while in free fall? Not likely!), power may be unavailable for charging batteries, and it is *completely* up to you to adapt to your environment, not the other way around. This means you'll be best off taking only what you specifically need, but be sure that you have the best equipment for the job and be ready for unexpected opportunities.

The photo in Figure 1-12 by photographer Will Wissman taken in Alta, Utah, required packing in camera equipment to difficult, deep snow locations.

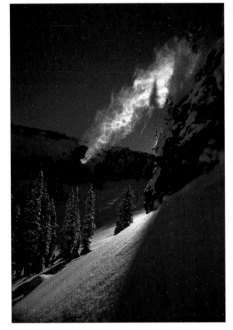

© *Will Wissman*

Figure 1-12: Shooting in extreme weather conditions and snow often requires packing equipment on your back and being sure that you can protect it adequately from the elements. It was worth the trek to see Nate Kies make a dramatic jump in fresh powder.

Special cases in sports photography

Some sports in this category include swimming and diving, scuba diving and snorkeling, indoor arena sports (such as football, soccer, baseball), and equestrian events

This category may require special equipment, such as for underwater photography; a different approach to traditional sports, such as shooting soccer indoors; or factors not found in other sports that can directly affect photography, such as live animals. Each of these areas involves special planning and diverges from how you might typically approach a sports photography endeavor. Even swimming can be tough to shoot in a humid, wet environment where you need to get close to the subject as in the shot in Figure 1-13 of a recreational early-morning swimmer.

The good news is that photographers who become adept at any of these areas, which by definition are less common than most sports, have a good opportunity of getting closer to the sport and getting to shoot high-end events.

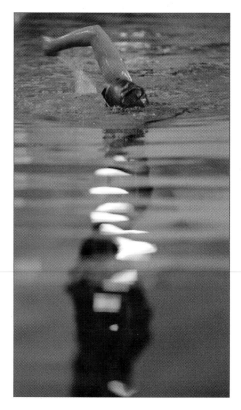

Figure 1-13: RAW format gave me the control I needed for this swimmer photo, taken without a flash to emphasize the ambient reflections on the water.

Summary

Shooting sports combines a variety of factors, including your knowledge of and access to various sports, the kind of equipment you're using to capture the action, and the environment in which you'll be shooting. As a photographer, how you compose and process the photos you take is equally important, as well, to ensure you not only get the shots but that the images you capture are the best quality possible.

Digital cameras come in many shapes and sizes, largely divided between SLR (single-lens reflex) and point-and-shoot models. While the point-and-shoot camera is small and nimble, the SLR is more versatile in its ability to get fast-action shots and use interchangeable lenses. Depending on what kind of equipment you're using, you need to know how to optimally set and control it to get the best shots possible of the sport you're after. This will give you the best chance of anticipating the action that's sure to come. Unlike posed or studio photography, in sports you may only get one shot at that great moment, so you'll want to be prepared.

Understanding where you're going to be shooting, what equipment you have, your access, and other factors are all key factors in getting the best shots.

✦ ✦ ✦

2

From Shoot to Print: Workflow

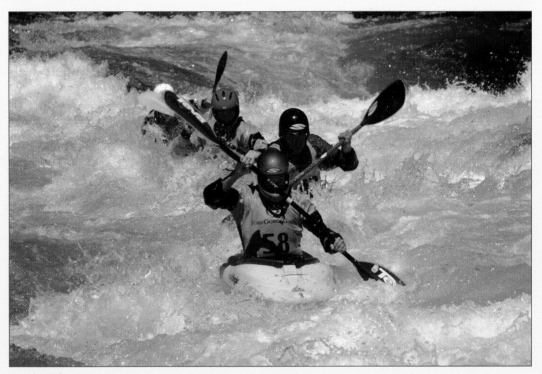

© Amber Palmer

Whatever sport you may find yourself shooting, your success depends on more than just getting the shots. Of course, being able to take a good photograph is an essential skill you need to develop, but it's far from composing the entire picture (pardon the pun).

One of the greatest paradoxes of professional artistry, whether it be photography, writing, painting, music, or any other pursuit, is that the more you do it, the less you do it. In other words, the professional artist spends more time doing the business of his art than pursuing the art itself. As a pro photographer, I spend time traveling, selling, managing and editing photographs, talking with clients and subjects, administrating and managing finances, doing e-mail, working with my Web site, and finally taking photos. The business of photography takes as much time as (and sometimes more time than) taking the photographs.

Understanding the flow of how your images are created and processed until their ultimate destination is essential for being able to effectively keep them organized, safe, and retrievable over time. This is the basis for workflow, which helps bring you one step closer to the professional photographer's ability of replication and consistency. This means that your photography overall improves, benefiting you, your audience, and the subjects you're shooting.

So, while the most exciting moments of your photography experience may take place on or alongside the field of play or hanging on the side of a mountain, equally important but less thrilling is the time you spend on the computer ensuring that your photos are treated in the best manner possible so they can be best appreciated. This is the part of digital photography that most photographers underestimate in how much time it can consume, the never-ending thirst for more power and memory as well as new technology, and how daunting it can be to master the complicated and sophisticated software applications available today. This chapter examines the workflow and what it means to you as a digital sports photographer.

What is the Digital Photography Workflow?

Workflow is a term that professionals use to describe the process of preparing for, shooting, and producing a photo. Because professionals manage so many photos, they must be extremely conscious of workflow issues. Even if you are taking dozens or hundreds of photos (instead of thousands or more), you'll find that consciously organizing this process makes your shoots far more successful. Nothing ruins a great photo like not having enough memory left to store it, enough battery juice to shoot it, or having it get accidentally trashed when you move it from your camera to your computer.

Today's digital photographer has many choices and options for processing, producing, presenting, and distributing his or her images to the world, whether the images are for sale or simply for sharing. If you approach your photography from the workflow perspective, you are more likely to produce better images, get them to more people, and generally be more creative.

Tip For a complete look at the digital photography workflow, pick up a copy of my book *Total Digital Photography: The Shoot to Print Workflow Handbook* also published by Wiley.

Having a consistent workflow enables me to free up a little more time. A digital sports photography workflow should be consistent from shoot to shoot. Although professional sports photographers require a more complex and developed workflow than even a serious hobbyist, the basic approach I developed can help *any* sports photographer organize his or her shoot-to-print process.

A digital studio should not have to reinvent the process for each photo job; instead, it should constantly strive to improve an established workflow. Whether you are a beginner or a pro, putting a workflow process into place in your digital studio and photography practices will give you more time for whatever it is you want to do, and it will produce better photographs that are much more easily managed, archived, and distributed.

The "workflow" term is used throughout the photography industry in a variety of ways, ranging from meaning how images are processed within an application, such as Photoshop, to a broad definition of everything that happens to a photograph from concept to print. This latter definition is how I typically refer to digital photography workflow and was the foundation for the predecessor to this book, *Total Digital Photography: The Shoot-to-Print Workflow Handbook* (John Wiley & Sons, 2004).

Digital photography workflow encompasses everything about how a photograph is created and treated. It's helpful to outline that process now, both as a framework for looking at what is involved and as an overview of what follows in this book. The following list outlines the basic steps in taking and producing digital sports photographs — at *any* level.

What to do with captured images

For sports photography, creating a plan helps to produce better images. Two essential parts of that plan involve the *pre-pixel* and *post-pixel* stages of digital photography workflow. The pre-pixel stage is what happens in photography *before* the image reaches your camera's digital sensor: lighting, camera exposure settings, and how you've set up the photo shoot overall.

The post-pixel stage involves everything that happens to the image after the sensor has converted light into bits-and-bytes: file formats, downloading files from camera to computer, processing and archiving images, and processing images with software, such as Adobe Photoshop, Adobe Photoshop Elements, Microsoft Digital Image Pro, or ACDSee. Finally, the post-pixel stage includes how your photos are distributed and presented, whether that's on the Web, in a slide show, or on paper.

- ✦ Pre-Pixel
 - The photo shoot concept
 - Setup, in-studio or on-location
 - Capturing the images
- ✦ Post-Pixel
 - Transferring images to the digital studio
 - Managing images
 - Archiving images
 - Editing images
 - Optimizing images
 - Distributing images
 - Printing images

In this chapter, you mostly explore the pre-pixel side of digital sports photography workflow, from preparing for the shoot to what you need to transfer your images to your computer to begin the post-pixel, digital stage. In Chapters 10 and 11, you get more into digital details as your photos are processed in the digital studio.

Digital sports photography differs from portraiture, commercial, wedding, and other types of photography is that only a small portion of images are posed or taken in controlled environment such as a studio. By far, most of the photos you take will be on location, whether that's on a baseball field, in a sports hall, underwater, or on a ski slope. Rarely, unless you're a practicing pro photographer, will you be doing portraits of athletes in a studio.

What does this mean in terms of digital photography workflow? Primarily, it affects the pre-pixel stage when you're preparing for and executing your photography. This means you have to adapt to your environment, not the other way around. In a studio, you can control your lighting precisely, but you don't have this luxury when you're in the field.

Another aspect of sports photography, in terms of workflow, is that it's a one shot type of photography. Like wedding photography, you typically only get one chance to get the "money shot." In weddings, it's the kiss at the altar or several other key moments that cannot be replicated; in sports, it's the winning goal, the passionate defeat, or the tearful embrace of coach and player after a tough event. These are moments for which you must prepare and be ready, because if you don't get the shot you can't go back and do them again.

Now, realistically, if you're shooting pee-wee football and catching precious moments of your eight-year-old's athletic beginnings, the pressure isn't quite what it is if you're working for a sports news bureau taking shots of Wimbledon's top seed finishing off his opponent for the championship. You may just want to know how to get a good photo of your kid on the field and making it spectacular isn't necessary, but you still want it to be good. And, for most of you reading this book, that's probably the case. However, if you're going to go to the effort of creating good photographs, you must practice digital photography workflow like the professional.

Creating a Digital Photography Studio

Underlying my discussion here of the whole shoot-to-print process is an assumption that, after you take your digital photos, you'll be processing and possibly printing them in your own digital darkroom.

I go into much more detail later in this book, but let me now preview the elements of your own digital sports photography studio. Given that the vast majority of your sports photography shots will be taken in the field, the digital studio for sports photography does not necessarily include facilities for taking posed photos. The primary role of your digital studio is *managing, editing,* and *producing* photos.

You want to have sufficient computer processing capacity and *plenty* of digital storage space in your studio, along with software to edit your photos. Printing options range from very high-quality home photo printers, to commercial and online printing. The digital photo studio is the last stop in the digital sports photography process.

Cross-Reference For a detailed examination of the range of options available for your digital studio, including helpful hardware and software tools, see Chapter 9.

Choosing a Camera

By far the most important decision you need to make as an amateur or enthusiast is the type, brand, and model of camera to purchase. There are myriad digital cameras on the market today, and new ones are introduced almost daily. Each touts new digital technology innovations, gadgetry, and features to entice buyers and promises better, bigger, and sharper images.

Note Many of you many already have a camera that you like to use, so consider this a primer on what to look for when stepping up to the next level of camera.

Some of the features advertised by camera manufacturers are more important than others. And many features are more or less self-explanatory. The *most* important and basic decision you can make involves the difference between point-and-shoot and single lens reflex cameras.

Budget is most often a determining factor when choosing a camera, so the first thing to decide is whether you'll buy a point-and-shoot or an SLR (single lens reflex) camera.

I'm concluding this section by arguing that you'll be much happier with an SLR camera. But the choice is up to you. Before I make my case that you should get an SLR camera for digital sports photography, let me break down the differences between the two types of cameras. Table 2-1 lists the main features of each type of camera.

Table 2-1: **Point-and-Shoot versus SLR**

Camera Type	Features
Point-and-Shoot Cameras	Fixed, non-interchangeable lens
	Optical plus digital zoom
	LCD viewfinder with small, non-optical viewfinder (digital, instead)
	Typically smaller megapixel size
	Often less common or proprietary flash card types
	Fewer manual controls that are often difficult to access/use
	Often no support for external flash or lighting attachment capabilities
	Small and lightweight
	Significant "shutter lag" and limited shot-per-second rate; limited buffer for multiple-image shooting
	Poor and/or slow auto-focus
	Limited sensitivity (such as ISO) and shutter speed
SLR Cameras	Interchangeable lenses
	Optical, through-the-lens viewfinder
	Larger mega-pixel size
	Multiple digital file formats (such as RAW, JPEG, sometimes TIFF)
	Most often, CompactFlash media; sometimes multiple types per camera (such as SecureDigital or SmartMedia)
	Fully manual controls in addition to limited or full automatic or "program" settings
	External flash and support for lighting attachments
	Heavier and more bulky, but usually very ergonomic design
	Less shutter lag, sometimes to the point of it being absolutely non-existent from a user standpoint; high buffer rate for multi-image shooting
	Accurate and fast auto-focus, often configurable for various viewing "zones"
	Wide ISO sensitivity range as well as shutter speeds

SLR: The best option for sports photography

As you may have guessed, I'm biased toward the SLR type of camera. If you can afford a digital SLR, you won't regret having purchased one over a point-and-shoot camera if you intend to shoot anything more than family snapshots. These cameras operate much like their film ancestors; the Canon EOS camera controls, for example, are very similar in digital and film.

Shutter Speed Priority and Sports

Most cameras — both point-and-shoot and SLRs — allow you to specify a limited automatic control that makes the camera shoot only at a specific shutter speed or aperture setting. For example, if you're concerned that light may be a bit mixed and your camera may, if set to completely automatic settings, shoot a bit too slowly and thus create blurry images, you can set it to shutter speed priority. This means it shoots only at the speed you set — say 1/60 or 1/125 — and automatically adjusts the aperture to suit the available light. If the light isn't good, such as when you're indoors, this is often a good way to make sure your camera produces the sharpest images possible. Try not to set it for anything less than 1/60 second, however. It's difficult to hand-hold at speeds slower than this. Instead, try increasing your camera's ISO sensitivity to the highest setting (for example, ISO 400 or higher).

That said, I often travel with a Canon PowerShot point-and-shoot camera only because it's easy to pull it out and snap a quick photo when it's inconvenient to open a camera case, mount a lens, and go to the trouble of putting together an SLR. But I wouldn't think of using a point-and-shoot for taking photos of fencing, even if I had nothing else to use. For my purposes as a pro photographer, it is simply not capable of producing usable images. It can't produce images fast enough, it can't deal with poor lighting, and it doesn't have the lens(es) I need to get the majority of the shots.

When will a point-and-shoot camera work? If the sport is taking place in good light (outdoors, most likely), the action isn't high-speed, and you don't need to be too far away from the players. This sounds limiting, but it works for a few sports — especially if you're trying to get shots when it's not in the middle of action. For example, taking photos of equestrian riders before or after riding a course, capturing a skateboarder perched at the top of a half-pipe, or even taking a snapshot while hang gliding are all good uses for a point-and-shoot. In many cases, a point-and-shoot will be all you can take with you in an extreme sport such as sky diving, hang gliding, or rock climbing because you are so limited in how much you can carry in terms of weight and size constraints. In these cases, you will be best off setting your camera to manual settings, or at least shutter-speed priority, before jumping off the cliff or beginning your climb.

Note *Shutter lag* is that irritating tendency of lower-end cameras to have a delay between when you press the shutter release and when the camera takes the photo. If you've ever pressed the shutter hoping to get the batter throwing the bat or the goalie stopping the ball, and instead gotten a photo of a bat on the ground or the soccer ball already thrown back into the field, that's what happened.

Part of the problem with point-and-shoot cameras is that they seldom offer usable manual controls, and these are really what you want to use when you're shooting sports. Why? When a camera is operating automatically, it has to process the image it "sees" before shooting. It has to take a meter reading on the light and white balance, focus, and then set its lens, shutter, and sensor sensitivity (ISO) as correctly as it can before the photo can be taken. When a pro photographer shoots images, all these controls have been preset in a manual mode, so the camera doesn't have to think about anything — it just has to respond to the photographer pressing the shutter release. For high-speed sports, this capability is essential and makes all the difference in getting great shots.

Available SLRs for the sports photography enthusiast

The fastest cameras on the market today shoot at between eight and nine frames per second, assuming that the photographer has set the camera to a multi-shot setting and that the other controls are optimized. The better cameras have high *buffer* rates, meaning the camera continues to shoot at this rate until it hits the point where it can't hold any more photos in its internal memory without downloading images to the flash card — professional cameras such as the Canon 1D Mark II can buffer as many as 40 shots.

Consumer and semi-pro SLR cameras, such as the Canon Digital Rebel, the Nikon D-100, and the Olympus E1, are quite capable for most general purposes assuming that you're not shooting elite or pro sports. With hot-shoe (external flash) support and a wide variety of lenses, they often can operate at two or more shots per second, which is a beginning-level of acceptable speed for most sports, and you have many manual controls, lots of settings for sensitivity and shutter speed, and the ability to use many types of lenses. These are all priced in the $1,000 range. For most amateur and enthusiast photographers, these are the cameras I recommend most often. And camera prices are coming down all the time, with newer models of higher-end cameras available today at a fraction of the cost of their predecessors. For SLRs, the real cost comes in what you spend on getting the lenses that you want — their prices change more slowly, and a *fast* lens (meaning a fixed aperture ability regardless of focal length) is always more expensive than a variable-aperture lens. Table 2-2 surveys some accessible and popular SLRs for digital sports photography.

The cameras listed in Table 2-2 are quite similar in their specifications; of course, you'll want to compare many more technicalities. I find retail Web sites such as B&H Photo (www.bhphotovideo.com) very reliable sources of features and specifications and an easier way to compare products, rather than going to individual manufacturer sites.

Table 2-2: **Comparison of Basic Features of Semi-pro SLR Cameras**

	Canon	*Nikon*	*Olympus*	*FujiFilm*	*Pentax*
Model	Rebel	D-100	E-1	FinePix S2 Pro	*ist D
Megapixels	6.3	6.1	5.0	6.1	6.1
Frames per Second (Burst Rate)	2.5	2	3	2	2.6
Buffer Rate	4	Not specified	12	7	6
ISO Range	100-1600	200-1200	100-3200	100-1600	200-3200
Shutter Speed Range	30 seconds to 1/4000	30 seconds to 1/4000	60 seconds to 1/4000	30 seconds to 1/4000	30 seconds to 1/4000
Media Type	CompactFlash	CompactFlash	CompactFlash	CompactFlash, SmartMedia	CompactFlash
File Formats	JPEG, RAW	JPEG, TIF, RAW	JPEG, TIF, RAW	JPEG, TIF, RAW	JPEG, TIF, RAW

Preparing for a Digital Sports Photo Shoot

Shooting sports is nearly always an on-location, out-of-studio activity. As such, you need to be prepared for working in the field and be as self-contained as possible. Things such as electrical connections, extra batteries, extra flash cards, various lenses, a computer, an Internet connection, and a printer may be inaccessible or unavailable.

Although digital photographers aren't hampered by carrying large amounts of film, they are burdened with lots of wires, computer equipment (even if it's just a portable hard drive), battery chargers, and other items. Flash cards are small, but are also expensive and easily lost among all the other equipment and must be made highly accessible yet carefully protected. Carry everything you need, and maybe a few items that you might need, but don't overload yourself because you need to be as mobile and portable as possible.

You want to put things together before you load up the car with equipment and head to the stadium. It means creating an equipment and photo shoot checklist, knowing something about what and whom you're going to photograph, understanding something about the sport, knowing if you will need or can obtain credentials, or maybe even just knowing ahead of time that you need model releases. As part of digital photography workflow, this is a very important early, pre-pixel step in ensuring great images at the completion of your photography efforts.

Cross-Reference See Chapter 13 for a discussion of the legal aspects of sports photography.

If you're shooting at anything more than a regular season youth game, you may want to contact the local or high-level sporting organization managing the event. Often, they have specific regulations, credentials, and information for photographers who are doing anything more than just taking snapshots of their family members. And, even if that's all you're doing, you still may want to see if you can get some special access because it means obtaining better pictures. Some sports events photographers from the media as well as have official photographers who may be shooting photos professionally to sell to families and athletes. For events such as these, you may be restricted somewhat in obtaining any credentials without having an official reason for being at the event.

Figure 2-1 outlines workflow for digital sports photography.

As discussed, the vast majority of sports shoots don't take place in a studio or other controlled photography environment. You need to be ready to shoot on an outdoor sports field, in a gymnasium, in a sports hall, in bad light, in the rain, or in a crowd. So preparing for these shoots isn't about setting up lights and understanding poses, but rather about how to have everything you need for the situation where you'll find yourself shooting and being able to adapt to it to get the best shots possible with the resources you have available.

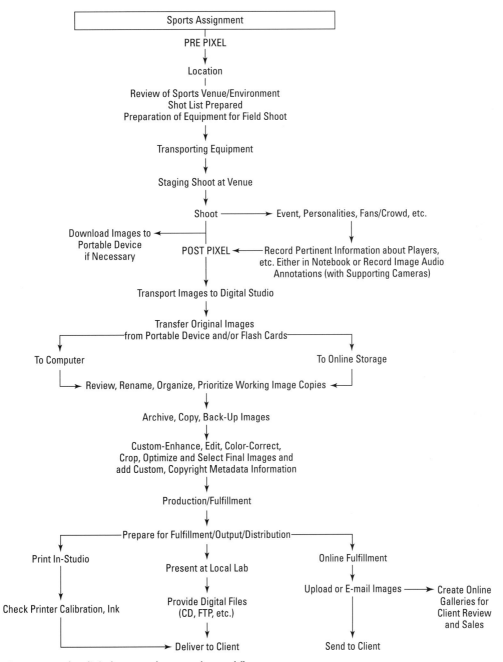

Figure 2-1: The digital sports photography workflow

A Digital Sports Photo Shoot Checklist

You may be surprised at how little you really need to take to a photo shoot. And the less you take, the less you have to carry! The following checklist can be used to organize your equipment as you rush out the door to be on time for an event:

✦ Camera 1

✦ Camera 2 (if necessary/available)

✦ Camera bag or backpack

✦ Lenses

✦ Wide-angle zoom (approx. 17mm to 28mm)

✦ Portrait/standard zoom (approx. 24mm to 70mm)

✦ Telephoto zoom

✦ Lens cleaner kit

✦ Lens cleaner fluid

✦ Lens tissue

✦ Brush/blower

✦ Bulb blower (for cleaning camera image sensor)

✦ Flash cards in a zippered belt container (for portability and protection)

✦ Portable hard drive with flash card support or laptop (for downloading and possibly viewing images on-site); if you have a laptop, you need a flash card reader

✦ Light meter (optional)

✦ Notebook and pen

✦ Flash

✦ Folding stool (a lifesaver!)

✦ Extra batteries for camera and flash

✦ Battery charger (if necessary) for camera battery

✦ A shot list of images you need and/or want to take

Tip Be sure that each lens has a haze or skylight filter mounted to protect the lens. These are flat glass disks that screw-mount to a lens; they are more common on interchangeable SLR-type lenses than on point-and-shoot lenses.

Note Taking a portable hard drive with flash card support or a laptop is not always necessary. If you have sufficient flash card memory to accommodate your entire shot, you can leave these items at home.

Fast glass, big glass, big bucks

Most amateur and semi-pro photographers use zoom lenses for sports photography, primarily because they are versatile and you never really know where you can stand to get the best shots. Pro photographers — especially for field sports such as football or soccer, where the plays can be very distant — most often use fixed lenses that don't zoom, such as a 400mm or 600mm "big glass." These very expensive (commonly $6,000 to $10,000 and more) lenses feature near-perfect optics, are huge (they usually require a monopod, which is a telescoping, single-leg version of a tripod that lets you steady a camera and hold it without strain), and get the very best shots. But they're overkill for anything but elite and pro sports, and even then only for certain sports where distance is a factor.

Another factor in lenses is referred to as "fast glass." A fast lens means that its aperture (f-stop) remains *fixed* at any focal length. Less-expensive zoom lenses often have an aperture range depending on to what focal length they are set. For example, an inexpensive 70–200mm zoom may have a range of f/2.8–5.6, meaning that if you are shooting it a 70mm, you have a wide, f/2.8 aperture capable of shooting in lower light; however, if you zoom out to 200mm to get that distant shot, less light enters the lens and the aperture is capable of shooting only at f/5.6. This means that shots for which there's plenty of light at the 70mm setting can turn out underexposed at 200mm.

Fast lenses have a fixed f-stop rating, often such as f/2.8, which is large enough to accommodate most lower-light situations in sports halls and other venues. The f/2.8 setting can remain constant at any focal length; for example, I shoot a 70–200mm Canon EF L series lens that, because of its extremely complex internal optics, can shoot at f/2.8 no matter the focal length. This means that I can manually set the camera to the f/2.8 setting and know that whether I am shooting close-in or zoomed-out, the light entering the camera is the same.

As with big glass, fast glass comes at a cost; you will often pay $1,500 and well beyond for this feature.

Packing up

When packing for your shoot, you want to think about how you can best access your lenses and flash cards and how you may be downloading images from flash cards. I favor the photojournalist-style fanny pack that lets me access everything right at my hip, and which zips open toward me (not away from me, as with most non-photographic packs). This way, I can easily interchange lenses, and there's room for my ImageTank portable hard drive so I can be downloading and storing flash cards wherever I go. Figure 2-2 shows my photojournalist fanny pack.

You may find a different way that suits your needs than what I describe, but photojournalists shooting at a wide variety of events have used fanny packs in this manner for a long time because they work well. Although many photographers also wear photographers' vests to carry equipment and other things, and these are required (and supplied) at some big sports events like the Olympic Games — primarily as a way of identifying photographers — they are less necessary in the digital world. In the days of film, photographers needed more pockets to carry a variety of types of film and to separate exposed from fresh film.

Tip

Wearing a photographers' vest may give you a more professional look, meaning that sports officials may be less likely to question your presence at an event if you get closer to the action than the average fan. Of course, you want to have something more than a point-and-shoot if you're going to attempt to carry off this persona!

If you're going to shooting a sport in a specialized environment — sailing or rock climbing, for instance — you'll do more specific equipment preparation; sailing photographers, for example, quite commonly use a cooler on the boat to protect their equipment from the salt water but still have it accessible. See the individual sports sections of this book to read more about these situations.

Figure 2-2: The camera fanny pack, like this one made by LowePro, is a staple component of the sports photographer, designed to support multiple lenses, flash cards, camera bodies, and portable hard drives all used on-the-fly without removing it from your hip.

For traveling, however, I carry my equipment in a rolling suitcase-style camera bag that holds more than I need on-site at the specific shoot. This case allows me to carry extra equipment, a backup camera, my charger, and even a small laptop in a protected case; it's perfect for taking all my equipment on a plane or in a car trunk. When I get to the shoot, I transfer just what I need to the fanny pack. Figures 2-3 and 2-4 show a rolling, suitcase-style camera bag.

Perhaps the most important thing in preparing for the photo shoot is to understand as much as possible about the environment in which you'll be working. Ask yourself these questions as you are preparing for your sports shoot:

✦ Do you have an idea of what the light will be like?

✦ Where will you be able to shoot?

✦ Will you be close to or far away from the action?

✦ Will there be any issue of accessing the area where you want to shoot?

✦ Can you use a flash, and if so, will it be useful?

✦ What kinds of shots do you need to get — action, crowds, individual players?

✦ Will you be able to leave your equipment in a secure/protected spot, or with someone who will watch it while you take photos?

As much as possible, try to set your equipment ahead of time. Don't take lenses that you probably won't need; for example, if you're shooting in a small martial arts studio, you probably won't need a big telephoto lens. If you know that you'll be outdoors or indoors and you know the weather or the specific lighting, you can set your white balance accordingly.

Figure 2-3: You can transport equipment securely in many ways, including the rolling suitcase style case. This case, made by Tamrac, has been all over the world and has protected my gear like a charm.

Finally, one of the most important preparatory steps is to think about the specific photographs you want to take:

✦ Do you have a shot list of images you want or need to take? Whether you've created it or it's been provided to you by a client, a coach, an athlete, or a parent, knowing ahead of time the kinds of "must have" shots can directly affect how and what you'll shoot. Furthermore, it will help you keep on-track as you get caught up in the excitement of the event.

✦ What will you do with the photos? If they are not being enlarged significantly, you can shoot a smaller image size, get more shots on your flash cards, and take up less archival/storage space.

Figure 2-4: The Tamrac photo case, ready to roll off to the airport. Note how it is indistinguishable from an ordinary piece of carry-on luggage.

Choosing a file format

The heat of the action is no time to be agonizing over the type of file format you'll use to capture photos. Nor is it the time to fidget around with your camera manual trying to find out how to change the file format to which your captured images are saved.

But file format is an important decision. Different file formats are more (or less) suitable for different final processing. JPEGs, for instance, are a standard for online image display. TIFF is a long-time standard for many print processes. RAW photos capture more data and use more space on your memory card.

This list summarizes when to use what file format:

✦ **JPEG** is the most common sports format, supported by virtually all cameras. It's also the easiest and smallest to work with, but potentially the poorest quality because it is a "lossy," compressed format.

✦ **TIFF** is a high-quality, lossless file format suitable for larger and more editable images, but it's not directly supported by all cameras. Files tend to be large.

✦ **RAW** is technically not a file format, but the actual and accurate image the camera "sees." RAW files require specialized support from the software you use and take more processing time and effort, but ultimately yield the best possible results of any images.

✦ **RAW+JPEG** is an additional option. Some cameras shoot two files for each shot — one in RAW and the other in JPEG. Although this takes up much more space on your flash card, it gives you the advantage of having a very editable, lossless, archival-quality image along with a nimble and small JPEG file to work with for common purposes.

You may have to change file formats on-the-fly at the event, depending upon the conditions in which you're shooting and how the environment changes. However, the more you can think about this ahead of time and prepare for the shoot, the better off you will find yourself when you get there.

At the Shoot

Whenever possible, try to get to your digital sports photo shoot early to find your place, check lighting, get set up, introduce yourself to officials, and maybe even get a few player warm-up shots. If you can stage your shoot, all the better: find a secure, fixed position where you can safely keep your equipment, possibly get a seat, and base your operations for downloading images, changing lenses, and the like.

For example, at the Athens Olympic Games, when shooting fencing I was able to keep my rolling bag with lots of equipment and a computer in the photography media center, upstairs and a short hike from the fencing venue. It was a secure location monitored by Greek Olympic officials and workers from Kodak, Nikon, and Canon. I took my fanny pack to the fencing hall, where I had a small stool, and left my pack and sometimes a laptop in a dedicated photography area close to where I was shooting. I didn't have to carry everything with me if I moved around; I could simply leave it by my seat. However, this luxury does not exist at most amateur athletic events.

Setting up

The best scenario is if you have an assistant, friend, or family member willing to baby-sit your equipment while you move around; if you can engage them in helping to download images, all the better, as long as you can truly trust this person to safely and securely manage this step.

Here are some guidelines to follow when you are planning a shoot at a sports hall or on a playing field:

✦ **Get to the venue early.** It's the only way you can really get the shots you want by being prepared and knowing your way around.

✦ **Find a good location from where you can stage your shoot.** Depending upon your equipment, you may need to have a spot to sit and carry everything with you. On the other hand, you may need to store things securely, which means you need an assistant or a way to ensure that no one bothers what you have. It's often not even so much a worry about theft as it is a concern someone will knock into or drop a beer or Coke into your computer, hard drive, lenses, or other equipment.

✦ **Scope out the environment where you'll be shooting.** What key points around the hall or field are good vantage points where you can perch without getting in the way? Are there high points or bleachers you can climb to get a wide-angle or distant perspective? How does the venue match the shot list you prepared before the shoot?

Having your camera ready

Assuming that you've scoped-out the area where you'll be shooting and you're comfortable that you have a safe spot where you can stage the day's activities, you can focus on some pre-pixel camera issues that are essential to getting good images.

If you've ever seen professional sports photographers or photojournalists at work, they often carry multiple cameras with different lenses, all preset and ready to go. While not at every event, I carry more than one camera at the end of a world-level fencing finals, because inevitably the moment the final touch is scored, the house lights come up, teammates leap onto the stage, and the winner is tossed into the air. Lighting, focal range, and other camera settings can change significantly in a minute or less, so shifting settings and lenses on one camera isn't practical.

In Figure 2-5, U.S. saber fencer Mariel Zagunis launches her gold medal–winning final assault on her opponent at the Athens Olympics. In Figure 2-6, her teammates rush the stage to toss her in the air. In only a few moments, the change in lighting in the venue, the colors and reflection of additional clothing and bodies on the fencing strip, and the added ability to use a flash all contribute to very different settings for how a photo needs to be taken.

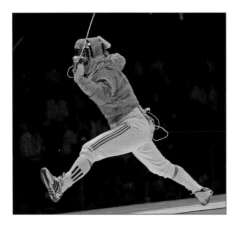

Figure 2-5: U.S. fencer Mariel Zagunis in her winning attack. The camera is set for high-speed, stop-action shots of a saber blade in motion, the lighting of the athlete and not the audience, and narrow depth of field.

Note Narrow depth of field means that only a small area is in focus and whatever is behind the subject is blurred.

Back Focus Benefits

The default for most cameras is to have the shutter release button also serve as the auto-focus button. Many pro sports photographers change their SLR shutter-release settings to allow them to *back focus*, or *thumb focus*, which means assigning a separate button for focusing other than for the shutter release. Depending upon how it's configured, often it is set to allow you focus with your thumb and shoot with your index finger. This allows for faster shooting, better focusing, and a higher percentage of good shots.

Typically, the special functions settings in your camera's menu allow you to do this; for example, on Canon SLRs, you can exchange the exposure lock button with the focus button. This allows you to focus with your thumb — and even hold down the focus, if necessary — while you shoot with your index finger. In this way, you can focus and shoot much faster!

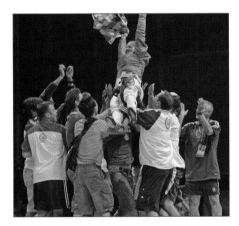

Figure 2-6: Less than one minute after the image in Figure 2-5 was taken, teammates of Mariel Zagunis celebrate victory. The camera setting had to be changed to allow a deeper field of focus, and it did not have to fire at such a stop-action speed (but it still had to be sufficiently fast to catch someone being tossed in the air!).

Use the following list to think through and prepare your camera to capture fast-moving images:

✦ **What lenses will you use, specifically, for what shots?**

✦ **What is the lighting like?** If outside, what's the weather doing? What will be your best camera settings for the venue to get stop-action, wide-angle, telephoto, close-up, or other shots? Will you need to fix your camera on manual, or can you get away with using a shutter-speed priority automatic setting? (Note: I don't recommend using a fully automatic or "program" setting except in rare situations.)

✦ **Consider special options that your camera may offer as a means to easier shooting.** In many cases, you can set special options that deviate from the standard SLR camera features. This ranges from shutter release functions to a wide variety of settings and behavioral attributes of the camera. You should be familiar with these and make any adjustments that will help you adapt to shooting sports in the field.

✦ **Consider carrying a spare.** If you are expecting moments during the game or event when lighting will change suddenly or you will need to shift from a telephoto to a wide angle or other lens, you may want to consider having another camera ready instead of having to change lenses — especially if you're going to be in a crowd or busy area.

The Sound of Photography: Recording Image Sound Clips

As an alternative to keeping written notes about images, some cameras today offer the capability of recording a short sound clip in WAV format that accompanies a given image. You can select a specific image you've taken, press a button on the camera, and an internal microphone in the camera allows you record your voice. It's stored onto the flash card along with the image, and when you download the image to your software package, the sound clip goes along with it. Most software packages, including Adobe Photoshop, Adobe Photoshop Elements, and ACDSee all support audio annotation to image files. Some applications also let you add audio to an image file while editing the image, but you must have a microphone (and a sound card) on your PC to do so.

In Photoshop Elements, adding audio to an image is very easy. Here's how:

1. **Using the Photo Browser, open a photo and click the Record Audio Caption button, which opens a small dialog box.** Alternatively, you can select a photo, and then click in the Properties window. Under the General section, you can click the Add or Change Audio Caption button.

2. **Click the Record button, and then speak into your microphone (you need to have one connected to your computer or one that's built in).**

3. **When you're finished, click Stop.** Listen to the annotation by clicking play. Rerecord, if necessary. You can also attach an existing audio clip to your photo, using the File ➪ Browse feature in the Select Audio File window.

4. **Close the feature.** The audio clip has been attached.

Attaching an audio file to an image in Photoshop Elements.

If your camera supports audio annotation, as the Canon 1D Mark II does, you want to test the capability before you use it in the field. The microphone may, for example, not record sound very well when you're in a noisy environment such as a stadium or sports hall, in which case you won't hear your recording later when you need to listen to the annotation. Also, you may need to be closer to or farther away from the microphone to get a good-quality recording, so knowing how it works ahead of time is a good idea.

Audio files can be a very efficient way of keeping quick notes of player names, events, stages of play (semi-final, final, and so on), or other information you'll want to know later on, as opposed to writing it down. If someone else will be editing your images, this is also a good way of communicating to that person important information about the image that can be more effective than having him compare images with your handwritten notes (especially if your handwriting is as bad as mine!).

Avoiding (or Dealing with) Disaster

I like to edit images and write books while sitting in busy places. I'm not sure why, but working in a bar, restaurant, or a coffeehouse works better for me than sitting in a quiet office. This can, however, invite disaster.

Sitting in a British pub last December, I was working on images from a fencing tournament that I had just shot in Paris, and I had taken a couple of days in London on my way home. While working, I kept a soda at what I thought was a safe distance from my laptop. As it turned out, it was too close to the edge of the table and a passerby bumped into it. The sugary liquid splashed directly into the keyboard of my laptop.

I immediately shut down the computer and got a dry towel from the bartender. I dried off what I could and, in a near panic, proceeded to remove the keyboard with a screwdriver. I then frantically dried off whatever looked wet in the complex electronic underpinnings of my system.

I thought all was well, but over the next month the computer kept overheating, shutting down suddenly, and generally misbehaving. Finally, a little more than a month later, it gave up the proverbial ghost in the middle of a photography workshop where I was presenting images.

Bad things happen to good photographers every day. Lenses drop, cameras fall from tables, drinks fall into computers, and a plethora of other catastrophes occur to any photographer, especially those working in the field. Fragile, expensive electronic and glass equipment, as bombproof as camera manufacturers can make them, can easily be damaged. In addition, theft — especially theft of equipment left visibly on a car seat, as the insurance companies will tell you — is always a threat anywhere you go.

Better safe than . . .

Before I share some tips on recovering from digital sports photo disasters, let me share some ideas on how to *avoid* them!

If you're careful, you can certainly prevent lots of problems, which is always best. The following list offers some suggestions that can help you do that:

✦ **Use a cable lock for your laptop and LCD projector.** They all have a little slot into which a special computer lock can be inserted, and the cable snaked through a chair, a table, or another secure, large object. These are commonly available at computer and electronics stores. Cables are not foolproof and can be cut with a strong metal-cutting tool, but they provide significant deterrence for all but the most prepared thieves. You can also use the lock through your briefcase or camera bag handle as a further deterrent.

✦ **For devices lacking a lock-slot (such as the case with my portable DVD player, which I sometimes use to show images), you can purchase similar cable locks that allow you to glue a metal ring to them.** You then slip the cable and/or lock into the ring, securing it. I don't suggest using this for cameras because it's typically difficult to find a clear spot where you can conveniently mount the ring.

✦ **Use your camera strap.** Put it around your neck and get used to it. A large percentage of camera and lens damage can be averted by this simple effort — much like wearing a seat belt in a car.

✦ **If you don't like camera straps, use a handgrip on your camera.** Adjusted properly, these quite comfortably allow you to hold a camera while your hand is completely at rest.

✦ **Use a haze or skylight filter on all your lenses.** If you do bump or drop the lens, sometimes these take the hit and protect the lens.

✦ **Use a lens cap!** Whenever you put your lenses away or you're not using them, keep the caps on. Also, and even more important, always, always use the cap cover for your camera body if you don't have a lens attached.

✦ **Keep drinks and food away from all equipment — FAR away!**

✦ **If you'll be in a challenging environment, such as snow, mud, rain, salt water, or other elements, keep your lenses and cameras in resealable plastic bags inside your camera bag.** If you're going from a cold to a hot environment, such as from the freezing outdoors into a heated room, keep lenses and cameras sealed inside the bags until they have adapted to the new temperature. This prevents condensation from building up inside the devices, which can be very damaging.

✦ **When you are changing lenses, have your lens caps ready to be placed on the lenses immediately.** Don't let them sit out, exposed to the elements, while you dig for the covers.

✦ **Know how to clean your image sensor.** Although it's a bit nerve-wracking if you've never done it, it's an essential procedure to understand and practice with your camera.

Cross-Reference

For more on caring for your camera and cleaning your sensor, read Chapter 3.

✦ **When in your studio, store your camera equipment in a camera bag or other safe, clean spot.**

Recovering from disaster

You've done everything possible to prevent it, but the unthinkable still happens: The spilled drink, the dropped lens, the smashed camera. It happens when you're a sports photographer, and it's more likely than not that it will happen if you're carrying lots of stuff out-and-about. What next?

When my laptop took the liquid hit in London and ultimately died, it was diagnosed with a failed motherboard, which would cost more to fix than purchasing a new computer. Fortunately, I had obtained comprehensive insurance through the National Press Photographers' Association (contact them for coverage information at www.nppa.org), which provides photography-equipment coverage through a major insurance company. The policies, which vary in cost according to how much and what type of equipment you're insuring, covers literally any type of damage anywhere in the world. This is essential for a photographer such as I am, who's traveling all the time to shoots in locations such as Qatar, Cuba, Greece, Algeria, Vietnam, and Brazil. Many photographers who have attempted to rely on their homeowners' insurance or automobile policies have been more than disappointed when trying to make claims for equipment loss or damage, especially when it has occurred in the field.

Obviously, if you're shooting with a camera that's $500 or less, then this type of insurance probably isn't necessary, especially given that most policies have a deductible of at least $500. However, if you're doing anything significant, no matter whether you're doing it professionally for a client or just for your own enjoyment, you'll want to invest in a policy for peace of mind wherever you may find yourself shooting.

As for dealing with disasters when they occur, repairing equipment in the field, for example, it is extremely difficult to undertake this yourself with the tiny, fragile parts and complex construction of today's computers and cameras. Even removing a keyboard key on a laptop can be challenging (but not as difficult as putting it back on!), and for the most part, we don't live in a do-it-yourself world anymore when it comes to photography. If you've spilled a liquid on your camera or laptop, follow these steps:

1. **Immediately power-off the device.** Much liquid damage that may not have hurt the camera or laptop if had been off or been turned off occurs due to it being short-circuited because it was on. Don't shut down a laptop in the conventional manner; instead, take out the power cord immediately and hold down the power button, which shuts it down immediately. Then remove the battery as quickly as possible; you can also simply remove the battery and power cord to shut it down instantly as well. This is *not* an advisable way to turn off the computer at any other time; you must realize that you will also very likely lose data when this happens.

2. **If you've shut down a liquid-damaged camera, do *not* remove the flash card immediately.** Wait until the camera has dried before doing so; sometimes being plugged in to the connection pins actually prevents liquid from penetrating the card. If you have a point-and-shoot camera that does *not* use a flash card, or has the ability to simply hold images in memory, then do *not* turn on the camera. Remove the batteries, and don't plug it in. You'll want to take it directly to a repair center. Only they will be able to recover any images that may still be present on the camera.

3. **Assess the type of liquid.** It makes a difference. If it's a sticky, sugary liquid like soda, a residue is left that can continue to damage the device and short-circuit various connections even after the liquid has dried. In this case, you need to have the camera professionally serviced as soon as possible and *do not turn it on.* Take out the batteries. Do *not* attempt to clean the camera with other liquids such as alcohol unless you do so with a lint-free cloth and touch only exposed surfaces. If it was plain water that was spilled, it should dry without a residue; salt water, conversely, leaves a salt residue, so it is imperative that you get the camera or computer to a repair facility as soon as possible because of salt's corrosive properties.

4. **If you're still in the field after the camera or computer has dried, you can attempt to remove the flash card if it's essential to do so.** Let it dry for at least 24 hours in a low-humidity environment before plugging it in to anything else because, although the camera or computer may have mostly dried, moisture may still be lurking inside the flash card.

5. **If you feel the damage was superficial, you've let it dry, and the camera or computer seems to be operating normally, you still need to observe how the device behaves for several weeks after the damage occurred.** If anything seems abnormal in how it's running, have it examined by a repair professional and document what happened. If you do have an insurance policy, they will want to know this information.

The Post-Pixel Stage: Working with the Digital Image

Your camera does the job of converting pre-pixel, analog light into a digital image. The point at which this takes place is when the image hits your camera's electronic sensor, a sensitive and delicate plate perfectly placed at the focal plane of the camera. Your camera probably has a little symbol on its side that looks something like the one in Figure 2-7.

focal plane

Figure 2-7: This symbol, as seen on the side of a Canon 1D Mark II, is common to most cameras — both film and digital — and accurately represents the camera's focal plane.

This symbol indicates the exact plane at which the light hits the surface of the sensor; the same symbol appears on film cameras showing where the film is held against the pressure-plate and the point at which the film is exposed. For digital or film cameras, this is an important mark especially for precisely measuring focal distance when shooting close-up images.

CCD versus CMOS: Which is Better?

Digital camera sensors are almost always either a *CCD* (charge-coupled device) or a *CMOS* (complementary metal oxide semiconductor) plate. Both are chips that do essentially the same thing: Through an array of light-sensitive points, representing pixels (*picture elements*), they interpret an image as a matrix of tiny sports of light that together make up an image.

Many of the higher-end pro cameras use CMOS technology, which is more expensive but higher quality and more controllable, although they tend to be more "noisy." They are expensive because the digital noise must be filtered, a costly process when the intent is to produce a perfect image. If you're shooting in RAW format and using larger format, CMOS chips are superior.

CCDs have been available for a long time and began as the key elements in digital scanners. They're reliable, inexpensive, and produce very good-quality images for cameras shooting at five megapixels or less.

After the camera's sensor has absorbed the image, it converts it into a digital file that is stored briefly in the camera's internal memory. It is then downloaded to the media you have in the camera, namely a flash card. When you're shooting multiple images, such as holding down the shutter to catch a sequence of shots of a running back catching a ball or a climber rappelling down a cliff, the camera may "choke," meaning that the buffer is full. The camera is unable to shoot additional photos until it offloads the images to the flash card. Some cameras have more memory than others; most consumer and semi-pro cameras can hold 4 to 12 shots at a time. So even if your camera can shoot more than four or five frames per second, it's only as good as its buffer rate because if the buffer fills, no more photos can be taken.

If you plan to shoot sports where action sequences are essential—such as I have to do for fencing—you want to make sure that the camera you purchase has a sufficiently large buffer and frame-per-second rate; otherwise, you'll miss key images that other cameras can capture. However, for sports such as sailing, hang gliding, and even wrestling or some types of gymnastics, these factors may be less important.

If shutter-lag occurs with your camera, meaning the photograph is taken a moment or two after you depress the shutter release, then you'll need to figure out how to anticipate the action whenever you can. It may be difficult and take some practice, but it's a necessary skill to acquire if you're shooting any fast-action sport with a slow-action response from your camera.

Another factor in multiple image speed is the flash card's write speed; cards have varying rates of how fast images are recorded on them. Some of the more expensive cards have write speed rates of 80X, which translates to a sustained data transfer rate of about 12MB (megabytes) per second. Less expensive cards with lower speed rates transfer photos more slowly (for example, a card with a 40X speed rating transfers about 6MB per second). Faster cards obviously allow your camera's buffer to empty more quickly.

Getting Images *into* Your Digital Studio

Your flash cards need to be downloaded to a portable hard drive or laptop, an essential and critical step in digital photography workflow. You want to be absolutely certain that your images have been secured on a hard drive before you do anything else with the flash card, such as formatting it or erasing the images to take more shots. Consider the two ways you might accomplish this with a laptop or with a portable drive.

Portable hard drives

I've become very reliant on a portable hard drive called the ImageTank when I'm in the field. It is a very simple device with a slot for a flash card (as well as one for SmartMedia) and a couple of operation buttons. Containing a 20GB hard drive, which is all I need for several days of shooting, it has a simple LCD display that shows only that the device is on, a card has been inserted, and the data on it is being transferred to the hard drive. Because it's so simple, the rechargeable battery lasts a very long time; it also runs on a 12-Volt DC cigarette-lighter connection or on 110-220 AC. When I'm back in my digital studio or in my hotel room, I simply connect it via a USB cable to my PC and back up the images.

Portable hard drives are probably the download device of choice for sports where staging a PC is difficult or impossible. They are light, portable, reliable, and easy to use wherever you may be. I typically store one in my camera fanny pack and download while I'm shooting.

Tip

When purchasing a portable hard drive, look for one with FireWire or USB 2.0 support. These transfer images much faster than USB 1.0, assuming that your PC supports these faster formats.

Other types of portable devices exist, such as a portable CD burner that allows you to directly transfer flash cards to a CD all on one device. Although they're interesting, I have found CDs to be fragile enough, and subject to failure often enough, that I hesitate to fully trust this type of a download when I can't verify the CD in the field.

In my experience, the portable hard drives that tout all types of extras — especially image display windows — typically consume battery time far too quickly; they also are poor at displaying images with any speed, so the feature is only of limited use. Finally, the fewer the features, the less expensive the device is. Simplicity reigns when storing images securely in the field! Figure 2-8 shows an ImageTank.

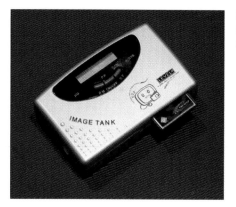

Figure 2-8: The ImageTank is one of the easiest and most reliable portable storage devices for Flash Cards on the market today.

Using a flash card reader with a PC

Although many types of flash card readers that can be used with PCs are available in today's market, reliability among different PCs, readers, and flash cards continues to be somewhat challenging. The most common type of reader, shown in Figure 2-9, is attached to a cable with a USB connection. Once connected, it appears and is viewed just like a drive. These can be purchased for a variety of types of camera flash cards, and some readers support multiple card types. The other common type of reader is a PCM-CIA or PC Card reader; this type of device can be inserted into the laptop "slot" on the side of the computer, and the flash card is inserted into it, as shown in Figure 2-10.

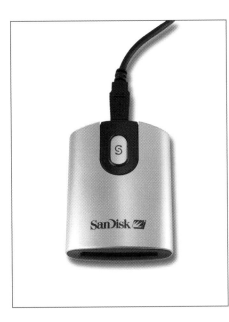

Figure 2-9: Attaching to your computer's USB or FireWire port, flash card readers like this one from SanDisk are a simple way to transfer images to your PC.

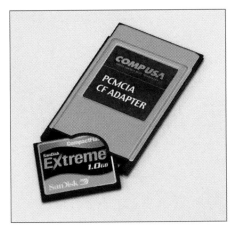

Figure 2-10: Designed for notebook and laptop computers, PCMCIA (PC Card) style readers allow you to attach a flash card by inserting the card into the reader, and the reader into card slot available on virtually all portable computers.

Tip

Test your flash card reader in your digital studio before taking it into the field! Record a full card of images, and download them into the computer you'll be using to be sure that everything is compatible.

Always take a backup flash card reader into the field, just in case your primary one is lost or damaged or fails for some reason. Doing so has been a lifesaver for me on countless occasions.

Image transfer: The software factor

The other factor that is important when downloading flash cards to your computer, or transferring files from your portable hard drive, is what application you'll use to move the files and store them on the PC. You can use any number of applications to do this, ranging from the tried-and-true Microsoft Windows Explorer window to applications such as ACDSee, which let you configure images as they are stored.

I actually use Windows Explorer commonly when transferring images, and I typically do not do anything with the images until they're safely on my PC hard drive. Follow these steps to save your image files to your PC via Windows Explorer:

1. **Connect the card reader or portable hard drive via the USB or FireWire connection (as appropriate).** If you're using a card reader, insert the flash card.

2. **A small window appears, indicating that your computer recognizes the files on the flash card and giving you options for what application you'd like to use to view and/or download them.** You can then select the application you want to use and your images will download and appear in it.

3. **In Windows Explorer, a window appears showing the files and drives on your computer, including the flash card.** Figure 2-11 shows the Explorer window in Windows XP.

Figure 2-11: The contents of the Flash card are displayed in Explorer, in this case, in Thumbnail view.

4. **If you haven't done so, create a subfolder to contain the images you're going to transfer.**

5. **Select the files/folders, and drag them to your destination subfolder.** Your files may be in a subdirectory on your portable drive or flash card. You can either transfer the entire folder or click down to the individual files for transfer. The images should transfer, one by one, to your hard drive. Note that they are still on the original flash card too.

ACDSee and Photoshop Elements also both include very good image-retrieval utilities, but I suggest that you keep it simple if you use them. You can easily and quickly download images, but you can create a problem just as fast. For applications that automatically transfer images from flash cards or drives to your PC, typically you have many options to configure, such as automatically renaming the files or moving them instead of copying, which means that, as the files are transferred, they are removed from the source device or card. Moving files isn't the most prudent method, simply because if fate intervenes and anything interrupts the process, you're in danger of losing images. Renaming images is relatively safe, but may slow down the transfer process. Renaming usually is much faster when done to files already on your hard drive.

Caution NEVER, NEVER remove a flash card while you're in the middle of transferring images. Doing so can permanently corrupt the card and cause you to lose images. If it does happen, some flash cards come with recovery software that may allow you to rescue files.

After your images are safely on your hard drive, you may want to immediately back them up by recording them to a CD or DVD or to another hard drive. Don't rename the files or change them in any way, especially if they are JPEG files. JPEG files are a *lossy* file format, which means that nearly anything you do to a JPEG file causes it to degrade by a fraction. When working with JPEGs, you should create archive files before working on any of the images. Basically, keep a copy of the original files; these are only for using as source files of which you can create copies. Store these in a very safe place!

Summary

Digital photography workflow for sports differs from studio photography especially at the pre-pixel stage because virtually all sports photography is done on-location. Preparing for a sports photo shoot means being prepared in the field, knowing your equipment, and having a good grasp of the sport, venue, action, and people you're out to capture.

Being prepared for and executing a digital sports shoot means knowing what to do as conditions and the environment where you're shooting change. The sports photographer knows how to adapt to where he or she is shooting. Being able to anticipate the unexpected makes all the difference in catching those once-in-a-lifetime shots — and being able to recognize them when they happen.

Knowing what to do when disaster or near-disaster strikes is important as well, and it means being resourceful and ready with backup equipment and resources. Photographers will do almost anything to ensure that their images are safe and that they have plenty of them from which to choose!

Finally, it's important to be ready to transfer images from your camera to a storage device of some kind so that they're ready to be processed back in your digital studio. You can do this in a variety of ways, and what your shooting, what equipment you can have with you, and how far away you are from your studio all have a bearing on how you handle the images you take.

✦ ✦ ✦

3 Equipment and Techniques for Digital Sports Photography

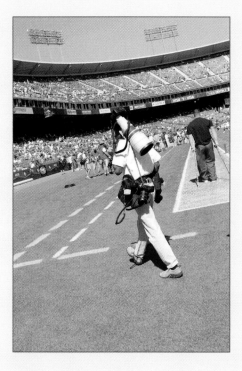

Sports photographers capture virtually all their images in the field, not the studio. Because of this, they have little if any control over their environment to be able to set up lighting, poses, and positioning for the best shots. As a result, the equipment and techniques used to get the photos take on greater importance because they are the only factors the photographer can change and adjust.

I've discussed how to prepare for the digital sports photography shoot, but how does this work in the field? What techniques should be used for what situations? What is the best choice of equipment for different sports scenarios?

Professional Photographer Terrell Lloyd

My friend Terrell Lloyd is an official photographer for the San Francisco 49ers. He travels with the team and shoots all the games, and his images appear in print and online on behalf of the team.

Although Terrell on occasion shoots posed portraits of the players and cheerleaders, most of his work is done from the sidelines of big games amidst sports chaos. He must navigate among coaches, cheerleaders, team support staff, photojournalists, TV crews, referees, equipment, and myriad other obstacles, all of which potentially may stand directly between him and a great shot. So he comes to the game prepared, carrying gear with him, equipped with telephoto lenses, extra batteries, CompactFlash cards, and everything else he needs. Terrell is prepared to get the shots he needs in an unforgiving world with little regard for a roving photographer. He then navigates his way around the huge fields and stadiums to capture as many shots as possible. Terrell's shot of an airborne 49er receiving a pass looks almost as though the shot was taken from the field itself and not the sideline.

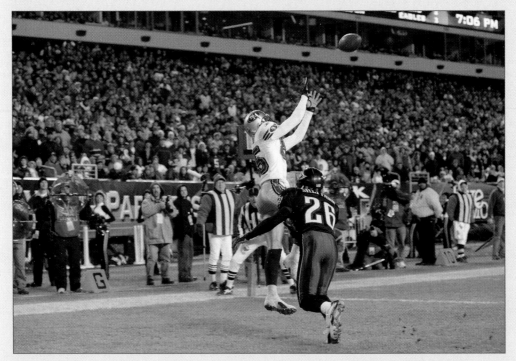

© Terrell Lloyd

Terrell Lloyd's photo of San Francisco 49er pro football action shows the many types of staff, referees, and official personnel on the sidelines—all of whom are intent on seeing the action without interference—with whom the photographer must contend.

In Part II of this book, we take a specific look at individual types of sports and how to best photograph them, with help from a variety of amateur, enthusiast, and pro photographers. In this chapter, we take a more generalized look at shooting sports in the field based on well-established photography equipment configurations and methods of shooting.

Nothing Beats a Great Photo

In the wonderful, high-tech world of digital photography, we tend to think that no matter what kind of photo you take—no matter how poor it is, primarily—something can be done to treat it later when the image is being edited. "Don't worry, I can fix it in Photoshop" is a phrase that many photographers have uttered time and again.

Don't believe it for a minute! No matter how sophisticated your software is or how well you use it, nothing beats a well-composed, well-exposed photograph. Sure, you can crop the image and even adjust contrast, color, shadows, highlights, white balance, and other features, but the less you have to do in the post-pixel stage, the better the image ultimately will be. Furthermore, it means less time for you to be working in the studio when you could be out shooting!

Understanding the best equipment for taking certain types of shots, how to best compose them, and what exposures and settings are perfect for what you're shooting are well worth your time. This means getting to the venue early enough that you can shoot some test shots and, at the very least, take a look at them on your LCD.

If in doubt, shoot dark

When I'm taking lots of photographs at an event, especially where conditions are changing and I don't have the luxury of checking all my exposures in detail, I often shoot dark. That means I adjust the image down a stop or two, such as shooting at f/5.6 instead of f/3.5. Why? If I'm uncertain about an exposure, I always prefer a bit of a darker, underexposed image than one that is overexposed. If an image is too light, it's often impossible to add information; conversely, if an image is underexposed, typically it's possible to *remove* information by lightening the image, often revealing a perfectly exposed photo. The following series of figures demonstrate images that were overexposed, underexposed, and adjusted from being underexposed.

Figure 3-1, which is obviously overexposed, was taken a very slow shutter speed. And, it is so overexposed that the image is far beyond rescue—there is literally no digital information with which to work, it is blurry, and has almost taken on an artistically abstract effect. Had the image been shot at a shutter speed of at least 1/200, there might have been hope for using it if was a critical shot. Optimally, it should have been shot at 1/400 or 1/500 second.

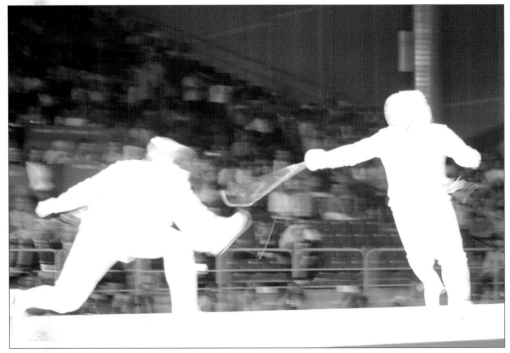

Figure 3-1: This overexposed shot of fencers was taken at 1/12 second at ISO 400 and an aperture of f/2.8.

Figure 3-2 is underexposed. Because the light on the fencing strip varied from very bright to slightly dark, I chose to keep the camera set at my typical, one-stop-down setting of 1/400, ISO 500, and f/2.8.

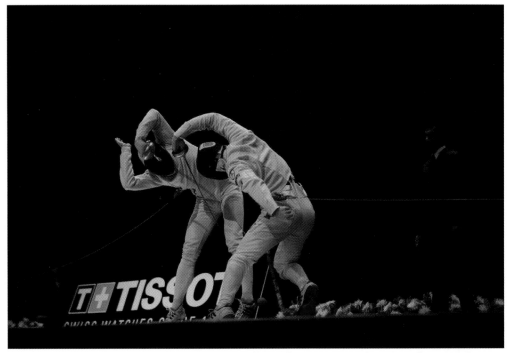

Figure 3-2: This image of men's epee fencers on the final strip at a Grand Prix in Doha, Qatar, is slightly dark with the fencers' jackets obviously not as white as they should be, which was intentional.

Figure 3-3 shows the same image from Figure 3-2. Using the Levels control in Photoshop, I was able to improve the contrast and color — something I would not have been able to do had I overexposed the image as in Figure 3-2. As long your images are underexposed by only one f-stop and not much more, they should be highly editable.

Using the stop down method, you have a starting point from which you know you have a good exposure. Jot down the setting in a pocket notepad; you can also check the information setting by viewing an image displayed on your LCD. If I have changed my settings by choice or by accident, this lets me refer back to an image I took earlier on the same flash card to see where it was set. It's not uncommon when you're shooting in the field to inadvertently change a setting when you're shooting in manual mode — which is also why it's a good idea to check your LCD image preview on occasion (but not obsessively).

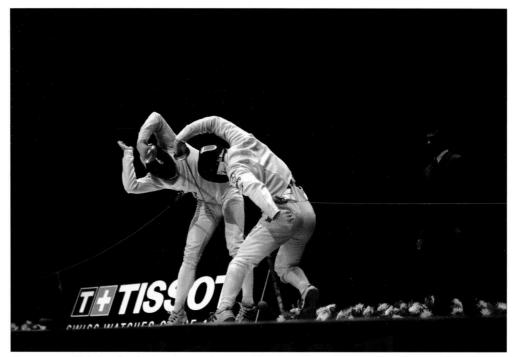

Figure 3-3: Slightly edited using the Levels control in Photoshop, Figure 3-2 was improved.

Cheat sheets

If areas of the field of play differ in terms of light, or if you'll have different lighting challenges during the event, then you should be prepared to shoot them with the appropriate settings. Figure 3-4, is an action tennis shot taken in bright, direct, midday sunlight — one of the hardest types of light in which to shoot. If you shoot too dark, the features in the person's face will all but disappear; if you shoot too light, you won't have any detail. Plus, with an action shot such as this one, you have to shoot with a fast shutter speed so that nothing is blurred.

I want to continue with the tennis track, thanks to Amber's action photo, and ask you to think about shooting a regional tennis match. You may want to put together a cheat sheet with notes that look something like Table 3-1 after you have a chance to check your settings. The settings here are primarily for SLR owners, and I've added suggested point-and-shoot settings as well (remember, your camera may differ according to the light, the venue, and other factors).

© *Amber Palmer*
Figure 3-4: A dramatic action tennis shot by photographer Amber Palmer taken in harsh sunlight

Table 3-1: **Outdoor Tennis Cheat Sheet**

Subject/Shots	Speed	f-Stop	ISO	White Balance	Lens	Point-and-Shoot Settings	Notes
Action	500	2.8	200	Outdoor Sun	400 mm	Set camera manually on the fastest possible shutter speed, a low ISO, and the widest aperture (f-stop) available. No flash!	
Crowd	125	11	400	Outdoor Sun	70-200 mm	Disable the flash and use an automatic setting.	Use hood!
Venue (wide)	80	16	400	Outdoor Sun	17-28 mm	Disable the flash and use a smaller aperture (f-stop) with an ISO of 400	Best from top of stands

Continued

Table 3-1 *(continued)*

Subject/Shots	Speed	f-Stop	ISO	White Balance	Lens	Point-and-Shoot Settings	Notes
Coaches/ Bench	250	3.5	400	Outdoor Sun	70-200 mm	Automatic setting or shutter-speed priority set to 1/125 or 1/250. If in shadows, use the flash.	Good shot from behind referee
Medal Ceremony	125	11	200	Flash	24-70 mm	Automatic setting with flash.	With fill flash

> **Note** A *fill flash* is a limited flash setting where you aren't shooting to completely illuminate a dark area, but, rather, to fill in the areas of an already lighted subject where a little extra light will serve to eliminate shadows and other unwanted features.

Obviously, these are examples and not absolute settings for you to shoot a tournament, but it gives you an idea of the variations of lenses and settings for an event. With practice, you won't need the cheat sheet; you'll simply know what settings will work best for what you're shooting. However, until then, you may save yourself from missing a few important shots by keeping this type of information. Furthermore, if you shoot in the same venue again, you won't have to recheck if you keep this information handy.

> **Note** Remember that no two shots are alike, nor are any two events — even if they're in the same venue. Assuming that the same settings will work always work and not staying in-tune with the individual situation will inevitably result in mistakes being made; however, having a general idea and guideline will save you time and help you learn to replicate shots better.

Zoom, Telephoto, Portrait, and Wide-Angle Lenses

If you are fortunate enough to be shooting sports with an SLR, you will find there are lenses for virtually anything you can imagine and accessory filters for them with almost equally as much variety. You can easily spend a fortune on just a few lenses, far beyond what your camera body cost. If you're shooting with a point-and-shoot camera, then you won't have to bother with changing or carrying lenses. Some point-and-shoot cameras come with remarkably sophisticated glass, which can have a notable effect on the price of the camera, but that good lens allows it to take far better, faster photos.

Lenses include an amazing amount of technology and engineering; optics is a fascinatingly complex area of science that has undergone tremendous advances and development over the last 50 years. A good lens can make all the difference in being able to get great shots by being fast, accurate, and well suited for a specific job. However, used incorrectly, it is just as capable of taking a bad photo as a good one.

Many sports photographers shooting big events like football, soccer, and baseball shoot fixed lenses that do not zoom. Why? Because, typically, fixed lenses produce better images that are clearer. Zoom lenses integrate extra components that can affect the quality of the image and prevent the photographer from

being able to shoot at a single f-stop setting, which is why the fixed zoom lenses that allow you to have the same f-stop at all focal lengths are so expensive. These lenses typically don't telescope in and out, but rather move internal optical parts to adjust the telescopic range while staying within the same physical space—an amazing and expensive feat of optical engineering. Figure 3-5 shows pro football photographers working with fixed-focal length (big glass) lenses.

Many camera companies offer various levels of lenses, from consumer to professional. The Canon L series of lenses (identified by a single L on the lens body), for example, are its highest level of quality and engineering, which is reflected in the lens optics, speed, and cost. These professional lenses exceed other lenses and, accordingly, the images they produce are of superior quality, clarity, and accuracy. The lenses have to interact electronically with the camera to ensure a fast ability to auto-focus as well as to provide other features, such as image stabilization, faster focusing depending on the distance from camera to subject, and enhanced focal abilities depending on whether the camera is being tilted or panned in various shooting scenarios.

For the average camera enthusiast, these ultra-fast, hyper-expensive lenses are probably going to be overkill if for no other reason than a prohibitively high price tag (Canon L series lenses, for example, are often several thousand dollars; the fixed-lens, long lenses can be well over $10,000). So what's a photographer on a budget going to do?

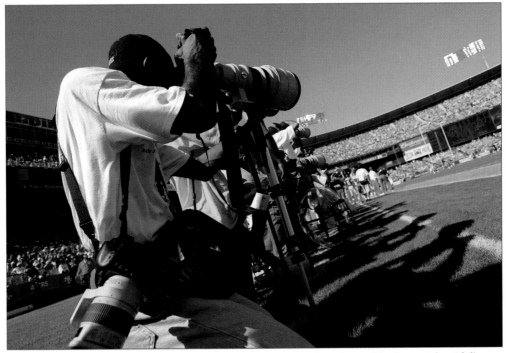

Figure 3-5: Terrell Lloyd, official San Francisco 49ers photographer, shoots big glass on the sidelines of a pro game. Note the monopod he uses to stabilize the lens, steady his shot, and keep his arm from wearing out!

First, it's important to note that you should have a set of lenses that includes the following, at the very least:

✦ **Wide angle:** A lens or setting on a zoom lens capable of shooting a wide angle of coverage, for example, capturing a full football field. Usually in the 15mm to 24mm focal length range.

✦ **Portrait:** A common, mid-range lens or lens setting suitable for getting a realistic photo similar to what you would see with your eye and commonly used for portraiture because of its true perspective. Typically in the 40mm to 70mm focal length range.

✦ **Telephoto:** A lens or lens setting allowing a telescopic view, meaning you can see things far away as if they were closer. The angle of view is narrow, however. Typically in the 100mm to 400mm range (although it can be much higher, up to 1200mm).

The next set of figures demonstrates wide, portrait, and telephoto shots, all taken with the same camera and similar settings within a minute or two of each other. Notice how you can really change the effect and feeling of the image based on the focal length of the camera. Shooting with a wide-angle lens (which is just a wide setting on a point-and-shoot zoom) as in Figure 3-6, it's easy to tell that I'm standing on a dock—another boat is in the scene, and a jet contrail even creates a bit of a distracting element. The sailboat at the center of the image is hardly a real subject of the image at this point. However, as I move into a tighter shot by zooming in, the telephoto lens (or telephoto zoom function on a point-and-shoot) allows me to emphasize the sailboat as the subject, as shown in Figure 3-7. In fact, with the telephoto setting used in Figure 3-8, it could almost appear as if nothing else is around for miles and miles, and I could just as easily have been on another boat in the middle of a large body of water taking the shot!

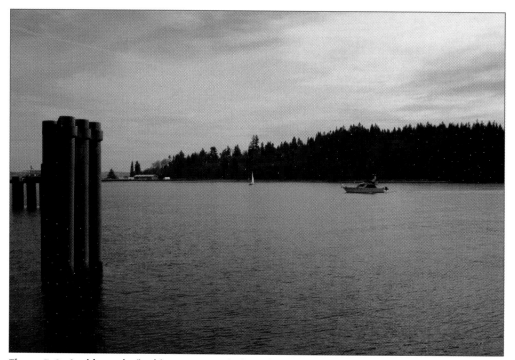

Figure 3-6: A wide-angle (in this case, 35mm) shot of a water-sports area. Note the sailboat in the center, which becomes the subject as I zoom in (shown in Figures 3-7 and 3-8).

Figure 3-7: At a portrait or common focal length setting, in this case 70mm, the sailboat has begun to emerge as the subject. However, the detail is still limited and the extra trees and water really don't provide much artistic support to the photo.

Figure 3-8: At a telephoto setting of 200mm, the boat is unmistakably the subject of the photo. If shot in a large enough megapixel format, the image could be cropped to digitally zoom in further; a longer lens (more than 200mm) would also bring it in closer.

While you might find some lenses that are all-in-one, featuring the ability to zoom from a wide angle to a distant telephoto, I don't recommend them because you're usually giving up quality. It's fine to have zoom capability in wide-angle, portrait, and telephoto ranges, but trying to go from wide to telephoto in one lens is a bad compromise.

Less expensive zoom lenses are incapable of keeping the aperture open to the same width at wide versus telephoto lengths. The longer the focal length, the more narrow the aperture—simply because they aren't letting as much light in. This means that if you're zooming in and out, even if you set your camera for a wide aperture at a wide angle, it will be physically incapable of holding that width at telephoto lengths, meaning your image may be underexposed. Expensive, fast zoom lenses will keep the same aperture at all focal lengths (which is one reason they cost so much) because this involves significant optical engineering wizardry. You can tell which type of lens you have by looking at its specifications (in the manual or on the lens itself). If it is a range, such as f/3.5–f/5.6, then it will vary (f/3.5 when wide; f/5.6 when in telephoto); if it is simple f/2.8, then you know it will keep that same aperture.

The faster the lens you can afford for sports, the better. Ideally, you should buy a lens that holds the same f-stop at all focal lengths. At the very least, make sure that what you're shooting doesn't have an f-stop range that's more than one or two stops. More than that, and you'll be frustrated with the inability of it to capture lower-light images at full focal length.

If you're going to be shooting all your images outdoors, and you're reasonably certain the light will mostly be bright and strong (for example, if you're shooting baseball in Arizona), you can get away with slightly slower lenses. However, if you're shooting like I am, in indoor halls with subdued and changing light with fast action, there's no substitute for fast glass.

Original equipment versus aftermarket lenses

There are many manufacturers of lenses that work with various camera types. Often, lenses such as Tamron or Sigma are significantly less expensive than a lens made by, say, Canon or Nikon.

Although these lenses may be perfectly good lenses, you want to test them with your camera to ensure that they focus as quickly as original equipment and that they are accurate. I've tested some aftermarket lenses that appeared to provide incredible speed for the price; however, several of these lenses shot images that were notably softer even when shooting exactly the same image at the same settings. On the other hand, I've had several aftermarket lenses I've used that have been excellent quality. One of my favorites, which I still use, is the Tamron 17–24mm wide-angle lens.

Note A *soft* image, in photography terms, is an image that is slightly out of focus.

Optimal optics: Making the most of point-and-shoot

If you're using a point-and-shoot camera, chances are good that you don't have the option of changing lenses; these cameras almost always come with a single lens that offers limited zooming capabilities. However, if you are considering a new camera or just want to better understand what your camera is capable of, this section ought to be very enlightening.

The optics in a point-and-shoot camera are probably the single-most important feature you want to consider when you buy one. No matter what whiz-bang features the camera may offer electronically, the bottom line is that an image is going to pass through the lens directly to the electronic sensor. How good the optics are determines how good your photo is more than anything else.

Most point-and-shoot cameras offer the ability to zoom *optically* or *digitally.* An optical zoom means that the glass in the lens is physically shifting to change the focal distance of the camera and shift from a wider to a more telephoto view or vice versa. When a digital zoom "zooms in," the camera simply crops some of the photo so that a smaller area is captured; in other words, a smaller amount of data is taken in by the sensor. You have a smaller photo, and you can't enlarge it to the full extent that you could with an optical zoom — at least not without losing image quality.

Some digital point-and-shoot cameras, such as Sony's Cyber-Shot models, attempt to use technology to overcome this limitation by using the full size of the sensor, but the result is still inferior to that of using glass to zoom. Camera companies resort to digital zooms because the technology takes up less space than providing lenses capable of broad-spectrum zooms, thus making the cameras bulkier than their marketing research tells them they should be to appeal to a size-conscious consumer base.

The bottom line is that if you're going to buy a point-and-shoot camera, look for the best possible optical range and size; typically larger cameras with bigger lenses mean better images (not a universal rule, but a place to begin). Certain companies, such as Canon, Nikon, and Olympus, also are known for superior optics as opposed to companies that come from more of a video or technology/computer orientation. Olympus, in particular, produces optics of very good quality because that was what the company primarily produced in its earliest days.

For shooting sports especially, you'll greatly appreciate a camera with superior optics. The ability to focus (manually and automatically) quickly and accurately, to be big enough to let in enough light, a large enough image that you can really capture what you see, and an optical zoom range broad enough to handle various distances inherent to sports are all important factors to consider.

Removing Spots from a Digital Sensor in the Field

Because the sensor in your camera — either a CCD or a CMOS chip — is extremely sensitive and expensive, a bulb blower is the best way to clean it. If damaged, the camera is virtually worthless unless you can replace the chip. Although most cameras protect the area in which the sensor is found — which is the focal point and plane upon which images are cast — nonetheless small bits of dirt and dust inevitably find their way onto them, and, in turn, into your photographs.

This is a particular problem for SLR cameras because they feature interchangeable lenses. Whenever you remove a lens and replace it with another, especially in a less-than-pristine environment, airborne particles can make their way inside the camera, behind the mirror, and onto the sensor.

You can tell that dirt is on your sensor when you see a spot consistently appear in your photos no matter what lens or setting you use. Occasionally, the dirt moves around a bit on the sensor, but if you keep your camera still, such as on a tripod, and take several shots with different lenses, you can tell if dirt on the sensor is the problem.

You can also take your camera to a technician, but if you're in the field, this probably isn't convenient. You should absolutely consult your manual to follow directions for sensor cleaning. Basically, this means selecting a menu item that allows you to press the shutter release and lock the mirror in the up position. This way, you expose the sensor and can reach it for cleaning.

Composition, Angles, Exposure, and More

Taking a good sports photo means having a number of factors working in harmony: knowing your equipment, understanding the sport, being in the right place to get the shot, and having a good eye for composition.

Most sports photography falls into the category of candid photography. According to Merriam-Webster, candid in terms of photography means "relating to photography of subjects acting naturally or spontaneously without being posed." This is a perfect description of sports photography!

Although it's not completely uncommon for athletes to ham it up for the camera or to have a bit more of an adrenalin rush knowing that they're on-camera (although this happens more for TV than for still photography), typically they're quite oblivious to photographers and cameras unless they get in their way. Even world champions, when you get them away from the sport or when they're finished competing and are celebrating victory, have light, stress-reducing moments that make for great photo opportunities. Figures 3-9 and 3-10 show examples of lighter moments in sports photography.

Athletes pose only for a medal ceremony or for the obligatory team and player photos. Regardless of whether the players are kids or pros, taking these posed shots is a necessary part of professional photographers' athletic off-field responsibilities. This book isn't about doing that kind of photography, although I cover a few poses later in this chapter, so I want to focus on action-oriented, candid shots, which are the ones you're most likely going to be working to capture.

Figure 3-9: No matter what kind of photography you're doing — either for your friends, clients, or the public — adding some personality and fun to your images is good. Here, Ukrainian Olympic foilist Sergei Golubitsky, one of the most famous contemporary Olympic fencing champions, shares a light moment during a world championship in Bulgaria.

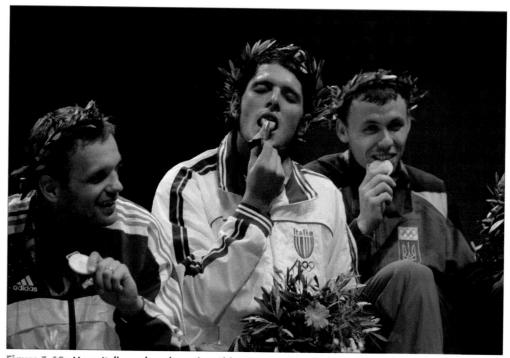

Figure 3-10: Here, Italian saber champion Aldo Montano literally licks his gold medal for all the cameras at the Athens 2004 games.

Composing a good sports photograph

Good composition in sports photography means being able to see the action before and while it's happening, along with having a sense of what makes a good photo in general. Composition is a long and well-addressed topic in photography; entire books are dedicated to the topic.

Perhaps the most important factor in sports photography composition is being able to focus on a *subject*. If someone viewing the photo isn't sure what it is centered on — for example, if the photo contains just a group of players on a field, randomly placed — the photo is not meaningful or interesting. When a group of people isn't posing and the photos are candid, it's essential that you pick a subject for each shot — a central point in your image around which everything else revolves.

A sports subject may be an individual player alone, two players, where one or both of them is the subject, a single player running for a touchdown amidst a sea of other players, a sailboat tacking in front of another, or a race car in the process of overtaking another on a track. In any event, the photo is focused on something specifically happening in the scene.

This isn't to say that your subject is always in the center of the photo. She may be off to the side as a ball flies toward her racquet, or he may a crashing surfer at the bottom of a towering wave. Yet the person viewing the photo is drawn to the subject because you intended it to be so when you took the shot or when you adjusted the photo in post-production.

In fact, you may have a photo that isn't very focused in terms of a subject. Sometimes, you can fix this later by cropping the photo to emphasize a part of the image that then becomes the subject and eliminates any confusion as to what the viewer is looking at. At other times, you may see something that requires you to adjust how you're shooting in order to capture a subject. Figure 3-11 shows a large group of Olympic fans in Athens, but it's not very interesting. However, by turning on the flash and singling out an individual fan — in this case, a Polish man who had even painted his face in his national colors — the shot suddenly became far more interesting, and it's still obvious he's in a big crowd, as shown in Figure 3-12.

This isn't to say that a well-composed photo with a subject must be a tight image of just one person; it may be a wide shot of a large space. Because we're talking about sports crowd shots, look at two photos of the opening ceremonies from the Olympic Games. In Figure 3-13, you can see the Icelandic performer Bjork on the far left of the image spreading her gown across the tops of all the athletes in a stadium of 70,000 people.

Figure 3-11: In this crowd shot, there doesn't seem to be a single focal point.

Figure 3-12: By singling out an overzealous fan, the shot becomes more interesting.

Figure 3-13: Icelandic singer Bjork is the subject of the image, yet she's not in a close up and not even in the center of the photo.

In Figure 3-14, the center of the image is the just-lit Olympic flame and the final Olympic torch carrier, seen below as the flame rises into its permanent spot.

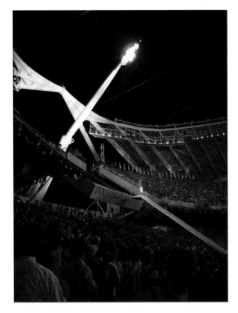

Figure 3-14: The relationship between the flame and the torchbearer is clearly the subject in the midst of a massive crowd of onlookers.

The rule of thirds

A classic method for composing photographs is known as the *rule of thirds*, meaning that any photograph is divided among a tic-tac-toe–style grid of four lines forming nine squares.

In Figure 3-15, photographer Neal Thatcher's spectacular shot of an extreme snowboarder in Canada's Blackcomb Mountain nicely represents the rule of thirds. The image is divided into a grid of nine squares. Top to bottom, one third of the image is the sky, one third is the sky with the subject (the snowboarder), and one third is the trees and snow.

The subject would be far less dramatic without the sky above and trees and slope below. The other parts of the image serve to emphasize the athlete and how high he is; in some cases, the empty space will make the subject look higher than he actually is.

Also, although the subject is roughly centered amidst the nine-square grid, this certainly isn't always the case using the rule of thirds. However, in this image, it works very well, and the composition is nearly perfect.

That said, one of the things to remember about the rule of thirds is that it is a rule made to be broken. Photographers are always working with the thirds in creative ways, consciously and subconsciously. They may put the subject at the top, or they may flow action from left to right or bottom to top. However, they are almost always working with the simple rule of thirds in mind; making this a habit helps to ensure that images are more likely to be well composed from the beginning and yet have a tremendous amount of creative leeway. For example, in Figure 3-13, the performer Bjork is in the bottom, left-hand side of the image, but she could be considered the focal point; this is but one example of how the rule of thirds can be applied creatively.

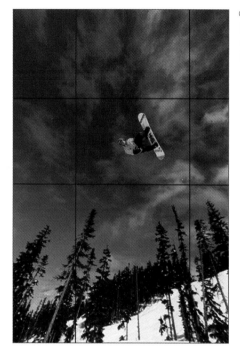

© *Neal Thatcher*

Figure 3-15: The left and right thirds are the sky, trees, and snow, sandwiching the last third of the boarder in the middle.

Taking great digital action shots

Action shots are the heart and soul of sports photography. They are the shots where the goal is kicked, the ball is hit, the boxer is punched, the climber is caught in mid-rappel, or the snowboarder is upside down above the half-pipe. Whatever the shot, suffice it to say that the athlete is in the midst of an important and often game-making or winning move.

Note Taking good action shots often requires taking lots and lots of bad or, more likely, boring shots to get a few good ones. This is something you just have to get used to in sports photography. In championship fencing semi-final and final events, I typically shoot multiple shots of every encounter between all fencers in every bout, for every event; in other words, I may shoot several hundred shots per hour for several hours. However, I cannot afford to *not* shoot all of them, simply because I never know from bout to bout when I'll see a spectacular move, and I have to be ready.

Let's say that you're shooting a diving competition. From the moment the diver appears at the top of the platform to when he or she hits the water, you should have your camera shooting and tracking the diver. The vast majority of images are probably going to be tossed later, but you're looking for the ones with perfect form, composition, focus, and so on. You may have one good shot of each diver or maybe several.

When you're shooting action where there is significant lateral movement as well as forward and backward movement, manually focusing on them may be difficult or even impossible. Assuming that your camera has a reasonably fast and accurate auto-focus, you want to set the focus on a *spot* focus — focusing just on a center point of your viewfinder, not the entire image.

Some cameras' auto-focus capabilities include being able to choose between a single-shot focus or what's called an AI Servo setting. With the former, you focus by pressing the focus button each time to focus on a subject; this can get tedious and inaccurate for fast-moving action sports. With the AI Servo setting, your camera keeps focusing and tracking on the center point as long as you keep the focus button pressed. This is very useful when an athlete is moving toward you or away from you and you can simply keep shooting — and it's another reason that pro photographers often set separate buttons for focusing and shooting. Otherwise, after each shot you take, your camera refocuses when you depress the shutter release for your next shot. That is unless you have the lens or camera set to be manually focused.

If your camera is slow and has significant shutter lag, this type of shooting — in fact, any kind of action shooting — may prove very challenging. Anticipating to the point of dealing with shutter lag is a crap-shoot at best; you're much better off with a camera that can at least reliably shoot three frames per second. Although you'll experience a little shutter lag at that speed, at least you can get some shots even of fast-moving sports.

The more you can close in on action, the better. It's tempting to take wide shots where all the athletes' bodies are shown, but some of the most dramatic shots are quite close and leave out something in the image. Getting a tight image of an athlete's face gripped in the tension of competition outweighs a full body shot any day; notice in magazines such as *Sports Illustrated* how many shots leave out body parts that no self-respecting portrait photographer would dare eliminate.

Capturing key moments

The best action shots aren't just the classic poses and typical images that everyone expects to see. Look for interesting perspectives, angles, and expressions — the more original, the better.

My work as a fencing photographer became successful as a result of thinking not of the classical fencing move, but rather what would look exciting to people who may not know what fencing was all about. Fencing is a sport rife with passion and exhilaration, athletes ripping their masks off and screaming out a victory cry, leaping high into the air with gymnastic talent to achieve a single touch, but the images portraying it lacked energy, motion, and excitement. So I set out to change that and ultimately changed how the sport has been portrayed.

Look for key moments in any given sport. Such a moment may very well occur when it's expected, such as a baseball player sliding into a base, a goalie missing a ball as it goes into the net, or a rider poised atop a horse jumping a tall set of poles. However, it may also be something different as well: a swimmer's body as he does a kick-turn, a close-up of a hockey player's face riddled with intensity, or a coach's hopeful look as her gymnast completes a routine for a gold medal.

Action doesn't always mean conflict, a player in motion, or a ball in the air. It can mean a player just *after* a particularly difficult or successful move or before it — such as a baseball player poised for a hit. All these either directly show or *imply* action, and they can piece together a story about the athlete, how a sport is being played, or what that sport is all about.

Getting a good angle

Getting a good angle is key to being able to take sports photos. As a photographer at sporting events, you are often in a privileged group and can often perch somewhere that others cannot — even if you're doing it as an amateur. Consideration is frequently given to someone with a camera, no matter who he is, and it's up to you to take the opportunity. Don't assume that you won't be allowed to get close to the action just because you're not an official. This is definitely one pursuit where it's often easier to "ask for-giveness rather than permission." Photojournalists are notorious for getting themselves into spots no one ever thought they could and dealing with the consequences later.

But you must do this diplomatically and quietly, and you must behave according to acceptable standards. At a U.S. national fencing tournament a few years ago, I saw a parent get into a near fistfight with a coach over a camera. The parent wanted to shoot video of his son fencing an important elimination bout and was getting in the line of sight of the coach, who insisted that the parent get out of the way. The bout between the coach and parent became more heated than the one on the fencing strip, and the referee at one point had to stop the fencers because of the distraction on the sidelines.

Who was right? Without question, it was the coach. A coach or other official *always* has the right to the sporting field over anyone from the media, family members, or anyone else who stands to get in the way.

Caution When you take photos of a sporting event, you can often get closer to the action than spectators. However, that doesn't mean you can distract officials or athletes, and you have to be very careful not to get in the way of anyone involved in the games — on the sidelines or the field.

Look for angles that give an unusual perspective of the sport, in addition to common or familiar ones. Perhaps you can get above the action or shoot it from floor-level by lying on the ground. Climb up into the stands, get where other people may not be, and explore close ups and distance shots from each spot. Find out what works and what doesn't. This is what ultimately yields some of the best photos you can ever take.

Don't be afraid to shoot *tight*, closing in on an athlete's face or body. However, these should be only a part of your entire set of photos; just having tight shots — even good ones — isn't sufficient to get a full picture of an entire event any more than just having big, wide-angle shots.

Some of the most dramatic angles in sports require you to get into an uncomfortable or special position; they may even require special equipment or be risky, including these spots:

✦ An underwater shot of a diver or swimmer, which means you need diving training and underwater housing equipment for your camera

✦ Climbing to a part of a cliff that's not a routed part of an ascent to view a fellow climber on a tricky precipice

✦ Getting access to a catwalk above a sports court to shoot players from directly above

The photo in Figure 3-16 was taken of a desert four-wheeling Land Cruiser in the Saudi Arabian desert in Qatar. The driver took me on a different route through sand dunes so I could get a better view of the other vehicles as they barreled down a dangerously steep slope.

The tendency of many photographers who are looking at a sport for the first time through a viewfinder is to shoot it straight on, as you would watch it from the stands. This can be difficult, however, because athletes are often moving around, and a position that's 90 degrees or perpendicular to the line of action can be limiting in terms of your ability to focus on a maximum range of play, and it consequently reduces the number of usable shots you can take. Instead, poising yourself between 30 and 45 degrees from the center line of the action can yield the best results in action sports such as tennis, football, baseball, soccer, and others. After you establish a baseline of shots from these angles, you can begin to explore other perspectives to creatively fill in the story you're trying to tell.

In Figure 3-17, you can see optimal positioning based on this method. If you're shooting at a fast shutter speed with a narrow depth-of-field aperture, the 30 to 45 degree method is the most forgiving and gives you the widest range of focal accuracy. Furthermore, it gives you a perspective of the players, the action, and an opportunity to capture both close and wide-angle shots.

Figure 3-16: A desert race captured from the most dramatic vantage point

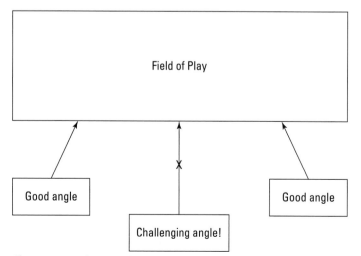

Figure 3-17: Diagram of positioning yourself to the action

Telling a story

Still photography tells a story, and it may be in a single shot or a series of them. Think about what you're doing at an event, no matter what type of sport you're shooting. Are you trying to emphasize the drama of the sport or the technical demands? Are you showing the abilities of one athlete in particular, even if it's your son or daughter, or are you trying to show a wide range of players? How can you personalize a sport where you can't really see athletes' faces because they're wearing helmets, masks, or goggles?

The person viewing the photo doesn't necessarily have to see the entire set of images from the event to get a story out of it; you may very well be publishing an image that will be accompanied by a caption. Or perhaps you plan to put together a slide show that gives you the opportunity to present a sequence of action and events. What you intend to do with the photos may very well have an impact on what types of photos you take and how many of them you shoot. If you're waiting just for a couple of key moments where a player has a dramatic move or response to something happening, then you can focus just on that and work with close-ups to ensure that you catch the shot. On the other hand, if you need to show scores, interaction, movement, and other elements of a sport, then you need to take lots of photos from as many perspectives as you can locate.

Here are some thoughts about how you tell a story when shooting sports:

✦ Decide ahead of the event what you intend to get out of it, photographically. Don't just shoot random shots.

✦ Identify any players you need to shoot ahead of time, and make sure you can recognize them (or take good notes).

✦ Mix your shots, between wide-angle, portrait, and close-up/telephoto. You may not use all of them, but this way you'll have the option later.

✦ Determine whether you need a sequence of action, such as showing progression through a table of eliminations (quarter-finals, semi-finals, and finals, for example).

Developing a style

As you develop your sports-shooting skills, you'll find certain shots that you are especially good at, as well as ones you like to take more than others. This may be because you find that you have an eye for certain angles or images, or perhaps because you know a sport well and can anticipate action that other photographers seem to have a hard time getting.

As a photojournalist, I spent much time shooting people and faces, sometimes in difficult or challenging situations. I also have shot many images around the world and have found that I really love photographing people in all walks of life — many times when they weren't necessarily looking at me or even realizing that they were being photographed, which gave me a documentary style of photography. I very much enjoyed shooting in this manner, and it ultimately paid off in my sports and portrait work, and much of my sports work features faces of athletes as much as it does athletic action.

Figures 3-18, 3-19, and 3-20 give a sense of some of the elements of my own style.

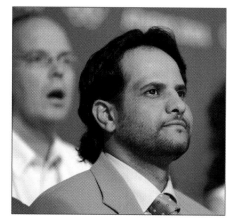

Figure 3-18: A narrow depth-of-field photo captures Sheikh Saoud Al-Thani, prince of Qatar and vice president of the Asian Olympic Council, watching a fencing final in Athens. Behind and to the left is Monaco's Prince Albert.

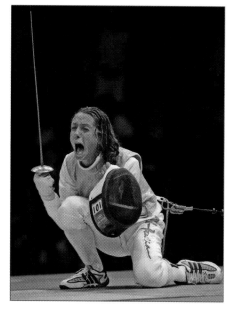

Figure 3-19: International Italian fencing star Valentina Vezalli cries out in victory.

Your specialty may be something entirely different. You may be adept at catching special aspects of a sport, and you may favor a certain angle over another. For example, you may love getting surfers inside a curling wave or skiers holding an extreme edge as they carve around a racing pole. You may find that you're especially good at shooting wide-angle shots of two football teams grappling with each other over a ball.

Whatever it is, it's important to be aware that you either have or will have a style that is distinctly yours, and that is a signature type of image you create just as a painter or a musician can be identified by a certain brush stroke or tonality on an instrument. Over time, people will begin to identify, critique, appreciate, and recognize you for this style as it develops and is cultivated.

Figure 3-20: U.S. saber gold medallist Mariel Zagunis and silver medallist Sada Jacobson pose for their medals — the first gold medal for the United States in 100 years of Olympic fencing.

Getting proper exposure

In photography, a good exposure is as important as, and often related to, good composition. It means that every part of your subject can be seen clearly and is in focus, and that there aren't areas that are overexposed or underexposed unless it is obviously intentional.

For example, you may shoot a baseball player's face in a *split*, meaning one side of his face is illuminated by the sun, and the other side is in shadow, which creates a dramatic effect. A good exposure takes into account all parts of the image: the main subject, the background, the light and the direction in which it is being cast, and areas of focus, as well as those that are blurred or obscured.

Posing

As a sports photographer, chances are good that you won't be posing many photos unless you decide to "go pro" and start shooting team and player shots on a regular basis. Still, it's good to know a little about posing athletes, so you may find these hints helpful, even for a family snapshot:

✦ If you're posing individual players, have them sit or stand comfortably with their sports equipment: a bat and ball, a football and helmet, a fencing foil, or a lacrosse stick.

✦ Don't try to have them hold their sports equipment unnaturally. Ask them how they hold it when they play, and have them hold it as naturally as possible given your limitations within the shot. Don't worry if you don't get 100 percent of the equipment in the photo.

✦ Focus on the player's eyes for the best possible focus, especially if you're shooting with a wide aperture.

✦ Have the player sit or stand with his body angled about 20 to 30 degrees away from you, with his face looking directly at the camera. If you angle him too much, the neck looks strained.

✦ For large groups, put them into tiered layers about three deep with some people sitting or kneeling in the foreground. Have the people in the back row stand on benches or chairs.

✦ With groups, instead of having people stand in straight lines, curve them into a slight semicircle; this naturally matches the shape of the lens and the eye.

✦ Consider what's in the background, and make sure it enhances rather than distracts from the group.

✦ To make sure you don't have anyone with their eyes shut in the image, have everyone close their eyes, and tell them you're counting to three and that on two you want them to open. Don't count too fast!

✦ Have the members on either end of the group put their hands in their outside pockets, to wrap the group (this is providing they have pockets). This is better than having them stand with their hands loosely at their sides.

Be creative! Don't be afraid to take some fun photos of the group as well as formal, posed shots.

In Figure 3-21, Olympic fencing referees are posing with the fencing federation officials at the main venue in Athens. The background, with the Olympic fencing symbol, makes for an interesting backdrop as opposed to merely having everyone sit in the stands. Note how the group was arranged in a semicircular fashion; I was limited on available benches and had to improvise with a mix of standing and sitting. I probably should have had the gentleman on the far right pocket his handkerchief, however!

Figure 3-21: Olympic referees pose with international fencing federation officials in a formal shot.

In Figure 3-22, a model poses for a shot that I use as a primary image for marketing materials for FencingPhotos.com. I was careful to have her hold the fencing foil correctly—something that athletic clients are especially aware of—and to make sure the foil wasn't brand, spanking new (that makes it look *too* posed!). The image was shot in RAW for a broad range of color and tonal definition (which is explained in more detail in the next section).

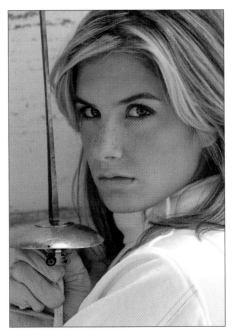

Figure 3-22: A fencing model poses for a glamour shot.

Choosing a Digital Format

In today's digital world, many photographers rely on the RAW format to be able to carefully control detailed aspects of an image's exposure, emphasizing and de-emphasizing various areas of it to bring out or suppress various elements. This is something you can do also with key images where you want to do some touchup work.

Cross-Reference There are several file formats used in digital photography. Most cameras today shoot in JPEG format. For more details on the various formats, see Chapter 2.

However, generally speaking, sports photography differs from portraiture in the amount of work performed on the images in post-production. Furthermore, most sports images are shot in JPEG, which is a more nimble and easy format to use, but also one that isn't as forgiving and versatile when it comes to adjusting the exposure later.

This means that, as much as possible, sports images should be exposed as well as possible from the get-go. You need to understand exposure to take good photographs. Ask these questions:

✦ What is the light like that you'll be shooting?

✦ What is the very best white-balance setting for the event?

✦ How bright or dark is it, and what should your ISO be so that your camera is sufficiently sensitive to the available light but limited enough to prevent digital noise?

✦ Will you be shooting stop-action shots? If so, what is the minimum shutter speed that you'll want to have, and how wide-open should your aperture (f-stop) be accordingly?

Shutter Speed, Aperture, and ISO

Here's another rule of thirds. Earlier, in terms of composition, I spoke of the rule of thirds and how it applied to composing good photos. Another rule of thirds relates to composition and involves the intricate interplay among three essential factors in photography:

✦ Shutter speed

✦ Aperture

✦ ISO

Every camera, even the simple point-and-shoot models, uses these three factors to take photos. They are the foundation of photographic exposure, and you must understand them to take the very best photos possible.

If your camera's shutter speed, aperture (f-stop), and ISO (sensitivity) setting work together to create the perfect exposure. If any of these is set incorrectly, the image can be adversely affected.

If your ISO is set too low, then you may not have enough light for how you have your speed and f-stop set. As with film, you need to increase the sensitivity of the media (in this case, your electronic sensor) to handle a lower or brighter light entering through the lens. Too much sensitivity, and your image may be overexposed or, in very low-light situations, have too much digital noise (this was called grain with film). Too little sensitivity, and your image is underexposed.

If your f-stop is set too high, meaning the aperture has a smaller opening (allowing less light into the camera), you may also have an underexposed image. However, if you want to have a broad depth of field, meaning much of your image, no matter how deep the image is, will be in focus, then you need a higher f-stop. Let's say that you want to shoot a team of football players and you have four rows of players standing on bleachers. Your f-stop needs to be higher — say, f/11, f/16 or more — in order to have all rows in focus. A low f-stop, such as f/2.8 or f/3.5, would limit your ability to focusing only on one row.

Tip Remember, a low f-stop (such as f/2.8 or f/3.5) means a *wide* opening (more light gets into the camera). This is what you want to use for narrow depth-of-field images.

If your shutter speed is very fast, such as 1/500 or 1/800 second, then you aren't letting in much light. However, at these speeds, you can produce a stop-action image without any blur, such as a ball about to hit a bat or a skier in mid-air. To do so, however, you need to have a wide enough aperture opening to accommodate the reduced light because of your fast shutter speed, which also means that you have only a limited area in which to focus. If you add a low-light situation to that, then you also have to make sure that your ISO is set high enough that you can catch the action.

Are you beginning to understand how these three factors — f-stops, shutter speeds, and ISO settings — work together?

If your camera is set to aperture or shutter priority, then it remains fixed on the setting you give it for one or the other and does everything else automatically. You may want to do this if you know, for example, that you want stop-action shots at 1/500 of a second but the light is changing a little — perhaps clouds are going in and out of the sun. If you set your camera to shutter-speed priority and make sure you have a good ISO setting for the light you have (outdoors, it may be ISO 200 or 400), then your camera automatically adjusts the aperture to the proper setting for the light as it changes. You should note, however, that this may slow the camera just a hair because, for each shot, it must measure the light and set itself accordingly, which is one reason so many photographers shoot manually.

Tip Use the lowest ISO setting you can without compromising your ability to shoot in the light you have. ISO 400 is a good indoor setting with or without a flash, and 200 is good in daylight outdoors on all but the sunniest of days.

Likewise, if you know that you want to have lots of narrow depth-of-field shots — such as getting close-ups of pitchers' faces as they stand on the pitcher's mound — then use your aperture priority setting, as low a number as your camera allows, and as the light permits.

Nonetheless, if you're just getting comfortable with shooting manually, using an aperture or shutter priority setting is a good mid-way exercise to get you accustomed to thinking along with your camera. Learning how these three factors interplay is essential to becoming good at taking photos that are well exposed and easy to edit.

Summary

When it comes to equipment and technique, sports photographers must be at the top of their game. Because they do all their shooting in the field, they have almost no control over their environment and must adapt their photography to suit the situation.

Selecting the right equipment can make a big difference in taking the best shots, and for some types of sports, inadequate equipment may make taking good photographs nearly impossible. So it's good to plan ahead and understand ahead of time what will be photographed, where, and how, not when it's taking place.

Technique also is an essential part of sports photography, and the adept photographer understands the fundamentals of exposure, light, and camera operation to ensure the photographs taken are intentional, not inadvertent. If the photographer is in control of the camera and understands how to take the shot he or she wants, then it frees up the ability to be creative, to tell a story with the image(s), and to be able to replicate shots that are successful. This, then, allows photographers from amateurs to pros to be able to develop their own distinctive and recognizable styles.

✦ ✦ ✦

Shooting Sports on Location

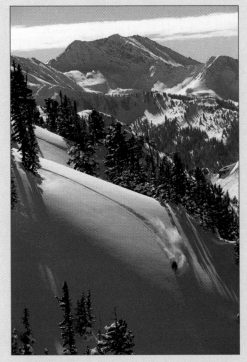

© *Will Wissman*

Chapter 4
Outdoor Field and Court Sports

Chapter 5
Outdoor Recreation and Competition,
On and Off the Water

Chapter 6
Indoor Competition Sports

Chapter 7
Extreme and Adventure Sports

Chapter 8
Specialized Sports

4 Outdoor Field and Court Sports

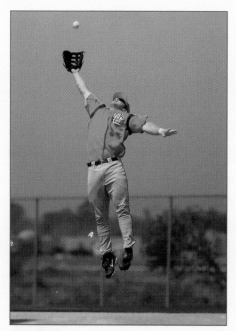

© Joy Absalon

When it comes to athletic endeavors, outdoor field and court sports account for a large percentage of what we play and watch. Whether it's football, baseball, soccer, or tennis, one of these is always in season somewhere in the world. It's hard to drive into any town on earth and not find a few kids swinging a bat or kicking a ball. These sports have become a part of our national and cultural identity and are pastimes occupying the free moments of many people.

This chapter covers how three major sports — football, baseball, and soccer — can be photographed effectively whether you're taking snapshots of Little League or you aspire to bigger ranks; then, we will touch on key photographic elements for a number of other outdoor field and court sports such as tennis, track and field, lacrosse, and volleyball. While some of these sports, such as volleyball, track, and tennis, can also be played indoors, we're covering them in the outdoors section because a significant number of events take place outdoors (beach volleyball, especially, has become a notable outdoor sport).

General Positioning

Much of how you watch and participate in field and court sports takes place while watching TV, where you can see all of the action as if you were on the field. Then you take to the fields and courts of your own neighborhoods and towns to mimic the pros and Olympic stars with tennis leagues, youth football, Little League baseball, soccer teams, and so on. On any given Saturday you can find weekend warriors of all ages out in pursuit of glory and fame among their peers and families. Access to some events — such as track and field — is relatively easy because of fewer spectators. As you can see in Figure 4-1, there are many options for positioning yourself to get good shots.

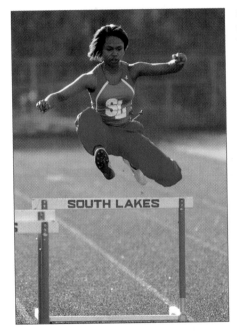

© Joy Absalon

Figure 4-1: Images that catch athletes at their best in high school and college sports can last a lifetime.

Professional sporting events

For neighborhood shots, getting close to the action isn't an issue. However, in the world of pro sports, including soccer, baseball, football, and tennis, you'll be lucky to shoot much beyond your seat in the stadium or arena. And, for sports such as football and soccer, the fields are so big you can't be sure you'll get very much from all but the very best seats — and that's assuming the action happens on your end of the field. Credentials for these types of events are hard to come by and are reserved for qualified media from recognized organizations and the few team and individual photographers recognized and/or hired by the sports organizations.

For professional photographers like Terrell Lloyd, photographer for the San Francisco 49ers, access to the best locations is part of the job. Figure 4-2 shows a photo taken from an area limited to authorized photographers.

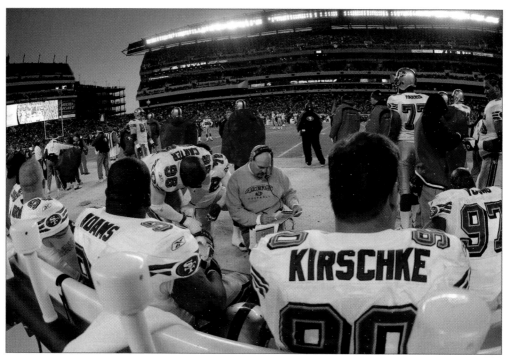

© *Terrell Lloyd*

Figure 4-2: Getting close to pro teams and action is highly restricted and reserved for the media and staff photographers.

Even shooting regional championships for various sports can be challenging in terms of being allowed close enough to the action to get any good shots. Teams, leagues, and sports organizations are very skittish about granting rights to photographers — especially if an official photographer for the event.

Cross-Reference For an interesting look at shooting at amateur events, see Chapter 13. Not only does it touch on legal issues, you can also read about my trials and tribulations with a state soccer official intent upon securing his championship more tightly than the Super Bowl.

If you show up looking like a pro — fancy vest, big lenses, and other pro equipment — at a major professional or even a championship amateur game, you may be questioned by officials and/or security. While they may not mind someone coming onto the premises with what they perceive to be amateur equipment, they very well may take issue with you if they think you're a professional photographer.

Before you shoot an event of any significant size, you should check into any restrictions, limitations, or credentialing requirements there may be for photographers. Often officials may be concerned that you will be selling photos to which their own official photographer has an exclusive right to take and sell, or they may be concerned about player and team permissions to publish and/or sell photographs.

Local and amateur sporting events

For local and amateur sports, getting access is usually not a concern. Unless you're planning to sell the images or use them commercially in some way, it's often easy to gain access to most areas of the court or field to shoot, as long as you're not in the way of players or officials.

Caution More than one parent has been known to use a camera as a decoy and disguise just to get closer to his or her child on the field and then subsequently become involved in the action, much to the discontent of the coaches and referees. This isn't an advisable use of your camera.

For some sports, such as baseball, if you position yourself close to home plate or first base, you're bound to get some good shots. However, it may be tougher for big-field sports like football and soccer; you have to be close to an end zone, goal, or scrimmage line where action is going to take place — and you have to be there when it does.

Some outdoor sports allow you to position yourself in a spot where you can be certain athletes will pass. This way, you can preset your camera to the right exposure and even a manual focus, as shown in Figure 4-3.

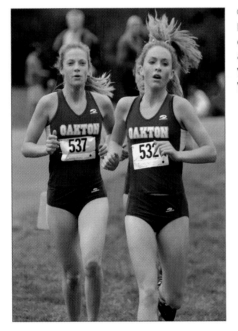

© Joy Absalon

Figure 4-3: It takes preparation, such as setting your exposure and focus manually, to shoot an action photo at the exact time when athletes cross a focal point you've chosen. Then you can concentrate more on your composition and timing.

At a local or amateur event, if you're politely walking around the venue or sitting in the stands with a point-and-shoot camera, or even with an SLR that doesn't have a gargantuan lens on it, you're probably going to be able to get plenty of shots. It is when you attempt to look the part of something that you're not by wearing a photographer's vest, carrying a big monopod attached to a large camera, and toting a bag full of gear that you may run into a few problems and attract unwanted attention. You may get questions from officials or coaches who take issue with you shooting; you may also get people wanting to buy photos. If you agree to do so (of course, you don't have to), it's important that you've got a good idea as to how you'll handle the workflow, processing, and fulfillment — and how much you'll charge.

Equipment

The type of equipment you use when shooting outdoor field and court sports is almost entirely dependent upon three crucial elements:

✦ The size of the venue

✦ The access you have to the field or court and athletes

✦ Weather and lighting

However, a monopod or tripod is a good tool to keep on hand regardless. For example, if you're using a bigger camera, or if you're trying to get long shots from up in the stands with any type of camera, you may find a monopod or tripod useful to steady things (it also helps prevent arm fatigue with big cameras). Or, if you're doing a really long exposure, such as a night shot where the light is very subdued and your camera is set for a timed shutter release, a tripod to hold your camera steady is a definite necessity.

Venue size

If you're going to a pro game, you need a camera with a long lens in order to get shots that show a player and action very well. A point-and-shoot will let you get venue shots and you will be able to get player images if you sit close enough — or you can walk down to the edge of the stands by the field to take a few shots. But to get up-close images of a pitcher on the mound or a goalie deflecting a kicked ball, you need a fast telephoto lens that will hold a constant aperture at various focal lengths and a camera capable of responding quickly with multiple frames.

For a small game, it's possible to shoot with a point-and-shoot camera, but you're still going to have to overcome shutter lag for shooting action even if it's a six-year-old diving for the base. Fortunately, some of the newer mid- and higher-range point-and-shoot cameras are getting faster, but being able to anticipate the action never hurts your ability to get a good shot. Learning to set your camera on a shutter- or aperture-priority mode to minimize automatic settings optimizes the speed of the camera, and therefore your ability to get better shots.

Field or court access

The access you have to the field or court will dictate the lens you need to use. If you're at a big-field game, like soccer or football, a long lens comes in handy, or, if you're using a point-and-shoot, a camera with a long telephoto capability. This is true whether you're up in the stands or on the field. For tighter venues, such as for tennis, and also if you're able to get close to the action, then using a wide-angle as well as a portrait-sized lens works well. For sports such as track and field, you'll want to keep your distance from the athletes even if you can get close to the field, so here's where a long lens is useful as well.

You may also want to use a wide-angle lens to take a shot from the stands to show the full venue. If you're giving a slide show, it's good to have establishment shots that show the scope of the facility, as well as images that get people excited about the images to come. Figure 4-4, for example, helps tell a story about the 2004 Olympic Games in a slide show — and builds anticipation of the images to come.

If you have access to athletes after an event, such as when medals or trophies are being awarded, you'll want to use your flash. If your point-and-shoot supports it, or if you're using an SLR, then using an external flash that mounts to the camera provides better light and prevents problems such as red-eye.

Figure 4-4: Establishment shots of a sports venue — like this one of the Athens 2004 Olympic track-and-field site — are part of the photo story.

External flashes have the option of being swiveled into different directions to *bounce* the light and alter its intensity and area of coverage for your photo. By bouncing the light against the ceiling or a wall, you can limit how intense the flash is against your subject. Some photographers attach a white piece of cardboard taped to their flash that allows the light to be bounced to the subject with the flash facing up or back (you can also buy products that do this with a variety of effects). However, if you try bouncing the flash, your distance between where the light is bouncing and your subject, the color of the ceiling or wall, how you have your flash set (for example, if you set it manually at a lower intensity), and other parameters will affect your image. As a result, before you take critical photos with a different flash setting, it's good to practice it and understand how it will behave in various conditions.

Generally speaking, using a flash when shooting any type of sport is a bad idea, especially if you're close enough that an athlete or referee can be distracted by it. In large stadiums, it's common to see flashes going off in the audience all throughout the venue. However, they seldom have any effect except to illuminate the spectators in front of the camera — certainly not the stadium or the players. And, if you're close enough to competing athletes for it to be effective, you're probably prohibited from using it by the organizers. Save your flash for times and photo ops when athletes aren't competing, such as at medal ceremonies, off the field, locker-room shots, on the bench, and so on when it's most effective.

Weather

The weather plays a significant role in outdoor field and court sports, and it will have an effect on you as a photographer, as well. When it rains, obviously you do what's necessary to protect your equipment and to get shots that don't affect your equipment or mar your shots. If it's sunny, you need to deal with the light from whatever direction it's coming — directly overhead, from the side, through openings in a stadium, and so on. Whatever the weather, if the game continues, then you'll need to adapt to the conditions with your equipment and ability to shoot.

Chapter 5 describes products that can help you deal with the rain, even with a big camera with a long lens. There are rain covers available for your gear through which you put your hands to operate the controls, and they leave an opening at the front of the lens that provide an unobstructed view or your subject. However, this is challenging if you have to get inside the camera to change batteries, lenses, or flash cards; the last thing you want to do is to expose your camera's tender insides to the elements. In that situation, find a dry spot protected from the rain where you can work.

You can use a camera lens hood to help keep out unwanted light, whether the source is artificial or from the sun. However, using a hood may obstruct your flash — especially if you're shooting with a long lens or using a wink or built-in flash (not an external one). This can cause a dark semicircle at the bottom of your image; be careful to check this out before you use it in a critical situation.

Baseball and Softball

Baseball is the great American sport, and it presents the perfect opportunity for taking great sports photos. Unlike some sports, in baseball many of the athletes stay in roughly the same place for just long enough to have their photos taken. Furthermore, because it has a pattern of play, you can predict where much of the action will take place. Finally, unlike football or soccer, baseball tends not to be play in inclement weather. What could be better?

The good news — maybe even great news for some photographers — is that to shoot baseball you don't necessarily have to have a really expensive camera and a giant telephoto lens. If you're up in the stands, you'll want something that has a long range and that can capture images without losing too much light to a small aperture. But if you have a good seat close to the field, or if you're shooting a small game, you should be able to get along fine with something less than professional.

Stop-action baseball shots show things the naked eye and even a TV camera won't catch, such as the moment captured in Figure 4-5.

Positioning

Like shooting any sport, to document baseball you want to make sure you tell a story with a series of photos. That means you want to accomplish several things that you will be able to apply to many of the sports described in this book:

- ✦ Establish the venue
- ✦ Personalize the athletes
- ✦ Visually describe the fans, coaches, and referees
- ✦ Capture the action
- ✦ Present the emotion
- ✦ Glorify the victors

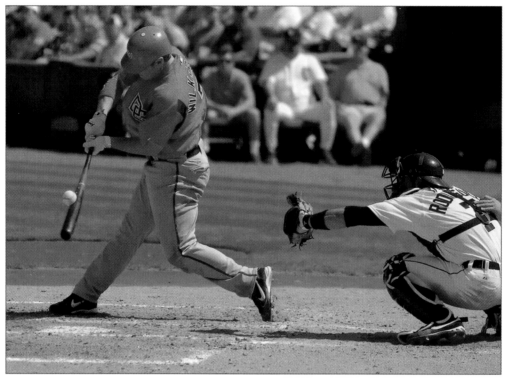

© *Joy Absalon*

Figure 4-5: This remarkable shot shows the ball being indented by the force of the bat.

The bad news is that baseball is a very restrictive sport in general in terms of getting close to the action — even getting a spot on the sidelines of a semipro and a pro game is essentially impossible. The bigger the game, the farther away you're likely to be; even pro photographers with press credentials are rarely, if ever, able to get as close to baseball action as they'd really like to be.

As part of establishing the venue, you may be able to get some good shots of players warming up in the bullpen, sitting in the dugout, or in some pregame activities. And, of course, that's when it is likely to be easiest to move somewhere in the stands to take a photo where you might be shooed away during the actual game.

During a professional game you may have a tough time getting the spot you really want to get a good shot. If you're lucky enough to have a great seat, and you're using a camera with a fast lens and shutter, then you stand a chance of getting the shots. But, all too often, you'll find yourself behind the home-plate net, obstructed by a big fan who jumps up just at the moment you want to shoot, or so high in the stands that it would be challenging to get close to the player even with a 400mm lens.

If you can get close enough to the action to get some good shots, you're going to want to do the same thing as the batter: Keep your eye on the ball! Baseball shots, and in many cases any sport that involves a ball, are usually better if they contain the one critical nonhuman element: the ball, as you can see in Figure 4-6.

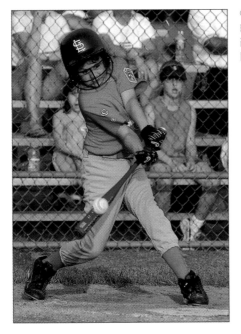

© Joy Absalon

Figure 4-6: This photo not only shows a youth player in a very complimentary pose, but it also caught the ball at just the right moment.

If you can capture a shot where the ball is just being hit, thrown, or caught, or being used to tag a sliding runner, you've achieved something important in baseball photography. To do this, you'll need to anticipate when and where the ball will be, as well as the person who will be catching, throwing, or hitting it. And, referring back to the beginning of this section, this is where baseball is a bit more forgiving than some other sports: The pitcher stays put, the batter hits from one place, and the first baseman often stays put too. Unlike football, you won't have to wonder where the athlete will run when the action starts — at the very least, he's headed for first base and you can base your photographic plans on this assumption.

Of course, every now and then, it makes a nice portrait to show a batter standing ready to receive the ball even if it hasn't yet been pitched. That dead-serious, focused look on a Little Leaguer's face hits a home run in the heart of any doting baseball mom or dad, so don't miss these shots because you're so intent on getting the ball in the shot.

Settings and getting the shots

What are the best settings for baseball shots? As with other sports, your shots will vary depending on the light, the action or shot you're trying to get, and how close you are to your subject. Note the impact of the camera angle in Figure 4-7.

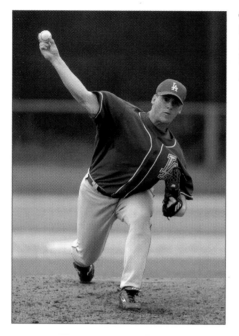

© Joy Absalon

Figure 4-7: Extreme baseball shots, such as this one of LA Dodgers pitcher Chad Billingsley, are ones that have been made exceptionally dramatic not only by the player's body position, but also by the camera angle.

What Do All These Numbers and Letters Mean?

Most pro photographers use fast glass, which I've described in other parts of this book. It means that their lenses can shoot at a wide aperture — typically f/2.8 — at nearly any focal length they like, which means they can get a lot of light into the camera so that it can shoot at faster shutter speeds. Consumer telephoto lenses, even interchangeable ones for SLR cameras, typically have a rating that looks something like this: Zoom Telephoto Lens, 70-210mm f/4.5–5.6.

So, what does this mean? The term *zoom* means that the lens can be adjusted to provide a range of focal lengths. In the case of the example, focal lengths range from 70mm (slightly longer than a portrait lens) to 200mm (a pretty good telephoto length to see things relatively far away). You can zoom the lens in and out by turning a ring on the lens or sliding them in and out; some point-and-shoot cameras achieve this by moving a rocker switch back and forth between tele and wide (or similar) settings.

But, what about the f/4.5–5.6? Well, when the camera is at its widest point, in this case 70mm, the aperture can be open to f/4.5 at its widest. Not bad, although not as wide as the f/2.8 some pro lenses achieve. However, if you zoom out, the aperture capability drops to f/5.6, meaning that to get the same shot with a good exposure you'll need to slow your shutter speed down or increase the sensitivity of your ISO setting — neither of which is a very desirable tradeoff.

Many of the same principles and rules described for shooting baseball apply to softball, as well, as illustrated in Figure 4-8.

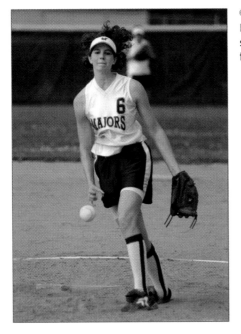

© Joy Absalon

Figure 4-8: This shot incorporates the ball, the player, some intense action, and a nice, big softball clearly focused at the center of the shot.

To get good photos of baseball and softball, use the manual settings on your camera — at least use a shutter-speed priority so you can get a stop-action shot if possible. To get some action good shots, you'll have to make a few compromises. The first thing to do is set your ISO rating as high as you can stand to, based on how much digital noise the images have when you look at them on your computer or print them. Most point-and-shoot cameras are self-limiting for digital noise and may not be able to shoot above an ISO setting of about 400, which isn't that bad, but it reduces the camera's sensitivity in poor light. Compare that with many SLR cameras that can shoot at ISO ratings of 800, 1600, and even 3200.

Note Digital noise is tiny spots of color or black specks placed randomly throughout an image. Digital noise is most visible in shots taken at a high ISO in subdued light. If you have experience with film photography, then you will know the term digital noise as grain.

For sunny days, choose the brightest light setting (often a sun icon). Using the automatic white-balance setting may slow down the camera when you're trying to get action shots. If it's bright outside, you can shoot at ISO 200 or 400 without too many worries. If it's *really* sunny and you can get away with a fast-enough shutter speed, drop your ISO another notch to 100; this gives you the best-possible image quality. In sunny weather, it's a tradeoff as to whether you expose your shot for the player, the ball, or the uniform, bat, and arm. Figure 4-9 is a great illustration of the right way to expose a shot where so much brightness and darkness are at play with the overall scene.

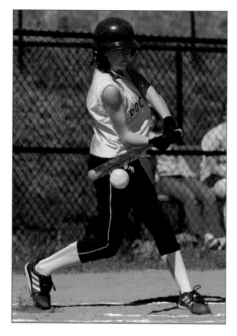

© Joy Absalon

Figure 4-9: This softball shot is nicely averaged. The face is a bit underexposed, the ball is a bit overexposed, and the majority of the scene — the arm, bat, and uniform — are dead-on.

With your ISO set to a suitable speed, set your camera to the shutter speed you think the camera will handle in order to get stop-action shots in baseball, given the lighting conditions. If it's bright enough, you will be able to get good action with the shutter speed at 1/500 second; if possible, go a little faster to 1/800. The faster the shutter speed, the more likely you are to stop the ball in midair just before the bat hits it.

If it's not bright enough, then you may need to drop the shutter to 1/250; this might cause a slight blurring of a fast-moving baseball, but you might get lucky. However, if you can't get your ISO above 400 and your lens aperture won't open more than about f/4.5, you may have to settle for a slower speed. Typically, the internal light meter will tell you if you've set your camera to a speed that is going to create an image that's too dark (check your manual). For example, the aperture or shutter speed you see in your LCD or through your viewfinder may flash at you.

Tip If you're shooting with a flash, such as taking a fan or a dugout shot, you typically cannot take photos with a shutter speed faster than 1/250 second. If you do so, you're likely to get a black horizontal stripe across part of your photo where there is no image. So when you're setting your camera manually, remember that if you have to take flash shots you'll have to limit your shutter speed.

Nighttime shooting in a lighted baseball stadium is more difficult. Because you must work with artificial light instead of sunlight you'll need to bump up your ISO, lower your shutter speed, and alter your white-balance settings. Most stadiums use tungsten-type lights; set your camera to that setting or, if your camera has one, the little lightbulb icon for white balance. You might try the flash setting, as well. Generally speaking, you're most likely to get good action shots in the daytime rather than at an evening game.

Shots like the softball photo in Figure 4-10 aren't just the result of a fast camera and lens; they also require you to have a good eye, good positioning, and a strong sense of timing for the sport — and a bit of luck!

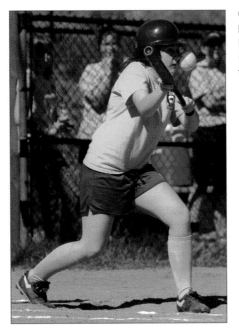

© *Joy Absalon*

Figure 4-10: Keeping your eye on the ball sometimes has its disadvantages! Baseball and softball often provide great opportunities for exciting action shots like this one with your subject in a predictable, visible spot.

For fan, dugout, and coaching shots, drop your shutter speed to somewhere between 1/60 and 1/250, depending on how much sun is available. But these shots are in darker areas, and, if you're closer to your subjects (either physically or using your telephoto lens), you'll need a bit more light. Also, these aren't typical action shots (well, an angry coach or screaming fan may be) so you don't need the stop-action features.

Football

The rougher, tougher All-American sister sport to baseball, American football (as opposed to soccer, because the rest of the world calls soccer football) is more difficult to shoot than baseball for a number of reasons, whether at the local middle school field or at a giant professional stadium.

Positioning

The good news about shooting football is that, unlike baseball, you will probably have much better access to the sidelines even though you may need credentials for college and pro games, as well as larger high school events (however, in pro games, if you have credentials you *will* get onto the sidelines — also unlike baseball). The bad news is that, also unlike baseball, your subject isn't going to stand in one location at the beginning of every play, nor is he or she going to run in one direction each time! As a result, while you might be close to the action, a bit of luck has to be in play as well as the athletes for you to be in the right place to get the shots.

Interview: Terrell Lloyd

Throughout this book, I've included several photos from my friend, San Francisco 49ers photographer Terrell Lloyd. I asked Terrell to offer some tips and tricks as well as top-notch examples of football photography because he's at the top of his own game as a football photography specialist with a very high-profile team.

What makes your sports photography different?

Whether it's an engagement session, a studio portrait, or fast, hard-hitting sports action, an image is a dull canvas without the essence light can bring. My subjects have been great, exciting, and at times beautiful, but in attempting to find the best shot I am constantly on a quest for the best light. Like Tangina in the movie "Poltergeist," I find myself telling and willing my subjects to "come into the light."

The quest for light began when I took an environmental portrait class many years ago, prior to shooting sports. The instructor taught us the art of finding light, not light found in the classroom or available from a window, but light that can be found on location. She believed in the art of finding the best location, assessing the direction of the light, and placing the subject in the best position to shoot from the direction of the light.

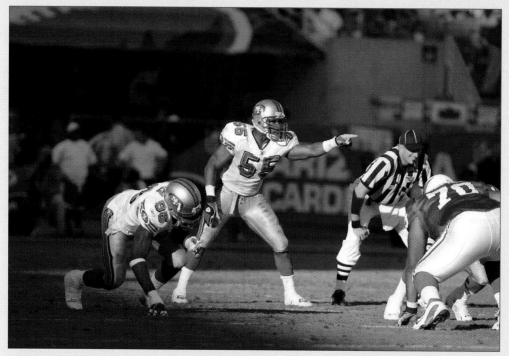

© Terrell Lloyd

Terrell Lloyd uses ambient light to his advantage when shooting pro football as well as other types of image.

What's your best positioning?

Open shade, of course, and the direction of the light source in order to produce the best lighting situation for your subject. These are concepts that I learned in that environmental portraiture class years ago that I apply daily when shooting sports photography. Whether it's Little League baseball, club soccer, or professional football, I always try to put myself in the best possible light on the playing field by assessing the direction of my light source.

Sometimes the game will dictate my position. It may be a backlight situation or even shooting into the sun. Shooting under those conditions will not produce the best image. But if I can move to a different angle and find the direction of the light source, I seek it out.

© *Terrell Lloyd*

Terrell uses a 400mm lens along with gear capable of handling the elements common to pro football games. Here you can see his equipment stored just away from the sidelines where he can reach what he needs for various parts of the game.

Continued

Continued

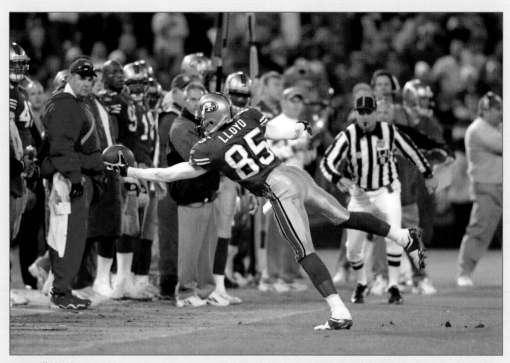

© *Terrell Lloyd*

A fast camera with a fast f/2.8 long lens is what it takes to make an image feel like it was taken from on the field.

How does lighting affect your settings and shots?

> *During the course of a complete game or match, the lighting will shift as the day progresses. In those instances, you have to take advantage of the direction of the light source and shoot as many images as possible while the favorable conditions exist. Whether it is offense or defense, as a photographer, you want the best shot the light brings you.*

> *With the advances in technology, as photographers we can always adjust the settings on our cameras to assist us when the lighting is not as perfect as we would like it to be. Whether it is an aperture setting, shutter speed, ISO, white balance, or shooting in RAW mode, I can still attain high JPEG resolution by manipulating the different settings.*

Football action can be very busy. The athletes and referees are running in several directions, the sidelines buzz with the cheerleaders and coaches, and then there are the fans in the stands screaming in the background. Assuming you are granted some free-ranging liberties around the field, you'll want to take these factors into consideration as you select a position on the sidelines to get the best shots.

Positioning yourself ahead and to the side of the action by about 30 to 45 degrees will ensure a good perspective of the play. If it's really tight, you may want to narrow it to be a bit more perpendicular to the line of scrimmage. However, you will want to be ready to not only take shots when the play begins, but when it ends, when the ball is in the air and being caught, and when the tackle takes place.

Once again, knowing the sport can help — even for a peewee game. For example, on third down the odds are that the next play will be a pass, so it's good to be a bit farther down the field and, hopefully, on the side where the receiver will be catching the ball. If it's close to the end zone, position yourself at the end of the field with a telephoto lens, if you have one, and possibly get a direct shot on the ball as it flies toward the receiver's waiting hands.

Shots from the stands can be good, as well, if you have a telephoto lens, or to take wide establishment shots of the field of play. Also, with a telephoto, you're in a position to take shots of the cheerleaders; they almost always spend more time facing the crowd than the players. Narrow depth-of-field shots of the faces of cheerleaders with the players blurred in the background can make for a nice environmental image to round out a slide show of a high school or college game.

Settings and getting the shots

As with positioning, getting the shots in football can be tricky given the cacophony and activity surrounding a perfectly good subject. However, as with baseball, keeping your eyes on the ball isn't such a bad idea — as well as on the person carrying the ball or about to carry it.

A random group of players running and falling in different directions has no inherent compositional value in photography. However, if a key person in the image is carrying the ball, suddenly a subject has appeared in the scene and gives new relevance to the seemingly chaotic action. With a player in motion carrying the ball, the image can be interpreted and perhaps even understood based upon the direction of the ball, the player's uniform, and what is ahead of and behind him. In Figure 4-11, the subject of the image is clearly identified by the fact that he's carrying the ball, everyone is after him, and he's the most clearly focused element in the photo.

So, here are a few guidelines to follow for getting the best shots in football:

✦ When possible, shoot at a narrow depth of field to ensure your subject is obvious; this means having your aperture as wide as you can manage it to be and still stay focused.

✦ If you can get close enough, and/or if you have a telephoto lens to get you close, shoot tight action. Don't worry about getting the entire team in the shot, or even an entire player's body. Fill your frame with action, faces, the ball, muscles, and motion.

✦ Get personal with the players: Facial expressions, grimaces, pain, and concentration are all great aspects of the sport that most spectators can't get enough of and can't see very well from the stands.

✦ As much as possible, be in front of the action, not behind it. You're better off with it moving toward you, not away from you.

✦ When shooting narrow depth-of-field shots, you'll want to keep constant attention to your focus; it's very easy for a player to get out of focal range with a wide aperture, but this setting will often give you the best shots.

✦ Get as close as possible, but stay out of the way of the action if it starts to come your way. You don't want to get hurt or to hurt a player.

Tip

If you are going to be on the sidelines, use a rubber hood on your camera lens — especially if you're shooting with a larger telephoto lens. Many lenses come with hard-plastic hoods, but this can actually injure players if they run into you. Instead, you can buy collapsible rubber hoods that I actually find more versatile and portable — and they also protect the lens if you bump it.

As for settings, in football your camera will have to be adjusted for whether the game is at night or during the day, as well as in sun, rain, snow, or other conditions. Most often, you'll want to have it set for aperture priority, or a wide aperture if you're shooting manually; this will give you the best narrow depth-of-field images that will highlight the players and blur the surrounding scene. With a wide aperture, you'll also be able to have a fast shutter speed for stop-action shots. You should plan on shooting minimally at 1/250 second, and preferably faster if you can.

To adjust for the light conditions, you should change your ISO accordingly before narrowing your aperture or slowing your shutter speed. Today's digital cameras are much better at handling digital noise than they were a few years ago, so shooting at higher ISO settings isn't as much of an issue as it used to be.

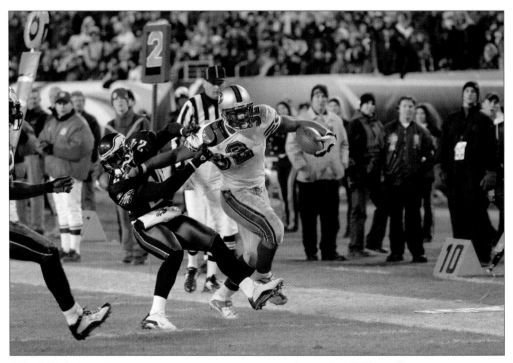

© *Terrell Lloyd*

Figure 4-11: Narrow depth of field is a good tool for identifying a subject, but it can be challenging to get perfect focus on fast-moving targets.

You'll also want to adjust your white balance settings for the conditions—a gray sky versus a sunny one, versus a stadium-light illuminated field. Each will create a notably different colorcast in your images depending upon how your white balance is set. You can set it to handle white balance automatically, but typically your camera will be marginally faster at shooting if you set it manually.

Don't forget that your work isn't over when the game ends. Getting shots of players celebrating and perhaps even commingling with fans is an essential part of the story you want to tell; images of defeat and loss, also, can be very emotional and powerful. Whether it's a pro football player who just guaranteed himself a starting position for another season or a nine-year-old who just scored his first winning touchdown, keep shooting until you've fully documented the event!

In Figure 4-12, sports photojournalist Jim McKiernan didn't worry about getting everything in the shot — he went for a close-in shot to emphasize action and emotion.

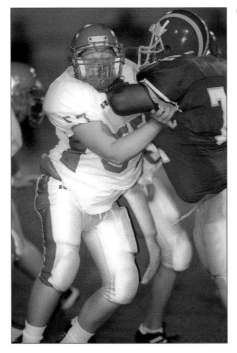

© *Jim McKiernan*

Figure 4-12: This tight shot of high school football action is colorful, interesting, and fun.

Soccer

Soccer, or football as it's known outside the United States, has become a major force in world sports at every level, from amateur to pro, young to old. It's the only team and spectator sport in the United States that's in a major growth curve, and in many cases it has eclipsed baseball and football. There are photographers who specialize in taking soccer team and player photos for a living, and soccer action shots are now common in the major sports magazines, sports sections of newspapers, and on the Web.

Yet, soccer is even tougher than football in terms of shooting action on a big field. The action is fast, unpredictable, happens virtually anywhere on the field, and the goals are spread far apart. In football, at

least, the action is being driven in one direction unless there's an interception. For soccer, possession of the ball can change hands in an instant, making a goal at either end of a large field at almost any time a real possibility.

A telephoto lens is nearly essential in soccer. The distances are just too great — even for pro shooters — to be able to get close without one. Most pro shooters in soccer use anywhere from 300mm to 600mm lenses and even higher; this means big, fast, hyper-expensive glass is being used to get almost anywhere on the field visually.

So much for the bad news. The good news about shooting soccer is that team members tend to be more spread out than in football, so you can close in on a few players instead of two clustered teams. The ball is in play more than football or baseball, so your opportunities to get shots of kicking, head shots, and two players vying for control of the ball are all quite good if you're ready for them and have some basic equipment.

Positioning

Finding the right spots from which to shoot in soccer can be challenging. From the stands, you will be hard-pressed to take good photos of tight action without a long, long lens. Getting close to the field is highly desirable, but you'll need to be cognizant of what's going on in the game to ensure you can be where the action is — which, in the best of situations, involves a bit of luck as well as awareness.

Access is an important element in soccer if only because the field is already so large that you want to be as close as possible to effectively represent the game, show players' faces and emotions, and get tight action shots when they occur. Other than from the stands, there are three primary locations you'll want to frequent in shooting soccer:

✦ The end zone, either behind the goal or at a 30- to 45-degree angle (meaning about 10 to 20 feet to the side of the goal, shooting toward the area just in front of it).

✦ The centerline of the field, where statistically you will be able to get beginning starting shots as well as have a good reach to much of the play on the field. You can also often get shots of officials from the centerline, such as the one shown in Figure 4-13.

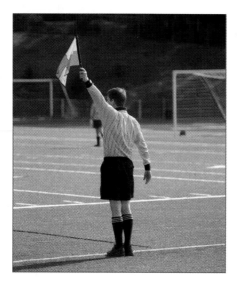

Figure 4-13: Don't forget that photos of game officials add to a nice presentation of a big soccer game.

✦ About halfway between the center and end of the field (one quarter of the entire field, as measured from the end of one side of the field). If you work between the center and the halfway point, with a telephoto lens you can capture a majority of the action.

Save the goal-area shots for exceptional situations and free-kick images; otherwise, you may find yourself at one end of the field when the players have suddenly run to the other!

In soccer, almost more than any other field sport, the concept of telling a story is essential. Because soccer games are long and sometimes few or no goals occur, you are in a unique situation to be able to show a lot of action and key moments in the event that someone can view in a short amount of time. And good soccer photos can be very dramatic and exciting; the camera can often capture moments that spectators will miss and will surprise even you when you get them downloaded onto your computer.

Settings and getting the shots

Long shots require a steady hand, image stabilization, and a setting that lets in enough light for a good exposure but fast enough to catch athletes in motion. A good example of a narrow depth-of field photo is in Figure 4-14. Note the nice stop-action effect in this shot.

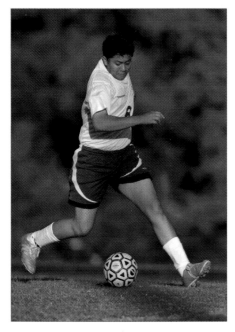

© Joy Absalon

Figure 4-14: This soccer photo was shot using a 300mm lens.

Tip Assuming you have some telephoto capability, even if it's not 300mm, you will want to make use of it with soccer. And, when shooting with a telephoto lens, a monopod is helpful because nearly all of your shots will be long ones. This will help steady your camera and let you shoot a bit faster.

For professionals, this means shooting with an f/2.8 telephoto lens and an ISO setting that matches the ambient light. However, most nonprofessionals will not have f/2.8 lenses — at least not ones that sustain an f/2.8 aperture when fully zoomed out. And because most of your shots in soccer will be long ones — perhaps at the full extension of your zoom's focal length — you will want to set your camera accordingly.

Tip

With sports like soccer, you will need to be able to carry as much of your chosen equipment with you as possible because the field of play is so large. You don't want to be traipsing all the way around the field and back to your car or the stands to change lenses or to download a card.

Here's how to set your camera for an optimal sports exposure at the extent of your camera's zoom capabilities:

1. **Assuming the light is reasonably good, set your camera to shutter-speed priority with a shutter speed of 1/250 and ISO400.** Check your manual if you aren't sure which setting shutter-speed priority is.

2. **Extend your zoom lens to its farthest setting.** This will be a fixed zoom lens if you are working with a point-and-shoot camera. If you have a zoom telephoto lens on an SLR, set a 70mm to 200mm at 200mm.

3. **Take a few test shots and see which ones are best.** The camera will have automatically set the aperture according to how it has read the light for the shots you took. Because the camera will make various choices of settings, you will want to review them and see which looks the best.

4. **View the best shot on your LCD.** Change the display to the information setting, if your camera has one (and many do). It will tell you the aperture setting (f-stop) it used for the shot.

5. **Change from shutter-speed priority to the manual setting.**

6. **Set your camera to the same settings as mentioned in Step 1, but also set your camera's aperture to the f-stop that you noted in Step 4.** This gives you the best settings under your specific circumstances.

These steps are just a starting point for getting the best settings. Your camera is now optimally set to continue to take shots based on a setting you know works — at least for the shot you took in the test, and with the light as it was for that shot. If the light changes, if you change the focal/zoom length, or if you get substantially farther away or closer to the action, then you may need to adjust the settings accordingly.

At 1/250 second, your camera will stop the action in soccer reasonably well. You can still shoot faster, especially if it's a sunny day, to get even better shots where the ball appears to be frozen in midair or at the end of a soccer shoe. But 1/250 is a safe, general setting that will help you begin to take good shots that are exposed well for various lighting and action situations. From there, you can branch out and experiment with different settings.

Multiple-frame shooting capability will help you when you're photographing a goal kick or heading. And, you can actually get away with fewer frames per second in soccer than in some sports if you follow the action and keep shooting. This means that you don't have to necessarily be using a super-fast shooting camera; however, a fast lens (meaning f/2.8, typically) will help if you have one.

Tip

Be prepared for shooting in inclement weather. Rain, snow, or mud will not necessarily stop a soccer game. Camera rain products like those made by Kata and Tenba will help you protect your gear if it's nasty outside.

Sometimes warm-ups can provide excellent shot opportunities, like the one in Figure 4-15. If you do get closer to the players — such as before or after they go onto the field — remember that you will need to adjust your settings, and you may even want to use a flash. If you're trying to get various shots around the stadium or field where players are in various situations, then you can effectively set your camera to the automatic setting, with an ISO of 200 or 400.

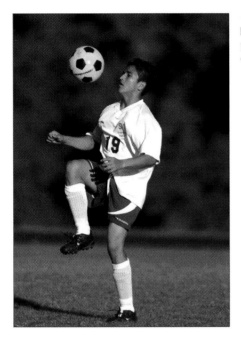

© Joy Absalon

Figure 4-15: Images of soccer players warming up or just playing with the ball can be fun to take and will help add color to documenting an event.

You may also want to take a nice, wide-angle shot of the field, end zone/goal, or crowd. To do so, you probably won't want to use a flash but you'll want to use a slow shutter speed — perhaps as slow as 1/60 or 1/125, depending on the time of day and field lights — and an aperture setting that's small enough to have a wide depth of field (f/5.6 at the very least; perhaps as much as f/11 or higher).

Also, a wide-angle lens, on occasion, can be put to good use if you're standing behind the goal to catch a dramatic shot where you can get close and the action is wide. It's a good way to catch a diving goalie.

Other Outdoor Court and Field Sports

There are so many field and court outdoor sports that it's impossible to fit each into this book — even though they all require some specific and specialized considerations for capturing great photos of them. Many of the techniques for positioning yourself to take good shots, as well as how to set your camera effectively, with the major sports already covered in this chapter can be applied to other sports as well. Be logical. Keep your eye and lens on the ball or the subject of the play (it might even be feet, for example, in a race), look for tight action, and capture emotion. All of these are common to photographers shooting every sport taking place on the field of play.

For any sport, the more you can personalize it, the better. Figures 4-16 and 4-17 are a good example of capturing very different dimensions of a player — in this case a field hockey goalie.

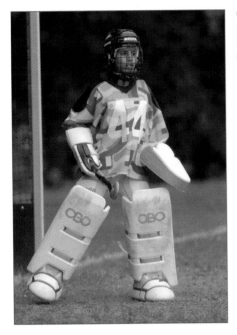

Figure 4-16: A field hockey goalie in full gear — an interesting and important photo for documenting and visually describing an event

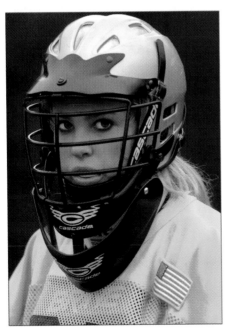

Figure 4-17: A player's face close up is an equally important photo because it presents a very personal side of the sport and event, even if it's not showing action, victory, or defeat.

Before you take a brief look at some other sports, first look at some general rules for shooting almost any type of outdoor competitive sport:

✦ Focus your shots on a distinctive element of the sport.

- An individual player carrying or hitting a ball or engaged in a specific action

- The ball in motion as it leaves or approaches a player(s)

- A critical moment of action

- A personal reaction or response to a play

✦ Don't be afraid to shoot tight shots of players and action.

✦ Get establishment shots of the venue, fans, and officials.

✦ Move around as much as you can to gain various perspectives of the game.

✦ Simplify your images as much as possible, whether that means limiting the players in a shot, blurring the background by using narrow depth of field, or finding unique angles that isolate plays and players.

✦ Make sure your photo has a subject, as opposed to just a mass of athletes — a runner with a ball, two players engaged in a battle for a ball, a player hitting a ball, a sprinter in the lead of a race.

Track and field

Track and field has many events, so shooting from the stands is difficult without a long lens. Try and get onto the field and move around the various events as much as you can; however, be careful where you go so that you don't get in the way of an event that's starting or ending (not to mention to avoid getting in the way of an airborne object like a javelin or shot put).

Track and field events allow athletes to be shown close up in moments of extreme exertion, as shown in Figure 4-18.

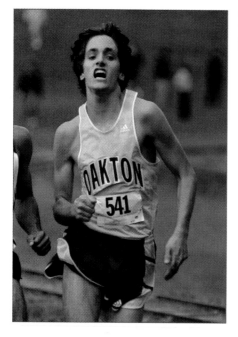

© *Joy Absalon*

Figure 4-18: A narrow depth-of-field telephoto image captures this intense moment.

Use a fast, stop-action setting (for example, 1/500 second or faster) with your camera on shutter-speed priority or manual mode to get a runner breaking the tape at the finish line, leaping over the high jump bar, or pole-vaulting. Track them with your camera after having set your focus on the point where you'll take the shot ahead of time, and this will optimize your chance of getting a well-focused, stop-action image, like the midair photo in Figure 4-19.

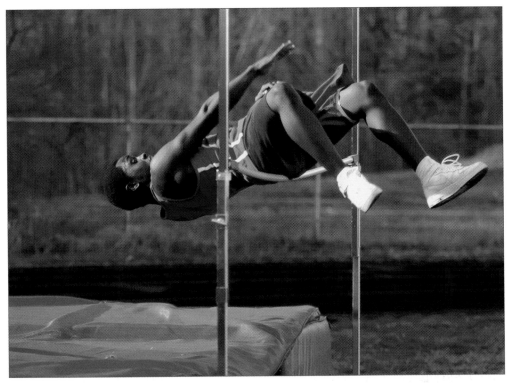

© *Joy Absalon*

Figure 4-19: Classic action photos of athletes in midair, such as this one of a high jumper, never lose their drama and interest.

Track and field events today have taken on a real sense of cool, which you can leverage in tight action shots that make the athletes look their best, as shown in Figure 4-20.

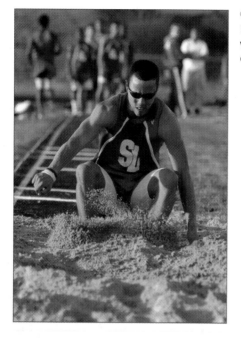

© Joy Absalon

Figure 4-20: The long and triple jumps have become very popular among spectators, have turned more than one athlete into a star, and make for good action shots.

Whether you're shooting on a track or at the finish line of a big race, isolating individual runners exerting to break a record or just win a tight heat make for very dramatic shots. Another good shot is a cluster of runners at the beginning of a big race. To get good shots, position yourself ahead of the finish line where you can really see the athlete's face as he or she finishes.

If you're trying to catch the action from the sidelines, such as when they pass by, then you'll need to *pan* your camera by moving it from left to right or vice versa. Keep a single focal point so the camera isn't constantly adjusting its auto-focus, which will slow it down and likely not be focused when you want it to be.

Note Higher-end cameras use an AI Servo mode that lets them auto-focus constantly on a target that is very fast; however, this feature is not as fast or reliable on anything but the top-level Nikon and Canon products.

The beginning of a marathon race makes for some good wider-angle shots, such as the one in Figure 4-21.

Tip For any school sports — whether primary, middle, high school, or college — be sure to inform the officials on the field or running the event that you are going to be photographing if you intend to be anywhere but the stands. They will want to know you're there and give you permission to do so (or not, as the case may be).

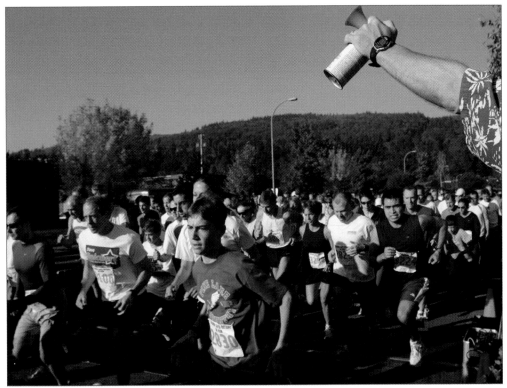

Figure 4-21: The runners take off as the air horn blows the start signal.

Lacrosse and field hockey

A fast-action, increasingly popular field sport, lacrosse is enjoying a surge in popularity across the U.S. with both girls and boys. Taking photos of lacrosse players in action means dealing with a large field, a relatively small ball, and lightning-fast moves among players. In Figure 4-22, Joy Absalon has taken a unique shot of players battling for the ball.

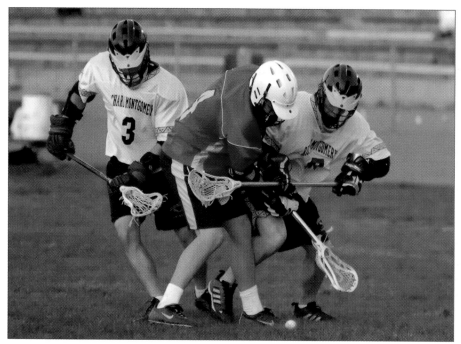

© Joy Absalon

Figure 4-22: In lacrosse, some of the best shots are of a ball lying still on the field.

Add to that the players wearing lots of protective gear, and you have a sport that, for shooting, is like a combination of soccer, baseball, football, and racquetball all in one.

As with other sports, lacrosse and field hockey involve receiving and passing the ball, but with a stick, on the ground or through the air. You can focus on the ball in football and soccer, but when the ball is such a small object as it is in lacrosse and field hockey, you may find it tough to do so — especially when shooting with a telephoto lens. It's better to be aware of the ball and shoot the human action, but don't worry too much about the ball being perfectly poised in each shot. Photos like the one in Figure 4-23 are very tough to catch.

Field hockey, while less challenging for the photographer due to far less protective gear, nonetheless represents some of the same challenges with a big field, small ball, and fast action, as shown in Figure 4-24. Be prepared to take lots of telephoto images to get a few good ones.

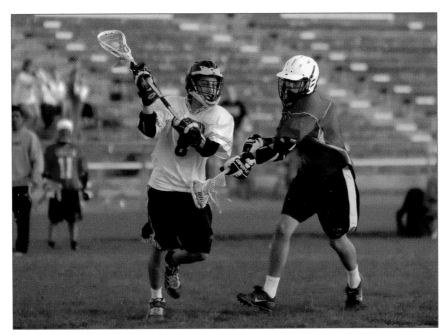

© *Joy Absalon*

Figure 4-23: Getting the ball in the lacrosse stick basket (head) is great if you can combine it with action.

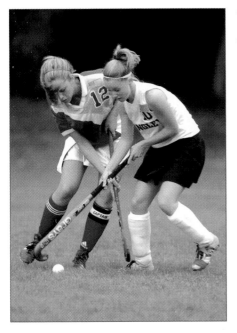

© *Joy Absalon*

Figure 4-24: As with lacrosse, field hockey is best shot with a telephoto lens; some of the most exciting shots are of opponents battling for control of the ball.

Volleyball

Volleyball shots are most dramatic when they show players diving for the ball or slamming it down over the net. At the Athens 2004 Olympic Games, beach volleyball was one of the most popular sports to be televised and photographed because of the scantily clad athletes as well as cheerleaders — a recent development in Olympic sports.

Whether it's on the sand or a field, volleyball shots are almost all stop-action and tight. With so many players in a relatively small area for full-team games, it may be hard to close in on just a few players, so you'll want to shoot narrow depth-of-field shots and get tight either through the net or just to the side.

Cross-Reference For more on photographing volleyball, see Chapter 6.

Tennis

Shooting tennis requires a good sense of timing and some knowledge of the sport. Knowing when and where the ball will be, as well as the player scrambling to hit it, can make the difference between a good shot and a bad one.

Does that mean you need the ball in every image? Not necessarily, but it helps. An action shot of a tennis player with his or her arm and racquet extended might look good, but it will almost certainly look better if there's a ball approaching or leaving the scene.

The three tennis images in Figures 4-25, 4-26, and 4-27 are similar, but different in distinctive ways. Each of the shots is taken from the same position, about midcourt at an angle facing the athlete as he or she moves toward the side where the photographer is shooting, which provides optimal perspective.

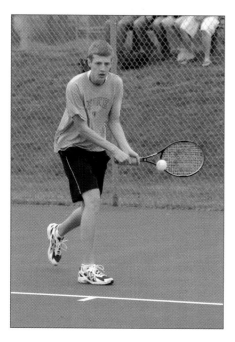

© Joy Absalon

Figure 4-25: This image is taken with an overcast sky, giving an even tone to the athlete and scene, a stop-action effect, and yet no shadows that over- or underexpose any part of the image. For this image, the camera ISO needs to be a bit higher than in open sunlight (it was shot at ISO400).

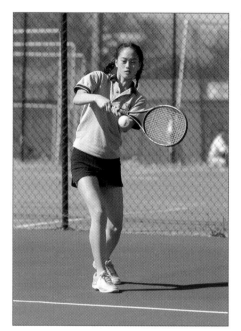

© Joy Absalon

Figure 4-26: Strong sunlight makes for some nice shadows that, while causing a bit of a split effect on the athlete (meaning one vertical half is darker than the other), add to the depth and drama of the shot and give good color and saturation.

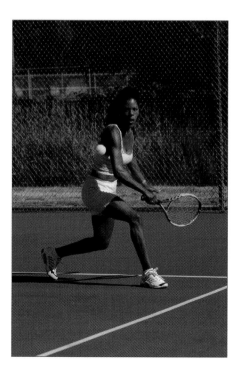

© Amber Palmer

Figure 4-27: In this shot, strong sunlight also provides saturation and contrast to the image, as well as a split on the athlete. The exposure has to be set correctly also to match what the athlete is wearing — you don't want the ball to disappear against a shirt or shorts of the same color — and for the skin to ensure the exposure optimizes skin tonality. In this case, the angled sunlight helps to emphasize muscle tone and athletic exertion.

If you have a telephoto lens, shooting tennis from the stands at a higher-level match isn't a bad idea at all. Tennis matches tend to be a bit closer in than other outdoor sports, so a good 70-200mm zoom lens can do wonders from a midlevel seat. If you can get to court level, you'll want to be close to the net, shooting at an angle as athletes run toward you. This may present a challenge for you if you choose to use auto-focus; it's better, at least with less-expensive cameras, to pick a point on the court where it's likely the athlete will cross your line of focus in a good action move, and where you've focused manually. Then you can pan and wait for the right shots; this method is more likely to return a good photo of the many you'll take than trying to randomly catch a good focused action shot anywhere on the court.

If the light is strong — such as midday sun — you can catch faster-action tennis shots with good exposures; however, you may find that detail in the athletes' faces is lost due to shadows. Flat light, such as what you get on a cloudy day, is optimal because it allows you to get good action shots and retain facial detail unmarred by shadows caused by overhead bright light.

Summary

Outdoor field and court sports are some of the most popular sports played, and the most photographed. Yet, taking photos of baseball, football, soccer, and others can be challenging in many ways and require knowledge of the sports, the best access possible, and, in some cases, high-end equipment.

Yet very much can be accomplished with consumer digital cameras in photographing these action sports, and outdoor light, at least during the day, is almost always superior to any indoor lighting you'll find. So many point-and-shoot cameras are very capable of catching memorable moments even in high-speed sports like lacrosse or football.

Getting the right position around a big field is as important as having the right exposure. Knowing where you're most likely to catch big action is essential no matter what kind of camera you shoot. Also, having a sense of how to document an event is important, meaning presenting a rounded set of images that include action, player personalities, victory and defeat, spectators, officials, and the venue overall.

✦ ✦ ✦

5 Outdoor Recreation and Competition, On and Off the Water

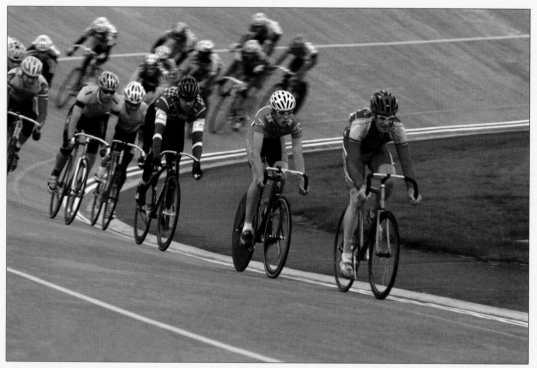

© Amber Palmer

Shooting outdoor recreation and competition can be some of the most thrilling and challenging photography you'll encounter. Be prepared to shoot fast action in bright conditions, and often in conditions where you'll need to protect your equipment carefully — as well as yourself! Whether you're boating, standing alongside a car racetrack, or carrying your equipment on a bike trip, you'll want to take some specific things into consideration not only to get the best shots, but to make sure you get your equipment home safely.

This chapter covers some specific areas of outdoor recreation and competition, but there is a seemingly endless variety of sports that take place outside that people are doing for both the competition and just for the fun of it. I've divided this into some specific areas that you might encounter, and if you're doing something different altogether (ice sailing, anyone?) you should be able to extrapolate from what is covered and apply it to your chosen sporting pursuit.

In this chapter, some of the same principles apply for all of the sports. Then again, there are specific issues for each sport in terms of positioning, equipment, and settings. So even if you aren't planning to shoot boating, for example, you may still want to read through it to see how some of the techniques will apply to another sport you may want to go after. And who knows? You may find a new niche you never thought you'd like! Figure 5-1 was taken at Seattle's Pacific Raceways, where I was able to get about 20 feet away from the racers.

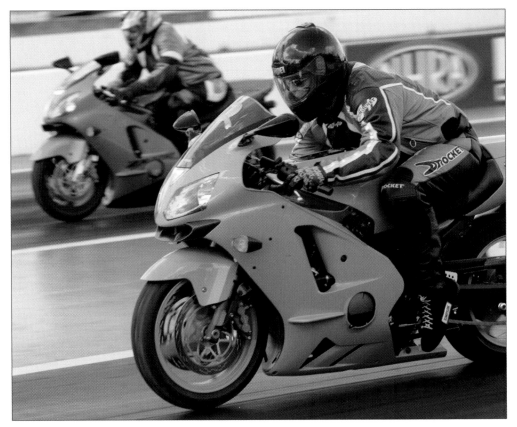

© Amber Palmer

Figure 5-1: Getting close enough to take cool shots of car and motorcycle racing such as these bikes at Seattle's Pacific Raceways requires a fast camera, access to the track, and earplugs.

I've personally shot quite a bit of outdoor recreation and competition, but this chapter also includes photos from a number of great photographers. It's lots of fun to shoot outdoors and you always get shots that surprise and delight you when you get back to your computer and download them — as well as some shots that you thought would be absolutely great that turn out to be disappointing. Outdoor recreation and competition can take place on land, water, or snow, as illustrated in Figures 5-2, 5-3, and 5-4, all of which are covered in this chapter.

Cross-Reference Other outdoor sports, including rock climbing, surfing, hang gliding, and other extreme/adventure forms of recreation, are covered in Chapter 7 and Chapter 8.

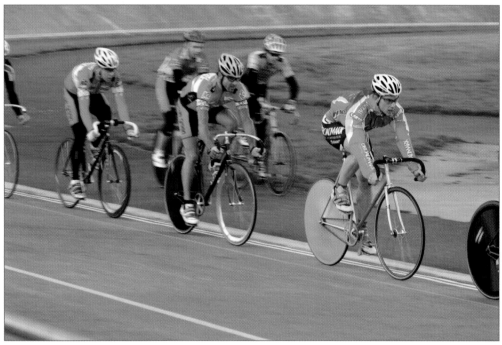

© Amber Palmer

Figure 5-2: Cycling, whether racing on road or track, is a fast sport that can benefit from the effect of motion being used in your images. As in this photo, you can achieve this effect by panning with the riders, making them focused and crisp but giving a lateral blur to the surroundings.

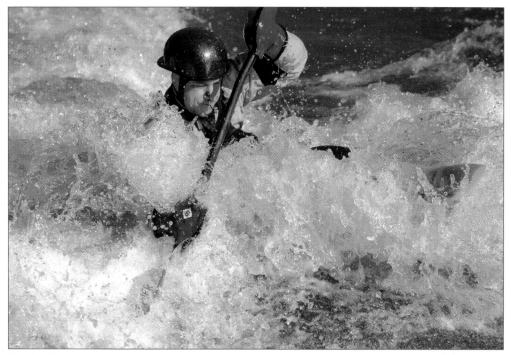

© *Amber Palmer*

Figure 5-3: The challenge with water sports like kayaking is getting close enough to the athlete without getting drenched. Stop-action shots, taken with a wide aperture and a fast shutter, really allow you to capture detail.

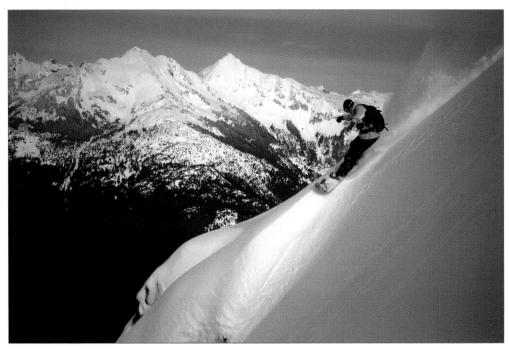

© *Neil Thatcher*

Figure 5-4: Skiing and snowboarding shots require that you have the winter sports skills and ability to reach spots on the mountain where the action is taking place.

Equipment

Whether you're in a ski boat or on the ski slope, reviewing images on your camera may be very difficult. Furthermore, downloading them to a hard drive may have to wait until you can get your equipment in a more suitable and safe location. Carrying a laptop on snow-covered slopes or opening your camera to remove a flash card in a ski boat isn't the greatest idea.

When you are photographing very active sports, you'll need to have a good grasp of how your camera operates, a good idea of the settings that will give you the best shots, and the ability to judge whether you're getting good photos because you may not have the luxury of being able to effectively review your images — even on your LCD. It's difficult to see even the best LCD screens in bright light, much less in a moving vehicle such as a boat.

Tip Products such as those made by Hoodman are small rubber or plastic baffles that attach to your LCD, allowing you to view images in bright outdoor light. These help, but sometimes get in the way of shooting (especially on SLRs, where you have your eye against the eyepiece and the baffle bumps against your cheek) and are not always that effective. However, I have used them with reasonable success in very harsh light, and they're worth trying.

Considerations on the water

There are some special considerations for shooting around water for a variety of reasons. For starters, you need to protect your equipment from moisture, you may not be able to get as close to your subject as you like, and being stable can be tough in a boat that's pitching and rolling. A long lens may be need for shooting many types of water sports, especially when shooting another boat or skier from the shore or from another boat; on the other hand, you can use a fish-eye lens (for example, 15mm) to get dramatic close-up shots of a boat you're on as well as interesting perspectives of the boat, the water, and other boats.

Sometimes you'll have a luxury of space on the water, if, for example, you're on a large powerboat. On the other hand, if you're in a kayak or canoe, equipment stowage space may be extremely limited, not to mention hazardous. So equipment considerations for sports photography on the water not only have to do with just the water, but if you're situated on or beside it. In addition, you may be further limited by a lack of power sources; for example, if you are on a multi-day canoe trip, you're not likely to be able to recharge batteries, and you'll need a way to download and store images on something other than a laptop.

Protecting your gear

Getting close to the water may be necessary for good shots, but it also means protecting your equipment from getting wet. Figure 5-5 shows a photo of a water skier falling; even if you're in the boat, when surrounded by water your equipment is at constant risk.

© Amber Palmer

Figure 5-5: Shooting spectacular shots in and around the water? Get those great shots, but protect your gear!

Having a way to protect your equipment from the water, as well as from being bumped and jostled, is essential. A Swiss sailing photographer friend uses a cooler; inside, it is cushioned with spongy foam to protect the equipment from bouncing around. You can also use a photographer's fanny pack and place it in a cooler. For smaller boats, bring a few bungee cords to tie down your gear and the cooler. If you're on a very small boat (canoe or kayak, for example), you'll need to store your equipment in a case that's 100 percent waterproof and that will float if it goes into the drink.

Tip Pelican makes some very durable and airtight cases. I've used them successfully in very adverse conditions, including on the water.

Note On really hot days, it's good idea if possible to keep your cooler out of direct sunlight. Even though it's insulated, it's better not to get the camera gear too hot if you can avoid doing so. And, don't store drinks, ice, or anything other than your equipment in the cooler!

Unless you're on a larger boat, taking a laptop along on a photography trip in the water isn't the best idea. They are more sensitive to humidity, water damage, and being bumped than cameras. The best idea of all, if possible, is to be able to store all of your images on a single flash card that you don't remove from the camera — thus protecting the camera and the flash card from any possible environmental damage. If you must change cards, keep them in a sealed case or small, watertight containers that also float. And, if you must download images, use an ImageTank or other portable hard drive that you can easily access, begin the download process, and place back into your sealed and protected container.

Also, using a well-made fanny pack allows you to access your equipment quickly and keeps it as dry as possible. You can place lenses and other components in Ziploc bags inside the pack. If possible, use a journalist-style fanny pack — this type of pack zips open from the inside top (in other words, they flap open away from your body so you have access to your equipment while the pack is still attached to you) and some packs even include a rain cover that is concealed in an outside pocket, which can be pulled over the pack.

Tip *Desiccant* is moisture-absorbing material, such as the silica gel in little, white sealed envelopes that is often found in packages used to ship new electronic equipment. You can buy this in larger quantities at photographic supply stores; it comes in plastic containers slightly smaller than a cigarette box. You place this inside your equipment and it absorbs moisture very effectively. And, once the desiccant becomes saturated, you can place it in a microwave to dry it out (usually you know when you need to do this because it changes colors).

Choosing the right equipment

Few cameras are waterproof. However, if you're shooting on and around the water, having a camera that is at least somewhat water-resistant is a good idea. The Canon EOS 1D Mark II, for example, is made for photojournalism and sports photography. Its magnesium alloy body along with many rubber seals and other features that protect its interior parts keep it very protected against the elements. The Mark II, however, is very expensive, and most cameras do not feature these types of protective elements. You can purchase water-resistant cameras, underwater housing systems for almost any camera, and even some actual cameras that are themselves waterproof (Nikon's Nikonos series of cameras has been the standard in underwater photography for many years, for example), but you may generally be limited in features and paying more than for what you need.

One idea is to use some of the products made to protect camera gear from the rain — primarily used by pro photographers shooting outdoors at soccer and football games. Tenba and Kata are two brands of this type of gear (Kata is distributed in the United States by Bogen), as shown in Figures 5-6, 5-7, and 5-8. Extras like those pictured can protect your camera from the spray, but aren't intended to make your camera waterproof or safe for underwater use. Rain covers keep your equipment dry, yet allow your lens to see the action unobstructed.

Tip If you have a camera or a camera lens that offers image stabilization, boating is a great place to use it. It is a feature that you can turn on and off, and it has become very sophisticated technology. I have it on my Canon 70–200mm 2.8 lens, and I can hear it "whirring" while I shoot as the electronics, motor, and lenses operate in synch to make my images steady — even when shooting as slowly as 1/15 second. You don't need as much image stabilization for wider shooting (such as below 70mm); it's much more useful for telephoto shots, which are more susceptible to blur when there is slight movement.

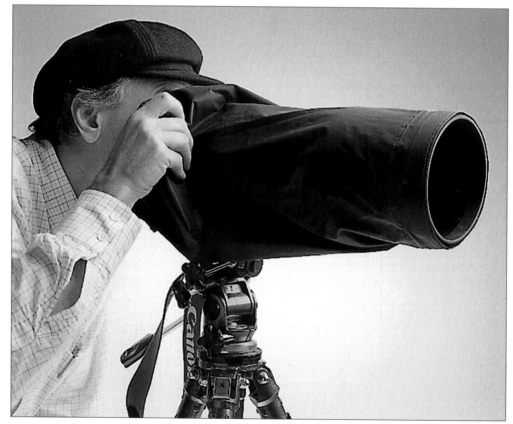

Courtesy of Tenba

Figure 5-6: Notice that rain covers, such as this one made by Tenba, protect all of your camera from the rain yet leave the lens exposed so you can still take photos.

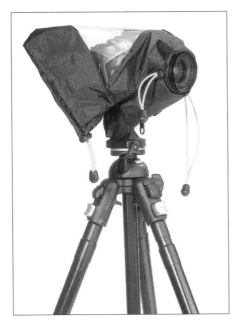

Courtesy of Bogen Imaging

Figure 5-7: Bogen's camera rain covers allow you to insert your hands for direct access to the camera controls, which also keeps your hands dry. Also, you can see the controls through the clear plastic.

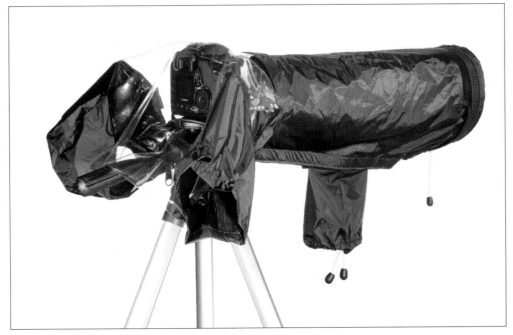

Courtesy of Bogen Imaging

Figure 5-8: Camera covers for SLRs require that they accommodate a variety of lens sizes, such as this one made by Bogen that is made to cover a large telephoto lens.

When you shoot action on the water — such as skiers who are jumping or making hard turns — a fast telephoto lens will make your life a lot easier. If you're shooting from land, especially, you'll need some long glass — many pros shoot with 400mm, 600mm, and even longer lenses to really make you feel like you're about to get wet when you see the photo. Much of this type of photography is shot in bright sunlight, so you may want to use a polarizing filter to help balance overexposed areas of sky. Also, a camera capable of multiple exposures will help ensure you get some of the best shots if it can shoot at least three frames per second. Figure 5-9 shows a wakeboarder jumping a boat wake, stopped in midair. The camera position from the boat makes it look almost as if the photographer is in the water.

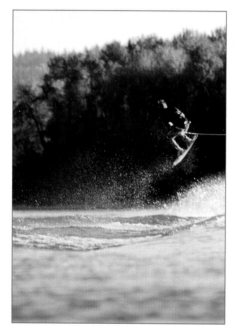

© *Amber Palmer*

Figure 5-9: Stop-action, water-based photography requires lots of shooting and good exposure settings to ensure any number of factors — sun, water reflection, blurry action, to name but a few — don't prevent you from getting the shots.

A monopod, especially if you have a large camera and lenses, will help you steady your shots, make them more consistent, and keep your arm from getting fatigued. If you're shooting with a long lens, you'll most likely have a mount that lets the monopod attach to the lens instead of the camera so that it's located at a better balance point.

Considerations on land

Shooting outdoor recreation and competition on or from land means being mobile, protecting your gear, and having enough variety of focal lengths to be able to get whatever shots you need and want to take, whenever and wherever they may present themselves.

Whether for skiing, car racing, or a triathlon, I bring the same setup: a rolling equipment bag for the brunt of my gear that stays in my hotel room, car trunk, or other safe location, in addition to a large photojournalist's fanny pack that lets me carry whatever I need around my shoot. I used to carry a backpack, and certainly some photographers swear by them, but I like to have the immediate access to equipment without having to remove anything from my body (see Will Wissman's description of equipment for shooting skiing, later in the chapter; he carries a backpack).

Tip

If you carry equipment in your car and leave some of it there when you're off doing your shoot, be sure to stow it in your trunk or a covered area. Insurance companies that insure photography equipment often have a "trunk policy" that covers equipment differently if it's stored in a concealed area versus exposed on a car seat or the visible back of an SUV.

While it sounds paradoxical, carry as little equipment as you can get away with and still have everything you need. Paring down too much on your gear will inevitably land you in a situation where you don't have what you need and you'll be too far from your car or home to conveniently retrieve what you need. Of course, if you use a point-and-shoot camera, this isn't an issue!

Including the same packs of desiccant as described for water-based photography is also useful on land, especially if you're in areas of high humidity, rain, or snow. They're small and fit neatly into any type of pack. If you're carrying a point-and-shoot camera, look for smaller packs of desiccant from photo stores or online.

You should always carry a bulb-blower and a brush to be able to clean dust from your lenses and/or your image sensor, should it become necessary. However, be careful where you perform any equipment maintenance and make sure you're in a dry, reasonably dust-free area so that you don't make your problem worse!

Caution

Be *extremely* careful when you're working around an exposed digital image sensor. Never touch it with your fingers or anything else that isn't specifically designed for cleaning it (image sensor cleaning kits are available from camera stores).

Tip

Bring yourself a folding three-legged stool if you're sitting on a pier or dry land. You'll be more comfortable and shooting for long periods will be far less tiring.

Specific Sports

Outdoor recreation and competition can take place in a wide variety of conditions, and where you position yourself to shoot varies tremendously. You may be limited to a small space, or you may have an entire lake or ski slope open to your creativity. The next several sections look at some of the major types of sports you're likely to encounter and explore how shooting can differ in terms of location, settings, and getting the shots.

Boating

Powerboats have the advantage of speed and maneuverability — you can get where you need to be quickly and without having to change course because of the wind or other environmental factors. Also, powerboats are more stable and flat, allowing you to stabilize yourself relatively easily (but you should always be prepared for that sudden wave or wake). Sailboating, conversely, is one of the most challenging of outdoor sports to shoot — whether you're on land or on a boat. The first thing to consider is the type of boating you're after: racing or cruising? Fishing? Fresh water or offshore? A regatta of Sunfish or big boats?

For big offshore racing, many pro photographers hire fast offshore boats or even use helicopters to capture the action. However, most readers of this book are unlikely to resort to these types of options. While on assignment in Athens, I met a Swiss photographer who shoots all types of sailboat racing, including the races at the Olympic Games.

To get the best shots, he took a boat about the size of a ski boat or a day cruiser into the Mediterranean Sea. He put his cameras and equipment into coolers, which protected them from the elements — meaning not only water, but also the heat (some days it exceeded 108 degrees). He could follow the racing from a distance that wouldn't disturb the boats but that got him close enough to get good shots with telephoto lenses. And he brought lots of backup equipment, flash cards with big capacities (2GB minimum), and made use of the Olympic Canon and Nikon support staff extensively (usually to clean up equipment and avoid salt-water damage).

Note If you are wondering where the support staff came from, they are usually located in the media centers at the various professional sporting events, in this case the Olympic facilities.

Positioning

If you're on a sailboat, shooting can be tricky and treacherous. Because sailboats heel (lean), you're not working on a level surface. Water can come flying over the deck if it's at all windy or the boat is sailing against the wind on a beat, and equipment can rapidly get in your way — or even swing across the boat and hit you. So finding a good position to shoot the boat you're on or another boat is something you'll want to think through very carefully.

On a powerboat, depending on the size, you have quite a few options. On a larger boat, you may be able to get up onto a flying bridge so you get a crow's-nest perspective of the boat and the surrounding waters. On smaller boats, you'll want to get as far forward as possible, especially if the boat is moving quickly, because you'll be away from the spray a bit more and you can position or even anchor yourself against the seats.

If it's not too windy and you're careful, you may be able to shoot from the foredeck. This can give you a good perspective of the entire boat from the very front. If there's any notable wind (which most sailors like), you'll probably want to be in the boat's cockpit, where you can quickly cover your equipment or hand it to someone below (in a larger boat). Figure 5-10 shows a medium-sized sailboat. In calm water, getting a shot is easy. When the weather gets rough, then so does the water as well as the shooting!

Note For a discussion of how to protect your equipment on water, see the section "Considerations on the water" in the "Equipment" section at the beginning of this chapter.

Positioning yourself at a vantage point where you have good visual access to another boat is very difficult. If you're not ready to shoot, the moment will pass quickly and you will lose that great perspective; getting to another good spot may take time and effort. You'll want to make sure you stabilize yourself as much as possible and stay out of the way of the boom or other equipment that could potentially get in your way.

Really, the best way to shoot sailing — or any type of boating, for that matter — is from a powerboat (unless you have a helicopter handy) so that you can get to virtually any vantage point quickly and with relative stability.

Note Shooting sailboats and powerboats from land is not a common pastime. Often these boaters get too far out too quickly to get any really good shots.

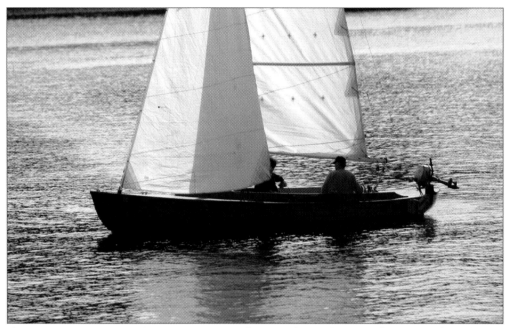

Figure 5-10: Getting a good perspective on a sailboat can be tough, especially from another sailboat.

Settings and getting the shots

Boating photography can take on a variety of conditions for lighting, action, and exposures, and these can make for lots of opportunities for incredible shots, but it can also be challenging to do things right. Water is very reflective, and often you're shooting from a moving vehicle plunging and bouncing in three dimensions — which means you have to adapt your shooting, equipment, and settings accordingly to get the best shots.

Very often the best photography takes place early in the morning or late in the afternoon, when the sun is at an extreme angle and casts shadows that lend themselves wonderfully to dramatic shots. However, given the time of day for much of boating, this may be a luxury you'll not have.

Bright light

For much of boating, you'll be shooting in bright light, even if it's not sunny. If you're shooting high-speed boats, such as hydroplane racing boats or even ski boats, you'll need to shoot at a minimum shutter speed of 1/500 second. If you're trying to get something dramatic and quite close up — such as a long telephoto shot of the bow of a sailboat as it dips into an oncoming wave — you will want to use narrow depth of field, such as f/3.5 or f/2.8. If you set your camera to one of these f-stops and use aperture priority mode, then the camera will automatically determine the shutter speed. If you use manual mode, set the camera to a wide f-stop such as f/2.8 and your shutter speed relatively high (depending on brightness) for some great stop-action water splashing away from the hull.

Panoramic shots

If you need clarity for an entire set of boats, then you will want to use a higher f-stop so that you don't have limited depth of field (focus); this means that your shutter speed will have to be slower. This will work for sailboats, in particular, where speed isn't as big of an issue.

Limited light

Night shots on the water can be beautiful, and the twinkling lights from boats make them even better. However, a long nighttime exposure taken from a moving boat isn't an ideal combination. Instead, you'll need to take shots such as this from a pier or other stationary site. A long exposure also requires the use of a tripod and a timed shutter release (set to go off a few seconds after you press the shutter) or a plunger, if your camera supports it, to make the shot steady.

Tip For a fun effect with water — in daylight or nightlight, but it's especially dramatic at night — use a star filter. This takes each point of bright light and turns it into four-, six-, or eight-point stars (depending on the type of filter you purchase). Used with detachable lenses on SLR cameras (not point-and-shoots), they screw onto your camera lens. Don't forget to take the star filter off when you finish with it!

Water skiing, wakeboarding, and jet skiing

Shooting fast-moving, in-the-water sports is lots of fun. But how can you take these shots without getting drenched?

Jet skiing is included with water skiing and wakeboarding in this section because, from the standpoint of photography, it requires much of the same approach — meaning you won't be able to be on a jet ski to take photos unless you're using a waterproof camera. You'll have to be on a boat or on land to get shots of any of these water sports.

If you're at a ski race, you'll probably have access to the shoreline or a pier where it's close enough to see the action. Otherwise, being in a powerboat (either the tow boat or a boat following your subject) is essential.

As with boating photography, when shooting water skiing, wakeboarding, or jet skiing from a boat many of the same rules apply:

✦ Keep your equipment dry.

✦ Don't change flash cards unless you have a dry place to do it.

✦ Keep equipment safe from jostling.

However, these types of sports are most-often best represented by getting as close to the action as possible, meaning you'll want to shoot most of it with a telephoto lens or on the telephoto position/setting in a fixed-lens (a point-and-shoot) camera.

Positioning

Get yourself situated where you have as clear a view as possible of the person you're shooting. Many ski boats have equipment at the rear of the boat, as well as a rope for the skier. Try to get to the side of the boat and shoot at an angle so the rope and other things don't get in the way.

For skiing and jet skis, wait until the skier is at an extreme angle off to the side of the boat, or when he or she is just coming through the wake; this will provide a dramatic perspective. A shot of the skier being pulled by the boat isn't very compelling. If the skier is doing a water start, try getting shots of him or her just coming up out of the water.

For wakeboarders, tricks are what the sport's all about, and the better you can make the boarder look, the better your photography skills will appear. If you're on the boat, get as low as you can and shoot high — much like shooting a skateboarder or snowboarder. Figure 5-11 emphasizes the effect of shooting from low to high with an exposure set nicely for the athlete's face.

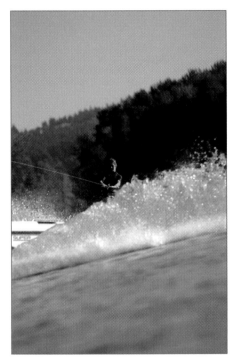

© Amber Palmer

Figure 5-11: This shot, taken from the tow boat, is well balanced for the entire shot in terms of color, tonality, and composition.

Skiers who are slaloming and jet skiers like to make hard turns to put up a big wake. You can get one of the best shots for this move if you are positioned with the sun behind the skier and get a silhouette of him or her with the light shining through the spray. This kind of shot is best taken early in the morning when the water is glassy-smooth and the sun is at a dramatic angle.

Tip

If you're shooting a skier or wakeboarder on a rope, guess what? As long as you're close to the point of where the rope is attached to the boat, you're at a fixed distance — meaning your focus doesn't have to change! You can set your focus manually or automatically, and then turn it off so it's in full manual mode. There's no reason to keep focusing or have the camera do it for you.

Settings and getting the shots

You'll have different strategies for getting good shots depending on whether you are on land or on the water when you take your best shots. For the most part, this, more than the lighting conditions, will determine how you shoot, because seldom will you be photographing skiers, wakeboarders, or jet skiers in anything except bright daylight.

From land

If you're sitting on land watching boarders, skiers, or jet skiers, use a long lens or at the very least your longest telephoto setting, and you'll want to keep your camera as steady as possible. Use a monopod and image stabilization, if your camera supports this feature. Find a comfortable spot on an embankment, if possible, or a bleacher, and lead the skier or wakeboarder as he or she comes to your best spot for your shot. *Leading* means to track the skier laterally and anticipate when they'll hit the spot where you want to get the photo. Here's how to get the shots as a landlubber:

✦ Watch your subjects come by a few times and get a sense of the timing, speed, and action. Determine a point in their path at which want to take your shots.

✦ Get your settings correct — preferably on manual for everything — based on the skier's face and skin tone by shooting someone on land to get the best exposure.

✦ Try bracketing your shots, which is a feature many cameras offer. This automatically lets you shoot one or more f-stops above and below your setting, as well as your specific setting. This way, you get three shots in one but with different settings so you can choose the best one.

✦ Try to use as even a horizontal plane as possible for tracking the athlete.

✦ Don't worry about the skier or boarder being out of focus when beyond where you want to shoot him or her. You're only concerned with shooting him or her at your predetermined point.

Depending on your camera's burst rate and shutter lag, you'll need to start shooting multiple exposures *before* the athlete hits your point — unless your camera will choke as a result because it hits the extent of its image buffer. It's important to realize you will have some throwaway shots no matter what you do and how good your camera is.

If you have a point-and-shoot, make sure the flash is off as well as any other automatic settings that can slow the camera down. If the camera suffers from significant shutter lag, you'll want to try and figure out how much time it takes from when you depress the shutter to when you want the shot to fire, and lead the shot accordingly.

From the water

If you're in the boat, get yourself as steady a position as you can and give the driver some direction as to how you want to set up the shot. Unless it's a competition, communicate ahead of time with the skier so that he or she knows what types of shots you're trying to get; you may want them to emphasize tricks and jumps on one side rather than the other, if possible.

This is a situation where you'll want your camera operating as fast as possible. Whether you're using a point-and-shoot or an SLR, put your camera on the most manual settings available. If the day is sunny, shoot at ISO 100; if it's cloudy, ISO 200 will probably work well. Set your white balance for daylight — if possible, turn off your automatic white balance because it, too, can potentially slow down the camera.

Note Remember, in any type of bright light, your LCD will not give you a very good indication of how your lighting and exposure settings are working, so learn to work without it.

Automatic camera settings — especially the ones that are general and don't allow you to control specific aspects (such as the ISO or when using shutter or aperture priority) — are taking an average reading of what is "seen" through the lens. The problem with using this while boating is that there is a wide range of exposures. Especially in a moving boat, it's anyone's guess as to what the camera will see more of when it takes a reading of the scene — it might be a bright, dark, or in-between area, or an average of all. This limits your chance of getting a good photo.

Cheat-Sheets for Bright Light

Take the guesswork out of bright-light shooting on a boat: Review the metadata from photos you've taken that turned out well; know at what levels the shutter speed, ISO, and f-stop were set. (The metadata is found under "File Info" in Photoshop Elements when you open a photo taken with your camera.) Make a list of the settings you use in various light conditions. Next, type a small, luggage-tag-sized chart and print it onto a small card or paper. Laminate the card (most Kinko's have a lamination service and can make a laminated luggage tag). Keep this in your camera bag as a quick reference when you can't look at your camera. Your details might look something like this:

Condition	Speed	ISO	f-Stop
Cloudy	1/400	200	11
Silhouette sun	1/3000	100	5.6
Midday sun	1/800	100	16

These specific settings are just an example of settings that may work in general conditions described. They may or may not work for your camera and may vary from lens to lens.

When you add to that the fact that the camera, on an automatic setting of any kind, has to "think," it is slowed down. If you're shooting multiple-frame exposures, or even if you're just taking a single shot, no doubt it will take place more slowly in automatic mode than on manual. When shooting water sports, manual settings are the key to getting the best shots. However, they take some practice and effort to get to know various conditions, your camera, and the sport well enough to increase your percentage of good photos.

Car and motorcycle racing

Racetracks are a veritable candy store of photo ops, and racers almost always love having their cars or bikes shot. While getting a pit pass to a large event like the Indy 500 is tough, many places have local tracks where you can either get into the pits or get close enough in the stands to get good shots.

Racing allows you to use a wide range of settings and lenses. You can practice shooting high-speed, multiple-frame exposures, or you can take your time to set up detailed, wide-angle shots of a car or bike before or after the race. Furthermore, you're likely to be able to find a place to stage your shoot — perhaps near your car, if you're at a motocross track — so you can bring a bit more equipment with you. If you have a long lens, this is the place to try it out!

Positioning

One thing that's important to remember in all types of sports shooting, but in racing especially, is that you need to be aware of your surroundings. Are you in the way of oncoming racers? Are you obstructing the view of any officials or spectators? What's just happened, happening, or about to happen? These are important elements of racing because things happen fast, and on a busy track — in particular, if you're in the pits or close to the action — not only can you get in the way, but you can be seriously hurt or killed.

Motocross riders especially like shots where they're catching "big air," or at least *look* like they are doing so. If you can position yourself ahead of and below a jump, you will be in just the right spot to catch the biker as he or she comes up and off the jump. Furthermore, if you're using a point-and-shoot camera, in this type of racing you can work with the shutter lag and burst rate to time things accordingly (which may mean pressing the shutter as you hear or see the biker going up the hill before the jump happens).

Figure 5-12 is a photo taken at Pacific Raceways near Seattle, where I positioned myself as described: ahead of and below the motocross racer. His actual height for this shot was about 10 feet off the ground, but it looks much higher, especially with the trees behind him!

Figure 5-12: A motocross rider catches air — plus a little, with the help of a good camera position. Another good vantage point, which works for both bikers and cars, is at a curve. Not only are the racers at a dramatic angle and in a potentially tight spot with other racers, they are moving more slowly — meaning you have a better chance of getting a good, tight shot.

For drag racing, obviously there are no curves, but there are a couple of good points where you can get some interesting angles. Try placing yourself about 10 to 20 feet ahead of the start line (obviously, off to the side a bit); this allows you to see the racers' faces, their equipment, and to get a nice, angled perspective of both vehicles and riders/drivers. Figure 5-13 shows the face of a drag racer preparing for the race; this personal approach makes for nice personalization in a photo that's otherwise impersonal. Another good location to try is from the side or even behind the car or bike. You won't necessarily see the driver, especially in drag racing because there is a lot of smoke as the rear tires spin, but getting a shot of the car buried in the smoke can look great. Finally, if you get a shot of the racers just when they get the green light, you can frequently catch them popping a wheelie. While they don't do this intentionally during the race because it slows them down, it looks cool if you can get a shot of it.

When shooting car or bike racing, especially if you're a motor-sports enthusiast, it's easy to forget how important and nice it is to get shots of people. Fans, close-ups of racers' faces, officials, and others make for great color. And, if you're working to sell photos, remember that racers will want as many photos of themselves in the winner's circle getting their trophy as they do in their car or on their bike.

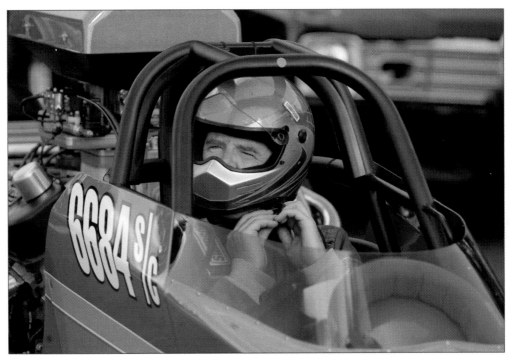

Figure 5-13: A personal racing image taken near the starting line.

Specialized equipment considerations

For car racing, you can make good use of almost any type of camera — from high-speed SLR to point-and-shoot. Of course, a high-speed camera with a fast lens will help if you're trying to get tight shots of fast action. Carrying a fanny pack with lenses you can quickly change to get different effects is a good idea; also, you tend to walk around racetracks a lot, so having your equipment with you is helpful if you get away from your things.

You will, however, need to protect your gear because racetracks can have everything from mud to dust to other airborne particles that can get into your equipment. Make sure you are careful when you change lenses, batteries, or flash cards — any time you open part of your camera, you risk getting dirt inside it; this counts in spades for changing lenses because this provides direct access for dirt to get onto your sensor. Make sure you bring a bulb-blower and brush to clean your equipment if you do get it dirty, and make sure you do it in a dry, relatively clean place. If you have access to your car, this is a good place to clean equipment because you can close the door and seal yourself away from the outside environment.

Using a telephoto lens is essential for NASCAR, Formula-style, or rally racing because you simply will not be able to get close to moving vehicles, nor do you really want to. A minimal focal length of 200mm, and preferably longer, will allow you to get "close" to the racers. While a wider establishment shot of the track and cars is good to have, you'll want most of your shots to be tighter and closer in. If you can get in the stands above a pit when a car is in to be serviced during a race, you can get some good shots with a medium- or wide-angle setting. If you have a fisheye lens (less than 17mm) you can get some cool images of the pits that really show everything going on in a dramatic way.

Tip Use a high-capacity flash card so you can take large images that can be enlarged, and so that you have enough space on the card to take lots of shots without having to reload. Also, because you'll probably be shooting on multiple-frame exposures, which will give you more photos, a bigger card is a must.

Settings and getting the shots

Unless you're shooting a motor sport that takes place in the mud — such as motocross — you'll be shooting in bright daylight or at night under bright, stadium-type lighting.

Bright light

On very bright days, you will not be able to see your LCD, but hopefully you can get to a dark spot indoors to look at shots you've taken to see what's working, and then return to take more. The idea of having a cheat-sheet card with your optimal settings is a good idea until you know the best settings for you camera and conditions well enough to deal with any changing lighting situations.

Cross-Reference See the sidebar earlier in the chapter for more about creating a useful cheat sheet.

Tip When shooting tighter shots, presumably on a racer, or any athlete for that matter, you need to either slow down your shutter speed, open your aperture (f-stop), or both. There will be less light coming into the camera, and the shot will be underexposed without changing your settings.

High-speed action

For high-speed racing, you almost can't have your camera and lens shooting fast enough — at the fastest your shutter can go, if possible. If it's bright and sunlit, try putting your camera on shutter-speed priority at the highest setting.

Most cameras — including point-and-shoots — have the option of partial manual operation in shutter priority or aperture priority.

This setting allows you to set your shutter speed but will not give you access to your aperture settings. This is because the aperture settings are automatically set by the camera according to the light. The shutter speed you specify remains constant. This way you can be sure to have stop-action shots of the racing.

Set your shutter speed to as fast a setting as possible, assuming there's plenty of bright light. If not, adjust your ISO to a higher degree of sensitivity such as ISO 400 or more.

Once you've taken a series of shots in shutter-speed priority, you can analyze which ones worked and which didn't. By examining the metadata for the shots you like, you can determine what settings to use next time — but this time, in fully manual mode to speed your camera even more. In Figure 5-14, the S-curve composition makes for an interesting shot.

Slower racing with big action

For motocross jumpers, pick a specific point where the bikes are likely to be at the apex of the jump or other critical moment. Watch a few jumps and get a sense of the best angles and the best moments, and how you might match that with your camera. Then position yourself as best as possible to get the most dramatic shots; it might be just as the jumper comes off the jump with dirt flying behind him or her in midair, or just as the bike hits the ground. Use a manual setting, preferably with narrow depth of field — especially if there is something behind the racer, such as part of the track, fans in the stands, or anything else — because you'll want the bike and racer to be in focus but all else to be blurred as you pan and lead the image and the shot.

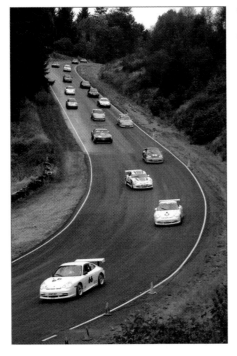

© *Amy Alden Timacheff*
Figure 5-14: Perspective is important for car racing, whether it's a close-up or a rally shot such as this one.

To get a narrow depth-of-field shot, you can use aperture priority mode or full manual with your f-stop set as wide as possible (this is the smallest number; for example, f/2.8 is much wider than f/16). Of course, you'll need to set your shutter speed faster to accommodate the additional light coming in, but this will give you better stop-action shots. Essentially, using a shutter-speed priority setting at high speed often results in a narrow depth-of-field shot, but there is no guarantee, in this semiautomatic setting, that the camera will always shoot the widest possible aperture. If it's narrow depth of field you're after, it's best to make sure you set it yourself.

Drag racing

To get the best shots of drag racers, watch the series of lights that signal when the dragsters are to go. In drag racing, the lights are vertical, beginning at the top with several red lights that go off, in succession, before hitting a final green light at the bottom. You can use these lights to your advantage: If you have a camera that has some shutter lag, and you've tried shooting drag racers and most often get either a blur or a shot of the empty spot where the racers were when you pressed the shutter release, watch the series of lights. Take a test shot when you see the first light go on. Then you can look at your photo in the LCD and see which light is illuminated in your photo — which tells you exactly how long your shutter lag is taking. If it's three lights, then you simply need to press the shutter three lights before green and, *voila!*, you'll be able to get the racers right as they hit the accelerator.

Night shots

Racing at night can be dramatic — especially drag racing, where flames shoot out of the cars and motorcycles as they accelerate off the line. The light will change at an event such as this, often because the bright stadium lights are dimmed to emphasize the dragsters flames —meaning you'll have to be quick-on-the-draw with your settings. Try various exposures to find what works best with this type of light; even a point-and-shoot camera can give good shots if you set it so that it's exposed for an illuminated vehicle.

Often the strip will be relatively dark to allow emphasis on the flames, which you can use to your advantage. Set your manual exposure so that something brightly lit is exposed correctly; this is the setting you'll use for the cars when they hit the accelerator. You don't want your camera shooting too long an exposure — you almost want the flames to act as your flash, lighting up the vehicle for dramatic shadows and color. If your camera is capable of spot metering, meaning you can determine and shoot the exposure for a given portion of the image you're shooting, this is a good time to try it out.

Tip
For any type of racing other than a car or bike that's parked and standing still, use the multiple frame exposure setting on your camera. You'll inevitably need the multiple frames to be sure you get the best shots out of a series, and you can also use the images to create a montage or image series with the car or bike moving around a corner or going over a jump.

Cycling and human-powered wheeling

Cycling is as varied as motor sports: There's road racing, BMX riding, trick riding, dirt track biking, and simple pleasure riding. Chances are, you'll be shooting some type of racing of your child or other personal friend. While there are professionals who shoot bike races or bike racing as part of triathlons, either as sports photojournalists or to present and sell photos to the racers, that type of photography is not addressed specifically in this book. But you can learn something from how they shoot and apply it to everyday photography with almost any type of camera.

Stop-action photography is always a good effect to strive for in cycling, boarding, and blading, whether it's a pack of racers coming around a street corner or a BMXer or skateboarder in midair. Many principles examined in boating and car racing also apply here: shooting narrow depth of field can be dramatic, having a telephoto capability will help, and finding the right position and testing it out will help you get better shots. Also, as with the others, you may very well find yourself in bright light and unable to see your LCD very well, meaning you'll want to have a good grasp of correct settings for your camera without relying on looking at the shots as they're taken. Figures 5-15 and 5-16 show skateboarding and rollerblading shots taken with multiple-frame exposures using an SLR-type camera, meaning the camera was set to take a quick succession of several high-speed shots.

Positioning

If you're shooting a cycling road race, you may only have one shot at the pack as it passes. If you've ever seen television coverage of the Tour de France, you know the cyclists pass the crowd very quickly. To shoot this event or any other road race you'll need to have your settings dead-on ahead of time and be positioned at a good vantage point where someone won't jump in your way at the last second. Getting to another good spot in a racecourse might be difficult. Because road races go on for miles and miles, unless you need a specific spot because of the background or unless you're shooting the finish line, you'll want to find an unobstructed location, perhaps out in the country where you can get a clear view. For dramatic effect, use a zoom lens at maximum telephoto length to get some very tight shots that compress the pack, making it look like the riders are closer to each other than they really are.

For BMX racing, you'll be on at least the sidelines of a track; if possible, try to get out into the track itself and position yourself to the side of key points. Don't just shoot for the biggest jump; see what kind of angles you can get in as many locations as possible around the entire course. Shoot from down low to up high for drama, as with motocross racing. Use a telephoto lens to get the racers' faces at the start; later, perhaps even at the very end of the race, getting a rider's face covered in mud from racing is always colorful.

Sometimes race officials have a birds-eye view from a stand. If you can get into the stand with them, and you have a variety of lenses or a point-and-shoot with a relatively wide range of focal lengths, you can capture good action because this is the broadest view of the track.

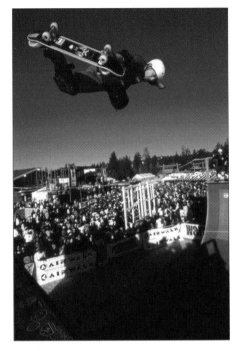

© *David Esquire*

Figure 5-15: Outdoor action shots with an athlete soaring in the air can be challenging with a large range of lighting and background conditions such as shadow, sunlight, sky, and crowds.

Figure 5-16: Skateboarding and rollerblading offer exciting stop-action shot opportunities.

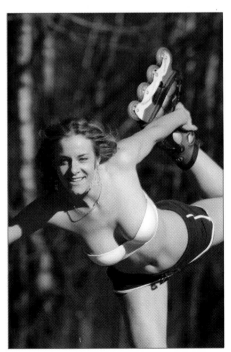

Trick cyclists and skateboarders ride in skate parks, half-pipes, and almost any urban form of construction imaginable. I was fortunate one time to shoot legendary cyclist Dave Mirra as he rode in a half-pipe along with legendary skateboarder Tony Hawk in a demonstration event. I was shooting from just where the bottom of the curve in the half-pipe almost flattened out, right alongside the edge of it, so that as Mirra passed over Hawk (literally) in midair, I got a shot of them together at maximum height.

While shooting, at one point, Tony Hawk fell on his skateboard just as I was about to snap a series of shots of Mirra; Hawk's skateboard flew up and hit me in the arm hard enough to leave a nasty bruise. Even though I was protected by a net on the side of the half-pipe, I was close enough to get hit — which is once again why I caution against getting *too* close to action sports and to always stay aware of your surroundings no matter where you are — even with a skateboarder!

The shooting was tough, because Mirra and Hawk were moving so quickly. There were bright lights shining on the half-pipe, and catching them in one position was almost as much luck as it was skill. Before they began, it was important to make sure settings were correct for their faces and outfits, and the camera was on full manual mode. It can be a challenge to capture the best tricks when your subjects are moving fast, but Figure 5-17 got it just right. It shows a rollerblader performing a seemingly impossible move taken at night using a flash — which is unusual for this sport, and generally not advisable in case it can momentarily blind the athlete.

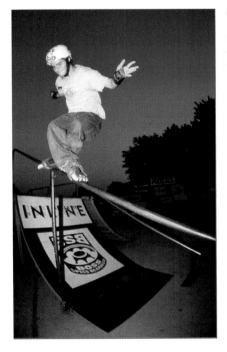

© *David Esquire*

Figure 5-17: The flash not only creates a stop-action image, but the contrast of the illuminated skater against the dark background increases the drama and "cool factor" of the shot.

Tip

Children like having photos of themselves on their bikes and skateboards — especially if it makes them look cool. To enhance them even more, stylize the image with an interesting effect or text with their name on it.

Cross-Reference

See Chapter 10 for details on how to add effects to your images.

Interview with Laura Little

Laura Little is a widely published British photographer based in New York who likes to "create work that is dedicated to flashing a little bling into a scene that is very blah." Here's what she says on shooting skateboarding:

Shooting skateboarding is one of those things where as a photographer you don't so much choose the location, the subject does. New York, where all of the images featured were taken, is truly a landscape that lends itself specifically to the sport.

Settings: *Natural light is always a preference for my photography, and I consider my work to be as much about documentation, which has more of a grounding in natural light than commercial sport.*

Getting the Shots: *In my opinion, there are two kinds of photography associated with skateboarding. One is based upon capturing "tricks" and the technicality of skateboarding, and another that is based upon the lifestyle, image, and documentation of the skateboarder.*

Tips & Tricks: *Skateboarders are like dancers: They move through space and integrate with one another seamlessly. Concrete is their stage. Capture not only the action-filled moments, but the moments of falling, recuperation, and personal style. If you're shooting sports tricks, learn what they are, think about perspective and the qualities that will make the trick a good technical photograph. Most importantly, remember that your work is about you; make the images recognizable to you and your perspective on the sport. Develop a style that is specific to you, and don't listen to too many people.*

Laura Little is managed by AmpGlobal.

© *Laura Little*
Artistic photography sometimes is enhanced by the use of "negative" space—implying or emphasizing a subject by an empty area. This image takes it one step further—the lack of the skateboarder and the board lying on the ground leads you to question where the athlete has gone or what has happened.

Continued

Continued

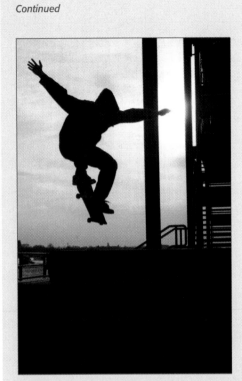

© *Laura Little*
Silhouetted action shots such as this one provide great contrast between light and dark, as well as curves against geometric angles.

When shooting in skate parks or half-pipes, whether for biking, skateboarding, or rollerblading, it's vitally important to stay clear of the area where athletes are practicing; not only can you get injured, so can they. Further, these are sports practiced by kids, and kids like to show off for a camera so the potential for them trying to do something more than what they are capable of doing is quite good — thus increasing their chances of getting injured.

In skate parks, it's going to be difficult to get a low-to-high perspective because you're most often shooting from the edge and the skaters and bikers dip down into the park. However, if you can angle yourself so that you catch them going into the air, that's a good spot to try.

© *Laura Little*

This motion shot says a lot about a sport where movement, light, and a rough tone are embedded features of the action.

Specialized equipment considerations

Biking is another good sport with which you can experiment with lots of lenses and settings and be as creative as you like. If you shoot racing, then you need a telephoto lens and a camera capable of shooting multiple frames per second in order to get top-notch images.

It's fun using an extremely wide-angle lens to get shots in skate parks. If you catch a biker doing a trick or jumping into the air at the center of the shot with a broad perspective of the park surrounding him or her, the effect is great, as illustrated in Figures 5-18 and 5-19.

© David Esquire

Figure 5-18: A wide-angle rollerblading shot in a big half-pipe. The late-day light creates a nice effect with the sun at a horizontal angle on the rollerblader's face, and the wide-angle perspective emphasizes the drama of the venue.

© David Esquire

Figure 5-19: This high-contrast shot of a rider in a half-pipe at a snow park emphasizes the relationship between skateboarding and snowboarding.

As you do with other outdoor sports, carry most of your equipment with you in a fanny pack or a backpack. Safely stowing it somewhere or with someone while you shoot, but maintaining quick access to it, will help you be more agile in getting around and to the right place for a good vantage point.

Settings and getting the shots

Cycling and boarding aren't easy sports to shoot. You have a moving target — often moving quite quickly — so focusing and lighting can be challenging to master. Relying on automatic camera settings is chancy; I suggest that you do as much photography of cycling as you possibly can in a manual mode (as you may have noticed, I encourage this in many sports, for all types of cameras).

However, even when you have a perfectly focused shot and the rider is exposed equally well, you may have a badly overexposed background. Or you may have something in the background that you didn't want, like the port-a-potty that inadvertently appeared in one of my BMX shots Whatever it is, when you're shooting moving sports, be cognizant of the entire scene, not just your subject — which is why I went into some detail in the previous sections; positioning is essential.

As a photographer, integrate with the environment in which you're shooting, but at the same time, remain aloof from it in order to have a broad enough perspective to get more than just a pinpoint view of the event. This is also the foundation for creative shooting, as well — think out of the box in order to innovate how a subject can be photographed to make them look their very best and most interesting.

You'll most often be using stop-action settings for these sports, but as you've seen in some of the images from various photographers, it's nice if you can integrate a sense of motion into the images as well. This means that it's not essential for each and every shot you take to have your camera set with a fast shutter speed and wide aperture. Sometimes you may want to slow it down a bit to get some intentional blur; this may be very easy if you're using a point-and-shoot.

Sports like skateboarding, snowboarding, and rollerblading are edgy — activities that can be made to look extra cool with some special camera effects and settings. While some sports are most often shot with conventional high-speed settings, with these you can be more artistic.

Narrow depth-of-field shots

Narrow depth-of-field shots have been discussed, and these shots work well for cyclists shot from a distance. If you're shooting an SLR, using a very fast, fixed 50mm lens (for example, with an f-stop of 1.4) can yield great images but you have to be close enough to the subject to get the shot. Figure 5-20 shows how highly effective a narrow depth of field can be in creating a dramatic action shot of groups of athletes vying for the lead.

Tight close-up shots

As I've mentioned, a shot with a long telephoto lens of a pack of racing cyclists makes them look highly clustered. To do this, shoot at least at 150mm focal length with as wide an aperture as you can and fast shutter speed. Get ahead of the racers and plan on shooting at a specific point where you can manually focus before they get there; obviously, this is much easier in a velodrome where they keeping coming around again and again rather than on city streets where they may pass you once. Take a few readings on sideline spectators to get the best exposure possible and be sure that your camera is set accordingly. Cyclists and boarders tend to wear very loud and reflective designs and their environments can be equally loud, so you really can't expect to have a perfect exposure for each article of clothing; it's better to focus on getting their faces exposed correctly. Figure 5-21 shows a busy environment where the subject and action are equally well exposed.

The settings you'll want to use for a tight close-up using a telephoto lens will be to have your aperture set as wide as possible (remember, on some zoom lenses that means it will be variable depending on your focal length) and a shutter speed set as fast as possible. From there, you can adjust your ISO to be able to expose the image correctly for the available light.

© Amber Palmer

Figure 5-20: A narrow depth-of-field image clustered cycling shot.

© Neal Thatcher

Figure 5-21: Skate parks can be as bold as their visitors.

Skiing and snowboarding (and snowmobiling, too . . .)

If you've tried shooting in the snow, you've probably found that it's not that easy. Not only is snow bright and reflective, it wreaks havoc on your white balance. Opening a skiing magazine and seeing all the fabulous shots of snowboarders and skiers in various states of action, you'd think it was as simple as pointing and shooting. It's not!

That said, it is absolutely thrilling to be out in the snow, camera in hand, ready to shoot. I've taken a camera with me helicopter skiing in British Columbia, downhill skiing in the Atlas Mountains of Morocco, and cross-country trekking in –42-degree Finnish Lapland 100 miles north of the Arctic Circle. Each location brought with it challenges but, at the same time, some of the most beautiful scenes I've ever viewed through a camera lens. From the aurora borealis to action on the slopes, my camera captured it all. For each, I had to prepare and make sure that not only would my equipment be protected from the elements, but that it would perform correctly in severe weather and temperature conditions.

Positioning

Depending on the types of snow sports you're shooting, your positioning will vary. Here are a few ideas to get you started:

✦ **Half-pipes and snowboarding.** Like wakeboarding, BMX bikes, and skateboards, snowboarding is about getting lots of air and aerial acrobatics. However, unlike some of these sports, you're going to find yourself hard-pressed to get down into the average half-pipe unless you've got a press pass at a big competitive event. Instead, you'll have to settle for the top of the edge and get close enough to the athletes that you can catch them catching air but don't get in the way. If you can catch them as they turn in the air — a 24–70mm or 70–200mm lens works fine — you'll be doing your job well. With the telephoto lens, you can also catch boarders as they drop in across the pipe. The higher you can get snowboarders, the more they like it, as shown in Figure 5-22.

© Neal Thatcher

Figure 5-22: Lots of air in a crisp blue sky

✦ **Downhill skiing.** Your positioning will be dictated by whether you're shooting racing, extreme, or basic recreational skiing. For extreme backcountry skiing, see Will Wissman's interview later in this section. For downhill skiing, park yourself in any of three locations: the beginning of the run when the skiers are just coming out of the gate; about midway down the slope, just ahead of a major turn at about a 45-degree angle to the path of the skiers where they come around a gate; or at the bottom of the hill as they're racing for the finish line. Depending on how close you are, a 24–70mm or 70-200mm lens will work for SLR shooting.

✦ **Cross-country skiing.** Here you can combine some wonderful nature shooting along with a sport. If you can get above a cross-country ski track where you have a sweeping view of the trail surrounded by the trees, snow, and terrain, a panoramic or simple wide-angle view that dwarfs a lone skier is a wonderful scene; if you can get it in late afternoon or early morning, all the better. Cross-country skiers look more elegant when skating or striding across snow more so than when making downhill turns, so it's better to work with them on flatter slopes than you would with a downhiller.

✦ **Snowmobiling.** Snowmobiles have the advantage of speed, of course, over man- or gravity-powered snow travel. Speed, then, is something to emphasize. See if you can get ahead and to the side of a snowmobile powering through deep snow or speeding down a track surrounded by deeper snow, and track the snowmobile so that it's focused but the rest of the scene is blurred. Figure 5-23 shows a snowmobile plowing through deep snow in a complex shot involving show, rider, snowmobile, water, and sky — very challenging to balance well.

© *Neal Thatcher*

Figure 5-23: Positioning for snowmobiling shots combines racing and skiing into one great chance to get thrilling photos.

Settings and getting the shots

Snow, as I've mentioned, is difficult to shoot because it's so reflective and it's just so *white* . . . Getting your white balance set correctly is essential to getting shots where the image is something other than gray.

White Balance: The Key to Snow Shooting

Why is white balance the key? A digital camera's white balance should, more precisely, be called a gray balance. Essentially, to ensure balanced and correct colors and tonal settings, a camera looks at the world by averaging everything that's lighted in its field of view. For most situations, that averages out to about 18 percent gray — the average of all color you see. White balance, then, measures the amount of light cast upon an 18 percent gray world.

If you shoot snow, the camera thinks that it's seeing something that's whiter than it actually is — it doesn't compute for an 18 percent gray world, so the camera automatically makes it more gray. If you keep your camera on an auto-white balance for snow, chances are the snow will look gray in the photos as shown in this figure.

© Dave Taylor

To overcome gray snow, set your white balance manually, and adjust it for a brighter, whiter light. If your camera allows custom white-balance settings, you can do so by shooting the snow and then setting it correctly. If your camera does not allow for this, you will need to experiment by setting the camera to various white-balance presets; take multiple photos of the same snow shot with the different settings, review them, and determine which is working the best. You'll want to experiment a little to see how the image comes out, but this is the trick for getting good, white snow shots as shown in this outstanding image of extreme snowshoeing.

Continued

Continued

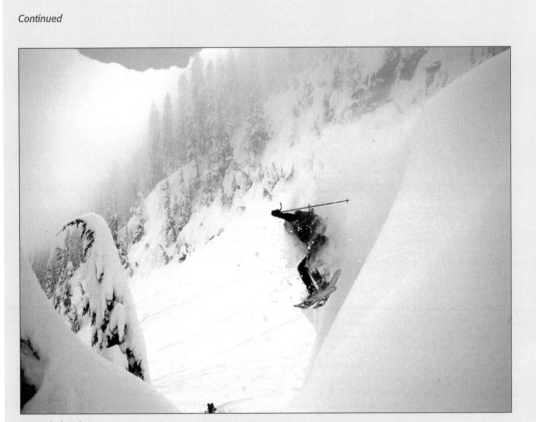

© Neal Thatcher

Once you learn to manage your white balance in a nearly all-white world, you can move on to other considerations, such as the type of light you're dealing with.

Overcast shooting

Often you find that it's overcast in snowy and mountainous areas, so shooting with flat light is common for everyday shooting or for events and trips that take place regardless of weather conditions. However, photographers absolutely love flat light because it acts like a giant *soft box*, which is a studio lighting tool that lets you shine light through a large white translucent material to give an even and shadowless tonality (also called high key lighting).

You will still want to work carefully with your white balance on gray days — everything may appear white (including the sky) to the camera, so you'll want to account for that with a preset white-balance setting of cloudy or actually take some test shots and adjust accordingly.

On cloudy days you often have to adjust your f-stop to a wider setting to allow more light into the camera, especially if you still want a shutter speed that is fast enough to catch action shots. This means your depth of field becomes narrower, so it's important to be especially cognizant of your focus — using auto-focus may be a bit risky. You'd be better off parking yourself at one spot and taking a focal test shot of someone standing about where your skier or snowboarder will pass in order to be sure of your shot.

Shooting in bright light

The reflective and bright nature of snow in sunlight also means that you need to use shutter speeds that are a bit faster and an aperture that's a bit smaller in order to avoid overexposing your scene. Of course, if you're trying to ensure you get all the color in your daughter's red cheeks protruding from her ski suit, then your settings will be a bit more conventional and you don't care too much if the snow detail isn't perfect. However, if you're trying to catch skiers on the slopes or emphasize the size and angles of a half-pipe, your settings need to be a bit tighter to avoid too much overexposure.

Snow often takes on a blue cast, especially in shadowed areas; this can equate to a blue cast as your camera tries to compensate with its white-balance setting. You'll want to change your white-balance settings accordingly (unless the blue tone is what you're *trying* to achieve). In Figure 5-24, the snow is overexposed to ensure the best possible exposure of the boarder.

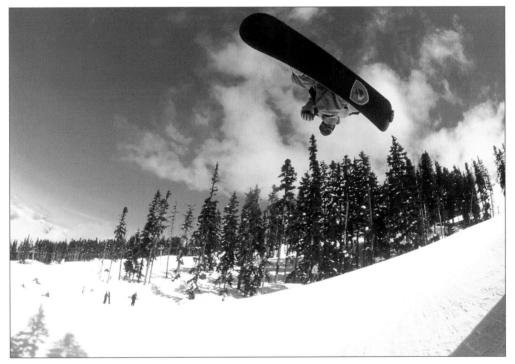

© Neal Thatcher

Figure 5-24: This bright-light shot shows how, in some cases, you just can't — nor do you want to — have an averaged exposure that is perfect for all parts of the image.

Shooting in the daytime and bright light with reflective snow also means you'll need a lower ISO — something that's available on all types of cameras, from point-and-shoot to SLR. Some SLRs come with a super-low ISO rating (such as ISO 50), but for most purposes and conditions the ISO 100 setting will suffice very well. Once again, your white balance will be your most important setting to test and perfect.

Specialized equipment considerations

First, do everything you can to keep your equipment protected and warm — nothing is worse for batteries or LCDs than cold weather. In the Arctic, my batteries had at best 50 percent of their normal life, and often less if the camera was out in the cold for too long. Keep at least one extra battery (or set of batteries, as your camera may require) in a pocket of your clothing close to your body — don't keep them in your pack where they'll get cold.

If possible, keep your camera under your jacket instead of in a fanny pack; but this may not be possible if you're lugging lots of gear. The warmer you keep your camera, the longer its batteries will last and the better it will perform. I found that when shooting in –42-degree cold, the temperature penetrated the camera very quickly so I had to keep tucking it back into my jacket to keep it warm enough that the auto-focus (which is in the lens) would stay operational (the lens is the most exposed part of the camera where the moving parts are closest to the surface). Do whatever you can to prevent snow from blowing into your camera, and most certainly, be exceedingly cautious when changing lenses, flash cards, or batteries. Your camera faces potential hazards any time it's open to the elements.

Interview: Will Wissman

Will Wissman shoots some dramatic outdoor photography, including skiing and snowboarding as well as hang gliding, mountain biking, and other adventuresome pursuits. He provides some great tips and insights into a variety of topics related to shooting snow sports:

Choosing Locations: *I always follow the snow. When the snow's good, I don't get much sleep. Plus, a lot of what I shoot is located in avalanche terrain. Knowledge of the mountains I'm in and the snow pack I'm dealing with are crucial factors. Next, I always think about what areas are getting light. The "golden hour" rule makes this more complicated: In the morning, south-facing slopes get the morning glow; by evening, the south faces are draped in shadow and you must work the more westerly slopes. Some days I like to let my athletes decide where to go. They are the ones doing the skiing and if they're comfortable it always shows in the images.*

Special Equipment: *One of the most critical pieces of equipment is my pack. I must be able to fit all the lenses with two camera bodies and accessories into it, and to be able to access it quickly. On a big day, my pack weighs almost 40 pounds; it needs to be comfortable for all the hiking and yet sturdy enough to ride on my back down a 45-degree couloir. The better your pack, the better your chances of getting some good images. Having fast lenses is the always the best. The way people are skiing these days you really need high shutter speeds to be able to catch the action.*

Settings: *Most of the time I use manual focus. This is when communication with the athlete/subject is critical. You both have to be on the same page or you won't get the shot! Often I will throw snowballs into the area the skier is going to be skiing to ensure we both are thinking the same thing. I like to set my shutter speed somewhere between 1/640 and 1/1000 second to stop the action. I usually shoot in aperture priority mode when the light is relatively predictable, and when shooting into the sun I go to full manual mode.*

Getting the Best Shots: *I think it comes down to working hard. I spend a lot of the winter hiking large peaks, usually early in the morning. When you're standing at 12,000 feet as the sun peaks over the horizon, it's hard to even decide what to shoot. Everything looks amazing!*

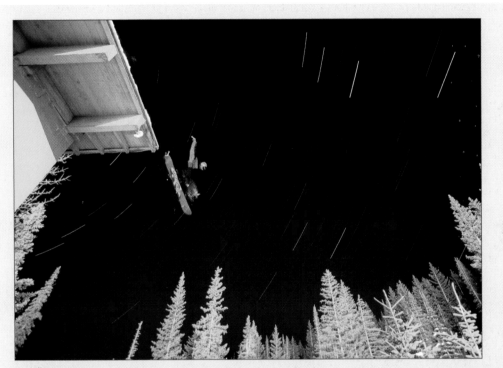

© Will Wissman

Mastering light and color in a snow-country setting — stars included (Brian Greggson, snowboarder.)

Another factor is whom you're shooting. The better the talent you shoot, the better your images. It's surprising how when you have a camera, good skiers and boarders flock to you. Spending time at a major resort, camera in hand, you're bound to run into some amazing athletes.

Yet, between weather conditions, snow quality, and light it can be tough to get good images consistently. Shooting in the mountains where it's cold and uncomfortable can be a real challenge, and keeping yourself and your camera warm is a constant battle. I use hand warmers and even have boot heaters. I always have an extra battery pack and find myself carrying it in my underwear half the time. And, of course, being a good skier yourself is always a bonus.

Shoot as much as possible. The more you use your camera, the more familiar you become with what works and what doesn't. Be creative. There are plenty of people out their shooting skiing and snowboarding, and you must find a way to stick out in the crowd. Try new things and see what happens. The great thing about digital is you can see your results instantly and make the proper adjustments.

Being passionate about what you are shooting is the key to success. I fell in love with skiing on my first run and dragging a 40-pound pack around in the snow is a good excuse to not miss a powder day. I enjoy the challenge of putting nature and all its glory together with the hands of man. With all the destruction that we bring to the earth it's nice to create something that shows a harmony and beauty between man and nature.

Will uses Canon cameras with the following lenses: Canon 17-35 2.8 USM, Canon 70-200 2.8 IS USM, Canon 15mm 2.8 fisheye, Canon 1.4 extender, and Canon 2x extender.

Tip If it's really cold, remember that breathing on your viewfinder or lenses can actually put a frozen layer of condensation on the glass — not a desirable effect. So cover your mouth and nose with a scarf and/or a neoprene mask.

Humidity can cause severe problems for cameras, even in very dry weather conditions — primarily when transferring between a warm and cold environment. When you're going outside or inside, place your camera in a sealed zippered plastic bag until it adapts to the temperature; otherwise, condensation may form inside the camera or the lens(es) that can be difficult to remove and damaging to it. If this happens, leave the lens or equipment in as dry a location as you can; if it doesn't dissipate within a few to 24 hours it may need to be professionally serviced. I've found that protecting it from temperature changes is especially important to do when coming inside to a warm room after being out in the cold. I keep the camera in the zippered plastic bag until I'm completely certain it's warmed to the environment.

Caution If you're skiing hard, don't keep the camera directly against your sweaty body or clothing! Keep it under your outer jacket, but not deeper in the layers, otherwise your body moisture can become a source of humidity by which the camera can be affected.

Tip If you leave your camera in the cold for too long and it stops working or seems to slow down dramatically, place it under your jacket for at least 10 to 15 minutes and then check it. Bringing its core temperature up should let it recover without any further trouble.

Summary

Outdoor recreation and competition sports can present a vast number of challenges when it comes to digital photography — as well as tremendous opportunities to create fabulous images. Knowing how to adapt to the environment and to be ready for the truly unexpected are the keys to getting the best shots.

Shooting on the water and off are primary considerations, including such factors as protecting your equipment, limited access to downloading images, and being very careful about exposing an open camera (for example, changing flash cards, batteries, and lenses) to a harsh environment. Snow, as well, increases your chances of damaging a camera with cold or wet conditions. Knowing your equipment and how to handle it for the photo shoot you're on are important.

Sports with wheels — whether they're on a car or under your feet — offer some exciting opportunities for cool photos. Being able to set your camera so that it is optimized for the different types of speed, action, and light helps to ensure you capture the action and represent the sport in the best way possible.

Photography in the snow is unique because of what it does to a camera's white balance. Understanding how to deal with this, in addition to other factors such as the cold, will help you achieve photos where the snow is white and the skiers' faces are suitably red!

Knowing how to create a cheat-sheet for exposures will help you remember the settings on your camera for the best shots, whether you have a point-and-shoot or a fancy SLR. The most important factor is that you learn to manage your equipment while staying very aware of your environment, whether it's on a racetrack, at a bike race, or on a ski boat.

✦ ✦ ✦

6 Indoor Competition Sports

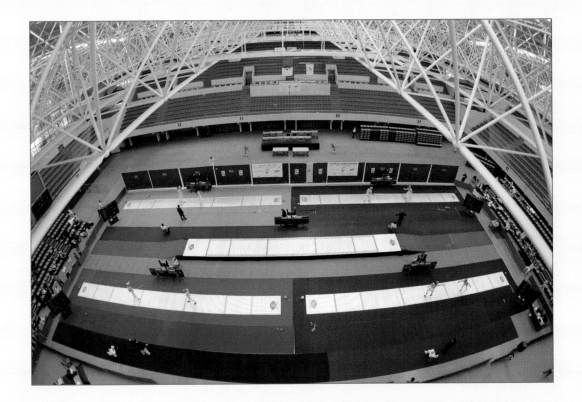

From basketball to wrestling, fencing to ice hockey, and gymnastics to martial arts, worldwide indoor sports constitute a tremendous amount of athletic sports competition and recreation from tropical to arctic climates. Professional, semiprofessional, school, and amateur sports thrive in venues where there's climate control, lights, and creature comforts to keep athletes, spectators, and others happy.

For the digital sports photographer, however, indoor competition can present some significant challenges. The lighting can be abysmal, it can be difficult to get around a crowded sports hall to get a good photo, and traipsing around on hard floors all day can be rough on even the toughest shooter's knees.

For every negative, however, sports inside a building can make for some opportunities the outdoors can't beat. Weather is never a problem, for example, and at least the lighting — even if it is bad — remains constant throughout an event in both intensity and temperature (for white-balance). Furthermore, staging your shoot, if you have extra equipment you don't want to carry, can often be stored or anchored somewhere safe.

So indoor sports of all types require you, the photographer, to adapt to the environment, both from a logistical standpoint — meaning where you position yourself and how you get your shots — to technical issues for setting your camera to optimize sports-action photography results while dealing with various types and conditions of lighting. This chapter looks at lighting challenges as well as equipment involved in photographing various indoor competitive sports.

Lighting

Indoor lighting for sports is often regulated and prescribed by sports organizations, but individual events may not adhere to it for reasons ranging from lack of awareness or inadequate resources and equipment to aesthetics or increased athletic drama. This may work to your benefit, or it may wreak havoc on your ability to get good shots. Figure 6-1 illustrates a fencer photographed where the only light at the tournament was from overhead spotlights — which, in this case, provided a dramatic low-key lighting effect.

Indoors is where I spend most of my time shooting athletic competition. As the photographer for the International Fencing Federation (FIE), virtually every tournament takes place indoors. Yet I'm continually surprised at what I find in every new venue.

In the last year, I shot in Qatar, Las Vegas, New York, Seattle, Bulgaria, Athens, Austria, Paris, Charlotte, and Algeria, and literally every venue had different lighting, different access issues, angles, challenges, and various other factors that directly affected my ability and my opportunities to get good photographs. In October 2003, shooting in Havana, Cuba, the lighting in the preliminaries hall was so bad (inconsistent and dark, primarily) that the FIE authorized photographers to use flash photography — something unprecedented in fencing. This, of course, helped, but threw a new twist into how we as photographers had grown accustomed to shooting the sport.

While photographers deal with weather, temperature, dirt, and other factors outside, lighting is by far the biggest issue with indoor sports digital photography. Many cameras perfectly capable of capturing a good soccer photo outside even in cloudy daylight may be tough to use indoors without a flash. Furthermore, knowing how to set your white balance to match the lighting indoors without a flash is very important, and will prevent you from having to spend hours cleaning up color balance in an image editing package later.

Some indoor sports even combine the challenges of indoor lighting with the same problems found in outdoor shoots. For example, Figure 6-2 illustrates a good action ice hockey photo where the colors of uniforms, the ice, and players' faces are well balanced — despite the fact that photographing on ice can be similar to photographing sports in the snow.

The equipment you select and use for shooting indoors is often determined by the type of lighting you anticipate (or know) you'll encounter. When shooting at major sports events, both amateur and professional, lighting is typically very consistent and bright, conforming to international or professional standards prescribed by sports federations. However, for any other sports events, all bets are off when it comes to lighting.

Figure 6-1: A fencer photographed in a final match at Duel in the Desert in Las Vegas, where the entire venue was darkened except for spotlights on the competitors — a challenging photography scenario but one, if shot correctly, that produces very interesting effects.

In fencing, as well as for other indoor sports, the lights are lowered during the final matches and then raised during the medal ceremonies — although I often change lenses between these events anyway. Lighting during preliminary rounds of various sports, leading up to semifinals and finals, is often spread throughout a large facility and lighting is typical of any large sports hall or gymnasium. Sometimes the lights are spread too far apart for effective photography illumination without a really fast camera and lens, and, in addition, sometimes the light can be quite varied (for example, if there is a combination of streaming outside sunlight coming into the venue through windows in combination with artificial lighting).

So, in order to get good photos in the varied lighting conditions you may experience, you'll want to ensure ahead of time that you have the equipment to get the kind of photos you need — most often without a flash. If you're taking photos of people in the stands, athletes warming up or off the court, or other non-action images, you can usually use your flash. But the action shots are where the proverbial rubber meets the road in terms of the type of equipment you have versus the kind of images you want to capture.

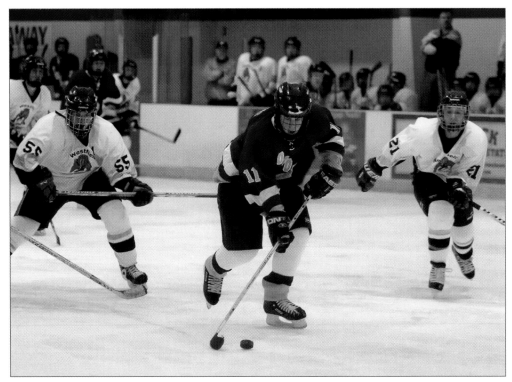

© Joy Absalon

Figure 6-2: Dealing with white-balance at an ice hockey game is similar to photographing in the snow.

Equipment

Indoor sports are most often played on smaller surface areas than you find outdoors, so the really big lenses that you see pro photographers using on football, soccer, and baseball fields — 300mm, 400mm, and 600mm — aren't as useful indoors and can even become unwieldy in a crowded arena. It doesn't mean they aren't used, but rather that they are used less often.

This is good news if you're using a point-and-shoot camera or if you don't want to pay thousands of dollars for big lenses for your SLR. Indoors you can sometimes get closer to the action, and bright indoor lighting may help you significantly to overcome any limitations your camera may have.

However, indoor photography can be challenging, as well, without higher-end equipment if the light is less than optimal or you don't have the access you'd like to players and action.

If you're shooting an SLR, it's good to have a few lenses that give you a focal length ranging from a reasonably wide setting — such as 24mm or wider — up to about 200mm or perhaps a bit longer — but not much more. Lenses longer than this, such as the 400mm lenses and longer that you see being used by photographers in football and baseball stadium shooting, are of less use indoors. This range is sufficient for most indoor venue, people, and action shots, even to get in rather tight if you need to. While more expensive, the fast zoom lenses that hold the same, wide aperture regardless of focal length (usually f/2.8 at the widest) are extremely useful and will allow you to shoot at faster shutter speeds (which is why they call them "fast" lenses).

If you intend to shoot sports indoors with a point-and-shoot, it's important that it's sensitive enough to capture the action without having to use a flash. That means you'll want a camera that can, preferably, range above ISO 400 (ISO 800 or higher is ideal), has a large-enough lens that it can let in sufficient light with a wide aperture, and can also shoot action shots at least at 1/250 second (and hopefully faster). Also, you'll want to be able to set these parameters manually, or at the very least at aperture and/or shutter priority modes. You can take some very good indoor sports shots with a point-and-shoot camera offering these features.

It's a good idea to carry your equipment in a secure, padded fanny pack or backpack when you're shooting sports indoors. Gyms, arenas, and other venues tend to be crowded and constructed of concrete and metal, materials that are not very forgiving if a camera or lens is knocked against a wall or dropped on the floor. Be sure to have lens caps on your lenses (a good idea no matter where you're shooting), use soft-rubber hoods (required for many competitions if you're close to the athletes), and always use a haze or skylight filter on your lens(es). More than once, the filter has taken a hit when I dropped a lens but the lens remained intact — the same concept as what a helmet does for a cyclist's head.

Consider This . . .

For many sports halls and all types of sports — at least for finals and the big action events — the action is bright and the stands are dim, or at least dimmer than where the main event is taking place. Many photography enthusiasts are dismayed when they arrive in a sports arena and are sitting in the stands, thinking their cameras are incapable of taking a good photo in the light that's immediately surrounding them. Here's what you want to think about in that situation:

✦ You're going to expose your shots for the main area where competition is taking place.

✦ Using a flash in the stands is of no use unless it's to take a photo of someone sitting near you.

✦ Using a flash close to the action — for example, if you are on the floor of a gymnastics event — is most often forbidden, and can even be dangerous to the athletes.

✦ You'll camera sensor will "see" more or less light, depending upon the focal length at which you're zooming. If you're intent on shooting from the stands, you'll want to use a telephoto lens or setting on your camera. For nonprofessional lenses and point-and-shoot cameras, this automatically changes your aperture to a more narrow setting. That means you'll have to slow down your shutter speed or bump-up your ISO in order to get the shots

Settings

At no other time will you need to be more aware of your how your f-stops — your camera's aperture settings — work than when you're shooting indoor competition with various focal lengths. It can make the difference between getting and not getting the shot you want. It's important to understand how shutter speed, ISO, and f-stops work with your various lens settings to optimize your image quality and to catch the action. Here are a few basics, just to remind you of how camera settings work:

✦ Aperture, which is measured in f-stops, is the opening in the lens that allows light into the camera when you take a photo. When you take a photo, it opens and closes to the specified f-stop width.

✦ Shutter speed is the amount of time it takes for the lens to open and close when you press the shutter button.

✦ ISO is the sensitivity of the camera's light-absorbing chip that captures the digital image and is measured/indicated in whole numbers (for example, 50, 100, 200, 400, 800, and higher).

These three factors are forever intertwined to define the quality of your image. If the lens opens wide (a low f-stop setting, such as f/2.8), then your shutter speed can be fast to capture a stop-action event (creating a more shallow depth-of-field image). If your lens doesn't open as wide, then your shutter speed needs to be slower so there's time for more light to get to the image sensor (which will yield a deeper depth-of-field image).

Additionally, if less light is coming in, you can increase the ISO sensitivity. However, this is your last resort, because the higher your ISO sensitivity, the more digital noise there will be in the photo; this is especially true of less-expensive cameras.

Telephoto considerations

Now, consider your lens; it can be various lengths. If it's long, not as much light can get in, so your settings must deal with this. You might wonder why your long shots turn out darker than your close ones, even if you think your settings are the same. They probably aren't — even in manual or aperture-priority modes, your camera's lens can only do what it is physically capable of doing.

High-end telephoto lenses, as discussed elsewhere in this book, have the ability to maintain the same aperture opening whether they're zoomed all the way out or all the way in. But this is an expensive feature, and, while pro photographers use it commonly, it is prohibitively expensive for most amateur, enthusiast, and even semipro shooters.

Cross-Reference
For more about the high-end and telephoto lenses, see Chapter 3.

This means your lens will probably have a different aperture if it's extended out to full telephoto mode or if it's set to be wide; often the gap between these aperture ratings can be quite significant, such as f/2.8 and f/6.3 — nearly one-third smaller (remember, a smaller aperture or f-stop number is a *wider* opening — f/2.8 is much wider than f/6.3). As you zoom out, the aperture will only open to a smaller width.

The tough part of shooting indoor competition is that if you're shooting in a telephoto mode — meaning anything but being as close as possible to the action — you're going to have to do either of two things to get a good exposure: slow down your shutter speed or increase your ISO sensitivity — neither of which may be desirable, but necessary.

If you need to get stop-action shots, and your camera handles digital noise at higher ISO settings reasonably well, increase your ISO before you lower your shutter speed. If you get too much noise, however, you may have to lower the shutter speed to get an image of good quality.

The main point to bear in mind when shooting with a zoom lens is that it is most likely going to have a lower, slower capability when zoomed out than when zoomed in. For optimal results, do whatever you can to get as close to the lighted action as possible — this is the best solution to avoid having to make changes to your settings on the camera.

Using a flash

Most cameras have a built-in flash, sometimes called a *wink* flash. SLRs and some higher-end point-and-shoot cameras may have both a flash and a hot shoe for attaching an external flash, and very high-end SLR cameras only allow external flashes and have no built-in flash.

Note Higher-end cameras also have the ability to have a synch cable attached to connect to external lighting systems.

If you have a built-in flash and you run on automatic mode, you need to be careful in sports halls to disable it unless you really plan to use the flash for a photo — and the use of a flash is allowed. Most indoor facilities are dark enough that the camera will think it needs to use the flash, and if you're close to the athletes this can be a bad thing as a sudden bright light can momentarily blind them. This can be dangerous to the athletes in many sports and is often prohibited (and, the last thing you want is an angry player or coach blaming you for an athlete losing in important point or score, or, even worse, being injured). Furthermore, if you're up in the stands, the flash firing won't do you much good. So turn it off and plan to compensate by running in a semi-manual or full-manual mode.

Red-eye reduction

Got red-eye? This is caused by the reflection of the flash off of the retinas of the subject's eyes. It's especially a problem with people who have light skin and lighter colored eyes.

Many cameras offer a red-eye feature that flashes the flash briefly before the image is taken; this causes the person's eyes to react to the light, constricting the pupils before the image is taken. However, the red-eye feature slows your camera's reaction time from when you press the shutter release.

Victory and medal shots are when you're most likely to be close to athletes and using a flash, such as the image in Figure 6-3 of the French men's epee fencing team just after winning a gold medal in Athens.

Tip If your camera supports it, using an external flash will help eliminate or at least reduce flash. You can also bounce your flash by pointing it away from subjects and using something to bounce the light in their direction — either a wall or ceiling, or a device you physically attach to the flash for this purpose.

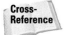

Cross-Reference If you do get red-eye, no reason for despair: Most image-editing applications today work very well to eliminate it in your photo. For more on this, see Chapter 10.

Figure 6-3: If you shoot straight into athletes' faces, use your red-eye reduction feature to prevent red-eye from occurring. The other option, such as in this shot, is to shoot them at an angle.

White-balance

Your camera's white-balance is the other major factor you'll want to be on top of when shooting indoors. Whether you set it manually or you use a camera's white-balance preset, you'll find different light in almost every facility in which you shoot.

As covered in the section on snow in Chapter 5, digital cameras see the world in averaged 18 percent gray. The term "white" balance is misleading; it's really a balance between black and white and an average of the full spectrum of light that's available. How the world is illuminated is measured in temperature (degrees of Kelvin); some lights are "hotter" than others. You want to have your camera setting matched as closely as possible to the temperature of the venue lighting in a sports hall.

This can be tricky. Lights, such as household lamps and spotlights, are not as hot as some other lights in terms of their temperature; this type of light is called *tungsten*, which refers to the kind of filaments used in the lamps. Other lights, such as studio flashes, are much hotter and vary according to the type and quality of strobe. A small built-in flash on a point-and-shoot may be very hot. Still other types of lights, and those that you commonly find in a gymnasium or sports hall can be fluorescent, sodium or mercury vapor, or a variety of other types of lighting. However, these three are by far the most widely varying types of lights in terms of temperature, which can wreak havoc on your white-balance settings — and it's why no two venues are the same. Table 6-1 lists the types of light you are likely to encounter and the approximate Kelvin temperatures of each, as provided by Mark Rezzonico, vice president of Profoto.

Table 6-1: **Kelvin Temperatures for Common Lighting**	
Type of Light	*Temperature Range (in Degrees Kelvin)*
"Wink" flashes	Approx. 10,000°
External SLR camera flash	Approx. 5500°
Medium-quality Studio Strobe	Approx. 7500° (may fluctuate as product ages)
Professional Studio Strobe	5300-5500°
Common light bulb (tungsten)	2800-3200°
Sunlight	Can vary between 3500° and 10,000°. The variation depends on time of day, direction of sunlight, and time of year/light intensity.
Daylight/sunlight average	5400-5500°
Sodium or mercury vapor, fluorescent	Varies

Your camera probably has icons referring to various types of light you'll encounter: a sun, a little light bulb (this is tungsten), a fluorescent lamp, a flash, and perhaps clouds. Each of these is a specific Kelvin temperature that, when you select it, sets the camera to that corresponding white balance setting. For the fluorescent setting, which you would also normally use for sodium and mercury-vapor lights, the camera manufacturer has chosen to preset a temperature, but the temperature of these lights vary so widely that the preset can often be unreliable.

You may also have a custom white-balance setting that allows you to specifically set your camera to whatever temperature you want. Your camera may also be capable of allowing you to take a photo of something such as a gray card and then set the camera's white-balance to make the image balance correctly.

If you're intending to shoot regularly indoors with a wide variation in lighting (meaning many different locations), you may want to look at a product called the Expodisc White Balance filter, which is sold by most pro camera retailers including B&H Photo, Adorama, and others. This is a light disc that you hold in front of your camera lens as you take a photo in the light where you intend to shoot. It then allows you to take an accurate reading and set a custom white-balance in your camera (assuming it supports doing so) that, instead of simply reflecting light off of a white-balance gray card, the camera actually sees the light as it is. I've met several photographers who swear by this product.

A Brief Lesson in Kelvin

The concept of temperature, warmth, and cold can be confusing when it comes to light. Temperature as measured in Kelvin doesn't relate in the same way to Fahrenheit or Celsius in that a higher temperature feels warmer. Instead, it is a measure of wavelengths, not heat. The reason it is referred to as cool or hot is the *color:* a lower Kelvin degree produces redder light, which is considered warmer and a higher Kelvin degree produces a bluer light, which is considered cooler.

Tip For more information about the Expodisc, visit www.expodisc.com. Expoimaging, makers of the Expodisc, also make similar filters for warm balance.

Whatever the method, white-balance is something you'll need to change for various facilities. The first thing to do is to take a look at the types of light being used and set your camera accordingly. Chances are, the lights in a gymnasium, convention center, arena, or other venue are sodium or mercury-vapor types. While these lights, which are usually spaced about every 20 feet or so, are slow to warm-up, they provide a lot of bright, white light in a large facility. For this type of light, you will want to try using a fluorescent preset in your camera. If it looks too blue or too red, you can also try your lightbulb or flash setting to see if it improves.

If you're shooting a highly spotlighted event, try the lightbulb (tungsten) setting first. Sometimes the lights at these events will also have colored *gels* (synthetic colored sheets) placed over them; the setting on your camera is the same regardless of the specific color. As you can see in Figure 6-4, in a stylized image of a fencer, gel-covered tungsten lights are shining behind him.

Figure 6-4: Whatever the colored filter placed in front of the light, the temperature is usually the same, such as this series of tungsten spotlights at a fencing tournament.

Basketball

In the last 20 years, basketball has become a big-action sport with high-flying dunks and spectacular plays. Every sports photographer shooting the game has dreams and hopes of catching a player in midair dropping the ball into a swishing net.

As a team sport that moves back and forth across the court, shooting basketball is similar to shooting soccer and hockey, which is described in Chapter 4. The players move very quickly; keeping a visual lock on them as well as the ball can be very difficult. At the same time, you don't want to shoot too widely because then you risk losing the subject and the action in a busy arena.

If you do get onto the floor of a basketball game — whether it's professional, high school, or any other level of play — above all be cognizant of the players, fans, officials, and referees as you should be when photographing any sport. It's a fast, chaotic game, and it's easy to get in the way; this is also the sport that most commonly requires photographers to use soft-rubber hoods to protect the players should they run into the end of your camera.

Positioning

To get the big-action shots in basketball, position yourself along the sideline at the end of the court. Most action of all types — whether it's battling for control of the ball, guarding a dribbling player, or shooting a free throw — takes place in this area, although it can happen equally at either end of the court so you will need to make some choices as to where you're located.

Many teams — high school and college included — are known for players who are the stars of the team, because of their abilities at handling the ball, scoring points, and making the big jumps. If you know who these players are, you can better choose which end to be at to be able to catch them when they make their moves. If you don't know the players, ask some fans; they'll be more than happy to give you more information than you probably ever wanted to know. Shots like the one in Figure 6-5 are a product of anticipation and positioning.

If you're in the stands and locked into a specific seat, you may have little control over your positioning; moving away from your seat and going to the edge of the rails to shoot might work for a shot or two, but you'll probably have someone yelling at you quite quickly if you're in the way. With the right lens — meaning relatively long and fast — a potential solution may be going higher in the stands where you may have easier access and the fans are more likely to tolerate your presence (as long as you stay out of their way!).

How Do They Do That?

Back focusing (also known as thumb focusing or back-button focusing) is something pro photographers do to increase their speed in catching action shots and their ability to focus accurately. Instead of focusing using the shutter-release buttons, as is the default for most cameras, they change their focusing to another button — which allows them to just use the shutter release to snap the photo, while they focus with a different finger or keep the focus unaltered even with a shutter release (even though it's still on auto-focus). This is one of the ways pro photographers get the shots that they do; the back-focusing feature is available only in higher-end SLR cameras made by Nikon and Canon.

Another popular focusing trick with pro photographers is to set a camera's focal point in a different area. Many SLRs allow you to shift your focus point to the left, to the right, or up or down; the higher-end cameras have as many as 45 or more points that can be selected in various ways for focusing on individual areas or regions of the viewfinder. This allows the photographer to shoot two or more players and use auto-focus, and to avoid inadvertently focusing on what's behind the players (due to the players being on either side of the image, with the default focus being in the center).

If you're on the floor, you may have some options for seating and you may not. You'll need to plan to sit on the floor itself, out of the view of everyone else who needs or wants to see the action. Because you'll need to move around some, and because even semipros won't really need gigantic lenses, using a monopod is optional but you may find it just gets in the way. Wear comfortable clothes and plan to sit on a hard surface for a long time. You can also bring a small, portable stools or an insulating cushion (sports floors can get uncomfortably hard and cold).

Close to the action, use a wide-angle lens or setting on your camera — at least for some shots — to get enough of what's right in front of you into the image. If you're using an SLR camera, a fisheye lens (15mm or smaller) can make for a fun and interesting perspective, but not one you'll want for every shot. The distortion the lens creates is a great effect for establishment and dramatic one-of-a-kind shots, but it is not meant or intended to be used to document an entire event.

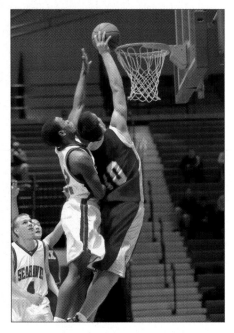

© *Joy Absalon*

Figure 6-5: Good positioning is essential for getting tight dunk shots like this in basketball.

Settings and getting the shots

For basketball, getting the shots means getting the *shots* — as in basketball shots! Whether it's the ball being dunked, a tough lay-up, or even a nice free throw, you want the ball to be the center of the action. Another nice perspective is when a player is moving fast while dribbling with a defender tight at his or her side, or a face-off between opponents, such as the one in Figure 6-6. These common types of basketball action shots never lose their interest or value among editors, parents, sports fans, or players.

Your camera settings in basketball need to be ready to catch big, fast action. You probably don't want to start by taking images that are too tight; they'll be hard to focus and you want to get a bigger-game perspective before you begin to zoom in. If you're trying to get a jump shot, just having the photo of the players' hands and heads at the top of the basket won't reflect the drama created when seeing their entire bodies a few feet off the floor.

What does that mean in terms of specific settings? Have a medium-wide focal setting on your lens — for an SLR, that means probably somewhere between 50mm and 100mm — with a shutter speed of 1/250 at the very least, and preferably 1/500 or faster. Your f-stop should be set to as narrow a depth of field as you can handle to get the shot.

For a point-and-shoot camera, you'll want to be zoomed at a medium range and, if your camera offers shutter-speed priority, set your shutter for 1/250 or 1/500 second at the highest ISO you have. Take a look at the shots you get with that setting, and then adjust your settings from there accordingly — perhaps slowing the shutter speed if the shots are too dark, for example. If they're over-exposed, then you can decrease the ISO sensitivity.

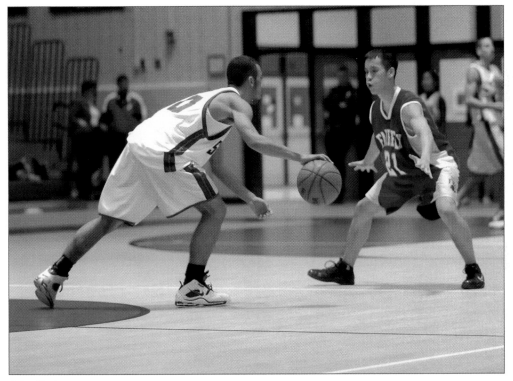

© Joy Absalon

Figure 6-6: Whether in a tight run or a face-off, getting a basketball player dribbling a ball while facing an obstacle or challenge always makes for good visual drama.

One good bit of news about basketball photography is that you can fix your focus on the basket and know that many basket shots — especially lay-ups and rebounds — will be just about within that distance. Jump shots may take place farther away from the basket, and your attention to a changing focal range will need to be keen. This means you can keep the focus on a manual setting as long as you're specifically shooting the basket shots — but don't forget that you've got your camera on a manual focus if you go back to shooting action on the floor.

Interview: Joy Absalon

Joy Absalon is an accomplished Virginia/Washington, D.C.-based sports photographer who shoots a variety of sports around the U.S. Some of her work is featured in this chapter and in Chapter 4. While Joy specializes in baseball — her passion and the sport about which she is most knowledgeable — she freelances in all sports photography and shoots for Potomac Nationals minor-league baseball team. Her work appears in various publications such as *At the Yard* magazine, and she is an active member of Sportsshooter.com.

Joy Absalon, digital Nikon SLR and monopod in-hand, shoots a baseball game.

While Joy shoots baseball more than anything else, her prolific technique and photography skills can be and are applied to sports both indoors and out, including wrestling, volleyball, basketball, ice hockey, tennis, track and field, and gymnastics.

What camera settings work for you?

> *For most sports action images I shoot everything at f/2.8 or f/4 and a narrow depth of field. Doing so helps keep the background blurred so that the subject is the main focus of the photograph. I use no special lighting.*

What does it take to capture the best photos for your sport(s)?

Since I specialize especially in pro baseball my response is geared toward that. A fast shutter speed is of the utmost importance when shooting a 95 mph fastball. For night games, I constantly monitor my shutter speed to maintain a minimum of 1/1000 of a second. If that means bumping the ISO up, then I do it. Knowledge of the sport is also extremely important. Being able to anticipate what is going to happen next is very helpful; for example, if there's a runner on first with no outs, I stay focused on second base in anticipation of a double play or an attempted steal.

© Joy Absalon
Baseball is the primary sport Joy shoots.

What tips do you have for aspiring sports photographers?

Watch your backgrounds. Make sure you are at the best angle possible to prevent distracting backgrounds; this is especially important if you do not have a fast lens that would help to blur or distort the background. If you are shooting your subject or child on a community field, local park, or school field, make sure there isn't a tree or pole that appears to be growing out from his or her head. Check that there aren't any trashcans or port-a-potties in the background. Don't just snap without looking around . . . if you see these items in the viewfinder, move a few feet to your right or left and check your composition again.

Don't cut off a limb. Try not to cut off a player's arm or leg. If you must do so, then don't cut the limb off at the joint. Doing so tends to make the subject appear to be an amputee.

Continued

Continued

Fill the frame with your subject as much as possible. Your subject should be the main focus of the image, not the entire playing field. Using a telephoto zoom lens will assist you in properly framing your image over shooting with a fixed focal length lens.

Use the fastest shutter speed possible. This will help freeze action such as the movement of the ball, bat, or runner. Lenses with larger apertures, although much more expensive, will permit the camera to select higher shutter speeds.

Timing takes practice. And practice, and more practice. Timing peak action so that you can get a photo of your subject throwing a ball, hitting the ball, or running/sliding takes time. It's not something you master overnight. The wonderful thing about digital photography is that you no longer have to worry about the cost of buying and developing film. A favorite saying of mine is "shoot early and often." The more you practice (shoot) you should begin to see an improvement in the quality of your photographs. Keep a folder on your computer of images from the first game of the season. Periodically throughout the season, go back and open that first folder, and you'll be surprised at the improvement in your latest images. It's like everything else, the more you practice, the better you become.

Understand the rules and strategies of the game you are shooting. If you are interested in shooting the game and not just one subject (for example, your child), familiarize yourself with the rules of that game. In baseball you should look for the obvious: a runner on first with no outs (or one out) means you should watch for an attempted steal at second base or a possible double play. If you have a runner on third with no outs (or one out), watch for a play at home. Leadoff hitters tend to steal bases, so pay attention each time the leadoff hitter gets on base.

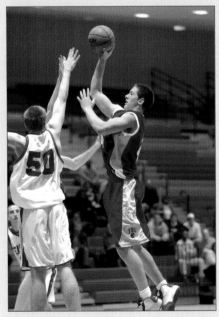

© Joy Absalon

Basketball, like baseball, is best shot looking up at the player.

Position is important. If at all possible, position yourself so that you are at field level. Try not to shoot down on your subject. You will get a better image if you are able to shoot up at your subject. Don't be afraid to get dirty. Kneel down on the ground and shoot. In baseball the player's hat or helmet tends to cast a dark shadow on the face. If the subject is looking down (at the plate or the base, for example), then being at a slightly lower level than the subject will help to capture the face. When shooting younger children, it's always best to shoot from their eye level, never down at them.

Be respectful and courteous. Don't get in the way of the players, coaches, officials, or professional photographers who may be there to photograph the event. Keep in mind that these people are working. I am always more than willing to share my knowledge with a parent or amateur photographer between innings or after a game. But even though it doesn't look like work, it is work for the professional who may be shooting that Little League game.

Don't be afraid to shoot through the fence if necessary. But remember, kneel down if at all possible and try not to obstruct another fan's enjoyment of the game while you are trying to photograph your subject.

Avoid shooting into the sun as this may cause lens flare. Again, move around and scout out a better shooting position.

To get tighter action shots in basketball, you will need an eagle's eye for focusing because it moves in all directions at high speed. Your auto-focus may be fast enough to catch it. Perhaps you have focus tracking (Nikon) or AI Servo (Canon), which lets you keep focusing on a subject while it moves toward or away from you by keeping your finger down on the focus button. But even with automated features, it's tough to always be in focus. When using your auto-focus, it's easy to accidentally slip and focus on the crowd behind two players instead of the players themselves.

As discussed with a other sports, if you pick a spot where you think action is likely to occur — such as under the basket or at another spot on the court — and set your focus for that spot, you can wait for the action to pass in that focal range; depending on your camera's speed, you may need to depress your shutter release as the athletes approach the spot instead of waiting to shoot the moment they are there.

For tighter shots, either increase your ISO or lower your shutter speed — or both — because the image will be too dark if kept on the wider setting that takes in a more highly lighted area. However, don't drop your shutter speed too much or you'll blur the action.

Martial Arts

There are many types of martial arts: Tae Kwon Do, Karate, Judo, Aikido, Jiu Jitsu, Kung Fu, and others, all of which have various techniques and ways of presenting the sport. For example, some types are non-competitive, but offer demonstrations and other events, while others host competitions.

It's very important that you know something about the specific martial art you want to shoot, because martial arts athletes are very particular about various ways the sport is presented, posed, and practiced. Subtle differences in how participants stand, hold equipment such as a sword, or at what point they are in a specific series of moves is important. As such, unless you're familiar with the intricacies, protocol, etiquette, and details of the sport, you'll want to have someone who's knowledgeable advise you so that you take not only well composed and exposed shots, but ones that are appropriately important for the sport itself. This is especially important if you are shooting a posed shot.

Positioning

Finding the right position from which to shoot in martial arts will depend greatly on the type of event and martial art you are photographing. If it is a competition, then you'll want to find a good, unobstructed spot that's close enough for you to get good shots of the athletes' faces during moments of exertion and determination; however, you don't want to get so close that you are in danger of being in the way of a falling participant.

Commonly, you'll be shooting up toward the participants from a sitting position around the event if it's a competition. As with basketball, this will not only work as the best perspective for you, it also ensures that you don't get in the way of spectators or officials.

You should be able to get onto the floor at larger competitions and close to the area where the event is taking place, so finding the right spot should be relatively easy. In a more confined martial arts club, this becomes a bit more difficult as they tend to be small and sometimes dark. In this situation, you'll want to watch an event or practice first before shooting so that you can scope out the area to find the best spots and to check your settings to be sure your camera will be able to get good shots. Getting a good, low angle in martial arts is desirable whether it's a demonstration or a competition, as you can see in Figure 6-7.

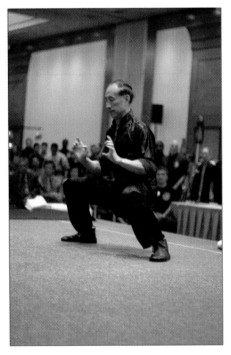

© *Craig Chan*

Figure 6-7: Specific moves and poses can be as important in martial arts photography as action shots.

Settings and getting the shots

For martial arts, a narrow depth-of-field setting (meaning a wide aperture combined with a relatively fast shutter speed) is optimal to blur the background and emphasize the action — whether it's one or several athletes.

Because you can get closer to the subject, you typically won't have to use a telephoto lens; instead, you can use a standard portrait-length lens (approximately 50mm or so) and get perfectly good shots. Furthermore, in all but the most aggressive martial arts events and styles, a super-fast shutter speed isn't needed; you should be able to catch moves and even some action in the 1/125 to 1/250 range.

Some martial arts events, such as the one shown in Figure 6-8, feature exciting displays of extreme endurance or human capabilities. These can be lots of fun to shoot and serve as very memorable shots for personal use or for sale.

For martial arts competition where there are two participants in combat, you'll get optimal shots if it's possible to move around them to get various angles and catch the action. This means you'll be standing and shooting, so you'll need to be careful about your focusing — focusing manually with an SLR works very well, but takes a bit of practice — and you need to be cognizant of not getting in the way of spectators.

The use of flash, as in other sports, is often discouraged in martial arts.

© *Craig Chan*

Figure 6-8: Seeing is believing! Shooting an exciting moment at a large martial arts demonstration event.

Ice Hockey

A popular, big-arena sport, ice hockey is one of the toughest indoor sports to shoot. The crowds are notoriously wild (as are the players!); the venue stands are dark, and the ice is bright and white; the puck is nearly invisible when looking through a viewfinder or, worse yet, an LCD; and the action is fast and furious. As with baseball, the bigger the level of game with the best action means you may have the most limited access. This is an event where you will have to shoot from the stands, and, depending on where you are seated or positioned, you may have a large Plexiglas window in front of you.

For smaller regional or school games, you may be able to get special access where you undoubtedly will have one of the best views of the game where you can get not only great ice shots, but images of the players in the team boxes as well — which is very tough to do from the stands.

Positioning

Getting a good position to take great shots in ice hockey may be tough unless you have special access. Pros like Joy Absalon shoot ice hockey from player level, as you can see in Figure 6-9. However, given that the rink is surrounded by protective, transparent material, if you don't have special access then you'll most probably want to be above that level because shooting through it will, without fail, cause your images to be distorted, unclear, and of poor quality (unless you can find a spot where there's an opening in the Plexiglas, which is what pro photographers are provided). The only exception to this is when you happen to get a shot of players banging-up against the Plexiglas and you're on the other side with a wide-angle lens to show in gruesome detail their faces and equipment squashed flat.

If you do have access to the side of the ice, you will want to get tight shots of the players at directly across the ice at body/eye level, or perhaps slightly up. You won't be able to move easily around the ice rink so you'll need to use your zoom lens capabilities quite a bit. If you have more than one camera, you can also have them set to different focal lengths or, in the case of SLRs, have different lenses so you can get various shots. You'll need to change lenses or have multiple cameras to shift from images down or across the ice to ones close by.

From the stands, you will need to be above the level where the Plexiglas obstructs your view; if you can't do that, do whatever you can to prevent reflections from distorting your images. You'll want to use a telephoto setting in most cases, although you may have to limit how far you zoom out in order to have the optimal aperture opening.

Let's Not Forget Ice Skating . . .

While not that much different from ice hockey, shooting ice skating is somewhat easier if only because you're not trying to track a nearly invisible, high-speed puck and there aren't entire teams of players on the ice. However, the sport is still high speed and you will need to carefully monitor your focus and determine if you are going to (or are able to) focus manually, automatically, or by using automatic tracking. You might try using a slightly longer-than-usual exposure — such as 1/30 — to get an interesting blur effect if the ice skater is doing a pirouette or similar move, for artistic effect.

Another factor to consider with ice skating, if it's higher-level skating, is that the skater will be illuminated by one or more spotlights, some of them colored with gel filters. You will want to shoot with an exposure set for the skater — don't let your camera set itself automatically — and you'll need to check your shots at the beginning of the event to ensure you're getting the images. If you can expose properly for the skater, even though your naked eye can see the surrounding stands and spectators, they probably won't be visible in your shots.

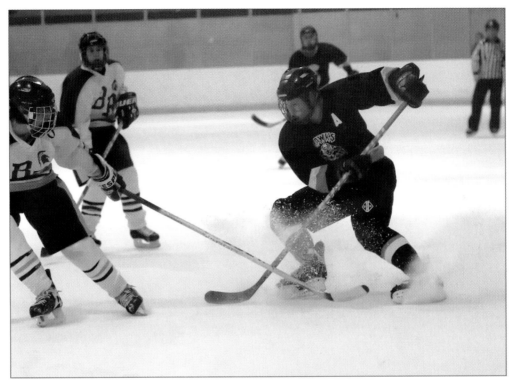

© *Joy Absalon*

Figure 6-9: Pro photographers have access to the ice and to positioning that allows them to avoid having to take photos through Plexiglas.

Tip If you have a newer point-and-shoot camera that has a decently high megapixel capability, you may be able to use the larger images to get better shots; here's how: Instead of shooting at your maximum telephoto setting in a lower-light venue, take your photos at about one-third the telephoto range. This means you'll have a photo of more of the ice and players than you really want, but you'll be able to shoot at a better, wider aperture. If you shoot at your camera's highest megapixel capability, then later on when you're doing your image editing, you can crop the photo. If you shoot at a smaller megapixel level, you might end up cropping a photo that is too small to print effectively.

Settings and getting the shots

In ice hockey, there is a significant issue with white-balance; not only must you consider the lighting in the venue, but you also have to take into account the same factor as with snow: a large, white surface. If you simply take a photo of the bare ice with nothing on it, and you leave your camera at an automatic white-balance, it will render the ice a gray tone. As with the snow, override this by turning off your camera's automatic white-balance; try a preset for the specific kind of lighting in the venue (for example, the light bulb, or tungsten, setting may be a good place to start).

The most important factor in your settings is to ensure your camera is properly capturing skin tones and uniform colors; if the ice is a bit off-color, better it than the player. Also, ice in a hockey rink isn't going to have quite the same pristine whiteness you expect in a photo of a ski slope. Getting the puck, the players' faces, the uniforms, and also the ice exposed well — as in Figure 6-10 — is challenging even for high-end cameras.

© Joy Absalon

Figure 6-10: Shooting ice hockey involves making sure your exposure is set properly for the players first and the ice second.

Because of the relatively limited access you will have to shooting the players, you're going to have to adapt your camera's focal and exposure settings to accommodate your lack of mobility. Hockey is a fast-action sport, and you want to emphasize higher shutter speeds if at all possible on your camera — so the trade-off, as is so common for indoor sports, will be your ISO. Even at your camera's widest aperture setting, you may get images that are just too dark if you're shooting at a shutter speed of 1/500 or faster. So you'll have to bump up your ISO to a more sensitive setting; for cameras capable of it, this might mean shooting at ISO800, 1200, or 1600. While the images will have more digital noise, it's better than blurred players.

Tip Digital noise that comes from shooting at high ISO settings (1200, 1600, 3200) can be somewhat improved by using noise-reduction tools in various software packages. Adobe Photoshop CS2 has some sophisticated tools for noise reduction that you can selectively apply to images. Additionally, there are software packages that run as plug-ins to Photoshop and Photoshop Elements — Dfine is one that I use — that will reduce and, in some cases, virtually eliminate digital noise.

Because high school and other minor league and nonprofessional hockey games may be played in smaller venues, they often have lighting that's more conducive to being photographed with a camera normally challenged in darker conditions. For example, many of these games take place at commercial ice arenas where the lights are turned on all the way, and the illumination is more like a large gymnasium with sodium or mercury-vapor lighting. However, you'll still want to adjust your white-balance settings to account for the white ice and the players, but the white-balance will probably be different than in a professional sports arena where the ice is spotlighted.

Wrestling

Shooting wrestling is about getting the action, but it's even more about getting dramatic face shots of wrestlers pinned down, exerting themselves, and in a state of extreme physical endurance.

The area where the athletes wrestle is contained to a relatively small area, meaning you don't have to worry so much about covering the large space you do in full-arena sports like basketball or ice hockey. Instead, focus on the space inside the ring, in which you can often move around relatively freely.

Positioning

Some of the best shots of wrestling are from floor level, which means you may need to lie down and shoot straight across the floor with a midlevel telephoto setting. At the very least, you want to shoot while sitting on the floor to get an athlete's-eye view of the action, as in Figure 6-11.

There are distinct stages during a wrestling match. It normally begins with the athletes standing. At this stage, getting the takedown is a good image to capture and rarely results in anything but a good action move where both athletes are working hard at their game. You can use the same positioning with this shot — sitting on the floor — or you can shoot it from the stands if necessary. Generally speaking, however, it's better to try and avoid shooting down onto the wrestlers if at all possible; one or two shots from the stands won't hurt, but your perspective from floor level will have much more impact.

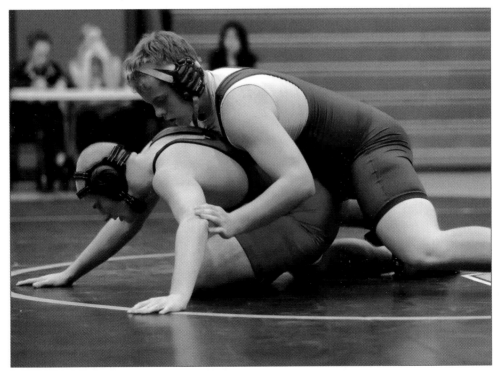

© *Joy Absalon*

Figure 6-11: A very narrow depth-of-field wrestling image (shot at f/1.8) taken at the eye level of the competitors. The image was taken at ISO1600 to be able to stop the action.

Settings and getting the shots

You'll probably want to shoot at a higher ISO setting, if not the highest that your camera features, in order to get some nice narrow depth-of-field images where the action is crisp. You can probably shoot at 1/250 but 1/500 or faster will stop the action much better.

In addition, you may want to experiment with a few intentionally blurred shots at lower shutter speeds — say 1/15 or slower — when the wrestlers are actively engaged and moving (not just when they're holding steady and trying to pin one another). While you shouldn't set all of your shots this way, a blurred image can have some interesting artistic effect, and you can play with it in Photoshop elements later by adding some cutout and/or poster-edge filters; this will work well with a blurry image.

To set your camera for the slower action, select your shutter-speed priority feature and set it to the slower speed. Still keep a high ISO, however, unless the image is much too overexposed after trying it and reviewing the image in your camera's LCD. Figure 6-12, for example, while an action shot, didn't require a very fast shutter speed.

When shooting at floor level, use your telephoto lens or focal length (for a fixed-lens point-and-shoot) to get close to the action. You want the image to appear as if you were only a foot or two away from the wrestlers. And, once again, you'll want your ISO as high as possible.

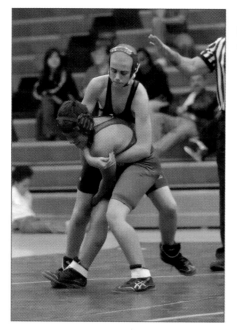

© Joy Absalon

Figure 6-12: These wrestlers are locked in combat as each tries to take the other down.

Watch for good color reproduction in your athletes' faces; this adds to the effect of them exerting themselves. Wrestling is a colorful sport with bright, fitted uniforms emphasized by the often lean, muscular builds of the competitors; you want to capture this aspect of it and use it to photographic advantage as much as possible.

Shooting Boxing

Boxing is a growing sport, but still relatively limited in broad-scale interest other than the big-venue, high-level events. At those events, use of cameras is often restricted and limited to professional photographers and journalists. When you do have the chance to shoot boxing, however, it's a sport where the very limits of human endurance and effort can be captured photographically.

If you get the chance to shoot boxing, work to get tight shots from a low-to-high perspective. Obviously, the best shots are when a punch arrives on an opponent's face; if you can get a shot like this, they are the ultimate in stop-action shots. To do so requires a fast, long lens and shooting at a shutter speed of 1/800 second and preferably faster.

Gymnastics

Shooting gymnastics is like photographing a three-ring circus: There's much from which to choose, and you can get a wide perspective of the entire event with all of its complexity and excitement, or you can choose to focus on a single event and aspect of it. This is another fast-action sport, and when shot indoors requires hard work to get the right settings on your camera to achieve the best possible image reproduction of the event.

Most commonly, gymnastics events are broadly lit with lighting that's relatively even throughout the venue. If you can get a good setting that stops the action, you should be able to use it with only minor variation for nearly every event. (You definitely don't want to use a flash in this sport; it can be quite dangerous to the competitors.)

Positioning

You may or may not have freedom to move about in a gymnastics event. For larger, higher-level competitions, credentials are often required to be on the floor. There is too much going on to chance having someone unfamiliar with the layout and/or the sport get in the way of an athlete at a critical moment; it can be distracting and even dangerous. However, for lower-level events, you may be permitted to be on the floor, and if you are, you need to be highly aware of what's going on and at all costs do not get in the way of any event, athlete, or official. Figures 6-13 and 6-14 were shot from the floor at an exhibition. They required an ISO1600 setting to be properly exposed.

If you are on the floor, be sure you avoid getting in the way of the judges observing the athlete; however, they often have the best view in the house, so whatever you can do to be at a similar vantage point is often the surest way of being in the best position. For floor exercises, get a seat alongside the floor space but don't get so close that you constantly need to make dramatic focal-length changes; standing or sitting back just a bit, as long as it's unobstructed, is better than being right at the edge.

For more non-floor events, such as rings, balance beam, vault, parallel bars, and uneven parallel bars, the best perspective is shooting up from a lower position. It makes the athlete look higher, the moves more perilous, and the action more dramatic than if you are at their level. However, from the stands you may be limited; if so, try to get a tight telephoto shot that emphasizes the athletes' faces and bodies as they exert themselves.

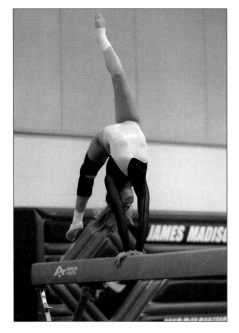

© *Joy Absalon*

Figure 6-13: This balance beam photo works because of the perspective from which it was taken.

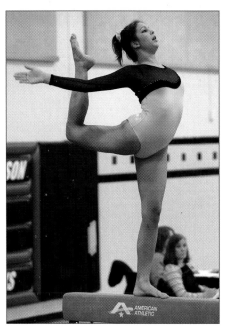

© *Joy Absalon*

Figure 6-14: When shooting gymnastics, it's often tough to avoid background clutter. In these cases, it's especially important to be shooting narrow depth of field.

Settings and getting the shots

From the floor, you can shoot with a midrange setting from 50mm to 120mm; a wide-angle shot is sometimes effective, as well, if you're up close to an event (but don't get too close).

For the vault, rings, and other events where the athlete is moving in a relatively small area, you can set your focus manually and, for the most part, not have to worry about it. If you decide to close in tightly on the athlete's face or another part, such as hands or flexed muscles, then remember you'll probably need to bump up your ISO or drop your shutter speed to ensure your exposure is on target.

For floor exercises, athletes will be using a wider area for their performances; as a result, you'll need to vary your focal length accordingly and you should program your settings for more of a high-speed event. To get a gymnast in a midair flip or somersault, set your camera to at least 1/500 if you want to catch him or her in a stop-action shot. You may have trouble with a point-and-shoot camera if you try to auto-focus and catch the gymnast in an action move; you are better off setting the focus manually and finding a spot where you think the athlete will pass and trying to get it that way or by focusing on a single spot at the start of finish. Sometimes the shots where athletes throw their hands in the air as a signal of a victorious finish is worth as much as an action shot — especially if the action shot is going to be a poor exposure.

Stop-action gymnastics images require different positioning and settings for a balance beam (where the athlete is in a relatively small area) versus a floor exercise, where she may be virtually anywhere in a large area, as demonstrated in Figures 6-15 and 6-16.

If you're limited in your access to the floor, you'll need to shoot in telephoto mode to get the best shots; there's simply too much going on in a gymnastics meet to be able to get much out of a wide shot. That said, if it's too dark, then, as with hockey, you may want to have your camera set to its highest megapixel setting, take a wider shot that lets you have a reasonable shutter speed for action, and then crop it down later in your studio.

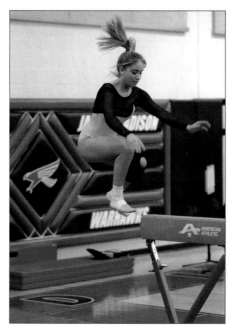

© Joy Absalon

Figure 6-15: You can predict where to shoot a stop-action shot on the balance beam if you know the side where the gymnast will dismount. This allows you to preset a manual focus ahead of time.

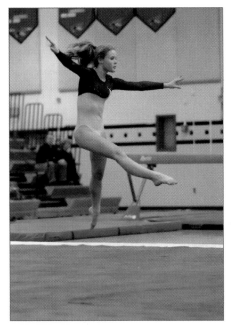

Figure 6-16: Floor exercises are more difficult when it comes to capturing stop-action images because you may not know where the gymnast will be executing his or her moves and the floor space is large.

Fencing

Because fencing is so close to my heart and it's what I spend most of my photographic time shooting (I'm a competitor in it, as well), it's hard for me to only spend a minimal amount of space writing about how to shoot the sport. However, I realize that there are some sports photographers — amateur, enthusiast, semiprofessional, and professional — who may never shoot a fencing bout.

Fencing, as mentioned elsewhere in this book, is a tough sport to shoot; the action is fast, the lighting is bad, and no flashes are allowed. Added to that, it's a sport where you cannot see the athletes' faces until their competition is finished (although this is changing somewhat now with clear face masks), so your ability to personalize your images of the fencers is also limited.

To effectively shoot fencing, you have to first understand the sport and the three different types of weapons — epee, saber, and foil — and how they are fenced because it is quite different. Epee is more slow and methodical, punctuated by fast moves; saber, on the other hand, happens very quickly and each encounter is over in an instant. High-level, championship fencing finals are fenced typically with bright overhead light and a darkened background and audience; however, the preliminaries as well as most other tournaments take place in standard venue/gymnasium lighting.

Note To see the variety of venues and lighting, take a look at the many shots from all over the world on my Web site, www.FencingPhotos.com.

Positioning

Most large fencing tournaments restrict photographers without credentials from being very close to the fencing strip; the referee moves up and down the piste (fencing strip), there are electrical cables every-

where to stumble over, and generally speaking being too close to fencers and shooting — even without a flash — can be distracting to them (or, worse yet, to their parents or coaches). It's been said that, second only to shooting, fencing is the fastest Olympic sport.

Most photographers who first try to shoot fencing attempt to do so from a 90-degree, perpendicular angle to the fencing strip. This is perhaps the most difficult and limiting spot from which to shoot the sport, and the likelihood of getting good shots is low. The best position, I've found, is to be about one-third to one-quarter from the end of either side of the fencing strip, and about 25 to 30 feet away; this provides optimal focal range for narrow depth-of-field shots so that you don't have to be constantly changing your focus.

Another reason to be at the position just described is that the referee may very well be in between you and the fencers as he or she moves back and forth — and often is in the way just at the wrong time during a great move. From the other side, if you are opposing the referee, you may have to deal with scoring equipment between you and the fencers. Figure 6-17, a stop-action shot from Athens 2004, is a dramatically athletic move by Russian fencing champion Tatiana Logounova.

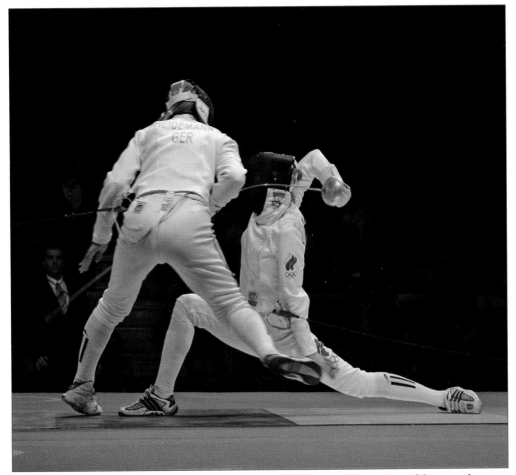

Figure 6-17: This move by Russia's Tatiana Logounova (right) never fails to astound fencers who see the image.

If you're in the stands watching a large fencing match, you will need a telephoto lens, or if you have a point-and-shoot camera, a telephoto setting and a high-enough ISO level that enables you to get the fencers in motion. From the stands, being at the angled position from the centerline is less important; the farther you are from the strip, the more you'll be able to simply pan your camera back and forth to get good perspectives.

Another interesting position is to be directly at the end of the strip, where you can get a shot of the fencer from the perspective of his or her opponent. This can be a really tough shot, however, because you must constantly change your focus setting to get the shots.

Settings and getting the shots

There are key moments in a fencing match that are good to capture: The salute by the fencers to each other and the referee at the beginning of the bout; big actions where the fencer is *fleching* or making another large, long attack; in-fighting, where the fencers are contorted at close range; and at the end of the match when they tear off their masks in victory or defeat. There are other moments and points, but these are important ones that typically take place in almost every bout.

When I shoot fencing, I most often use a 70–200mm zoom lens, and I shoot almost all action at f/2.8 and a shutter speed of at least 1/500. My ISO varies, of course, in order to do this, given the changing light in the different venues. The settings have to change during various non-action points during the bout; for example, I lower my shutter speed to 1/125 or 1/250 when the fencers take their one-minute breaks because they then take off their masks and I can get a good exposure of their faces, as well as their coaches.

Because the fencing world is slowly changing to clear face masks, the need to get good images of faces through the masks is increasingly important; this change has been driven largely by the International Fencing Federation's interest in having TV cameras and still photography personalize the sport to a greater degree. Figure 6-18 is an image of U.S. saber fencer and Olympic gold medalist Mariel Zagunis, taken in Athens at the 2004 Olympics. It highlights the value of clear masks.

Figure 6-18: The introduction of clear masks is helping to personalize fencing.

For shooting at local and regional fencing tournaments, using a point-and-shoot camera requires you to shoot at its maximum ISO setting and widest aperture in order to be able to have as fast a shutter speed as possible without the image being too dark. It's better, also, to even shoot a little dark if you have to and then to lighten the photo later in Photoshop Elements or another image-editing package in order to get the shots. Fencing is so fast that even when I shoot at 1/500 second, I occasionally am unable to stop a fencing blade in motion.

Unless you can change your camera's settings very quickly, optimally you might want to have two cameras: one set for action, the other for people's faces. Barring that, usually you can take an automatic shot — including using the flash — when the fencers finish their bout and remove their masks (as long as it doesn't interfere with other fencing going on around you). To do this, you can shoot manually during the fencing bout and then, at the end, quickly change your camera to the automatic setting (for many cameras, this is done only by turning the wheel at the top of the camera from M (manual) to P (or whatever the automatic symbol may be for your camera). To get the shot of the Ukrainian fencing champion in Figure 6-19, I changed my camera settings to get a good exposure showing her face and details of her teammates instead of settings for high-speed action in white uniforms.

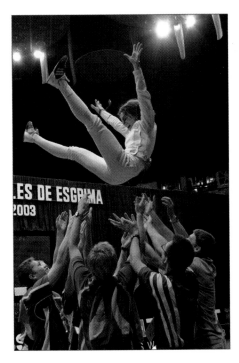

Figure 6-19: To take good shots of fencing champions being tossed in the air immediately after winning, the settings on my camera have to be changed quickly from where they were set only moments before to shoot competition.

Summary

Indoor sports are tough to shoot because the lighting can be so varied and limited that it's challenging for most cameras to capture high-speed action without being pushed to the maximum capabilities of aperture and ISO. You'll need to practice your photography and learn how to effectively shoot stop-action images up close and from far away, depending on the types of sports you're shooting and the access that you have.

When shooting indoors, be cognizant of officials, spectators, athletes, sports equipment, and other factors that can get in your way — or vice versa. Moving around venues may be limited, as well, so how you position yourself is an essential part of getting the best shots.

Whether you're in a giant indoor stadium or at the local gym, indoor shooting can also be easier than outdoors because you don't have to deal with weather, and very often once you do get your camera settings right, you're set for all the shooting you'll do from that location. However, you'll also need to know what you might be able to do after the event in the digital studio, such as cropping bigger megapixel images that you take in order to get more light into your camera to allow you to take better action shots.

✦　　✦　　✦

7 Extreme and Adventure Sports

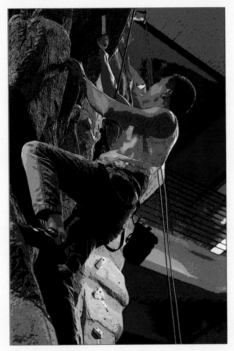

© Amy Alden Timacheff

In the last decade there has been an explosion in new extreme and adventure sports, ranging from bungee jumping to average citizens climbing Mount Everest. And wherever these ordinary people are attempting extraordinary sports, digital cameras are sure to come along for the ride. With the large-print capabilities of small point-and-shoot cameras, the huge array of products made to protect and carry them, and the ability to display images display online — even from the top of the world — you won't find a Himalayan expedition or a sky-diving day trip without at least one camera packed.

Of course, the list of these types of sports is growing daily, with new adventures being concocted by adventure seekers who have done and seen it all. And virtually everyone wants to document the event on video and/or in photos. This chapter covers several of these sports — some on the ground, some in the air — to give you some good ideas and advice as to how you can effectively and safely capture great photos of them, whether you're an observer or a participant.

Equipment

Unless you're able to watch an adventure sport from a safe, accessible location, you'll most likely pack your photo gear with you. For sports such as rock climbing, hang gliding, paragliding, backpacking, sky diving, and back-country skiing, in addition to carrying your gear, you'll need to ensure you can store images and change camera components safely and quickly without needlessly exposing open cameras and lenses to the elements. For long-term journeys, such as backpacking or ski trips, you'll also need to be sure you have sufficient power to keep your equipment running.

Several companies today make excellent, highly rugged gear suitable for nearly any situation you may encounter. Tamrac, Tenba, and LowePro are three fine manufacturers (there are several others) of packs made for carrying all sorts of camera gear, ranging from a small point-and-shoot to large packs with plenty of room for extra lenses, camera bodies, and even large laptop computers.

If you're carrying other gear on your back, such as for a backpacking trip, you may be limited in the amount of equipment you can take on a longer trip and still be able to travel comfortably. In those cases, prioritize the equipment you carry. For longer trips, power is king: If you run out of battery power, you can't take any more photos — plain and simple. If you use a point-and-shoot camera that is powered by standard alkaline batteries, such as AA or AAA size, you can carry extras, but other cameras and larger SLRs run on batteries that must be recharged with a power source; in this case, for long trips, you'll want to have several extra batteries along. Even extra batteries, however, can lose some power over time— especially in cold weather.

Whenever possible, I take an extra camera on a long trip just in case something happens to my primary camera or if I run into battery problems. Even if you shoot with an SLR, if it runs out of batteries before you expect it to, you may be very glad to have a small point-and-shoot backup on hand to catch a few shots you otherwise might have missed.

In addition to your camera, you'll also probably need to think about power for any storage device or laptop you may bring along. Once again, a device capable of using common batteries is preferable for long trips where you can't recharge. I generally guide people away from taking laptops on long backcountry trips because they are fragile, heavy, and suffer from limited battery life. If you can resist looking at your photos until you get home, other than on your camera's LCD, use a portable hard drive for downloads — or take enough flash cards to store all of your images.

Go Solar!

One option for keeping power going on long trips where power's not available is to use a solar-powered battery charger. These are remarkably inexpensive (most are under $100) and are used by high-altitude and rock climbers, sailors, backpackers, and other adventurers who expose their gear to long trips and energy-eating weather conditions. Creative Energy Technologies (www.cetsolar.com) is one source for these chargers, which are quite compact and durable; you can get them in a variety of sizes and capabilities to recharge various types of batteries such as 9-volt, AA, AAA, B, C, and D sizes as well as for many other devices. Charge time will vary depending on how much sunlight you have, and it's slow compared with charging a battery from an AC power source. For example, charging two AA batteries may take as much as three to four hours, much longer than the 15 to 30 minutes it takes with a good AC charger.

Tip Want to determine how many batteries you'll need for a long trip? Consult your camera manufacturer's Web site or your manual to check how many photos one set of charged batteries can shoot. If it's not specified, contact the manufacturer directly. Then you can estimate the number of photos you'll shoot in a day and carry about 20 percent more battery power than your estimate. Also, remember that using your flash and your LCD will decrease your battery time.

A final note about digital cameras and batteries: For longer trips, do whatever you can to limit your camera's power consumption. Many cameras, for example, can run either without displaying images on the LCD (which uses power) immediately after they are shot, or the amount of time the images are displayed automatically can be reduced to the shortest possible time. You can also select, on some cameras, how quickly your camera automatically shuts down after not being used; you should set this to as short a time as possible as well. Also, remember that if you review images on the LCD, you're using battery time, so try to resist looking at your shots until you get back to civilization.

If you put your camera gear into a pack used for other equipment, you need to ensure it is protected yet accessible. Unless the weather is especially cold, and when I'm not traveling with a dedicated camera pack, I wrap my cameras and equipment in thin sheets of closed-cell foam that I hold together with strong rubber bands or small bungee cords; I then place these into waterproof bags (the heavy-duty zippered or press-and-seal bags work well); if it's going to be an especially wet trip, I use waterproof bags designed for kayaking, which are available from REI, Eastern Mountain Sports, and other outdoor equipment specialists. If the weather is exceptionally cold, I do basically the same thing except that I keep my gear a bit deeper in the pack and closer to my body; it's less accessible, but it takes much longer for the cold to penetrate and consequently preserves battery life.

Before your trek, format all of your flash cards so you won't have to bother doing it later when you're in the backcountry or in the air. Keep flash cards in a safe, waterproof case where you know that they will be protected from any harm whether it be from the elements or just from being squashed in a full pack. I use small pelican-style, waterproof cases. Inside the cases, if you are keeping all of your images on the cards and not downloading them, make sure you have a method for knowing which flash cards have been used and which have not. Some people use two cases (one for used cards, one for fresh); others store spent cards in a small bag inside the case. Whatever your method, do whatever you need to in order to prevent having to put a used card back into your camera to check it (which reduces battery life).

If you're going to be hang gliding or paragliding, you will need to secure your pack to an accessible point on the harness or on the front of you where you it can easily be reached. Placing it on your back obviously won't work. Furthermore, you may want to attach cameras and other equipment with a light lanyard to a secure point on the pack, such as to a D-ring or carrying strap. Providing you don't have too much equipment, even if you accidentally drop something, it will still be relatively safe. Of course, this won't work as well for lenses or other SLR components; however, I don't suggest that you change lenses while in the air unless it's absolutely necessary. It's a better idea to carry two cameras with different lenses instead.

Another equipment factor to consider with extreme and adventure photography is that you will need and want to protect your lenses with great care. Use lens caps on all of them, along with haze or skylight filters. Having a lens-cap keeper is a good idea; these consist of an elastic strap that goes around your lens with a small cord that connects to the outside of the lens cap with a small adhesive cap. Of course, if you are sky diving, removing and replacing a lens cap isn't really practical; then, you'll simply need to have the lens exposed, but consider a filter — it will be good protection and still let you shoot.

Depending on the type of adventure you're on, you may or may not want to have a camera strap. Sometimes a simple handgrip is sufficient for holding your camera safely, but if there's any chance of dropping the camera, then use the strap. There are also some camera restraint systems that allow you to attach the camera to the front of your body using an elastic harness that has a special release to allow you to remove the camera to take photos and bring it up to your face while it is still attached. These are useful for some aerial sports and for hiking or skiing; however, you need to be sure the camera is protected if you were to trip and fall on a trail or ski slope.

Hang Gliding and Paragliding

These sports present incredible photography opportunities regardless of whether you are in the air or on the ground. And, they are slow enough that when you are in the air, you can take the time to actually get your equipment out safely, frame some great shots, and take decent photos (as opposed to sky diving, for example, where photography is much more difficult).

Note Instead of shooting from the ground, which isn't necessarily much of a technical challenge, I'm focusing this section on how you can actually take photos from the air — of yourself and others in the sky with you.

Positioning

Generally speaking, when shooting from the air, paragliding is easier than hang gliding for taking photos. Because you're sitting in a harness, you can attach equipment before you take off in such a manner that it's reasonably accessible. With hang gliding and other sports where your body is in a more awkward position for accessing and taking photos, it will take some forethought and practice to be able to effectively get to your gear and use it. Photography in any sport, paragliding included, where your space is tight, access is limited, and dropping equipment is disastrous requires some thinking and practice to become proficient at shooting. While you may be accustomed to whipping out your camera and shooting quick shots in other sports, in these situations it's not so simple.

Interview: Marc Chirico

As part of writing this book, I visited Seattle Paragliding to get some photos and tips about shooting in the air. Located on the side of Tiger Mountain, on Seattle's East side and very close to my home, on any nice day I see 10, 20, and even as many as 50 paragliders soaring above the mountain. Catching the thermals spiraling as high as they can for as long as possible, on clear days they get breathtaking views of Mount Rainier. Marc Chirico, the owner of Seattle Paragliding and veteran paraglider, has seen many years of exciting paragliding action and has a good personal perspective of what makes for good photography of paragliding — whether it's done by professionals or amateurs.

At the training facility, which is located in the top floor of an old barn, we sat in paragliding harnesses suspended from the ceiling to talk about how the sport can be photographed.

What advice would you give about choosing position?

Try to get good action sequences on launch, and get the whole picture of the glider, pilot, and detail of the situation. However, I also like to key in on the pilot and his or her relationship to the ground; when people shoot they tend to get back too much and try to only get the entire thing, and they end up losing the personal moment as the pilot breaks free of the Earth.

© Marc Chirico
A self-portrait of Marc Chirico, taken at 5,600 feet with his camera on the end of a pole

What kind of equipment do you prefer?

When taking passengers with equipment in a moving sport like paragliding, I don't think you normally have the stability for long-lens shots. Wide-angle shots are much better, typically. We push more for family-style digital shots with auto-focus or the focus set on infinity. I also like using a camera on a 6-foot pole with remote or timed activation to get a shot of a body in the abyss or myself flying.

What about getting the shots?

Try to take advantage of the terrain and the light. The first shot that comes to mind is when the sun is in your face (not above) and you get a silhouette at the 'golden hour.'

I also like 'perspective' shots taken with relation to topography and/or meteorological conditions. When taking a shot, even when handheld, it's nice to show it against a vertical rock face to show contrast and the frailty of the human body against something exposed. I like high-held shots with nothing underneath, and also cloud shots where you have a crisp blue sky against a sun-side cumulous. Another favorite is when there's high contrast, such as between an oppressively dark cloud with a bright ray of sunshine shining through.

Consequently, safety and accessibility are the two essential factors you'll need to add to your mix of steps to good digital photography if you intend to shoot while soaring above the Earth.

Taking photos of hang gliders and paragliders from the ground can yield some spectacular shots, whether they're taking off, aloft, or landing. Figures 7-1 and 7-2 are two such shots, one of the paraglider in flight and the other of one landing. In Figure 7-3, you can see a smaller-sized, lower-resolution snapshot of a tandem flight coming in for a hard landing.

When shooting from the ground, use your telephoto lens and position yourself so that you can get shots with features such as a mountaintop, cloud, or trees in the image to add perspective. You can get shots of gliders by themselves, such as in Figure 7-2, but these should not be the only images you shoot. Try to include the gliders with other gliders, and include as much perspective as you can.

If you're shooting from the air, your perspective and position may be limited to where you're flying. A tandem flight where someone else is operating the glider is optimal for shooting because you don't have to worry about flying; instead you can concentrate on photography. However, if you're flying as well as trying to shoot photos, do as much preparation work as you can to ensure your access to equipment is even easier.

Watch for good positions where you can get other gliders in flight with a nice background whenever possible. Photos that make it appear that another glider is close to the trees or a cliff always add drama and interest to the photo — even if it's an illusion caused by your telephoto lens.

Figure 7-1: This photo of the paraglider aloft is a nice perspective, looking straight up. The emphasis of exposure on this shot is more on the canopy than the pilot.

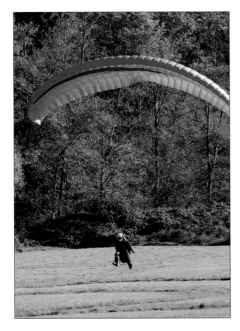

© *Marc Chirico*

Figure 7-2: Landing shots, when they show both canopy and pilot, should be exposed so that neither is over- or underexposed. Unlike shots where you're trying to really show the entire glider aloft, shots such as this can be a bit tighter; you don't have to worry if the entire canopy isn't in the photo.

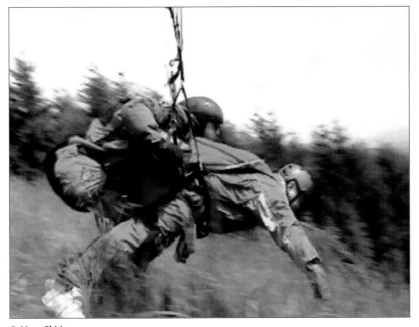

© *Marc Chirico*

Figure 7-3: This is a lower-resolution still image captured from a video. While a snapshot, it's a fun photo with motion and energy.

Settings and getting the shots

When taking shots from the ground, be sure you expose the images for the glider and not the sky or background. An alternative would be if you wanted to silhouette a glider against a bright background such as a cloud or near-direct sunlight. To do that, set your camera on a very fast shutter speed, such as 1/2500 or faster if your camera features speeds that high.

To get photos of pilots landing or taking off, you'll want to be set for stop-action photos by using a manual focus to ensure your camera is running as fast as possible. For cameras with shutter lag, make sure you time your shot so that you depress the shutter button before the "moment of truth" when the pilot lands or releases from Earth; this takes a bit of practice and, undoubtedly, you'll miss a few shots before you get your timing right.

Don't be too anxious to shoot tight shots at first; focus on getting your timing down and a well-focused image before closing in on a pilot's face. Set your exposure on someone standing at or near the landing zone or takeoff point, and make sure you're on manual mode for all settings — shutter speed, aperture, ISO, and focus — to have your camera operating as fast as possible. You may be able to use the flash, as well (this is especially useful if there's any backlighting that might cause problems); however, double-check with whomever is responsible for the landing or takeoff operation to be sure he or she doesn't mind the flash being used.

When in-flight, to get a good exposure of a glider, you should not rely on your camera to do it automatically. It tends to expose for the entire scene, which may be very much brighter than the exposure you'll want to have to get a good view of the pilot and possibly the canopy. If you have the ability and time while aloft, take some experimental shots and then make adjustments accordingly; however, to begin with, set your camera before you take off by taking shots in as similar a light as you can to what you think it will be while flying.

Silhouette Shooting

Here's some general steps you can follow to get a good silhouette shot:

1. **Set your camera ISO to a lower sensitivity, such as ISO 100 or ISO 200.** This limits the amount of digital noise in such a bright photo.

2. **Try taking an automatic setting just shooting at the brightness.** Check your LCD and read the information about the shot; see what settings your camera "chose" for the image.

3. **Set the aperture (f-stop) and shutter speed manually to the numbers from your automatic shot.** Chances are, you'll want your camera on its fastest shutter speed, whatever that is.

4. **Using the settings from step 3, shoot your subject against a bright background, such as a bright light, cloud, or the sun.**

5. **Check the image and make adjustments.** If the subject is too visible (not enough of a silhouette effect) and the background is too dark, try making the shutter speed faster or making your f-stop higher. If the image is too dark overall, open your f-stop a bit (make it a lower number).

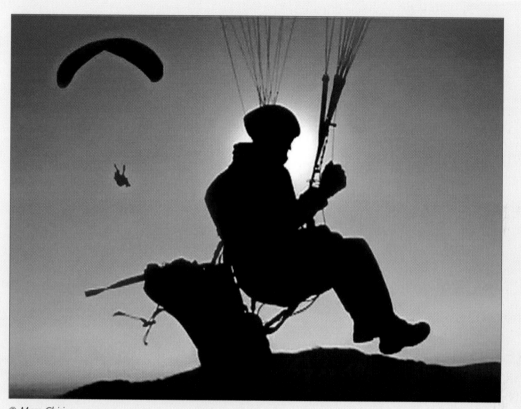

© *Marc Chirico*

A silhouette of a paraglider with the sun low in the sky.

High-contrast images with a glider against a sky or cloud are often excellent candidates for playing with artistic effects in image editing packages, such as seen in Figure 7-4.

As Marc Chirico points out, shooting with a telephoto setting probably isn't very useful when flying unless you're trying to get a shot of something on the ground. Plus, in this mode, your camera and your shots are more susceptible to motion and, unless you're set for very fast shots, you may end up with blurry images. If your camera has an image stabilization feature, it's a good idea to use it when you're flying no matter what settings you use.

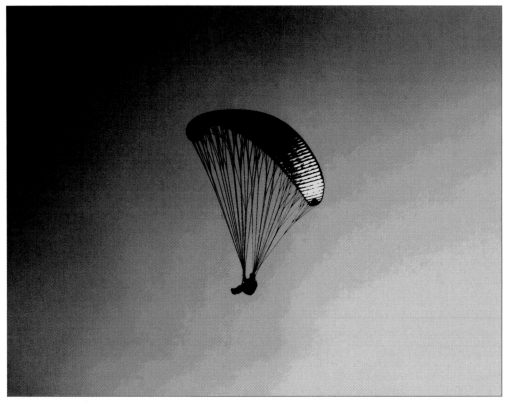

Figure 7-4: In Photoshop Elements, I used the Poster Edges filter with some adjustment to color balance to achieve this effect on a photo of a paraglider.

Skydiving and Parasailing

Skydiving has ascended to new heights in recent years — meaning not just altitude, but in the antics and flying tricks people are attempting. Today, skydivers are jumping out of planes not just with parachutes, but also with snowboards, surfboards, skis, boogie boards, and other sporting goods that provide any type of surface conducive to "surfing" the sky.

As with paragliding and hang gliding, this section addresses how to shoot skydiving from the air. Photographing this sport as a participant, as you can imagine, isn't easy. Not only do you have to use a camera while plummeting to Earth at breakneck speed, you have to operate it in a rushing wind while looking through a pair of goggles.

Parasailing isn't as commonly shot from the air, but, more typically, as an observer. Also, it's a much more common type of parachute sport. As a result, it's also photographed more often than skydiving — and it's relatively easy to take shots of a parasailer if you're on the towboat. Shooting from a parasail isn't as simple a proposition, however, primarily because you're typically launched from and land in (or too dangerously close to) the water to be carrying a digital camera that's not waterproof.

Positioning

If you're skydiving, you'll need to protect your equipment because of the speed and wind factors. If you're shooting other skydivers, you will want to jump behind them and slow your fall some, taking shots of them with a wide to medium lens setting (telephoto is really tough). If your camera has a multi-shot setting, use it and take as many photos as you can without maxing out the buffer. Another angle is for you to jump ahead of the other skydivers and shoot them coming toward you either at the same rate of speed as you or a bit faster.

Caution Sky diving as well as other flying or sky sports can be extremely hazardous without proper training and experience. Be sure to obtain proper training, and gain substantial experience aloft before attempting to try a secondary activity, such as photography.

You can also shoot skydiving from inside the airplane by attaching yourself to a harness and leaning out of the plane as the jumpers go off the wing. They fall quickly, however, so you'll only be lucky to get one good shot of them if they've released from the plane.

If you're jumping, once your chute is open, you can get photos of other skydivers more easily, similar to paragliding.

You'll want to use a harness system of some kind that allows you to fix your camera snug against your body, yet enables you to release it to take photos while still attached to the harness. Some pro photographers have devised ingenious camera systems that attach to their helmets and other out-of-the-way places.

Tip For some good shots and information about shooting skydiving, take a look at www.normankent.com, a fascinating Web site about an accomplished sky-diving photographer, stunt man, and cinematographer. His site also features some advice for photography while jumping.

For parasailing, your position may very well be rather limited if you're on the boat. If so, work to document the event: the takeoff, ascension, some good shots aloft, and then the landing. If you've got buildings, mountains, or other objects behind the parasailer, try to get a nice perspective with both in the photos for good contrast.

Settings and getting the shots

For skydiving, it's tough to change your camera's settings once in freefall. Instead, have the camera set ahead of time to a setting based on shooting out of the airplane or from the ground before. You can try an automatic setting, as well, although this can be risky if you expose for a wide shot with your subject only being a relatively small part of the image. As a result, the subject may turn out too dark if the shot automatically adjusts for the surrounding sky. If your camera has the feature, using a spot meter-type setting will help you set it for a specific subject.

As I've said, unless you're a pro with high-end equipment, I don't advise using telephoto settings while skydiving; they're far too difficult to focus, stabilize, and center on a subject. Instead, shoot a midlevel setting at the very most and, in some cases, use a wide setting. If you're using an SLR, using a lens in the range of 24–70mm will be a good choice. Also, SLR telephoto lenses are large and cumbersome, which may be difficult to manage while skydiving.

Obviously, you won't be changing flash cards while skydiving. That means you'll want to use as large a card as possible, and, because you're shooting subjects on a wider setting, you'll want to use a high megapixel shot because you'll probably need to crop the image later (you'll also need to crop because poorly framed and/or centered shots while skydiving are very common).

Remember, also, that you can obtain some spectacular shots from the ground, as well — especially if you're shooting someone coming in for a landing. When doing so, first set your camera for another sky-diver or hang-glider pilot on the ground and be sure you have a good exposure. Then try that exposure on another person as they approach and touchdown at the landing zone.

For parasailing, you'll most often be shooting low to high, most likely from the boat (see Figure 7-5). When doing so, remember that the sky is very often brighter than your subject, meaning backlighting is a risk in getting good shots. You'll want to make sure you have set your camera manually so that it is exposing a person's face and body correctly, not the sky. Inside the boat, there is less light on a person than when he or she is soaring above, so take this into consideration. If you simply set the camera for the person in the boat, it may be a bit too much exposure, so increase your shutter speed by one level and, perhaps, decrease your aperture by one or one-half stops.

A telephoto setting might be used for one or two shots when parasailing; however, a wide perspective of the entire boat with the person behind it in the air is also a very good shot to take.

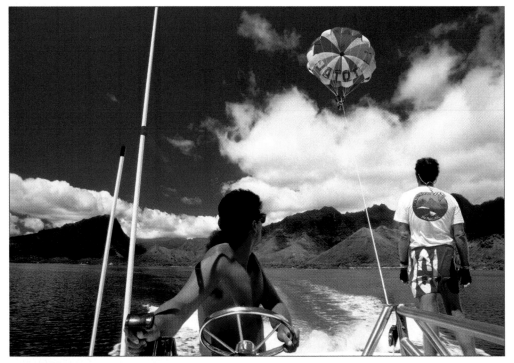

© *Wernher Krutein*

Figure 7-5: Shooting from the towboat and capturing the boat with the parasailer and nice background scenery makes for a well-composed shot, which was taken in Tahiti.

It's Three Shots in One!

Bracketing is a term in photography meaning that your camera actually shoots three images for one with different f-stop settings — one above, one at, and one below your main setting. Some cameras offer automatic bracketing and may even offer the ability to set how many stops (or even half-stops) will be taken above and below your primary setting. For example, if you set your camera to an aperture of f/7.0 and select automatic bracketing, the next three shots you take will be at f/7.0, f/6.3, and f/8.0 (depending on how many stops and half-stops your camera is bracketing). This way, you have three photos at different exposures instead of just one, and you can later select the best exposure you took. If you aren't going to easily be able to change settings, bracketing may help you get the shot you want.

Climbing

Climbing has become a very popular sport, both indoors and outdoors. Many gyms now have climbing walls (see Figure 7-6) that enable climbers of all skill levels to practice inside. Some may even trade perching themselves on treacherous rock faces for these indoor venues permanently. On the other hand, many serious climbers still love to head for the mountains for the challenges of natural rock faces and the thrill of getting to the top.

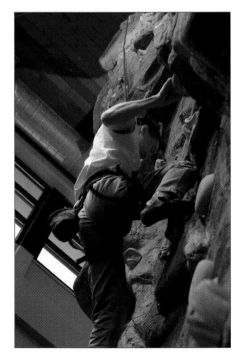

© Amy Alden Timacheff

Figure 7-6: Climbing walls are popping-up in gyms, health clubs, schools, and recreational equipment stores everywhere.

Photographing climbing can be spectacular, capturing athletes in peak condition under tremendous strain — both mental and physical. As with many other adventure and extreme sports, there are two ways to shoot it: while doing it or while watching it. If you're a spectator rather than a participant, your choices are limited to a low-to-high perspective when on the ground below or, if you're at the top of the rock, you can shoot down. When climbing, you are limited by the equipment you can safely carry and your mobility to get a good perspective.

Positioning

Shooting from the ground, try to get more than just straight up from immediately below the climber, although images shot straight up can be cool especially if the climber is in a tough spot, as in Figure 7-7. If possible, get as far to the side as you can and shoot with a good angle to be able to show the person across and up the wall with a narrow depth-of-field shot.

Some indoor facilities will have midlevel and upper decks where you can observe climbers; these also are good spots from which to get good shots. However, remember that getting height is something climbers love to do, so you don't want to just shoot tight shots of them against the wall where you can't tell how high they've ascended. Also, a negative angle, where people attempt to climb up and backwards at the same time (for example, to scale an overhang), which is very difficult, makes for great shots. If you can get to the top of the rock or climbing wall and shoot down at an angle or diagonally, as in Figure 7-8, at a climber coming up the face with a lot of distance between him and the ground, it makes for an exciting image.

© Amy Alden Timacheff

Figure 7-7: A climber negotiating a difficult move at an indoor facility, shot from the ground with a telephoto lens

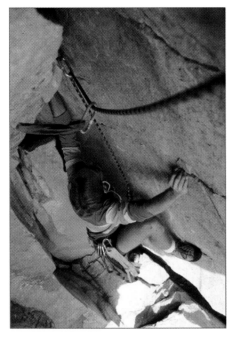

© Harry Haugen

Figure 7-8: Shooting down at a climber from above and from an angle — whether shot from the top of the climb or while climbing it yourself, indoors or out — can be especially dramatic.

Positioning yourself while climbing can be tricky, especially if you're free climbing (meaning you're not using a rope or harness) and have no way to steady yourself other than leaning into the rock face or wrapping your leg around a nearby tree trunk. You want to be in a position where you can access your equipment but you still may have to keep a grip with one hand on the wall. This may actually be easier on some outdoor climbs than on a climbing wall because natural rock faces (with some exceptions, of course) typically offer more spots (including trees and shrubs) where you can stop and rest without holding on with both your hands (see Figure 7-9).

The main thing to bear in mind when shooting climbers is that you want to present a broad set of images that show the various aspects of the ascent: the rock face, the difficulty of various aspects of the climbing, teamwork in belays, coming down if there's a rappel at the end, and so on. For positioning, this means you may have to do more work than some other climbers if you're working to document the climb, or that you may have to take an alternate route up in order to be far enough away to get good shots from above, across, and below the others.

Settings and getting the shots

When shooting from the ground, use a telephoto lens or setting on your camera to get up-close shots of climbers. Additionally, however, shooting wide shots to get full perspectives of climbers high atop a wall is impressive and can even be breathtaking. So, if you are shooting with an SLR and can afford to carry the extra lenses, do.

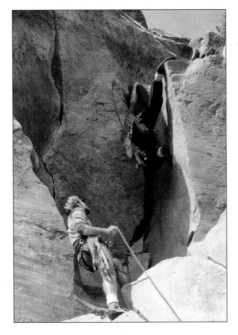

© *Harry Haugen*

Figure 7-9: Natural rock faces sometimes offer spots where you can stop without having to hold on; this can be a good spot from which to take photos of other climbers.

Now, if you are climbing with an SLR, you may want to carefully think about what kinds of shots you want to get. Because if you want both close ups of climbers and wider shots to include the landscape of the rock face, you'll need to carry multiple lenses with you. That will be in addition to everything else you need for the climb. If you are seasoned climber, you know it is best to travel as lightly as possible, and attempt to take only what you'll really need — every additional ounce in a climb makes it tougher. Also, remember that if you're carrying food or drinks in the same pack as your camera gear, you want to be sure nothing can break open and spill or expose your gear to undue humidity.

Carry your equipment as close to your body and attached as firmly as possible. A camera swinging from your shoulder or neck while climbing is not good for you or the camera. Harnesses, such as those made by LowePro and other companies, use soft neoprene straps to secure your camera to your body; however, also think about how the camera is positioned against you in case you are going to be very tight against the rock face or climbing wall.

Tip While chalk is commonly used in climbing to help you grip rock, it's not a very friendly substance for camera gear. If the minute particles get into your camera, they can cause severe problems with moving parts, spots on your CMOS or CCD, or dirt on lenses. When shooting, do whatever you can to prevent the chalk from getting close to your equipment, and try not to open your camera during a climb. While some cameras are more dust and dirt resistant than others, any equipment is subject to harm under these circumstances.

Because natural rock is an abstract form — meaning there are no precisely straight or geometric angles — you can shoot a distorted view such as you get with a fisheye or wide-angle lens and it can really look fantastic. However, if you shoot too close to a person with a very wide-angle lens (for example, 15mm), he or she will look very distorted and not particularly attractive; consequently, you should shoot wide shots with people in them from far enough away that the climbers are in the shot but not taking up more than about one-third to one-fourth of the image (or less).

Point-and-shoot camera quality, megapixel size, and electronics have improved vastly in the past few years, and the photos you can get with them are remarkably high quality. While to get truly commercial or fine art–quality images you will still need an SLR with an array of interchangeable lenses, for the average person, point-and-shoot cameras are a great place to begin shooting digital — especially if it's when you're dangling on the side of a rock face draped with karabiners, a chalk bag, and other hardware and gear as in Figure 7-10. The risks of dropping components, breaking them, and the sheer burden of carrying SLR equipment on a climb is such that your photography standards have to be pro level before you'll want to bother ascending with big gear.

Another factor that helps with photography in precarious positions is that point-and-shoot cameras have, in many cases, nearly full-manual operation — similar to what you find on an SLR — where you can set all of the controls, including shutter speed, aperture, and ISO to get good photos. While they may not have the range of an SLR, and the operation may in some cases be a bit more cumbersome, they nonetheless provide many climbers with all the photography they'll ever need — at a fraction of the weight and risk.

Regardless of whether you're using an SLR or a point-and-shoot, you'll want to shoot in semi-manual or full manual mode. While more tedious to learn and use at first, this will ultimately give you much better image quality and control over your photographs.

When shooting on a rock face in daylight you can disable your automatic flash unless you're shooting into dark spaces where a fill-flash might be useful. Generally speaking, automatic flashes tend to go off a bit too much when they aren't necessarily needed, and flash shots are rarely preferable over a naturally lighted exposure if there's enough ambient light to support it.

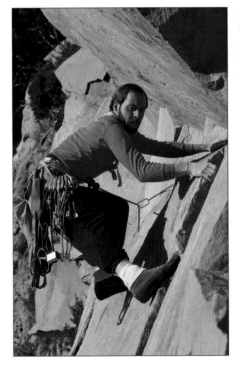

© *Harry Haugen*

Figure 7-10: Climbers carry enough gear that the portability, accessibility, and image quality of a higher-end point-and-shoot camera is perfectly suited to climbing.

When shooting at indoor climbing walls, whether you're on the wall or off, the light may be such that you'll need to use a flash. Some walls, such as the one at REI in Seattle (the largest indoor free-standing rock wall in the world) are surrounded by glass that allows lots of ambient light to get in; however, this isn't always the case. You can set your camera to a high ISO; if your images get sufficient light and the digital noise isn't too bad, that may work for you. Otherwise, using a flash may be necessary (if you can reduce the intensity of your flash — many external flashes offer this capability — it's a good idea because, while you may need some flash, you probably won't need to use it at full power).

Note There are many extreme and adventure sports not covered specifically in this book, and new ones are added daily. Some sports, such as backcountry skiing or scuba diving, could reasonably be included in this chapter but I've put them into other ones for various reasons. Some, such as bungee jumping or ice climbing, while not addressed directly can be shot effectively based on the concepts presented for similar related sports.

Summary

Extreme and adventure sports are all the rage worldwide, whether they involve falling through open space or ascending seemingly impossible objects. However, shooting them can be challenging due to the burden of additional equipment, being able to get a good position, the elements, or the ability to access your gear.

If you're an observer of these sports, you may have the luxury of being able to move around and use more equipment. But, you may be limited in getting good shots of athletes at the peak moments of their pursuit. If you're a participant, then you're going to have to plan carefully not only what you're going to take with you and how you're going to carry it, but also how you are going to set your exposure when there are a lot of other things going on.

Wherever you are, shooting extreme and adventure sports is smorgasbord for photographers — there are so many opportunities and wonderful shots to take you may get more than you know what to do with. And, if you work to understand your camera and make the most of managing exposures and settings yourself, the shots will be that much better.

✦ ✦ ✦

8 Specialized Sports

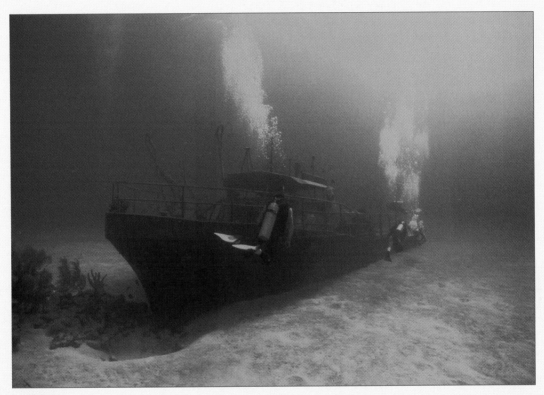

© Bill Garvin

What do scuba diving, golf, offshore sailboat racing, surfing, swimming, and horseback riding all have in common? For a photographer, they all require special considerations for taking great shots, whether that means using a simple point-and-shoot camera or a sophisticated SLR. In some cases, special gear and equipment may be necessary to shoot these sports; in others, it may simply mean that there are exceptional issues as to how the sport needs to be accessed, viewed, or photographed.

As with extreme and adventure sports, some of these specialized sports could arguably be included in other sections of this book. However, this chapter covers how they're different and, combined with information throughout this text, you'll be ready to go out and take winning shots!

Whatever your passion, there's a way to shoot it. Photographers are innovators and inventors at heart; they love to find new and creative ways to capture the world in a way it's never been seen before.

Specialized sports shooting often involves dealing with how to safely and effectively get in and out of a situation that has issues preventing normal photography. It may involve animals, water, special vehicles and equipment, or simply the need to be more than commonly aware of how the sport is played. As with extreme and adventure sports, how you protect and carry your gear, as well as how you access it effectively for where you are and what you're doing, is always a consideration; this also affects the style of camera and other photographic equipment you may ultimately select for the quality and type of images you want to capture — and what you want to do with them.

This chapter covers a number of specialized sports and includes interviews with photographers adept at capturing the action. In some cases, such as for photography in the open ocean, I let the photographers speak for themselves in covering positioning, settings, and getting the shots.

Equestrian Photography

They shoot horses, don't they? Yes, they do, but not in the sense meant by the movie and book of the same name. Photographing horseback riding, whether it's hunters and jumpers, horse racing, dressage, barrel racing, or any other style, involves knowing something not only about the sport but how to work around animals as well. Horses are easily spooked by sudden sounds and movements, and cameras are very capable of causing them to be suddenly startled — which can be disastrous for horse and rider, as well as you, the photographer. Even a simple shutter release can be enough for a horse to be distracted.

Interview: Amy Alden Timacheff

An accomplished and competitive rider as well as portrait and event photographer, Amy Timacheff has been around horses all of her life and now applies that knowledge to digital photography.

What is the best positioning for equestrian shots?

The angle is crucial. For jumping, usually the best shot is when the horse's front and back legs are off the ground. Dust is always an issue when shooting in arenas, so use it to your advantage. If the wind is blowing, try to have it at your back or seek shelter in the judge's stand, which is one of the best vantage points for getting the best shots. It helps to know the judge, or at least have introduced yourself before the event — you can always offer a photo of him or her judging a flat (non-jumping) class. Ego will play in your favor if you use the right approach!

How can you get the best shots?

Look for unusual events — a rider falling off a horse or a horse bucking; these shots can be cool and, more often than not, no one gets seriously hurt. Of course, you have to be ready to shoot these incidents when they happen, because you only have an instant in which to get the shot. If you're fumbling to get your camera set, focused, and positioned, you'll have missed the moment.

What are some tips and tricks?

Don't ever, ever be in the way. Horses can be fairly unpredictable and you don't want to be (or even accused of being) the reason for a rider having a bad round. If you're near a horse and rider, let them pass you before you make anything more than a slow movement; you want to be as much out of their sight as possible when you're working with your camera, positioning yourself, or moving around — especially if you're carrying cameras and equipment. If you do enter the arena, hide behind a standard and be still so as not to spook the horse. You want the horse and rider to know you're there, but think of you as part of the arena and not something out of place.

It can be difficult getting stop-action shots of any sport, and when you add an animal into the equation it can be even tougher. Take into consideration not only your camera and settings and how the event takes place, but make sure under all circumstances you are able to work around horses easily, calmly, and without disturbing them.

Positioning

Some professional photographers, accredited by the organization running the event, will have access to areas of an arena that you will not have. They may set up a tripod and camera at a key point where horse and rider will come across a final jump or a point where official photos are taken. While you won't be able to go out into the arena, the positioning these photographers take will give you a good idea of at least one of the best spots and angles from which to shoot.

If you can get an unobstructed view from behind the officials — meaning from the stands or at the edge of the arena — you can try an over-the-shoulder technique to get the same, or at least similar, shot. However, this image will be taken from farther away than where they are, so you'll have to use a telephoto lens or choose a camera setting that maximizes megapixel capability. That way, if you can't close in very tightly on the rider because of how far away you are, a high-megapixel image allows you to crop later and still have a large enough image to make a decent-sized print. If you can get some time practicing at a local training barn, such as shown in Figure 8-1, you can learn the best timing to get your shots prepared for a bigger show.

Find interesting points in the event; for example, in barrel racing, running tightly around the barrel is a better shot than when they're just in an open run. Horses clearing exceptionally high jumps make for better shots than just a simpler, lower jump; however, the less spectacular, lower jumps, as shown in Figure 8-2, are a good way for you to practice and to become proficient around horses.

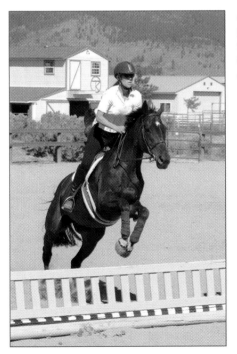

© Amy Alden Timacheff

Figure 8-1: Before shooting a big event, practice your timing and photography at a small schooling show or training arena to learn to get the best equestrian shots and how to work easily around horses and riders.

© Amy Alden Timacheff

Figure 8-2: Horse arenas are filled with angles, so try to shoot as evenly as possible or else you'll need to rotate the image in your image-editing package to make sure it looks straight, but not at the expense of the tilting the horse and rider.

Having a good angle from which to take the shot of the horse jumping or moving through an arena in any type of event is essential to getting a good shot. In jumping, you definitely want to be ahead and positioned at about a 45-degree angle from horse and rider so you can get them coming over the jump.

Sometimes an unusual shot can be dramatic, such as the one being edited in Figure 8-2, where a telephoto lens compressed a complex set of jumps, the horse, and rider for an interesting look. However, it wasn't quite straight, so a little tweak in an image editor is a quick fix. For events where the rider and horse aren't jumping, try a tighter, forward-angle shot in narrow depth of field with horse and rider concentrating, as in Figure 8-3.

One thing you don't want to do is take photos of a jumping horse from behind, even at an angle; in addition to not being able to see faces, typically this isn't the most complimentary angle of either the horse or its rider!

Settings and getting the shots

When you're shooting action shots — ones that involve a horse moving at anything more than a trot — you'll have to ensure you have a fast enough shutter speed. For a slower event, such as dressage, use a setting of 1/250; however, for jumping, cross-country, barrel racing, roping, or other events, set your camera to shoot at least at 1/500 second.

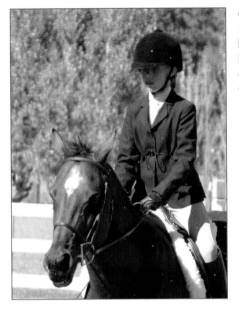

© Amy Alden Timacheff

Figure 8-3: Horse-and-rider shots don't always have to include the entire horse and rider. For tighter images, be careful about what limbs on both horse and rider are being cut off and at what point. Avoid cutting off arms or legs at a joint.

Don't use a flash at any time. Turn it off manually and be sure it's not firing. Also, make sure you turn off all sounds on your camera. A focus beep, startup sound, or other noises can startle horses. Some point-and-shoot cameras have bird sounds, camera click sounds when you release the shutter, and so on; turn all of these sounds off. Make sure that you also turn off anything else that might make noise, such as a cell phone. Digital SLR cameras also have mechanical sounds as their shutters release — primarily from the mirror moving up-and-down on each frame — and this noise can be loud enough to bother a horse; however, it's not a sound that can be turned on or off, so it's best to ensure you're distant enough that it won't be distracting.

Watch your backgrounds when shooting horses, because horse shows — like a motocross event — can be very cluttered. The last thing you want is a great jumping image that has a porta-potty in the background. Find a good angle where the background is as clean as possible to create nice contrast between the horse and rider, and the background.

Dust is a big concern for cameras in horse arenas (see Figure 8-4), and you will want to limit opening your camera as much as possible. If you need to change flash cards, be absolutely sure you're in an area safe from a sudden dust-filled wind gust; it's better if you can make the switch inside a car or building if possible. If you're shooting with an SLR, the best alternative is to have two cameras — one with a midrange to telephoto, and the other with a wide-angle to midrange lens. This way, you can have a nearly full optical range without having to expose an open camera body to dust.

If your camera has a multiple exposure setting, allowing you to take several frames per second, equestrian events are excellent opportunities to practice this feature. Remember, if you have a point-and-shoot camera that has some shutter lag, you'll want to begin shooting before the horse gets to the jump; it may take some trial-and-error to get your timing right.

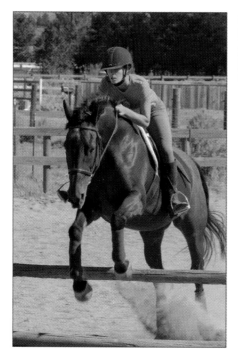

© Amy Alden Timacheff

Figure 8-4: Dust at horse shows can cause serious problems if it gets into your camera gear. Be sure to protect it from sudden wind gusts, and when changing cards, lenses, or batteries, do so in a safe area.

Golf

In terms of photography, golf is a specialized sport only because access and your behavior as a photographer matter so much around the sport. The ability to hit the ball with complete concentration is absolutely essential to golfers, and at all costs you, the photographer, must do everything necessary to stay out of sight and sound while shooting.

Large tournaments will, of course, be more restrictive than a friendly game among friends. If you're out shooting your wife or son on the course, then you can be more relaxed and free with the shots you take. However, for any tournament — whether it be a high school event or a pro tour — requires that you be exceptionally knowledgeable about and adept at the game and navigating a golf course during the event. For you to shoot from anywhere other than the spectator area will likely require that you obtain valid media or organizational credentials.

Positioning

Being to the side or slightly behind the golfer is optimal for shooting the game, where you can see the swing, or the golfer crouched and scrutinizing the best path for the ball to the cup on a putting green. You don't want to be in the golfer's line of vision if at all possible.

Some establishment shots of the golf course are good to have, and telling a story is a good approach to take when shooting an event. And, in the case of golf, the story really isn't going to be about tracking a small ball around a huge course; instead, it's going to be about people. Images of golfers' faces when they're concentrating, conversing, and swinging their clubs make for the most interesting images of the game. While TV coverage shows the ball in flight across the course, a photo of a tiny white ball in midair

isn't very compelling. While few, if any sports benefit from an image of a ball by itself in the air, golf is one of the few where the ball is commonly tracked by TV cameras (hence the suggestion of not following suit with your digital still camera).

I like to take shots where it shows something interesting about the course with the golfer in the midst of it — especially if the natural surroundings are especially beautiful or different. For example, Figure 8-5 is a photo I took at the Doha Golf Course in Qatar, where the terrain is rocky, sandy, and filled with cactus — not typical of most courses around the world.

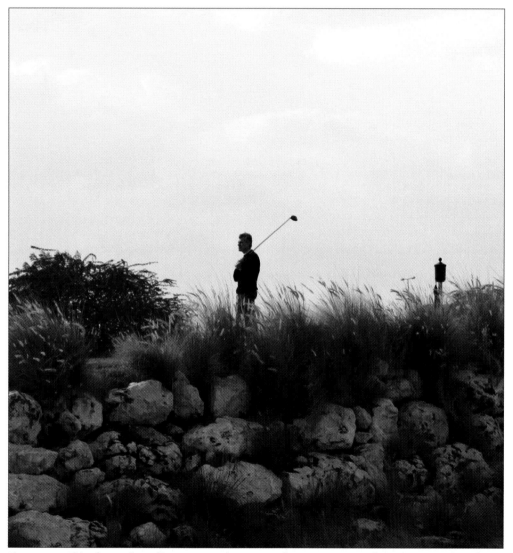

Figure 8-5: This photo of a golfer concentrating on a Doha, Qatar, course shows concentration, the game, and unusual terrain.

Following a golfer throughout a course means you'll want to experiment with shots and use the terrain to your advantage. Take shots above golfers as they are on a green, in a sand trap, or fishing a ball out of the water. Shoot across a driving range from within the trees, or get low on the grass and get a wide-angle, low-to-high perspective. Because you have a large area within which to move, you can be creative about your positioning.

Settings and getting the shots

A telephoto lens on an SLR or a decent telephoto capability/setting on a point-and-shoot is nearly essential in shooting golf, only because you really won't be able or want to get too close to the golfer so you can avoid distracting him or her. As mentioned in positioning, use the terrain to your advantage as much as possible.

As with equestrian shooting, turn off your flash as well as any sounds your camera makes — even a simple beep when it focuses can be rather loud on some models. Make sure you don't make any sudden moves, rattle equipment, or be otherwise noticeable at critical times during the game.

Wide-angle shots also can be effective to gain a nice perspective of the course with golf positioned in it. I don't really suggest getting too many shots of the course without a golfer in it — images just of tree lines, putting greens, and the like get boring quite quickly.

For driving shots, use a high-speed setting and multiple-frame exposure. Your shutter speed should be at least 1/500, and probably substantially faster if possible. A narrow depth-of-field image with your aperture wide open will look very nice with trees or other background scenes blurred and the golfer focused in contrast.

On the putting green, close-up, tight, narrow depth-of-field shots work well and should be shot from a low level, almost from the ball's perspective if you can manage to position yourself to that angle. Here, you don't need quite as fast a shutter speed — instead, keep your aperture wide open, drop your shutter speed to about 1/250 second or even slower, and make your ISO as slow as possible to still get a good exposure. This will create a very rich, low digital noise image with good color saturation — which is especially nice to show a beautiful green.

Ocean Sports

Shooting in and around the ocean is specialized digital sports photography for a number of reasons. Obviously, if you're in the water — for example, while scuba diving or trying to catch a surfer inside the pipe of a wave — you'll need a special camera housing or a camera that's specifically waterproof.

For non-waterproof cameras, salt water and sand can both be devastating to electronics, moving parts, lenses, and other equipment such as portable hard drives. Higher-end cameras used by journalists, such as the Canon 1D Mark II, feature extra seals and protection against the elements, but they still are not waterproof and can be damaged by salt and sand.

However, many photographers love the challenge and opportunities the ocean offers, and the resulting photos that can be so phenomenal and spectacular from a perspective rarely seen by most people.

Tip For any sport shot in or around the water, have a good supply of moisture-absorbing desiccant. Reusable containers of desiccant that will fit in your camera bag or case are available from most photography suppliers.

Offshore Sailing

Sailing large racing yachts in open ocean is a more elite sport, one that most sport photographers will not be able to easily access; merely the need to use a helicopter to really get good shots is enough to deter most nonprofessional photographers (see Figure 8-6). However, after recently meeting a photographer in San Diego who specializes in this sport, I wanted to share a few thoughts from it only because the images are so incredible and many photographers unfamiliar with how it is photographed are curious about it.

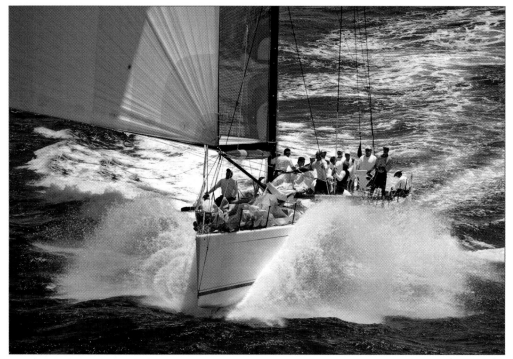

© Sharon Green

Figure 8-6: Offshore sailing photos may require a helicopter to get the best shots, especially in fast-moving boats far from shore in big waves.

Scuba diving

Underwater photography is challenging, requires very special equipment, and is a wonderful way to capture sights of another world right here on our own planet. For years, the Nikonos series of underwater film cameras have defined the market for shooting below the surface of the ocean. Today, they still are highly popular and many digital images result from scans of negatives taken with them. However, new digital cameras such as the ones made by Sealife are waterproof and rated to depths that, while not as deep as what the Nikonos can reach, are sufficient for many divers. And the price of these cameras, which can include special underwater strobe lights and macro-lens capability (for close-up shots), is surprisingly reasonable for the average photographer.

More than almost any other type of sports photography, scuba diving requires highly specialized equipment, as seen in Figure 8-7. Divers need to have cameras or housings for their cameras that are not only waterproof, but also that are capable of handling the pressure of being many feet underwater. Furthermore, visibility through the water is far less than visibility through the air, and so the cameras will often have to be set and used differently when underwater at various depths than they would above the water. Settings for a deeper dive may be substantially different than when only 20 or 30 feet below the surface — which means the camera must have the capability not only of being able to be set to these exposures, but to also be changed easily while underwater.

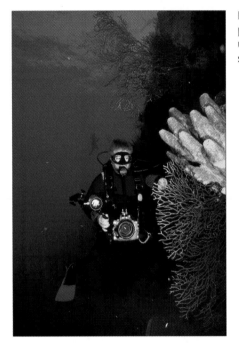

Figure 8-7: A shot of professional underwater photographer Bill Garvin at work with his SLR in an underwater housing along with specially mounted strobe lights.

Most underwater cameras feature large controls that can be changed while you are wearing gloves or have otherwise limited mobility. Further, they do not have SLR-type bodies, but instead use the *rangefinder* method of view finding because, when you're wearing a mask, you aren't easily able to see and frame your subject. Range finding involves framing your subject without looking through a through-the-lens viewfinder as you would in an SLR. Even if you are using an SLR underwater, you're still using a physical, crosshair-type attachment to frame your photo because you won't be effectively able to look through the camera's viewfinder with it contained in an underwater housing and with a mask on your face.

Instead of waterproof cameras, many photographers prefer to use underwater housings for their existing cameras. A number of manufacturers, such as Ikelite, Aquatica, Sea & Sea, and Ewa-Marine, make various types of enclosures into which you can fit nearly any model of digital camera made. Whether you have an SLR or a point-and-shoot, chances are you can find a waterproof housing to fit it for use at various depths underwater. And, while some of these are reasonably affordable (around a few hundred dollars), some of the more heavy-duty, deeper-water-rated models can be very pricey — as much as several thousand dollars.

Lighting is an issue with underwater photography, and if you're going to give it a try you should consider using specialized strobe lights; this can make a huge difference in the quality of your images. Most of the underwater housings include the capability to attach these lights to the housing and to connect to your camera.

Interview: Sharon Green

Sharon Green of UltimateSailing.com is a marine photojournalist who has been shooting the sport for more than 20 years. She shoots everything from small races to America's Cup, with a mix of boat sizes and classes. Based in California, she shoots everywhere from the South Pacific to Miami, Florida.

What does it take to capture the best shots in sailing?

Sailing is a magnificent, colorful, and dramatic sport. There are many variables with the constantly changing elements, such as sea conditions, boats, events, competitors, and locations. The challenge is to capture electrifying moments that take your breath away. Those moments and opportunities are very few, but when they happen . . .

What are some tips and tricks for the aspiring sailing photographer?

Get in close, anticipate the action, and shoot steady with a fast shutter speed. Use available light, and shoot at a shutter speed of at least 1/500 second.

Do you use any specialized equipment?

A cooler and a helicopter!

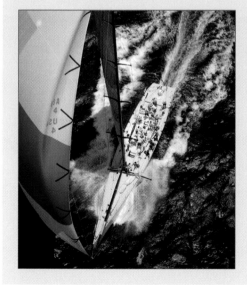

© *Sharon Green*

Shooting sailing is an elite and highly specialized type of photography to match the sport; however, the photos produced are often truly spectacular.

Surfing, wind surfing, kayaking, and boogie-boarding

Unlike ocean sailing or scuba diving, surfing can be photographed from the shore or the water. The types of shots taken from either location will be different in a number of ways: how the images are composed and exposed, the skill required to take them, and the equipment necessary to do so.

Interview: Bill Garvin

Bill Garvin, of Florida's Garvin Marine Photography, has been shooting underwater since the early 1980s and pursues it as a full-time career. He says he now lives "with manatees, birds, turtles, and many other photo opportunities."

What is the best positioning for underwater photography?

Get as close to your subject as you can. There is particulate matter in water; you can help reduce it by getting as close as possible. Avoid tail shots, save your disk space. Don't chase the fish, because all you'll get are tail shots and extra tired from swimming. Sometimes by being stationary and becoming part of the reef, the fish will come to you. When you do get one in view, you need to see the eye and it must be in focus. The preferred angle is looking slightly up, or on the same plane.

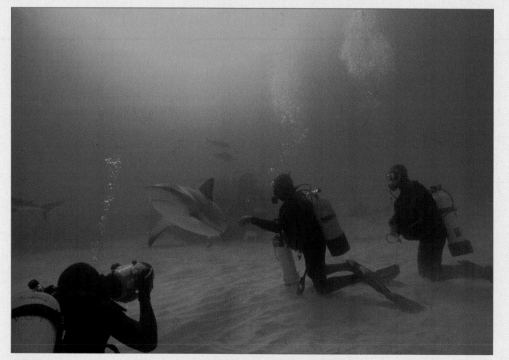

© Bill Garvin

Shooting underwater requires specialized settings that can accommodate the unusual and limited lighting. It also requires patience and the willingness to wait for underwater life to come to you — such as this photo of divers swimming with a bull shark.

What are the best settings and how do you get the best shots?

Start out with macro settings so that you can get good results quickly and gain confidence. The TTL (metering the image "through the lens," which is a capability of some cameras that is especially effective for close-up shots) works great with macro. On a wide-angle setting you will have to switch to Manual mode. You cannot fill 75 to 80 percent of the frame on wide angle to get good results from the TTL setting.

© Bill Garvin

Taking a shot like this underwater is difficult; the underside of the fish is highly reflective, the sky above the water causes backlighting, and barracudas are notoriously elusive and rarely come close enough to photograph well.

Here are some of Bill's best tips for successful underwater photography:

✦ When setting your strobes remember the 4-foot yardstick. Water magnifies a subject 4 feet away, making it appear to be 3 feet away. The camera's strobes, which are separately mounted from the camera, must be aimed at the actual image.

✦ Double-check that lens caps are off, batteries are fresh, and that the waterproof covers are closed correctly. The first 10 feet are the most critical — keep an eye on the camera for problems, and if necessary get it back to the surface quickly.

✦ The particulate matter in water can easily be lit up with a strobe. The typical over-lens strobe, as used in the air, makes underwater look like a snowstorm. Get the strobe away from the lens — hand-held to the side or away from the camera in some way.

✦ Take a small dive light with you during the day. By shining it on a possible subject you can see the real color you will get. Water robs color, making a strawberry sponge look black; with the dive light you will see it is a bright strawberry red.

Continued

Continued

What other tips and tricks do you have?

Slow down — the faster you go, the less you see. Go slowly, look around, look in sponges, look under ledges, there is a lot there to see by taking your time. Also, be critical of your pictures. Look at them as you would critique someone else's; be honest and ask yourself what you can do to improve the composition and exposure. Ask your dive buddy to make suggestions about how the image would be more pleasing. Learn from the feedback!

© Hollie Hailstone

With underwater shots, getting a finely detailed exposure of a diver's face or a fish's body isn't always critical. Sometimes, as in this photo of a manta ray and a diver, a silhouetted image against a blue ocean presents a dramatic, nearly duotone image.

Big surfing events always have numerous photographers perched on the shore with very long glass; if there ever was a perfect use for a 1200mm lens, this is the one. However, there has been increasing demand for cool, in-water shots that get close to surfers on big waves, as well as boogie-boarders, ocean kayakers, and wind surfers doing the same.

For shooting from the shoreline a long telephoto lens is necessary. It will be very difficult to get good shots of a surfer on a wave unless your camera has at the very least a 200mm lens, and preferably much longer focal length. Additionally, you will want to have your camera mounted on a monopod or tripod and use a hood large enough to reduce lens flare, glare, and blowing sand.

For many SLR cameras with interchangeable lenses, you can purchase lens extenders, which increase or extend the focal length of a telephoto lens. A 2x coupler, for example, effectively changes a 70–200mm zoom lens into a 140–400mm; however, extenders reduce the aperture rating of the lens and can also limit the auto-focus capability of the camera. When shooting surfing, however, you may be able to keep your camera on infinity, so auto-focus isn't a big issue. Because it's usually very bright, a limited aperture is less of an issue, as well. So an extender may work well for you if you want to increase focal length but don't want to spend the money for a new, longer telephoto lens.

Photos such as the one in Figure 8-8 require that you expose your camera to water, wind, and sand. Protecting your equipment on the shore and in the water is essential. Blowing sand will wreak havoc on a poorly gasketed camera if left exposed to it over time, so you may want to do something to protect it. Some of the rain covers from Kata and Tenba may help in blocking sand and, to a degree, moisture from getting to your camera on the shore. Because sand has a way of getting into everything, you will want to carry your extra equipment such as portable hard drives, a laptop, card readers, and extra lenses in an airtight, sealed case. Or simply leave them in the car. Just having them in a camera bag may not be sufficient protection.

In the water, the same type of system used with scuba diving is necessary — an underwater housing — although it won't need to be rated to deep depths unless you plan to dive with it. However, if you plan to shoot from the surf, because it can be so powerful, you still may want to consider purchasing a better-quality housing to ensure your gear is fully protected should it happen to get pounded by big waves or hit by a board.

© Amber Palmer

Figure 8-8: Late in the day or early in the morning is a good time to take shoreline shots, such as this one of two ocean kayakers.

Interview: Neal Thatcher

Neal Thatcher, the son of a professional photographer, grew up in Hawaii and has been surfing and shooting since he was 10 years old. Now a professional photographer and videographer based in Washington state, he has photographed surfing — both from the water and the shore — and now primarily shoots snow sports (see his spectacular shots in Chapter 5) in addition to his love for the water.

What kind of special equipment do you use to shoot surfing?

A water housing is required to get the types of shots I prefer — intimate and close up. Hawaii has an army of photographers on the shore capturing every wave a top rider breaks; having in-water gear and knowing where the wave will break is the most important part of getting shots that are different. I have three ports for my housings: one for my 15mm fisheye, one for my 24mm, and one for my 100mm lenses. If I'm shooting with my 100mm lens, I'm usually on a bodyboard for flotation and so I can be up higher to get a better vantage point.

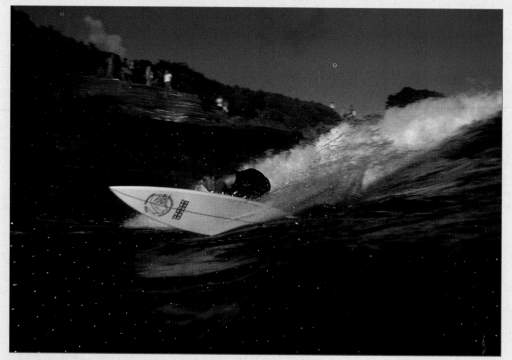

© *Neal Thatcher*
Neal Thatcher likes the intimacy of an in-water shot that's close to a surfer breaking a wave.

How do you get the best position?

It's about knowing where the waves are breaking. On Oahu in Hawaii, I like to shoot at Sandy Beach, Pipeline, and some secret south-shore spots. Finding uncrowded waves is tough there, so you have to shoot very early in the morning or late afternoon — which is usually the best light, anyway!

How do you get the best shots?

The most important part is a knowledge of the sport and working closely with the athlete. You have to have great communication and plan where you will be in relation to the athlete; he or she must feel confident you will be there and ready to catch something that often cannot be reshot — both in surfing and in snowboarding. Safety is an important factor for both of you, so you have to know where the athlete will be to catch the shot and to stay safe. This can be a huge challenge with surfing, especially where you are also at the mercy of ever-changing waves. However, good riders will make sure you know where they are in the lineup at all times and when they are going to catch a wave.

I prefer to freeze the action so I usually shoot at a high speed of 1/500 or higher, and an aperture of 5.6 or wider. I like the color saturation of lower ISO, so I try to shoot at ISO100 if at all possible; however I will shoot at higher ISO speeds if I have to in order to keep my target shutter speed range. I don't use flashes very often, and I like to shoot as much as possible in the early morning or late afternoon 'magic hour' lighting — especially for surfing.

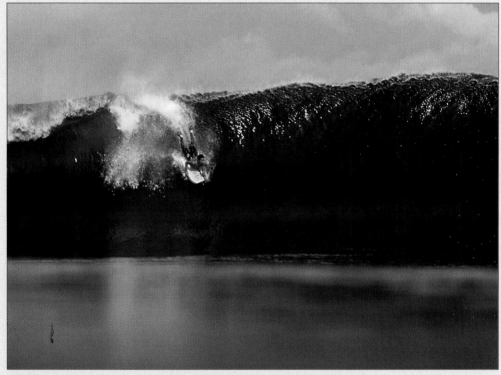

© Neal Thatcher

Boogie-boarding has become a popular big-wave sport and requires some of the same photography skills as shooting surfing.

Continued

Continued

Any tips and tricks?

You need to have a passion and knowledge of the sport you choose to shoot or it will show in your work. Get out and do the sport first and have an idea of what makes it fun to do and watch. When you find great subjects, work with them often to build a chemistry between the two of you, to know what tricks they are going to do as well as their general tendencies and directions. You must always stay aware of this as well as everything else going on around you from other less-skilled riders who can put you in danger, changes in the weather, and increasing swells.

Extreme and specialized photography is very much fun and can put you together with some of the most outrageous people you will ever meet, but sometimes you must be the voice of reason. You will find that some athletes will do things well beyond their skill levels just to get a photo of it, and it is really not worth it to allow that to happen. Don't push riders beyond their comfort zones, and don't take silly risks to get a shot.

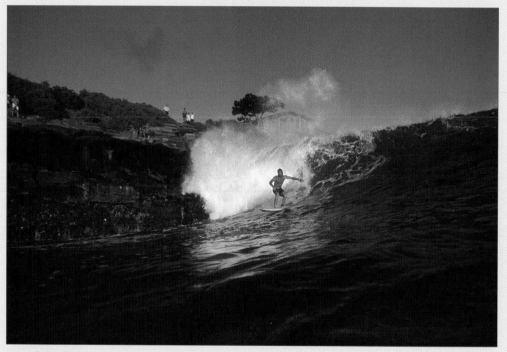

© Neal Thatcher

Waves are big and powerful, and can change in an instant, so it's important to be aware of everything around you when shooting in the water.

Swimming

Swimming is hardly considered an extreme or adventure sport unless you're swimming in the open ocean. However, even photographing swimming can place it in the category of a specialized sport because the photographer must be prepared to work in and around the water.

The Athens 2004 Olympic Games had many spectacular shots of diving and swimming from underwater in the pool as well as from above and at waterlevel. While you may not be donning dive gear and using an underwater housing to shoot your son's or daughter's local high school swim meet from the bottom of the deep end, there are some specialized considerations for shooting the sport if you're going to get some dramatic, tight shots of a competitive swimmer such as shown in Figure 8-9.

If you're in the water shooting swimming, you'll need a light underwater housing for your camera or for the camera itself to be waterproof (as described in the section on scuba diving). If you're shooting from underwater up at swimmers, you may want to use a flash so that the diffused light from above the pool doesn't cause backlighting problems.

However, even if you're shooting from the surface of the water or poolside, you will nonetheless need to protect your camera and gear from being splashed.

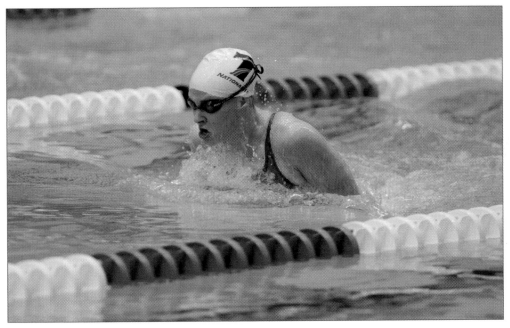

© *Nathan Jendrick*

Figure 8-9: The lighting in swimming halls can be dark and, while in some facilities you can use a flash, it may be prohibited in others — or simply not useful from where you are shooting. This image of US Olympic swimmer Megan Jendrick (Quann) was shot at ISO1600 without a flash.

You may be able to use a flash in swimming pools, as long as the event organizers allow it. For big, Olympic-sized facilities, a telephoto lens will be helpful to get close to the athletes even if they are far down a lane. However, a good wide-angle shot from the end of the pool as several swimmers come in for a finish can be useful and interesting, so having a wide-angle or even a fisheye lens can make for some fun shots.

Interview: Nathan Jendrick

Nathan Jendrick is a professional photographer and journalist who has shot many swimming celebrities, including Michael Phelps, Megan Jendrick (formerly Megan Quann), Natalie Coughlin, Justin Gatlin, and others. In addition, he shoots other subjects and sports such as bodybuilding.

What's the best positioning for shooting swimming?

When it comes to photography, don't be afraid to get on the level of your subject whenever possible. If you're at the pool, know that chlorine won't hurt you and your pants will dry. The vast majority of photographs are taken by someone, between 5 and 6 feet tall, standing and aiming down. You don't want your shots to look like everyone else's; instead, get on their (swimmers') level, and take a unique shot. Many photos like the one pictured here would look bland if they had been taken by a 6-foot individual looking down toward the pool, seeing the water act almost as a jacket on the swimmer. The mirror image in the water are things seen now only because of the angle.

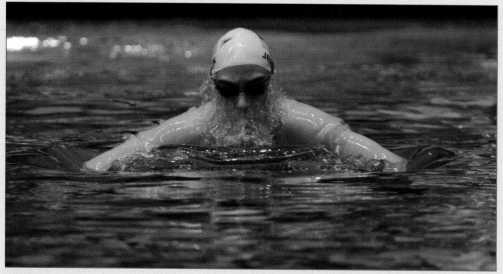

© *Nathan Jendrick*

Exploring angles, perspectives, and vantage points are the key to creating original and exciting images.

What do settings do you use?

A lot of people like to take pictures at less than their camera's highest resolution, mostly so they can fit more photos on their memory card. But depending on your location, this isn't always a good idea. Here's

why: In dark environments, you need to shoot at a higher ISO setting, such as ISO800, along with a fast shutter speed. These are necessary to stop the action, but are murder on your picture because a high ISO can create so much noise in your image. If you're shooting at half the capability of your camera, when you try and edit your work later on, you'll be in trouble. Images taken with a shutter speed of 1/640 of a second and ISO1600 without a flash can create some fairly major issues. Now, combined with these settings if the image is taken at a lower resolution, the images would turn out to be far too dark — even after adjusting the levels; without the resolution, you may not have enough information to work with. So remember, even with small memory cards, you can save room by using your camera's full capability and your talent, to take one or two pictures that are exactly what you need, rather than taking 10 and hoping one turns out.

How do you get the best shots?

When shooting sports photos you'll want to make sure you choose your depth of field wisely. In the next shot, the swimmer is coming off of the wall to start his backstroke race; you can't see the starting block, but the viewer doesn't need to — what the swimmer is doing is obvious. If the block was included in the shot, because it was taken high above from a catwalk with a 70–200mm lens, the picture would have looked far away and needed a lot of zooming in later on. Assuming you have the equipment to zoom in, you can preempt your subject and get a better-posed photo by isolating your depth of field solely to what you want to capture. This is easy when you know what they're going to do: Swimmers all start backstroke races this way; runners all put one foot in front of the other: It's simple! Select a shutter speed appropriate for the action and light and then prefocus on the area where you're going to be shooting. When the person is about to enter the frame, take your shot. If you try to follow him or her, your picture won't come out sharp or, in really bad situations, your digital camera won't be able to focus at all and won't take even a single picture!

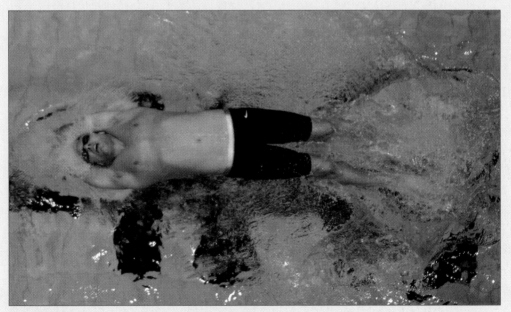

© *Nathan Jendrick*

A unique angle sometimes requires waiting for the subject to appear in your frame, as opposed to tracking him or her — which can result in poorer image quality.

Patrick Bates, a sports photographer and former high-level competitive swimmer who now works for Printroom.com also has these addition suggestions:

✦ Look for emotional outbursts of energy, exertion, triumph, and disappointment.

✦ Focus on the start and finish of a race.

✦ In a relay, the handover moment is very important, and you can often get good emotional and personal shots when the swimmer looks at the close. It's also important to capture the team environment for relay events.

✦ Capture swimmers that are poised on the blocks ready to dive or a water start for a backstroke event.

✦ Try to get a sense of the timing of a swimmer's stroke and how he or she is breathing — otherwise you might frame a photo just right, but the swimmer's head may be turned in the wrong direction.

Summary

There are a variety of specialized sports that are unique because of equipment, access, environmental conditions, and other factors with which you must comply to get the shots. Whether it's under water, on a sandy beach, at a dusty horse show, or even on a hushed golf green, the creative challenge is to be able to integrate effectively with the environment and allow the athletes to perform their best — and to still take photographs that document the event in the most exciting, passionate way possible.

Using a point-and-shoot camera, in some cases, may actually make your life easier for taking some specialized photos; for example, a small underwater housing for a point-and-shoot is relatively affordable, and operating the camera underwater can be easier than an SLR. Plus, image quality on point-and-shoot cameras has become so good that they might do everything you need. On the other hand, if you're doing something professional with the images, or even submitting them to contests, you may need to have an SLR — if for no other reason than to be able to use a wide variety of lenses to get photos that are fast, far away, or very wide.

A few concepts are common among all sports photographers: Rarely use a flash, do as much as possible to control your camera manually, don't be afraid to use a higher ISO setting as opposed to compromising speed or aperture, be creative about your angles and perspectives, and know the sport you're shooting.

✦ ✦ ✦

Working with Sports Images in the Digital Studio

© Amber Palmer

Chapter 9
Creating a Digital Studio

Chapter 10
Working in a Digital Studio

9 Creating a Digital Studio

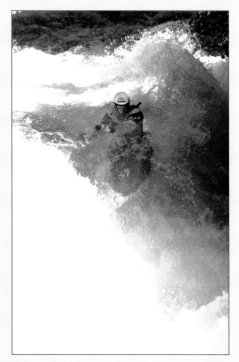

© Amber Palmer

When it comes to sports photography, most of what you'll be shooting won't require a physical studio space. All types of digital sports photographers are, by-and-large, field photographers who go on-location, gather their images, and then return to a studio used exclusively for post-pixel, purely digital photography work.

Note For more about workflow for studio photography, you can refer to *Total Digital Photography: The Shoot to Print Workflow Handbook*, also from Wiley, for more information.

Although setting up a digital studio may not necessarily be the most inexpensive pastime or semi-profession, the digital world has many advantages over the days of film. In the past, having a darkroom meant taking over the garage, a bathroom, or the basement where there was running water and a way to dispose of waste chemicals. Furthermore, for anyone doing even a part-time business as a film photographer, many

state governments require different classifications, disposal methods, and tax categories based on the photography studio having to process chemicals that are potentially environmentally hazardous.

Today's digital workspace hardly resembles the days of film studios. There are no enlargers, baths of chemicals, or darkroom. A very simple digital studio may include a single desktop computer and monitor with an Internet connection and a simple image-editing application, while a complex pro digital studio may include several networked desktop computers, a digital scanner, several printers, high-end, color-corrected monitors, banks of hard drives, an LCD projector with a screen, DVD/CD burners, and a sound system — as well as a lot of expensive software.

This chapter looks at the various aspects of and ways in which you can create a digital studio that will serve your needs but won't blow your budget. It's easy to get carried away with expensive equipment and software, but very often you can get virtually everything you need accomplished with less than you might think. Whether you want to consider selling your digital sports photography or you do it simply because you love it and want to share some photos with friends, see what it takes to create a digital studio that will be suited to you.

Visualizing Your Digital Studio

What do you need for your digital photo studio? Very possibly, not much more than you already have. Based on what we cover in this chapter, you'll be able to understand and prioritize what you have that may be useful for your studio, and what you may want to acquire right away, as well as what to put on your wish list.

Technology is constantly changing and new products are made available on a daily basis. One of the most challenging but essential aspects of being a digital photographer in a technical world is keeping up with advances in your field. To do this, you can join a local photography club or even a professional organization such as the Professional Photographers of America. Also consider subscribing to publications such as *Shutterbug* (more consumer-oriented) or *Digital Photo Pro* (more pro-oriented).

The items listed in Table 9-1 are the minimum that you need to put together your own digital photography studio.

Table 9-1: **Pre- and Post-Pixel Digital Photography Requirements**
Pre-Pixel (for in-field photography)
Camera equipment, including lenses, camera bodies, and flashes
Accessories, including carrying equipment for transportation as well as shooting, meters, cleaning equipment for lenses and camera sensors, batteries, and charging equipment
A portable storage device, whether a small portable hard drive or a laptop
Post-Pixel (for post-shoot processing)
A computer system capable of managing digital photography (one with an up-to-date operating system such as Windows XP or Mac OS X) with substantial memory, plenty of hard drive space, and a high-speed connection
A CD or CD/DVD burner
An external hard drive

Post-Pixel (for post-shoot processing)

	A good-quality monitor, preferably the CRT kind, not an LCD display
	For image processing and editing, Adobe Photoshop Elements, ACDSee, or Microsoft Digital Image Pro; Photoshop CS is desirable (but very expensive)
	For image archiving, Photoshop Album or iView
	For image presentation, Photodex ProShow, iView, or another slideshow software that meets your specific needs
	A photo-quality printer; an inkjet printer will work fine in most cases
	A way to post, manage, distribute, and possibly sell images online; this means signing up for a Web-based photography service such as Shutterfly, Printroom.com, or Kodak Gallery.

You may already have some of these products in your home or office that can be used as part of your digital studio. You may have a computer that is powerful, but doesn't have enough memory (1GB or more is preferable), or you may need to upgrade your printer. If you have equipment that's adequate and can be dedicated to your studio, that's great; however, it's best if you don't try to cut corners in certain areas. You always want to have more memory and hard drive space than less, a bad monitor can easily become the bane of your photography existence, and a poor printer will only serve to create images that clients and friends won't keep and that will produce inconsistent, incorrect results.

Today, many photographers' work is being presented in the form of online galleries where images can be shared, sold, and fulfilled in print and other forms. Services that display (and in many cases offer for sale) digital photos become an important partner and integrated component of digital studio workflow. Figure 9-1 shows photos displayed online at Printroom.com.

I use Adobe Photoshop extensively in my work as a pro photographer, but I don't consider it a requirement for everyone. It's a very expensive and very demanding software application. It's complex to learn and, although it's capable of doing virtually anything with a photograph, it can be very difficult to accomplish simple tasks if you don't know what you are doing. If you can afford Photoshop in terms of both time and cost, you won't regret having it. However, I believe and teach in many workshops that you can achieve a substantial portion of what you need to do with your images as an amateur, enthusiast, or even semi-pro with ACDSee or Photoshop Elements. Later, if you outgrow these applications, then it's time to consider spending the money to purchase Photoshop.

Tip

If you're using Photoshop, there are many books as well as online forums and information sites for learning more about this complex application and getting help when you need it. In addition, for $99 you can join the National Association of Photoshop Professionals, which includes a subscription to *Photoshop User* magazine and access to a members-only Web site featuring tutorials, support, galleries, forums, and more.

No matter what computer and software products you use, it's important to skimp the least on the pre-pixel stage. That means buying the best-quality digital camera you can afford. There is absolutely no substitute for beginning with a good photograph; no magic or whiz-bang software technology can do for an image what you can with the right camera settings, good-quality lenses, and enough megapixels to create your images at a decent size.

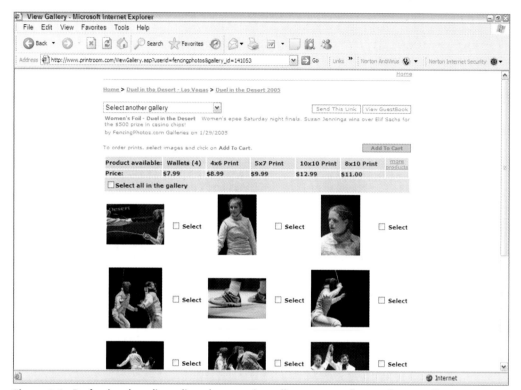

Figure 9-1: Professional quality online photo services allow you to sell your photos online.

> **Note**
>
> If your camera supports a RAW format (a format proprietary to higher-end cameras that creates files that are essentially just data as the camera actually saw an image), make sure that your software application supports RAW files and is able to process them quickly enough. Photoshop CS or CS2 are the best bet for working with RAW files (previous versions of Photoshop did not support RAW files). Most camera manufacturers also offer effective utilities for processing RAW files produced by their own cameras.

If you're making the shift from film to digital, you may already be overwhelmed or daunted by everything you must learn to get your photos finished. The days of film, although more complicated in terms of physical pieces of equipment to use, was more hands-on, and there were far fewer things to learn to process a photograph. Even simpler applications like Photoshop Elements can be complicated for the uninitiated, and setting up a computer for photography, especially ensuring that it is color-calibrated and working in-synch with a printer, can be a tall order.

Let's take a look at the three primary areas that make up a digital photography studio, especially as they relate to sports — although these will, in many cases, be common to almost any area of digital photography for the consumer, enthusiast, and semi-pro:

✦ **Hardware:** The physical equipment needed or useful for digital photography

✦ **Software:** Applications that are essential and/or desirable to produce the best possible results

✦ **Web services:** The online components of digital photography workflow

Digital photography studio hardware

The physical manifestation of the virtual workspace, today's photography studio is all about computer technology. Even today's digital cameras, while they are optical devices, contain more technology individually that what you would have found in an entire university computer lab in 1975.

It may seem that a camera is the heart of the digital photography studio. However, cameras weren't the heart of the film darkroom; it was the enlarger. Likewise, it's the computer that is at the core of your studio and workflow. In fact, you will probably find yourself using your computer far more than your camera in the pursuit of fantastic images from your digital sports photography.

Computer considerations

If you plan to shoot sports where you'll be able to stage your work at the venue, meaning you will have a safe space to store your gear, or if you travel frequently for shoots, then you will appreciate having a notebook computer capable of displaying photography and running memory-intensive applications (an image-editing package managing large image files). Some of the more powerful laptops are more than capable of being the primary computer in your digital studio. You probably won't want to use one as a server (the main PC that is the central computer in a networked environment); that should really be a desktop PC that doesn't go anywhere.

Also, if you're going to use a notebook computer as a primary system, you want to frequently back it up and have it insured. The loss you can incur from being unprotected in terms of saving your data and also having it financially secure can be devastating regardless of whether it is pictures of your kids playing soccer or a professional rock-climbing event.

You should standardize on one platform, either the Mac or the PC. Trying to mix the two is challenging at best. If you have more than one person using the studio, you want to have at least one system for each person; you also may want to consider having a separate desktop PC as a server.

No computer should have less than a 60GB hard drive, 768MB of RAM, and a fast microprocessor (such as a Pentium 4) running Microsoft Windows XP or Mac OS X. Another essential requirement is to have several USB 2.0 ports along with a FireWire connection. You'll never regret having high-speed data ports when you're transferring images from camera to computer.

Preparing sufficient hard drive capacity

Backing up images onto a portable hard drive makes them accessible, portable, and safe, and hard drives have become very affordable. They come in many varieties today, ranging from very small, portable devices that you can use on the road to bigger ones that remain in the studio.

You can even store your hard drive of images in a bank safety deposit box if you are going to be away from the studio for an extended period, and you don't have to worry about having them on a PC. Be sure to get drives that support either FireWire or USB 2.0, or both, for fast access to files. Some drives are stackable, as well, so you won't need more than one data cable and one power cable for several of them. Network hard drives connect either through a conventional USB or FireWire connection, but also can connect directly to a network cable into your router or hub, so they appear on the network as a separate device, making them easy for any computer on your network to access.

Tip Running out of storage room and thinking about going pro? You may want to consider a RAID system (the acronym alternately stands for *Random Arrays of Independent Disks* or *Random Arrays of Inexpensive Disks*). RAID systems are a combination of a controller board that is mounted in your PC, software, and a rack-mount system supporting multiple hard drives that back each other up. While a bit pricey and technical, if you're going to build a pro studio it's worth considering.

CD/DVD burners

There are relative advantages and disadvantages of various removable backup media (including DVDs, CD-RWs, and CD-ROMs) a bit later in this chapter. But in the computer capacity department, I want to emphasize the importance of a high-speed CD or DVD burner.

Backing up files to disk, copying them to CDs or DVDs for distribution, and being able to transfer large numbers of big files are just a few reasons for having a CD or DVD burner. No busy studio is without one today, and the prices have become so affordable that it's not tough to have one available.

You can choose between having an external burner that can be used on multiple systems or one that's installed internally on a computer.

The best monitor for digital photo work

A hot topic of discussion today in the pro photography community is whether the new LCD monitors are capable of displaying true photographic images. For you, as an enthusiast or semi-pro, a good-quality LCD display will be perfectly sufficient, especially if you color-calibrate it.

Calibration devices, such as the Monaco Optics SR Pro or the ColorVision SpyderPro 2, claim to work well on LCD monitors, and my experience confirms that the color-matching these devices produce on new, high-quality LCD screens provides a good preview of print color.

Die-hard, purist digital photographers still prefer CRT-style monitors, however, and these arguably still present the best-quality images. Get a monitor as large as you can afford that still has superior quality; you won't regret being able to display a big image!

Color-calibration devices

Several products on the market today let you calibrate your monitor(s) accurately so that you know you're editing images with accurately displayed colors. ColorVision (makers of the popular Spyder series of calibration devices) and Monaco Systems both produce devices known as colorimeters, which you can attach and run on your monitor to measure how your computer displays color, tones, brightness, and contrast.

Displaying Your Photos in the Studio

Whether you are presenting your photos for professional clients and colleagues or having fun sharing photos with friends, you can enhance the experience with the right equipment. Despite what you might think, a sound system is not a frivolous item. Audio can lend an important dimension to presenting digital sports photos. Consider the following:

✦ **Sound systems.** Get a good-quality set of computer studio-style speakers with a subwoofer if you plan to present your images to groups of people. Adding music and sound to slide shows really helps make them exciting. If you're using a notebook, as I do for many presentations, consider using an external sound card like the SoundBlaster Extigy to control the speakers, volume, and so on for slide shows.

✦ **Displaying photos with an LCD projector.** An LCD projector is an absolutely great and indispensable way to present your images to groups of people, whether in your house or at a sports hall. These devices can be expensive, however, especially if they're bright enough to handle displays larger than five or six feet in width at a reasonable distance. You want to carefully try out the different portable displays for image quality, resolution, brightness, and ruggedness, depending on how you'll be using it.

These calibration systems are bundled with software that generates a profile file that is loaded automatically when you boot your computer. Quite frankly, no pro studio is (or should be) without a calibration system, and you can get consumer versions of these companies' products affordably. Figure 9-2 shows the SpyderPro2 calibration system.

Figure 9-2: The SpyderPro2 system includes a colorimeter that is placed on the monitor and software that corrects color display.

Networks

While not necessary, a network can be a boost to productivity if you're running more than one computer. Connect your high-speed Internet connection into a router with an integrated firewall for extra safety. This way you can run multiple PCs, shared printers, and even shared network hard drives all on one easily configured network—all connected to the router.

If you expand, you can attach hubs to the router, to which you attach more network devices. For the most part, these devices connect and configure quite easily.

Printers

Having a printer in your digital studio is advisable because, inevitably, you'll run into situations where you need to print your own photos quickly and easily. Some very high-quality photo printers are available today that don't cost much, such as several from Epson and Canon that produce letter-sized photos and some even larger.

Don't kid yourself, however; printing requires paper and ink, and you will end up spending at least $1.50 per full-sized sheet once you breakdown the overall cost. This is especially true given that the occasional print will be incorrect, or the ink/color will be off, or something else will need to be tweaked and you'll have to print it again.

Tip

To calibrate the color on your prints, PrintFIX is a product that works well. It is produced by ColorVision, which makes the Spyder monitor calibration devices.

Deciding about film and slide scanners

If you have lots of film, photographs, and slides from the pre-digital days, you definitely want to have a high-quality, high-resolution scanner. If you shot medium-format film, you can even get scanners that support this type of negative and slide.

Scanner prices have become *very* affordable, so getting a great-quality scanner at a good price isn't very hard to find these days. However, you should realize that scanning film can be a time-consuming matter, and you'll probably get highly involved in tweaking image resolution and quality; if you don't have the time to devote to it, I suggest this as a lower priority and something you can outsource to a local lab much more easily.

Digital photography software

The computer is the core of your digital studio hardware, and your image-editing software will be the core of your software applications. This software is what you'll use to organize, review, edit, optimize, and manage all your images. You'll also want to have some other types of image-related software in addition to your image-editing package.

Photoshop

For pro photographers, Adobe Photoshop CS2 is the standard and an indispensable product, and I wouldn't really recommend using anything else. However, Photoshop is expensive and can be very complex to use; for the average consumer or even semi-pro photographer, it is often too much and has a steep learning curve.

Photoshop capably handles virtually any digital photography project, ranging from a simple crop and resize to the creation of incredibly complex photography creations containing multiple images, text, and other design elements. While some of the basic Photoshop editing tools aren't tough to use, one of the primary reasons the application is so powerful — as well as complicated — is the concept of layers that it uses. Photoshop users can create multiple layers of text, graphics, and photographs over (or even behind) an original image. These layers can then be combined into one integrated image that can be stored with the various layers separately or flattened into one file (such as a JPEG or other image). Additionally, Photoshop has an extensive batch processing capability that lets photographers apply the same complex actions to large sets of images.

However, one of the reasons Photoshop Elements, ACDSee, and other similar programs are easier for the average person to use than Photoshop is that they contain many more automated features that let the user apply artistic and editing effects without having to manually go through complicated steps (such as you'd have to do in Photoshop).

Photoshop Elements

Adobe Photoshop Elements is a scaled-down, consumer version of Photoshop. Many of its features operate similarly to Photoshop, it supports many files formats (including RAW), and it has lots of bells and whistles for both image management and editing, but it is altogether a different software package and its interface differs considerably. You won't be able to upgrade from Photoshop Elements to Photoshop CS

after you learn the digital ropes because Adobe only offers lower-priced upgrades for previous versions of Photoshop, not Elements or other packages. You work with Photoshop Elements later in the book. Image-editing packages such as Photoshop Elements can also be used to create sets of photos printed in various sizes, contact sheets, and albums.

ACCSee

As a primary editing package, you really can't go wrong with Photoshop Elements, but you may be able to do better with ACDSee. This software, currently in version 7.0, rivals with remarkable finesse many of the features available in Photoshop CS, but is priced more like Elements.

Additionally, ACDSee FotoSlate offers the widest variety and most capable set of tools for printing virtually any size and set of images on any size sheet of paper. It comes bundled in the ACDSee PowerPack, or it is available as a standalone product.

Although suitable for someone new to digital photography, ACDSee includes features and capabilities that suffice for many professional uses. If you're shopping for a new image-editing solution, I highly recommend taking a look at ACDSee.

Paint Shop Pro

Another very popular and affordable program is Corel's Paint Shop Pro. As with ACDSee and Photoshop Elements, it features a number of handy automated features such as being able to adjust lighting issues, add filters, and get rid of digital noise in addition to sharpening, editing, and brightness/contrast tools.

However, one of the ways Paint Shop Pro exceeds the ACDSee and Photoshop Elements is how it handles more artistic endeavors, such as turning your photo into graphics, paintings, and other images. While the other programs allow this to some degree, Paint Shop Pro has many more tools and capabilities for getting creative.

Note There are several other image-editing programs on the market that may be interesting for you to take a look at beyond Photoshop Elements and ACDSee, although I don't believe they offer anything more substantial than these two market leaders. Microsoft Digital Image Pro and Corel Photo-Paint are two other that you may want to consider.

Slide show software

If you're presenting your photos to groups of people — small to large — slide show software is indispensable. While you can get this, to a degree, in applications like Microsoft PowerPoint, there's nothing like a dedicated, good-quality image presentation package to make your show really shine. Several packages are on the market, and the best one I've found to date is called ProShow (ProShow Gold is the professional version) from Photodex Corporation. It allows you to easily put together an extensive slide show with transitions, motion, sound, and many other features and then either record it to a CD or a VCD, or in an executable program file.

Creative/artistic treatment packages

While many image-editing packages provide a variety of artistic filters and ways of changing photos into line art, painting-style images, or avant-garde designs, Corel Painter is, by far, at the top of the heap in offering these capabilities. Painter is the Photoshop of the creative image treatment world; however, like Photoshop, it is very complex and expensive.

If you want to do simple treatments, rely on what your basic image-editing package will do, but if you're a serious artist into photography, Corel Painter is your tool.

Image management tools

In addition to the file management capabilities of your image-editing package, if you have a growing set of image files, you may find it very useful to have software to help manage them. With a number of other lower-end features like calendar creation, simple slide shows, and image sharing, Adobe Photoshop Album can help you control your files. However, a much better package for the average photography enthusiast is produced by iView Multimedia. In addition to a professional application, iView MediaPro2, the company produces iView Media2, which I've found to be an invaluable tool for managing, cataloging, organizing, and backing up images.

Web Services

Working on the Internet today is an essential part of managing a digital photography studio, whether you're posting images into an online gallery, running your own Web site, or printing photos to an online photo lab. In any event, you'll find a plethora of services available for all types and levels of photographer, from the entry-level amateur to the world-class pro.

There are two types of online photography fulfillment services: those that allow you to share images with your family and friends and print them, and others designed to help you sell images. Kodak Gallery, Shutterfly, Snapfish, and Yahoo! Photos all allow you to share photos and print them for remarkably low prices. The quality is good, and it's a remarkably good alternative to printing your own photos or running them to a lab.

If you're trying to sell images, check out Printroom.com. This company leads the market in helping professional and semi-pro photographers to sell their images online — especially for sports photographers. This is the service that I use for my fencing images, and they have hundreds, if not thousands, of photographers shooting everything from baseball and football to rowing and lacrosse. They provide a way for the photographer to offer many types of sports-oriented products (templates, trading cards, and so on), and their print quality is top-rate. Their business model is to provide a way for you to professionally present images that are copy-protected, and then to allow customers to select and purchase prints. You upload the images and set the prices, and the company takes a commission and sends you a check every month.

 Cross-Reference Learn more about online print vendors and how you can completely integrate them into your digital studio in Chapter 11.

Using Removable Storage Media

Removable storage media refers generally to anything you use to store images that can be used among various devices. Flash cards, CD-R/RW discs, and DVDs all fall into this category.

As digital cameras produce larger and larger files, and high-speed CD and DVD writers are becoming more accessible, your options for removable storage media are evolving quickly. This section covers how to choose removable storage media.

Choosing flash cards

When it comes to flash cards, many are available on the market today in various sizes, prices, and speeds (how fast the camera can write to the card). Some flash cards are ruggedized, — made for extreme temperatures. Most, if not all, SLR cameras operate on CompactFlash cards, although some also support other types, like SD.

Most recently, I saw that a 12GB card had been released for nearly $10,000; clearly, this is overkill for anyone but the high-end studio photographer or war photojournalist who can't download for long periods. For most people shooting medium-sized JPEG files who want to get anywhere from 75 to a few hundred shots on a card, having two or three 512MB or 1GB cards is optimal. These cards have become very affordable in the past few years.

If you buy a camera that uses one of the alternative flash card types, be aware that you may be challenged in finding readers that support it.

Caution *Microdrives* are miniature hard drives that fit into the space of a CompactFlash card and are inserted into your camera in the same way. They typically are a bit less expensive than a flash card, at least if you consider how much space one will hold, which is usually substantial. However, I don't recommend these cards for any fieldwork, and especially for sports, because they are fragile. If you drop a CompactFlash card, nothing will happen to it; with a microdrive, that could be the end of it!

Storing photo files on CD-R/RW and DVD discs

These days you can choose from CD-Rs (readable only), CD-RWs (readable and writeable), and DVDs for backup, distribution, and display. Discs have become common and cheap, available nearly everywhere. However, not all are created equally, and although you may save money by buying a big stack of cheap CD-Rs, for each one that fails in the writing process, you lose your cost savings. For example, I purchased a stack of 100 off-brand CD-Rs from an office supply store to copy and distribute slide shows. I found that about one out of every five failed in the writing process, which made an inexpensive price more expensive because I had to re-ship discs to people in various countries. Paying a little more for name-brand discs like TDK, Fujifilm, or Memorex is worthwhile. Also, if you have the time, verifying your files (which is automatic with some CD-burning software applications) is a good idea.

CD-RWs are rewriteable, although I find these more expensive discs to be a bit persnickety: They must be formatted, they aren't always compatible with every drive, and they sometimes choke when you're trying to write to them. Furthermore, they can be erased, which is a distinct danger when dealing with a large stack of media — and also why you shouldn't use them for archiving and backing-up your files.

DVDs have become very popular for storing images because they hold so much data. Some now even feature a double-layer capability, virtually doubling their capacity. I find DVD-R to be a very useful and beneficial way to store data and images, as long as you store them very carefully. The last thing you want to do is have 4GB of images stored on a DVD that becomes scratched and useless! As with CDs, paying a bit more for a good-quality disc is worth the money.

You can also find archival-quality discs, rated for storage of a hundred years or more, featuring gold-plating and other enticements. I believe these are probably overkill for the average photographer; however, if you're really concerned about keeping files for the ages and don't think you'll ever be able to transfer them to something more down the line, you may want to consider them.

There are many, many tools for burning discs. The Mac market leader in these utilities is called Toast, and the PC standard is called Nero Express, and I haven't yet found a better tool. It tells you how full your disc has gotten so you can easily make adjustments, it is reliable across many burners and CDs, and it often is bundled free with various burners and PCs.

Summary

The digital studio is the center of all your sports photography, where you manage, review, archive, edit, prepare, distribute, and enjoy the fruits of your on-location labor. For many photographers, this is as much fun as actually capturing the action.

Setting up the studio, however, requires some forethought and quite possibly some expense on your part to put together the hardware, software, and online services you need. Understanding how images are processed and then put into physical or virtual form for your audiences is key to being successful. You want to get on top of the trends in computer and software technology just as much as with your camera equipment, and you should be aware of the many resources offered on the Web to help lessen your workload as it increases with your photography pursuits.

Whether you're an amateur, enthusiast, or pro, you *can* have a digital photography studio, and it's easier than you may think. Making the right choices based on what you need and how you may grow is essential to building a studio that's right for you!

✦ ✦ ✦

10

Working in a
Digital Studio

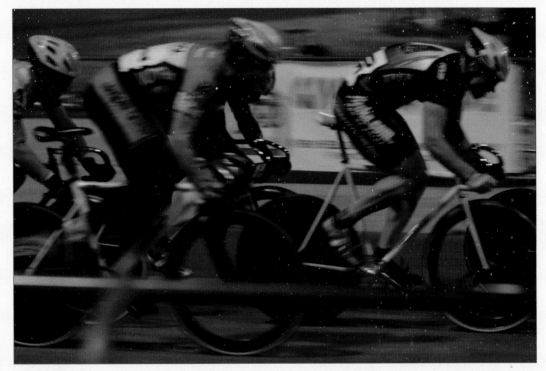

© Amber Palmer

The digital studio, or digital darkroom, as it's sometimes called, is an essential part of digital photography for amateurs, pros, and enthusiasts alike. And with digital virtually everyone has a computer and is at least potentially capable of processing his or her own photographs. While it's conceivable that you could simply have a digital camera and take your flash cards to a lab to be printed, it's by far the majority of photographers who process them to some degree on the computer first.

Figure 10-1, for example, is a photo I shot of U.S. Olympic and World Champion foil fencer Emily Cross winning a gold medal at the 2005 Junior & Cadet World Fencing Championships in Linz, Austria. The image is okay, but it could use a little improvement in the digital studio, such as cropping and sharpening. So, with just a little work in the digital studio, the final version emphasizes the subject much better, as you can see in Figure 10-2.

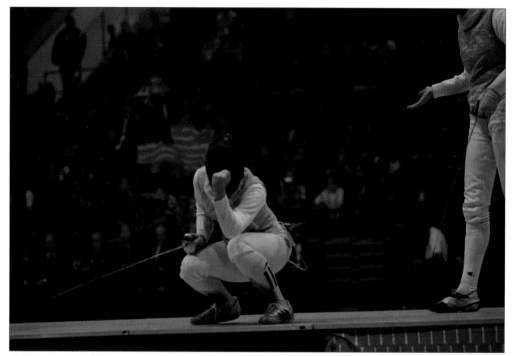

Figure 10-1: Emily Cross wins a gold medal. But the shot could benefit from some editing to really make it shine.

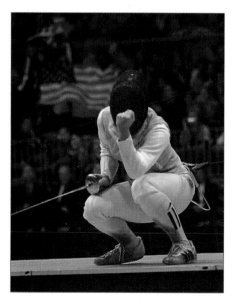

Figure 10-2: This the same photo of Emily Cross after being edited using sharpening, cropping, touch-up, and brightness/contrast levels tools to refine it for publication. You couldn't even see the American flag before the adjustments were made.

Going out and taking the photos is only half the battle in digital photography. Once they're safely in your studio, you begin the often laborious — but rewarding — process of backing up, archiving, editing, managing, and enhancing the photos you've taken. Take a look at what this involves, including the various stages of digital photography workflow, as well as the resources such as hardware and software applications that you'll want to have and to use.

Deleting and Transferring Images

One of the most challenging and important factors in processing sports photographs is being able to manage and catalog them so that they are protected, yet readily accessible. If you're a prolific photographer, this may mean managing lots of photos; for example, I have more than 400,000 photos of fencing alone, not to mention the photos the cities where the fencing events where held. Obviously, if you're a casual shooter or even a semipro, you probably won't generate this number of images. But with digital sports photography you tend to take more photos because you often shoot on a multiple-exposure setting, taking as many shots as possible to get the right angles, action, and exposures. This means being able to store and locate the images later.

Deleting photos safely

You're bound to decide after looking at your photos on the camera's LCD, that some of them are unusable. Should you delete photos on the camera or on the computer?

This is a tricky area. If you delete the images on the camera, you won't have to deal with them later and you'll keep a bit more space open on your flash card. However, what if you accidentally delete a photo you want? Worse yet, what if you inadvertently click the wrong setting and delete all the photos on the card instead of just the one?

Here are some tips to remember when considering deleting images when still in the field.

- ✦ When you have extra time — waiting for the next inning to begin, for example — look at the images on your camera's flash card and consider deleting *obviously* bad ones.

- ✦ If you are uncertain about a photo, *don't* delete it. Camera LCD screens are known for notoriously poor quality, and you may end up getting rid of a photo you really wish you had later.

- ✦ Don't just delete a photo because it looks *soft* (blurry). There are ways to artistically treat soft images to make them look very nice — which is covered later in this chapter.

- ✦ Remember that deleting photos leaves numerical gaps in your camera's file-numbering system, so don't be surprised later if you're missing some files!

- ✦ Use your camera's zoom, if it has one, to look at images up close to see if they're usable. I often look for the *catch lights* — the white twinkle — in peoples' eyes to see how well the image is focused.

- ✦ Don't delete photos because someone's head or feet have been cut off. These can often be edited further to create a tight and interesting shot.

- ✦ Don't be in a hurry. More than one photographer has deleted an entire card without meaning to because he or she was in a hurry and pressed OK instead of Cancel.

- ✦ If you are running out of room on your only remaining flash card and you must delete an image, look for very obviously bad, unimportant, or redundant images to delete.

If worse comes to worse, you can acquire rescue software for deleted files. Some of the more expensive and high-speed flash cards even come bundled with it, and it can get you out of a digital pickle if something goes wrong. Some even claim to be able to rescue images from cards that have been formatted.

Tip Check out a couple of these so-called rescue software packages for yourself: Lexar Image Rescue Software (which also comes bundled with some Lexar flash cards) or RescuePRO File Recovery Utility from LC Technology (also comes bundled with some SanDisk flash cards).

Transferring images safely

There are very definite steps that you take in moving your images from the camera to the computer and processed to a state of readiness. In virtually all cases, you'll want to know how to get your photos from the field—meaning from a flash card or a portable storage device—to your computer safely, uncorrupted, quickly, and ready to be processed in your digital darkroom. Then, you'll want to process the images, including renaming them (if necessary), storing and archiving the ones you want to keep, readying them for digital treatment, categorizing files according to events and subjects, and ensuring they are sized to the dimensions and resolutions that will be optimal for your needs.

At that point, you can begin editing your shots, which means everything from cropping and adjusting contrast and lighting to adding text or other decorative elements. Finally, you may want to get creative and try your hand at artistically treating sports photos to make them look like a painting or treating them with a variety of digital effects.

Let's take a look at these areas.

Moving sports photos from field to computer

If you don't shoot many photos at your sports event, or you have a large flash card, everything may still be on a flash card when you return to your computer. A 1GB card, for example, can hold approximately 600 photos taken at a medium megapixel size. If that equates to about four or five megapixels per image on your camera, it means you'll have shots that are good enough to be enlarged to 8×10 prints before you begin to lose quality.

You may also have photos stored on a portable storage device such as an ImageTank. Also, some of the new MP3 players, such as Creative's Nomad Jukebox Zen Extra, are now sufficiently large to hold many photos and offer the ability to connect as storage devices for data files in addition to music (the Zen, for example, has a 40MB hard drive).

Tip If you're using a portable hard drive, make sure it supports FireWire or USB 2.1 connections; USB 1.0 is dismally slow.

Transferring your files to the computer is relatively easy if you know a couple of basic things. First, how you move files onto your system depends on how they're stored in the field:

✦ **Flash card.** If you have your photos on a flash card, you'll need a flash card reader connected to your computer. Insert the reader's connector into your computer's USB (or, in some cases, FireWire) port. Put the flash card into the reader and it will appear on the computer like another hard drive.

✦ **Direct from camera.** Most cameras come with a cable that lets you connect directly from the camera to the USB port. The cable plugs into a small USB connection on the camera. Once the cable is connected, the camera essentially acts like a flash card reader and appears as a virtual hard drive on your computer.

✦ **Portable hard drive.** A portable hard drive also connects to the computer's USB or FireWire port. It appears as a hard drive and you can see the images on the drive, ready to be transferred to the computer.

You can use Windows Explorer or an image-editing package like ACDSee or Photoshop Elements to transfer images to your computer. Windows Explorer is a very simple but reliable way to transfer images; simply click and drag files from your storage device to your computer's hard drive. Image-editing packages are more elaborate and usually allow you to resize, renumber, rotate, and rename the files as they are transferred. You can also delete them from the source location.

Caution I consider it a bit risky to delete files as you transfer them; I prefer to transfer them and then delete them once I am certain they have made it safely to their destination.

File transfer tools and tricks

The biggest factor in transferring images is where they're going, more than where they've come from. Have a file folder that refers to your sports event ready to hold your new images, and make sure that if there are already images in it that there aren't any files with the same names as what you're transferring.

Some people like to use the My Photos subfolder of the My Documents folder that comes preconfigured with Windows. Others like to create a separate subfolder for photos or even several subfolders for specific events, for example.

If you store your images on a separate hard drive, create folders, as well. If you shoot lots of photos, storing them on your computer's main hard drive along with your operating system, applications, and other system information may fill up the drive quickly—especially if you use a camera that supports 5-megapixel or higher photos.

Caution Never stop a flash card while it is transferring images. This can permanently corrupt the images. Don't ever remove or unplug it unless you're absolutely certain it's finished.

I suggest you create folders to store your images based on event and be able to reference them by date as well. If you're shooting something more than just personal shots of friends and family members, you'll probably want to be able to reference files by player names, teams, or even specific games.

Processing Digital Sports Photos

Processing photos happens once you transfer your images to the computer and are ready to work with them.

Sorting and choosing

You may have done this when you first downloaded, but if you haven't already you'll want to separate your photos into logical groups that make sense for what you're shooting and for what you'll ultimately do with the photos. If you're just shooting shots for posterity of your son's or daughter's high school basketball game, for example, then your processing task is pretty easy—just eliminate the obviously bad photos, store the original files in a folder with a title that references the event, and then you can begin working with individual shots that you want to print or share.

For example, I took many pictures at the world fencing championships in Linz, Austria. I took several shots of Venezuelan junior champion Ruben Limardo receiving a World Cup medal from Rene Roch, president of the International Fencing Federation. So, when I began processing, I narrowed it down to the three I thought best (Figures 10-3, 10-4, and 10-5), and then had to decide on the one best image (Figure 10-5).

If you work with a larger set of images for more than just personal reasons, processing can become quite complicated and tedious. For example, if you shoot a college tennis match, the first thing to realize is you're going to generate hundreds of files from one day's shoot. You need to tag the images with keywords so you can sort them, possibly rename the files, and make sure you know who was playing in what match and to be able to access those files. Some cameras also allow you to add on-camera audio notes, meaning you can record a voice note onto the flash card using the camera; the note is associated with the image file. This can be handy for later reference and is a feature supported by most image-editing packages.

After a sports shoot, I typically sit down with all the images, and after I make an archival backup of the files, I make sure they are stored in subfolders for a specific event. Each subfolder represents an individual aspect of the event—a match between two players, one inning of a baseball game, and so on. Each sport will be different in how it is segmented and you'll want to logically match your subfolders to match the sport's structure and individuals. Remember, the key is to be able to process digital files into folders where you can most easily find and use them.

I suggest that you process the smallest number of photos possible to save time and keep your computer from choking on a giant set of images. Plus, doing anything on your computer in *batch* mode (processing many images at once automatically) will always take much longer for a big set of images. As a result, the next task is to find your best shots. This may sound easy, but unless you've done this in one sport for many thousands of shots, it's more difficult than it seems. Assuming you have several hundred photos in one subfolder, you probably need to pare down the set to as few as five to 20 shots—which means you have to be quite brutal in eliminating photos.

Figure 10-3: I discarded this photo because the fencer was looking down.

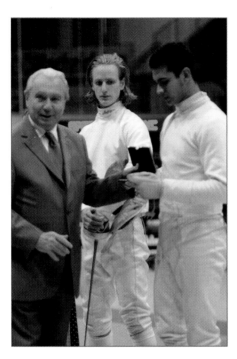

Figure 10-4: In this image, Limardo is also looking down, and the shot is a bit too busy.

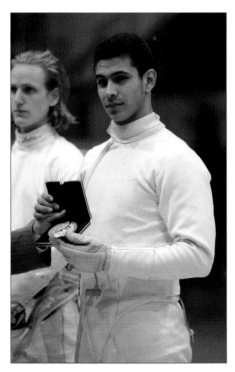

Figure 10-5: In what I determined to be the best of the three and the one I used, the champion is looking at me and holding the medal.

Prioritizing

When prioritizing photos, you don't need to erase the bad ones — just choose the best ones. Here are some tricks for doing this:

✦ Try not to select multiple shots that are redundant; you don't need several shots of the same swimmer poised to dive. Try to find the one that looks the very best, whatever that means to you — perhaps it's the athlete's position, the look on his or her face, or subtle differences in how the light is falling.

✦ Look for interesting action shots and movement — someone falling, a ball hitting a racket at just the right moment, or two athletes colliding on the field.

✦ Find classic sports shots, especially if you're shooting for a sports organization. For example, while a newspaper or magazine might want cool action of athletes contorted in seemingly impossible moves, a sports club or federation may only want to properly represent the sport with approved moves and actions.

✦ Personality and drama are always welcome — wins and losses, injuries, players celebrating together — and you may need to get quite close to the athletes to take these images. However, quite often this type of shot takes place immediately after play has ceased; it's when you see photojournalists and fans together running onto the field or court to rush the players. Even at a particularly important peewee football game, you'll want to be ready to do this to catch some cool shots of players.

In most image-editing applications, you can flag or prioritize the images you find to be the best. These images can be sorted separately from the others and you can store them in a subfolder *of* the subfolder, called something like chosen shots or something similar. This way, you have the best shots in a subfolder of each logical division of the sport you've covered; later, you can eliminate the unwanted shots, if you like — or just keep the subfolder structure the way it is and reference the chosen shots as you find necessary. In Figure 10-6, I use the number/rating feature in ACDSee to prioritize images.

Checking file sizes

Another important aspect of processing photos is ensuring the files are sized to bite-sized chunks. Many cameras — even relatively inexpensive consumer models — can shoot at high-megapixel rates today, which means the files you generate might be larger than you'll need and larger than images shot at lower resolutions. When you process images, you may want to resize a group of them to create a more workable set of files. Also, remember that TIFF files, while they are lossless, are much larger than compressed, lossy JPEG files — and, for most typical photography purposes, JPEG files are absolutely sufficient.

If you produce large prints, you need relatively large files, and you may not need to resize them. However, if you don't print anything larger than an 8×10, or if the images are to go onto the Web, then you definitely don't need images that are very large. Most Web images shouldn't be bigger than 72 dpi (screen resolution) and maybe 3-x-5 inches or so. Chances are the images coming out of your camera will be larger than this.

I think ACDSee, Paint Shop Pro, and iView Mediapro are the easiest applications for accomplishing this sizing task (plus, if you work with Windows, Adobe only offers it in Photoshop CS). ACDSee also gives you a number of options as to how you resize photos, as you can see in Figure 10-7. It lets you resize according to specific dimensions or by a percentage, and you can easily maintain or change the *aspect ratio* — the proportion of width to height. In Figure 10-7, I'm resizing a batch of photos in ACDSee.

Figure 10-6: Prioritizing files in ACDSee

Note
Remember, once you resize images to be smaller, you need to go back to the archive set of photos you made earlier to start again with the bigger image. If you try to enlarge the already reduced images, you won't be able to make them bigger again without causing jaggies (jagged, blocky edges and patterns).

Renaming

Finally, you may want to rename the images that have been put in order and processed. This is so that individual files can be referenced by something other than a number and, like keywords, allow you to easily sort and reference them. You can rename individual files if you don't have too many of them, but you can also batch rename files easily in applications like Photoshop Elements and ACDSee.

Caution
It's easy to rename files — even large batches of them — using various image-editing applications. However, if you've already backed-up and archived your files elsewhere, you'll want to be careful to keep the original file number at least as part of the renamed file so that you can refer back if you need to. This is especially true when you're working with large numbers of images, where comparing sets of photos could be extremely tedious. And it's difficult, once you've renamed files, to put them back to their original sequence.

Figure 10-7: ACDSee's batch feature for resizing images saves time and tedium.

Renaming typically involves renumbering and/or adding text. If you have a set of images that has been selected from a variety of locations, you may want to renumber them into a 1-2-3 order. Or, you may want to simply add a text reference in the filename that allows you to know these images are all common: For example, you may have gold-medalist players from a sport spread across multiple files; by adding the word "gold" to the filename, you can search a large set of folders all at once for that term, and those files will pop up.

I suggest that you keep your *original* file number—or at least a critical portion of it—when you're renaming images. This way the files can still be easily referenced-back to your archived originals. You can still add a different chronological pattern of numbers, however, so you can have the best of both worlds. For example, Table 10-1 shows some renaming ideas for series of files (one from a family ski trip to Aspen, and one from a soccer match between the Chargers and Strikers).

In Figure 10-8, you can see how to rename files this way using Photoshop Elements. Most image-editing applications use a system for renaming that requires you to type a special symbol or series of symbols (for example, ###) for the computer to recognize a number series; in many applications, you can also begin at whatever number you want — you don't have to start at 1 and go up; you can begin with another digit, as shown in Figure 10-8.

Simply placing images into named folders is a faster and easier way to reference, store, and access images; however, this may not always make sense, especially if you tend to combine photos onto other media like CDs or if you need to search frequently for individual shots.

Use Image Keywords for Easy Organizing

Every digital image has what is called metadata associated with it. For example, a JPEG image that comes out of your camera has information specifying the camera with which it was shot, the focal length of the lens, the shutter speed, the ISO, the f-stop, and much more. In addition, you can add keywords in most applications that let you store specific information about the image. ACDSee (shown here), iView MediaPro, and Photoshop Elements let you easily manage and create your own keywords; you can sort your files according to these keywords, and you can do a search for them using one or more keywords. (While you can view a file's keywords in Photoshop Elements, only in the Mac version can you actually change them. Hopefully Adobe will add this feature in future versions. It is a feature in the Windows version of Photoshop CS.)

Using keywords means being logical and using words that help anyone who needs to access the image locate and sort them according to whatever appropriate names may be necessary — too many make it overly complicated and too few do not allow easy location of key images.

While metadata is transferable from one application to another, be aware that it's not necessarily true of keywords. If you use them in Photoshop Elements, for example, they won't appear in ACDSee but you can see them in iView MediaPro. So if you use multiple image-editing or storage/archival applications, this is something you'll want to check.

A big part of processing digital images is arranging them in a logical order that lets you sort and access them easily over time. Using keywords is an excellent way to do this.

Table 10-1: **Suggested File Naming Schemes**

Original File Name	New File Name
HT70034.JPG	Aspen 2005 0034.jpg
HT71024.JPG	Aspen 2005 1024.jpg
HT79021.JPG	Aspen 2005 9021.jpg
IMG_2265.JPG	Falcons-Strikers 2265 001.jpg
IMG_3569.JPG	Falcons-Strikers 3569 002.jpg
IMG_3999.JPG	Falcons-Strikers 3999 003.jpg

Figure 10-8: Renaming images in Photoshop Elements

Storing and Archiving Digital Sports Photos

There are a number of ways to store photos, and many times this is driven by how you access those images. For example, if you shoot lots of photos but you don't need access to all of them on a day-to-day basis, then it might make sense to burn them onto a DVD or CD and keep them in a disk envelope. However, if you need to access many different images created over long time periods, then you'll also need to keep

them in *live* storage — most likely on a hard drive(s) (as opposed to being stored on a CD or DVD and not immediately accessible without locating the disc and loading it into a drive).

For most people, hard drives are the best choice for storing images. While you can easily store photos on external or internal hard drives (large storage capacity has become very affordable, usually less than $1 per gigabyte), there are a few things to keep in mind:

✦ Hard drives are machines with working parts, and they can fail. So it's good to have a nonvolatile (meaning they won't fail as long as they're stored properly) backup of what's on them, such as on DVD.

✦ If you have particularly important images on a hard drive, store them in a secure place — just as you would jewelry or other valuables — when you are gone, such as a safe-deposit box.

✦ Use USB 2.1 or FireWire hard drives.

✦ External hard drives are more portable and don't involve internal PC storage, although they are a bit more expensive.

✦ Some external hard drives are more portable than others based on size, weight, and durability factors.

✦ FireWire-connected drives can be connected from device-to-device in a chain, meaning you only need one connection to the computer.

✦ Some external hard drives can be combined so that you can stack them together and use only one USB cable and power cable. The RocketPod drives, for example, are high speed and have a docking port on the top and bottom of each; you can plug any one of them into the computer and still access all of them. This is a very convenient and space-wise method for adding storage.

When storing data on a DVD or CD, you'll need a burner. Most laptop and desktop computers today ship with at least a CD burner (identified by a CD-R/CD-RW symbol), and many also burn DVDs (DVD-R and DVD-RW). DVDs hold much more data — some up to 7GB or more using a new double-layer technology; they are quite reliable and durable. CD burners are much faster, writing at speeds of up to 40x and more; DVD burners are commonly 8x but are getting faster all the time. You can purchase external and internal burners if your computer doesn't have one; DVD burners almost always also support CD burning.

Cross-Reference Also see Chapter 9 for more information about building a digital studio and the equipment you'll want to consider using.

Tip Be careful about buying CDs and DVDs because the quality varies significantly. Sometimes the cheapest, no-name discs can have a high failure rate; it's better to spend a bit more and get a reliable product from a known name such as Fuji, Maxell, Memorex, or TDK.

There are a number of software applications available for burning CDs and DVDs, and oftentimes if you purchase a burner, the software comes bundled with it. While you can use the software that comes with Windows — Windows Explorer — to burn discs, it's not the most convenient application. Products like RecordNow and Nero Express are both very reliable and offer some really nice features such as showing you if you're trying to put too many photos onto one disc, options for choosing different burners you may have attached to your computer, options for copying multiple discs and saving the burn project you're doing, and the ability to verify that the disc burned correctly.

Figure 10-9 shows RecordNow in action. A number of conveniences like the ability to verify a successful (or unsuccessful) recording, easy audio or data recording, and a fullness meter make burning CDs and DVDs faster, more reliable, and convenient.

Figure 10-9: Using RecordNow to burn a batch of images to CD-R

Some software lets you do one-touch backups that intelligently know what you've already stored and what you haven't. This is convenient, although I tend to still do things the old-fashioned way of manually copying files and backing them up; I guess I'm a bit nit-picky and want to be 100 percent sure the files have been copied and are the ones I'm storing.

Using a catalog system of thumbnails, it's easy to move photos around and manage them without having to view full-size images, as you can see in Figure 10-10.

Products like iView MediaPro allow you to use a catalog system to manage all of your photos. Most photographers are visually oriented and want to be able to see the shots in thumbnail form, which tends to be an easy way to be sure the shots you took are in the place you want them to be. iView's system is very easy to use. Because it creates thumbnails of images, you don't have to view full-size images — which tends to slow image viewing down. However, you want to be sure that whatever photos you need to review that have been archived are on a hard drive, CD, or DVD that's attached to the computer when you're reviewing and working with them (otherwise, you're just working with the thumbnails).

Using Windows Explorer can be a quick way to locate a file, although large images, such as TIFs, tend to be slow to display on all but the fastest computers. Furthermore, you can't see images in RAW. I use Windows Explorer to reorganize files sometimes because it's a simple and easy way to move folders and large numbers of files. However, it won't rename batches of files so you'll need an image-editing or archival/storage package to do so.

Figure 10-10: A catalog of digital sports image thumbnails in iView MediaPro. Note how the keywords and image captions are displayed alongside the file for easy notation and identification.

Photoshop Elements and ACDSee are good tools for viewing images; however, they can be a bit slow when it comes to managing them — for example, copying them to a different subfolder and other similar tasks. Every time you access a subfolder in the Photoshop Elements image browser, it generates a preview of the image. Once all the thumbnails are fully loaded, you can skim easily through a large set of images in a subfolder, as shown in Figure 10-11. However, while the thumbnails are loading they appear jaggy (rough and blocky) before displaying at full resolution.

So for storing and archiving images, it's a good idea to know how to use Windows Explorer and your image-editing application in concert or use a dedicated archival and image-editing tool like iView MediaPro. Either way, getting on top of how your images are safely and easily stored and accessed is a key part of digital photo processing and being able to successfully manage the post-photo-shoot aspects of your digital photography workflow.

Figure 10-11: Photoshop Elements lets you preview thumbnails and enlarged photos before opening them for editing. Here, an irate Ukrainian coach argues with a referee's call at a world fencing championship.

Editing Digital Sports Photos

Few of your images will come out of the camera ready for distribution or display. As they are most likely sized incorrectly, you'll want to make sure the photos are the right width, height, and resolution — as well as file format. Next, they will probably need a little correction in terms of color, shadows and high-lights, and brightness and contrast. They also may need to be cropped. Then, once these factors have been addressed, you may want or need to do some touch-up editing, such as sharpening, facial/blemish removal, or removing or changing minor (or maybe major) factors in the image to perfect it.

This isn't creative work, per se. We get into that in the next section when you get going on some fun edits to images. Image editing is more of a nitty-gritty task with which you'll need to accustom yourself to ensure the photos you intend to use are truly ready for prime time.

A typical editing scenario

Providing photography services at a major world fencing championship in Linz, Austria, I was approached by the president of the Japanese fencing federation to do a photo shoot of its fencing delegation of about 30 people. I assumed she wanted to schedule the photo session for later that day; as it turned out, she said the delegation was ready immediately. So I followed her to a point in the venue where, lo and behold, the entire delegation was waiting for me, posed perfectly (usually this is the time-consuming part). I took several photos, and went back to my booth.

The delegation leader came to the booth and on the spot ordered an 8-x-10-inch print for each member, which I could print on-site. "A quick sale," I thought and assumed I could just make sure the color and brightness were good and I was ready to go. Figure 10-12 is the one she chose.

Figure 10-12: This is the original photo chosen by the Japanese delegation leader—a nice shot, but one that needs some editing work.

Notice the left-most member with his eyes closed? What about the sign above the group is cut off? Additionally, I had to add text to the photo to customize it for the delegation.

To clean the chosen image up, I took a copy of the cut-off sign from another image, and used the Duplicate Layers feature of Photoshop to paste it into the chosen image. I then used various editing tools to clean it up so it looked like it belonged there.

Next, using the Lasso tool, I copied the blinking fencer's face from another image where he wasn't blinking. I then pasted it into the first image, covering precisely his face with the face from the other shot. No more blinks!

Finally, I cropped and sized the photo to an 8 × 10 (I could have done this at the beginning to both images, but decided to do it in a larger size to have more detail at my disposal), played a very little bit with brightness and contrast, and then added text to the bottom of the photo to customize it. Voila! The image was ready to be printed, as shown in Figure 10-13.

While this is a professional example—you may not have an entire foreign delegation depending on your editing skills on short notice—many of the tasks I addressed in this example are ones you'll encounter in day-to-day image editing.

Figure 10-13: The Japanese federation photo, ready to print!

Photo sizing

Depending on how your camera has been set, it stores different-sized photos, usually in JPEG format (some cameras will store in TIFF and/or RAW). JPEG files are compressed to ensure the storage space they occupy is as small as possible, but each image is a specific width, height, and dpi (dots per inch, meaning resolution). Making the file larger than its original size quickly degrades the photo and makes it appear jaggy. This is a result of the software you're using *interpolating* or adding information between pixels that wasn't there originally. Figure 10-14 shows how an image that is enlarged beyond the size it came out of the camera causes a jaggy effect.

Take a brief look at image size and resolution to help you understand how digital images are constructed. Many cameras produce files that are quite large in dimension, but only 72 dpi, which is the right resolution for the Web but not for printing in a lab or on your printer. For this type of printing, you'll want your images to be 300 dpi. Every image is sized according to a grid of pixels — tiny picture elements of individual colors and shades — that make up your image's size.

Take a look at Figure 10-15.

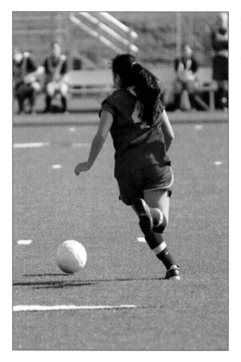

Figure 10-14: This image, originally shot at 14-x-9 inches and 240 dpi, was reduced to a 3-x-4 image at 72 dpi. Then it was enlarged again from that file to the 4 x 7 at 300 dpi.

Fresh out of my camera, you can see the image dimensions listed with the photo in the Image Size dialog box. You can see there are two separate dimensions shown—one of pixels (pixel dimensions) and the other of width, height, and resolution (document size).

The pixel dimensions show how many pixels are in the photo, given the dots per inch combined with the width and height. These factors are forever intertwined. Consider the following:

✦ If you multiply 72 dpi times the width of 43.111 inches, the result is 3103.99, which is the pixel width of 3104 (rounded).

✦ If you multiply 72 dpi times the height of 28.778 inches, you get 2072.02, the pixel height (rounded).

✦ If you change the dpi to more than 72, but you don't change the height and width, the pixel dimensions will go up.

✦ If you multiply the pixel dimensions by each other, you'll get the megapixel size of the photo (3104×2072 = 6431488, or 6.4 megapixels).

✦ If you change the pixel dimensions, then the height and/or width change accordingly.

✦ If you make the image smaller by changing the width and height, the resolution will go up—which is what you'll want to do to print on your own printer. This won't affect your photo visually.

✦ If you make the image bigger by changing the width and height, and you keep the dpi the same, the image becomes physically larger and the dots have to become bigger to interpolate the image artificially—which often causes the image to be distorted. This is also called *resampling* the image, and many editing packages give you optional ways of doing this.

Figure 10-15: A full-sized photo of a swimmer as opened in Photoshop Elements just after downloading from my camera

In Photoshop Elements, for example, you can choose to keep the ratio between the document size—width, height, and resolution—at a constant ratio, which can let you increase your resolution, and your image size will decrease accordingly. To do so, deselect the Resample Image option. Then the Width, Height, and Resolution are locked together. If I take the same example from above but deselect the Resample Image option and change the resolution to 300, the result is the shown in the Figure 10-16.

As you can see in the Image Size dialog box, the image changed to 10.347 × 6.907 inches, but the pixel dimensions remain constant. This means I basically have the same photo, but at a different resolution and physical size optimized for the resolution I need. What I've done is resize the image so that it's optimized for printing on an inkjet printer, or to send to a lab.

If I were going to use this photo to put onto a Web site, my original resolution of 72 is what I will want to use because screen resolution—what you see on your computer screen—can only display up to this size. In this case, I *would not* deselect the Resample Image option because, if I do, it will not be possible to make my photo small enough for the Web. If I change the physical size—say, drop my 43 × 28-inch image to a width of 4 × 2.67 inches, I want my resolution to stay the same (72 dpi); if I keep Resampling turned off, the resolution jumps to 776! This, then, becomes a very small file, which is what you want for storing and loading quickly onto a Web site.

So, resizing images largely depends on whether you intend to put them on the Web and computer screens or onto paper. If they're going to be printed, they need to be higher resolution, and if they're going to be on the Web or a screen, they need to be smaller. An image that's too small that's enlarged on paper will be distorted and jaggy; an image that's too big and placed on the Web will be unwieldy and take a long time to load.

Figure 10-16: The image resized to 300 dpi without resampling.

Tip

If you're submitting photos to a newspaper or magazine, make sure to send them in the larger (for print) size. While the publication may also put it on its Web site, it can always downsize the image to Web resolution; an image sent in Web resolution will not be able to be enlarged for print without becoming distorted with jaggies.

Before going on to the next topic, you might want to note that labs often have a way to make images larger than their original size and still look good. I won't go into deep technical detail on this topic, but suffice it to say that various high-end printers have technology that allows them to enlarge images without distortion. Another method involves actually projecting a digital image onto chemically processed, traditional photographic paper, thus bypassing the resolution limitations.

Correcting images

As I've mentioned, there are few images that need no correction at all. While you may have set your white-balance correctly along with your exposure, few photographers take the image straight from the flash card to printer.

That said, on occasion when I'm in a hurry to print a photo—such as at a big tournament where I'm providing lots of images to many customers—I print images directly from a flash card. However, the printer I use in a tournament vendor booth (in this case, a Canon Pixma 6000—a wonderful little printer that costs less than $200) lets me make minor image adjustments on-the-fly. However, I have to be pretty darned certain that the photo is close to being perfect in terms of brightness, contrast, shadows, highlights, and

color in order to do this. Also, I obviously cannot add text or other features to the photo like I could if I had processed it in an image-editing application first.

The tool that will help you the most when determining the level of editing an image needs is the histogram. Many people rely on their camera's display of a histogram to ensure the highlights and other light/dark features of an image are correctly balanced. Many digital cameras, including the better point-and-shoot models, can display a histogram and it can be very useful in helping you know your shot is correctly balanced — no matter how good or bad your LCD screen might be.

Checking your histogram on a test shot when you're shooting an event will help ensure your photos are well exposed when you get them into the computer.

The same histogram, then, is displayed in various image-editing packages, such as the one you can see in Figure 10-17 in ACDSee. The histogram features three major points: shadows, midpoints, and highlights. These are the three areas of a photo that make up full tonality; an overexposed or underexposed photo will have very flat points in a histogram, while one with full tonality will have points distributed throughout the display.

Shadows are the area of your photo that are completely dark. Highlights are those that are completely light. Midtones are the areas in between that represent the substantive subject of your photo. Together, these factors work in concert to portray a well-balanced image.

Figure 10-17: The histogram in ACDSee

The soccer photo in Figure 10-18 shows a histogram for the youth soccer shot, as displayed in Photoshop CS2 (it looks very similar in Photoshop Elements). The left side of the histogram represents shadows; the center represents midtones (often the largest part of your histogram); and the right represents highlights (the most lightly exposed area). None of the areas is particularly flat or without features. The three main slider points in the histogram represent, from left to right, Shadows, Midtones, and Highlights — which can all be adjusted on-the-fly.

Every histogram displays differently for different photos; none is the same as another. And the histogram changes for every adjustment you make to brightness, contrast, shadows, and so on. In higher-end image-editing packages such as Photoshop CS2, you can also look at the histogram on a color-by-color basis (for example, Red, Green, and Blue). However, what you're looking for are major features of the histogram to be within a reasonable scope to be sure you've got good, broad tonality.

Tip A histogram will not tell you if your colors are well balanced or if your photo is in sharp focus!

The histogram feature in Photoshop Elements, found under the Image menu, isn't as detailed as the one you find by choosing Layer ⇨ New Adjustment Layer ⇨ Levels, as shown in Figure 10-19. This is a true histogram giving you all the levels you need to make adjustments to the photo.

© *Terrell Lloyd*

Figure 10-18: In this soccer photo, note how the histogram displays full tonality.

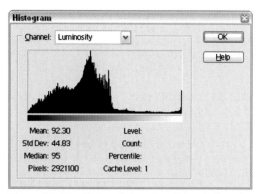

Figure 10-19: Click and drag the sliders below the histogram to make adjustments to the image in the three areas represented — Shadows, Midtones, and Highlights.

But what if you tested your histogram when starting your event shoot and the images are still not exposed correctly?

Brightness, contrast, and color are the three most common areas you'll be working with when making adjustments to a photo. Most image-editing packages offer a quick-and-easy way to do this using Auto Levels, Auto Color Correction, and Auto Contrast, as in Photoshop Elements. These sometimes work well and are worth trying if you have a monitor that's been color-corrected and you're pretty sure will displays the image similarly to how it will be printed.

I sometimes find that all I need is Auto Contrast. Often, if I let the computer do color correction — either with Auto Levels or Auto Color Correction — it isn't able to give me precisely what I want; however, Auto Contrast seems to be quite effective.

Enlightenment about Brightness, Color, and Contrast

Brightness refers to the overall amount of light in your photo (as opposed to highlights, which are just the lightest parts). Increasing brightness makes your photo look overexposed; decreasing it makes it darker.

Contrast is the difference between dark and light areas of your photo; it refers to the midtones of the image — which is always a balance of dark and light areas.

Color refers to the mix or basic combination of Red, Blue, and Green in your image that makes it a fully colored photograph in a video display. This is done by specifying percentages of each color — the higher the percentage a color takes of a color combination emphasizes the lightness of that color. When printing, your photo is composed of cyan, magenta, yellow, and black — CMYK. Some image-editing packages let you convert a photo from RGB (which is how it originates in the camera) to CMYK to optimize it for printing; for example, if you're taking your photo to a professional printer (to create a brochure, for example) the printer may require the image to be in CMYK.

Caution Once you save your original with changes, there's no going back. So, you should never do a correction on the original image. You can create a duplicate layer or add an adjustment layer and make changes on the new layer. That allows you to use various blending methods. With the adjustment layer, you can make change after change without hurting the original image. And remember, original refers to your working image — not the archive of the file that came from your camera; that should never be altered!

To get more detailed, you can use the histogram and begin to edit images at a deeper level; I suggest you play with some test images in the histogram and see how the Shadows, Midtones, and Highlights adjustments can make a difference.

Also, in Photoshop Elements, you can use the Quick Fix dialog box that presents many of the adjustments and lets you make them while seeing the results before they are applied, as shown in Figure 10-20. This can be very helpful and is a great way to get to know how images can be adjusted in various ways; it also contains some handy tips for what the various effects do and how they can be effectively used and manipulated.

Figure 10-20: Adjusting the test soccer photo using the Quick Fix dialog box in Photoshop Elements

Here are a couple of other areas of image-editing controls you'll want to use to explore and experiment with your photos, all of which are available in Photoshop Elements.

Backlighting

This emphasizes the shape of your subject, when, for example, the background behind a subject has been overexposed. Say you've taken a photo of a baseball pitcher standing on the mound, ready to pitch. Behind the pitcher, the sun is shining brightly, but you've accounted for this by exposing your camera for the pitcher, not the background (you can do this by setting your exposure based on a darker area of the baseball park and then applying that exposure to the scene in a manual mode on your camera). Once you have downloaded this photo, however, you may find that the background — the part for which you didn't set your exposure — is overexposed. Using the Backlighting feature in Photoshop Elements, you can darken the background to make it look better.

Fill flash

This software filter does the opposite of backlighting. If you didn't expose your pitcher photo correctly and the background looks good but you can't see detail on his uniform or face, then Fill Flash can help fix it. One way to compensate for backlighting is to use your flash—even on a bright day—to illuminate a scene like this. But, if you are too far away when taking the photograph for the flash to have any effect, the Fill Flash feature does this for you in the software.

Cropping

You most certainly will need to crop photos for many reasons. One is that you may simply have areas in a photo that you don't want or need. Another is that you may need to make sure the image is set to specific size requirements for printing. Either way, you'll need to crop your image, which means digitally cutting away parts of the photo.

In Photoshop Elements, you have two basic ways you can crop an image:

✦ **Rectangular Marquee, Elliptical Marquee, or Lasso tools.** You can draw a shape around the area you want to crop. By choosing Image ➪ Crop, only a rectangular shape (for any of these tools) defining the area you outlined remains; all else is discarded. In Figures 10-21 and 10-22, I've taken Will Wissman's photo of a mountain biker and cropped it using the Elliptical Marquee tool. You can see how, even with an elliptical shape drawn around my selection, a rectangular shape is still cropped to fit the photo's dimensions; only with the Rectangular Marquee tool will the precise elements of your selection be retained/discarded. Once you crop the photo, your dimensions will change (choose Image ➪ Resize ➪ Image Size).

✦ **Crop tool.** You can cut an image down to specific dimensions and resolution. This is very helpful if you're working to get a photo to a specific size for printing, such as a 5 × 7 or 8 × 10. In Figure 10-23, you can see I've specified 8 × 10 and 300 dpi in the space at the top of the page, and then outlined what I want cropped (the lighter area surrounded by the dashed line) using the Crop tool.

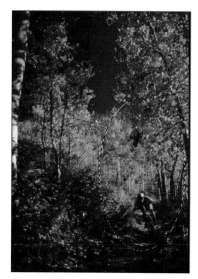

© Will Wissman

Figure 10-21: Outlining mountain biker Cory Saudabine using the Elliptical Marquee tool in Photoshop Elements

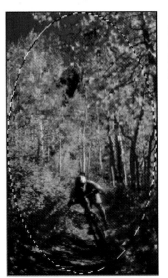

© *Will Wissman*

Figure 10-22: By choosing Image ➪ Crop, the image is cropped to fit the elliptical space, plus the extra space it takes to make the image fit a rectangular, standard photo shape. Cropping with other shapes is also possible in Photoshop Elements using the Cookie Cutter tool.

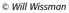

© *Will Wissman*

Figure 10-23: The original photo of mountain biker Cory Saudabine cropped using the Crop tool with 300 dpi, 8-×-10-inch photo defined

Tip Be careful that you don't select a small portion of the image and enlarge it by cropping. If you have an 8 × 10 image at 72 dpi and crop a portion of it to 6 × 9 at 300dpi, you'll have a pixellated mess on your hands!

Tip Some printers and software applications will automatically resize your image to a defined paper size and/or image size at the time of printing. While this is very easy and often works well, note that it essentially is an automatic way of cropping your photos. If you're not careful, key elements at the outer edges of your photo may be cut off based on the original image size and what is being printed (if the aspect ratio between the two is different).

Photo Touchup

Photos are seldom perfect, and neither are the subjects you shoot. Perfecting photographs becomes something of an obsession for some photographers, and the software tools available today are extensive and powerful. Portrait photographers become specialists in tasks like facial touchup to remove blemishes from high school seniors, making people look younger by removing wrinkles around their eyes or from their forehead and cheeks. Other photographers may have to remove parts of a photo they don't want, such as a power line obscuring an otherwise perfect sky, or add parts to a photo that they do want, such as a brand logo that should appear on a model's shirt in an advertising photo shoot.

In sports, touchup is often less of an issue because you rarely need to do facial retouching, and busy elements often enhance a photograph. Also, serious touchup requires tools available only in higher-end image-editing packages like Photoshop CS2. The Patch and Healing Brush tools are very intelligent features that are difficult and time-consuming to learn and use effectively. However, if you are at all serious about generating some income from your images, you should consider making the investment in Photoshop CS2.

Redeye tool

For most amateurs and enthusiasts, Photoshop Elements, ACDSee, and other mainstream image-editing packages will offer a good selection of touchup tools to experiment with. Red-eye, which is caused by a direct flash exposure reflecting off the back of the human eye, can be removed with some simple tools. In Photoshop Elements, the Redeye tool is available on the Tools palette, and it operates in a paintbrush manner. And, if you want to have a little fun, you can select the original eye color and replace it with another. In ACDSee, you select eye color from a list and then draw a little square around the part of the eye you want to correct, as seen in Figure 10-24.

Clone Stamp tool

For simple touchup of a blemish or other element in the photo (removing a soda can from a soccer field, for example), you can use the Clone Stamp tool available on the Tools palette of Photoshop Elements. For example, using the soda can example, you can sample an area of empty grass on the field and then stamp that onto the area where the can is. The tool intelligently blends the edges of your stamp so that it looks natural and doesn't have a cut-off look. You can adjust the size and type of the Clone Stamp selection brushes by right-clicking after selecting the tool. Play with this tool to try it out and get comfortable with it because it can be a bit tricky to use; you'll find that you can just as easily ruin a photo with it as fix one.

Figure 10-24: To repair the red-eye in this close-up candid photo of a French team coach, I used the red-eye removal selection tools in ACDSee 7.0, which not only provides various eye colors, but also has the ability to adjust the intensity of the change.

Sharpen tool and Unsharp Mask

Sharpening is another major tool offered in virtually every image-editing package. Like salt, it's best used in minor and measured amounts — too little, and it's unnoticeable; too much, and it ruins everything. If you have a photo where the subject is slightly blurry, you can sometimes repair the photo enough so that it appears to be in focus. However, you should be aware that sharpening doesn't actually make a blurred image focused; what it does, essentially, is increase the contrast among dark areas in your image and surrounding lighter areas. This has the visual effect of a sharper image, because it reduces some of the fuzzy qualities of the photo's elements.

To sharpen a photo in Photoshop Elements, you have a couple of choices. One option is a predefined Sharpen selection that automatically sharpens your image. Keep selecting the Sharpen tool, and you can keep changing the image until it's utterly distorted. Another and better option is Unsharp Mask (a term referring to a technique called *unsharp masking* used in film-based photography), which allows you to define a range of applied effect all at once. Choose Filter ➪ Sharpen ➪ Unsharp Mask to open a dialog box where you set values for sharpening your photo.

One thing you should note, in particular, is that the effects of sharpening are much more visible when displayed on-screen than what appears in print. This is because the resolution of printed pixels is much finer (300 dpi, for example) than on-screen (72 dpi).

Tip By selecting specific areas of your photo in Photoshop Elements with the Lasso or Marquee tools, you can just sharpen a specific area of your photo.

In the Unsharp Mask dialog box, you have three settings: Amount, Radius, and Threshold. The Amount slider lets you determine the amount of contrast for specific pixels; Adobe recommends 150 to 200 percent if you're going to print the photo (less if it's only being displayed on-screen). The Radius slider lets you be specific about the number of pixels you want sharpened around the edges of objects in your photo. The Threshold slider specifies how much different pixels will be from their surrounding area in order to be sharpened.

You need to experiment with these sliders on various images — see how they can help, and where they become too much for an image. When you find values that work well for a common type of image with which you might be working, then you might want to jot down the values you're using for Amount, Radius, and Threshold so you can replicate it in the future — at least as a starting place for a subsequent image.

Other useful tools

You'll find a number of other useful touchup tools that you may want to try. Photoshop Elements probably has the broadest and most intelligent set of touchup tools available in the mainstream consumer image-editing packages, although ACDSee has some powerful tools as well. Here is a selection of important Photoshop Elements features:

✦ **Eraser tool.** This tool erases anything you may have done that you don't want any more or that you added by mistake. You can adjust the size of the swath that is erased.

✦ **Step backward.** This isn't really a tool. This feature is how Photoshop and Photoshop Elements handle what other packages call "undo." It lets you go back several steps — even after flattening a layer or doing other seemingly irreversible actions. However, if you go back four steps, for example, and make changes, you can't go forward again. The changes you made and stepped back through are lost and will have to be done again. So, use this carefully to avoid losing work.

✦ **Blur tool.** This tool blurs hard edges by creating a softer look and reducing detail.

✦ **Sponge tool.** This tool changes the color saturation of an area that you've dragged over.

✦ **Dodge tool.** This tool creates a lighter effect over an area.

✦ **Burn tool.** Use this tool to create a darker effect over an area.

✦ **Gradient tool.** This tool allows you to gradually blend multiple colors.

✦ **Paint Bucket tool.** Use this tool to fill an area with a given color.

✦ **Selection brush.** This tool lets you select areas of an image with many types and styles of brushes.

Rotation

If you've shot a photo that isn't quite straight, image-editing applications let you rotate it. This is also useful if you want to turn a sideways image right-side up. Choose Image ➪ Rotate ➪ Custom to specify very precisely how much you want a photo rotated, down to hundredths and thousandths of a degree right or left.

You can also use the Flip function to flip a photo vertically or horizontally (note, however, that doing this reverses letters or numbers). Additionally, you have several selections of 90- and 180-degree rotations you can make automatically.

Layers

For really extensive alterations to an image—such as the earlier example of adding a complete tournament sign above the Japanese Federation's heads—you will want to use the Photoshop Elements Layer capability. Layers are used commonly in Photoshop CS2 and Elements. They are an important way of working with images, and they let you create images with many additional features and changes that can be turned off and on—so your original image is left intact but the entire effect may be dramatically different.

Note You cannot save an image with multiple layers in JPEG format. It first must be flattened, and the changes are then irreversible unless you also save your layered photo in Photoshop PSD format. Use the Save As command to create a JPEG or other file type to do so.

Think of a layer as just that—layers based on adding new things on top of your original image. They might be text, other photos, or color filters. Whatever they are, they affect how your image appears, can be turned on and off, and can be transparent or opaque to varying degrees to the image underneath.

In the earlier example with the Japanese Federation photo, I had to fix the partially cropped banner, the fencer with the close eyes, and add text. I began by adding a layer for the new, full banner. In another image, I used the Marquee tool to select the full banner that was to be added to the new layer I just created in the other image.

In the image with the full banner, I selected the Feather option (it feathers the edges out to create a softer edge) to make sure the edges would blend more easily. Depending on how much of the image you have selected and want to feather, and how broad you want the change to be, you can adjust the pixel range of the feathering tool (specified in numbers when you select it). By right-clicking on my selection, it allowed me to soften the image edges according to a specific amount. I then copied the selection and pasted the selection into the new layer in the image I was fixing. The full banner now covered the partial banner completely. To make sure the edges blended well, I selected the Clone Stamp tool and went over the edges of the pasted banner. This sign appears in my Photoshop PSD file as one layer that I can turn off if I want to.

I used nearly the same technique to fix the closed eyes on the fencer. I added another new layer to the image I was working in. In another image where the fencer has his eyes open, I used the Lasso tool to circle his face, feathered it, and copied it. I then pasted it into the image being fixed, positioned it on top of his face, and it was ready to go after just a little bit of lightening in the levels to make sure the color of the copy matched his skin tone in the new image. This copied face also then became yet another layer that could be turned on or off. It appears as Layer 1 in the Layers palette shown in Figure 10-25.

Layers are an important and unique aspect of working with images in Photoshop CS2 and Photoshop Elements. Even though I have been working with them for years, I am continually finding new ways to use them and new techniques for improving, editing, and altering images.

Figure 10-25: Notice the layers of changes in the Layers palette, shown here in Photoshop Elements. It includes a layer for the pasted sign, the fencer's face, the custom titling for the photo, and the background image (the original shot).

Achieving Artistic Sports Photo Effects

Sports art has become a genre unto itself, with high-end original paintings of sports events and athletes selling for thousands of dollars, and millions spent on various types of consumer artistic sports products. Likewise, computer art is now recognized and accepted as a legitimate and respected area of artistic endeavor.

John and Terry Reimer, owners of San Jose, California-based Legacy Artists, have made a successful business of producing art that combines computer technology with traditional artistic techniques. Part of their work is in the area of sports — in fact, most recently working with Terrell Lloyd, the San Francisco 49ers photographer who has contributed some of his spectacular football images to this book.

John Lexar, founder and former CEO of Lexar Media, the compact flash company, began Legacy Artists (www.legacyartists.com) in a vision developed with his wife, who is an accomplished oil-and-canvas painter. Together, they developed a technique that begins with a digital photograph (or a scanned photo from a slide or negative); they then digitally and artistically enhance the photo in Corel Painter, a high-end painting package that is often used to work with images.

After they transform a photo into what looks like a painting on a print, they transfer that to canvas and Terry literally paints the image to give it depth, texture, and relief — as well as to add artistic personal touches and elements that may not have even been in the original photo. This is really more than enhancing the original photo; it becomes a partnership between the artist and the photographer to produce a combined work of art, an example of which is shown in Figure 10-26.

This type of art is interesting and cutting-edge work, but may not very practical for the enthusiast or semipro photographer. But that doesn't mean you can't make art from your digital sports photos. So, take a look at some simpler, more readily available and achievable artistic effects in working with digital photographs. Consider trying some of these to make your images look really cool for your family, friends, teams, and maybe even customers.

Let's look at a few ways you can apply some interesting artistic effects to your images to get you going in the right direction. Then you can let your artistic juices flow.

Going black and white

Want to turn a color photo into black and white, as with the weightlifting images shown as before and after in Figures 10-27 and 10-28?

© *Terry Reimer*

Figure 10-26: A large oil-and-canvas painting based on an original digital photo by Terrell Lloyd of the San Francisco 49ers. The large work of art is 20 x 24 inches plus the size of the frame and sells for a considerable sum.

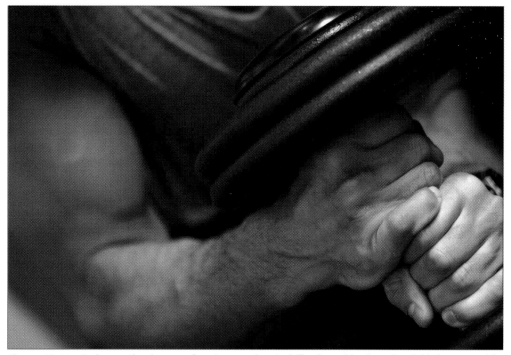

Figure 10-27: An interesting image when it was taken in full color, with nice rule-of-thirds composition, color tonality, and narrow depth-of-field . . .

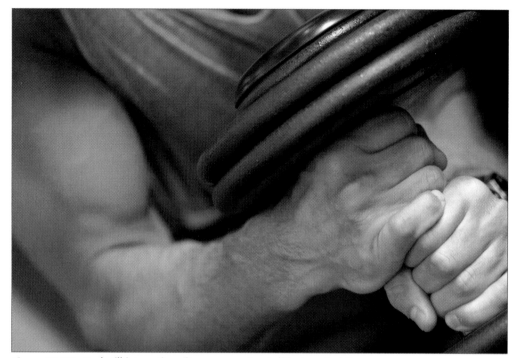

Figure 10-28: And still interesting after a conversion to black and white.

There are two ways you can accomplish a conversion from black and white using Photoshop Elements:

✦ **Choose Image ➪ Mode ➪ Grayscale.** This automatically converts your image into black and white. However, the effect has limited depth of tonality and you can't control the conversion. This option also doesn't create a new layer for the change — it actually changes your image.

✦ **Chose Layer ➪ New Adjustment Layer ➪ Hue/Saturation.** This is a more difficult, but much more effective and controllable way to convert to black and white. It has far better tonality, which is controlled through changing an image's hue and saturation. When you select this menu choice a dialog box opens. Click OK. A set of sliders appears (see Figure 10-29). By clicking and dragging the Hue and Saturation sliders to the left, you can convert the image to black and white; you can adjust Lightness in the same manner. This is a separate layer, so it can be turned on and off and your original photo remains unaffected.

Tip The Hue/Saturation dialog box can do more than covert to black and white. Try playing with the sliders to see what kinds of wild color effects you can create.

Hue/Saturation

Edit: Master

Hue: 0

Saturation: 0

Lightness: 0

OK

Cancel

Help

☐ Colorize
☑ Preview

Figure 10-29: By adding a Hue and Saturation layer in Photoshop Elements, you can create a beautiful black-and-white image and control the conversion to a detailed level.

Adding text

One of the simplest ways of artistically enhancing an image is to simply add text and a frame to it. In Photoshop Elements, the easiest way to do this is to select the Text tool (identified by a T in the Tools palette) and click on your image wherever you want to add your text. This automatically creates another layer that you can change later if you like. You can add layer styles to the text by clicking on Layer Styles in the menu tabs in the Layers palette; this will allow you to bevel or shadow your text to give it some depth and an interesting look. That's what I've done to the fall mountain-biking image in Figure 10-30 to see how it would look as a calendar image.

© Will Wissman

Figure 10-30: This fall mountain-biking shot has had text added to ready it for a four-season calendar.

When you're ready to work with the image, you can print directly from the image with the layers unflattened. However, do not forget that if you want to save the file as a JPEG and put it on a Web site, doing so gets rid of the multiple layers irreversibly. So you should also always save a working copy as a PSD (Photoshop) or TIFF file so you can continue to work on it later if you need to.

For fonts, you can use the fonts available in the Photoshop Elements font box. If you want to add more, many are available online from various sources (search Google for "free fonts") that you can install on your PC or Mac.

Additionally, you can add various effects to your fonts using the Effects option. For example, make sure you have the text layer selected in your Layer palette. Then, in the Effects palette, select Text Effects in the option box and you'll see a number of optional text treatment choices. Double-click any of them and your text changes accordingly; you can use Step Backwards to reverse your selection and try another.

Frames

While frames are of course a subjective element and up to each photographer's personal taste, I typically caution people when they want to add frames to an image only because the wrong frame style can detract from a very nice photograph. Frequently, if you need a frame to enhance an image, a plain line around it is all that's required. Another simple and effective — and quite impressive — frame effect is to give it a shadowed look. To do so, simply select Frames in your Effects tab. You have several options, one of which is the Drop Shadow Frame. Double-clicking this transforms your photo so that it has a drop-shadow, which makes it appear to be floating above the page.

There are a number of Frames styles you can select to apply to your image, but I only use them on rare occasions. You can find other frame options (as well as other effects) by searching Google for Photoshop Elements Plug-ins. These are made by third-party software developers and are downloadable (sometimes for free, sometimes not). You place them into your plug-in folders under the Adobe program file area on your computer. When Photoshop Elements loads the next time, the new plug-ins appear on the appropriate palette as new options.

If you want to make a larger area of space around your photo to a specific size, you can define a canvas around it. Choose Image ⇨ Resize ⇨ Canvas Size and define your canvas to be a bit larger than your original image (which is the default canvas size). This, in turn, allows you to put text below the image or add other effects to it to enhance your image; it's a good way of enhancing an image without actually adding to or changing the image itself.

Filters

The easiest way to apply artistic effects to your image is using what are called Filters. These are available as a menu item in Photoshop Elements, and several dozen are available in various categories. They vary according to style; some distort the image by adding effects such as rippling or a wave appearance. Others give it an artistic treatment, such as making it look like a watercolor or pencil sketch. Other tools add lighting effects such as lens flare (a reflecting set of circles like light based on a bright point in your image, as if light had reflected in a camera lens).

Note Many of the filters in Photoshop Elements are scaled-down, simplified versions of what Photoshop CS2 and Corel Painter will do. However, both Photoshop CS2 and Corel Painter also have many complicated, high-end tools that Photoshop Elements does not replicate.

Caution While there are a variety of filters, they can look at bit tacky and amateurish if overused or done too simplistically, so proceed with caution. It's best to keep it relatively simple and not too overdone to achieve the most powerful effects.

If you're diligent enough to keep notes while you work with various effects, the best thing to do is write down your settings when you achieve something you like. Most of the effects use sliders with numerical values — sometimes several of them at once — and it's often hard to remember which filter you used to create an effect, much less what the settings were.

Filters can be one of the very best tools you have to make that interesting, but blurry or soft image, work to your benefit. By applying one or more filters, you can sometimes completely overcome what otherwise would have been an unusable photo and turn it into something fun and, if you're inclined to do so, something able to be sold. At the World Junior Fencing Championships in Linz, Austria, one of the photos I took of an attacking saber fencer was a bit blurry and unusable as a photo by itself (see Figure 10-31). But it was a cool shot, and I still wanted to be able to use it somehow.

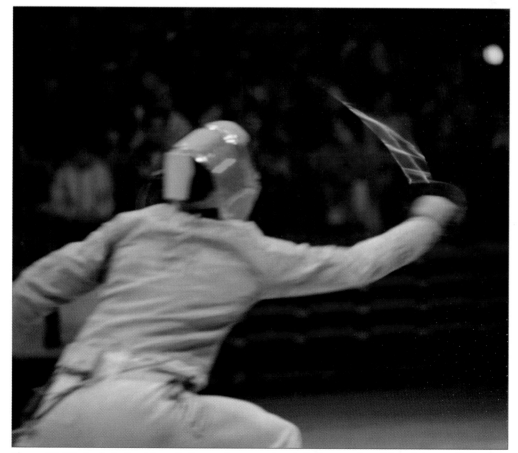

Figure 10-31: A photo too blurry to be used as an untreated photo and unable to be remedied using a sharpening tool

So, I decided to experiment on it. I opened the image in Photoshop Elements and tried some filters and effects. Eventually, I achieved an artistic look I was happy with.

✦ I started by cropping the image and adjusting the histogram a bit so it would have a bit more contrast. Oftentimes filters work better with images that have more, not less, contrast.

✦ I applied the Cutout filter (Filters ➭ Artistic ➭ Cutout) to the image. This cuts out major features of the image, simplifying its components (as shown in Figure 10-32).

Figure 10-32: The blurry photo with a Photoshop Elements Cutout filter being applied — an interim step in creating the artistic treatment and rescuing the blurry original

✦ To the filtered image, I then applied yet another filter — Poster Edges (Filters ➭ Artistic ➭ Poster Edges), which reduces the number of colors in an image, finds edges of objects in it, and then enhances them by drawing black lines around them. This gives a posterized effect, an almost cartoon-like look. You can add and alter various settings to give more or less intensity to the effect.

✦ I finished my artistic additions by adding text to represent the tournament, as shown in the final product, Figure 10-33.

The image was a hit in the booth where I was displaying fencing photographs at the competitions, and I printed them on-site and sold several as a souvenir of the tournament.

Tip Do you have a photo that you want to use publicly but you don't have a model release? Try treating it artistically with a filter that makes the person unrecognizable!

Filters can be a great way of not only creating interesting artistic effects, but also for rescuing images that you aren't otherwise able to use. Experimenting with them can be lots of fun, and you can create some very interesting and artistic effects with your photographs.

Figure 10-33: All filters and text added

Summary

Working in a digital studio combines elements of photography, graphic arts, and computer skills all in one. The infinite variety of talents you can exercise and develop in this stage of processing digital sports images is limited only by your imagination and resources.

Once your images are safely transferred to your computer, they will need to be managed so that they are safe and workable. Furthermore, they need to be accessible and able to be located with no more than a few mouse clicks, so it's good to understand how to wrangle large numbers of images in a logical and orderly fashion. There are software tools to help with this, and, depending on how prolific a photographer you are, you will find various ways to archive and manage photos and groups of photos that work best for you.

Once in order, images must be prioritized, cherry-picked, and then readied for whatever ultimate purpose they are intended. Software tools such as iView Mediapro, ACDSee, and Photoshop (Elements and/or CS2) become invaluable photographer's assistants in your efforts.

Most images require some form of editing, such as cropping, sharpening, resizing, and other small tweaks. Knowing how to do this quickly and efficiently, and in some cases in a batch mode, is common practice in the digital darkroom. Beyond that, knowing how to touch-up images and apply artistic effects to them provides an endless amount of perfecting of images to occupy your time.

In sports photography, it's common to take lots of photos to get a few really good shots. Knowing how to process these images efficiently and make the most of the top picks (and even a few of the not-so-top-picks) will be key to mastering your workflow and presenting your work in its best form.

✦ ✦ ✦

The Ins and Outs of Presenting Your Digital Sports Photos

© Amber Palmer

Chapter 11
Output: Getting Sports Photos Online, In Print, and On Display

Chapter 12
Going Pro or Covering Costs: Selling Sports Photos

Chapter 13
Legal Issues: Taking, Displaying, and Distributing Sports Photos

Appendix A
Photography Resources

Appendix B
Contributing Photographers

Glossary

11

Output: Getting Sports Photos Online, In Print, and On Display

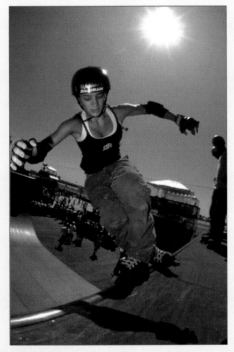

© David Esquire

As a child, I enjoyed spending time in the summer with my uncle Bernie, who had been a pro photographer and filmmaker working for the U.S. Navy and for the Eastman Kodak Company. I'd visit him in North Carolina, and he would take me to downtown Asheville to presentations known as travelogues. I was a well-traveled youngster, and I remember fondly seeing films and slide shows from around the world, such as my uncle's documentary of India. You may have slightly worse memories of photo slide shows by zealous, but very amateur, photographer relatives, intent upon sharing their photo journeys of woods, gardens, or tourist traps with a captive but resentful young audience.

Well, I have good news. As a photographer, now is the best time to have the world see your, whether in print, online, or on display. Printing fantastic-looking, long-lasting images is relatively easy and inexpensive, getting photos on the Web has become very simple, and creating a multimedia slide show with music and cool motion and transition effects is something almost anyone can do, and it's guaranteed to keep even the most fidgety nine-year-old captivated, at least for a little while!

With so many options for preparing your images, deciding what best to do with them, and determining how best to provide them to friends, family, or clients, it can get really confusing, really fast. You may find that taking photos is the easy part and that getting them printed or displayed is pretty hairy. In this chapter, your options are broken down into bite-sized chunks that get you started on how to prepare your images for distribution, and then what to do with them. But, really, there are only two options to consider: print or digital. First, this chapter looks at ways that you can create beautiful prints. Very high-quality deskjet and even dye sublimation printers are accessibly priced and fairly easy to use. Beyond that, professional print services can turn your spectacular shot into a poster, a coffee mug, or a frameable-quality 8 x 10. This chapter also explores some digital presentation options, including virtual contact sheets and slideshows.

Printing Options

It's a good bet that at least some of your photos will end up in print, even in a world where many images stay in a digital format. There's no substitute for the tangible, tactile feel and look of a printed image. Let's take a look at the various options you have for printing your select images so that they look their best and last the longest.

Printing sports photos at home

Rapidly evolving technology is making it possible for every digital sports photographer to produce great prints. In Chapter 9, I outlined the process of creating a digital studio to manage and edit your digital sports photos. And in Chapter 10, I presented a highly condensed introduction to editing sports photos in Photoshop Elements.

Digital reproduction and print reproduction use very different technology and logic to display color photos. Digital presentation (on your computer monitor, for example) involves combining backlit, glowing red, green, and blue elements. This coloring method is referred to as RGB (Red, Green, Blue). Color printing involves mixing colors to produce a spectrum of colors.

RGB digital display is capable of reproducing a wider spectrum of color than printed photos. On the other hand, digital display is done at a *much* lower resolution than printing. Most monitors display images at under 100 pixels (dots) per inch, while even photo printers that cost less than $100 can produce digital sports photos with a resolution of 600 dots per inch or higher. In short, digital display is better for color, but printed photos can come close to the color veracity of digital and display far more detail than a digital image.

Note When I say that digital display is better for color display, I mean digital display is *capable* of presenting color with more depth and accuracy. This, however, assumes that the viewing monitor has been accurately calibrated. Hardware and software packages like ColorVision's Spyder2PRO Studio adjust monitor colors to conform to display standards.

Preparing photos for printing

In addition to the overview of editing sports photos that was presented in Chapter 10, you need to be aware of a couple specific things when printing digital sports photos. First, most color photo printing processes create a wide spectrum of hues by mixing four colors — cyan, magenta, yellow, and black (referred to as CMYK, where black is denoted with a K to avoid confusion with blue).

Tip

The most inexpensive home printers may produce black by mixing cyan, magenta, and yellow, but most have a separate black ink cartridge for darker dark colors. Higher-quality inkjet printers can have as many as eight color cartridges to enhance colors, but the additional color cartridges are usually hues like light cyan or light magenta. So the four-color CMYK model remains the *basic* standard for digital color printing.

That means that even if you do your editing with RGB color model settings, you should switch to CMYK to see a closer approximation of how your photos will print. Do this in Photoshop by choosing Image ➪ Mode ➪ CMYK color. In Photoshop Elements, you can specify color output options in the Print Preview window by making sure you have the Show More Options selection clicked (File ➪ Print Preview). From there, you have numerous options for specifying how your output takes place and what it looks like in plain-language explanations (for example, basing your print on a specific printer profile and then making it match a perceptual setting). This, according to the Photoshop Elements Help system, ". . . preserves the visual relationship between colors that is perceived as natural to the human eye, although the color values themselves may change."

The other challenge in preparing sports photos for printing is that monitor colors are generally not synchronized very well with printer colors. The brilliant cardinal red on your monitor may print as hazy pink. Maroon and gold become gray and yellow. You get the point. The best solution is to calibrate your monitor to industry standards and then use *profiles* to synchronize your screen colors with your printer.

Cross-Reference

You calibrate your monitor to *ICC* (International Color Consortium) standards using devices/software combinations like SpyderPro II that I explored in Chapter 9.

Most Epson, HP, Canon, and other photo printers include *profile* programs in the installation software. You can configure your photo-editing program to display colors by choosing your printer profile. In Photoshop, this is done by choosing View ➪ Proof Setup ➪ Custom. Then choose one of your installed printers from the Profile list menu.

In Figure 11-1, a printer profile is being selected so that the photo of snorkelers in the deep blue water at Hanauma Bay prints the way it looks.

In Photoshop Elements, choose a profile for an installed printer by selecting File ➪ Print Preview and clicking the Show More Options check box in the Print Preview dialog box. This accesses more options than are normally displayed in the Print Preview dialog box, and you can choose your printer from the Profile drop-down list.

Other image editors also provide profile synchronization. In Paint Shop Pro, choose File ➪ Preferences ➪ Color Manager to pick a printer. In Ulead PhotoImpact, choose File ➪ Preferences ➪ Color Management. If you are using software not mentioned here, your profiles should be located similarly.

Calibrating your monitor and selecting the appropriate color profile in your editing software helps reduce the amount of guesswork (and wasted photo paper and ink!) involved in printing your sports photo with the colorization you want.

Figure 11-1: Selecting the Canon i860 photo printer profile in Photoshop Digital Photo Processing

Inkjet photos

Inkjet printers that spray jets of cyan, magenta, yellow, and black ink onto photo paper are the most popular and accessible home photo printers. They range from cute, toaster-sized printers that churn out great 4-x-6 prints to huge commercial/professional printers that are capable of printing posters.

Even if you end up taking (or uploading) your most spectacular shots to a commercial printer, you want to print up proofs at home. But if you invest some time and a bit of cash, you can produce very impressive inkjet photos at home that none of your friends will be able to distinguish from commercial prints.

Consider these factors in choosing an inkjet that meets your budget and quality needs:

✦ In general, higher resolution produces better color, because more dots per inch means that a printer can mix up highly tuned combinations of microscopic dots to match colors more accurately.

✦ In general, the more colors your printer supports, the better. Three-color inkjets (cyan, magenta, yellow) don't produce quality color photos, but I've seen amazing results from four-color printers from Epson, Canon, HP, and others.

✦ You *can* mix paper from one manufacturer with printers from another manufacturer and get good color reproduction. But mismatched printer/paper combinations produce prints that often fade *much* faster than when you use paper manufactured by your printer company.

✦ Printers with separate, replaceable cartridges for each color of ink can save you money if you print *lots* of photos. For example, you don't have to throw away your all-color cartridge every time you run out of cyan. But individual cartridges require a trip to the office supplies store every time a single color runs out, and the annoyance can wipe out the value of saving a few bucks by not replacing an entire cartridge when one color runs out.

Other home photo-printing options

Dye-sublimation printing mixes gaseous inks to produce colors that blend more smoothly and accurately than inkjet printers. Many of the commercial photo printers found in drugstores and many of the machines used by professional print shops use dye-sublimation (*dye-sub,* for short) technology.

Companies like Sony and Canon make personal dye-sub printers. Generally, these printers are affordable only in the sizes that print 4-x-6 photos. For small prints, dye-sub printing is something like 20 percent more costly than inkjet printing. And, because dye-subs can't double as a home/office printer, most of us end up taking photos to a commercial processor for the improved color available from dye-subs.

Color laser printers are a low-cost, high-speed option for proofs, but the color produced by laser printers is significantly worse than either inkjets or dye-subs.

Note For a full exploration of everything you need to print great digital photos at home on your Mac or PC, see the *PC Magazine Guide to Printing Great Digital Photos* by David Karlins.

Using lab services

You don't have to be a professional to get professional quality, services, and benefits. Pro photographers work with high-end labs as well as specialized school and sports photo services to produce sports packages and photos. Many labs, however, will work with any photographer, from amateur to pro. Printing at a lab can work two ways: You take it into the lab locally, or you send it to them via mail, e-mail, or another online method. Either way, you're relying on a professional service to turn your digital file into a print.

Moving Big Files on the Web: A Bit about FTP

FTP or *file transfer protocol* is a system that lets you send really large files over the Internet without having to bog down an e-mail system. Typically, a big lab has an FTP site that you can access. You enter a special address in your Internet browser that connects you to the lab's FTP server. You then input a logon name and password that they've given you, and you upload big files (even ones that are 50MB, 100MB, or more). You may need an FTP *client* to do so. A client is an application that let you access and manage uploads and downloads with FTP sites; one such product is CuteFTP. You can download a trial version of CuteFTP from www.download.com; several other clients can be downloaded there as well, but I prefer CuteFTP.

Sometimes, this may be as simple as taking your print to an electronic kiosk, where you insert a CD or flash card and your photo is processed automatically. For example, at the Olympic Games in Athens, Kodak had a service center where you simply went in, uploaded your card, and got your images printed in an hour or so.

For these services, you need to have full-sized images for printing high-quality prints. For an 8-x-10 print, for example, size it in your image-editing package to exactly 8 inches by 10 inches and make the resolution 300 dpi. Save it as a JPEG or TIFF file, and most any lab should be able to print it. If they require anything more specialized, they will tell you ahead of time and they will have information to help you on their Web site.

Walk-in labs

Assuming that you've prepared your file correctly, as described in the preceding section, you want to store your prepared images on a CD or a flash card and give it to the lab. They then process the files and produce the prints you order.

Some labs, of course, are better than others. Large companies with big services, even though they have a conveyer-belt-type operation, have very good quality and prices. Costco, for example, uses Fuji Frontier printers that print onto photographic paper (it's *not* an inkjet process; your images are actually projected and photographically exposed, which is a very permanent and high-quality method) and processes your photos in an hour or less. You can upload the images there directly into a little kiosk right at the photo center. These services, however, are not very accommodating if you need some special treatment to a print, such as touchup or color correction. For this type of file printing, you will want to keep your image in RGB color mode, *not* CMYK, as it is different than if it were printed using inks.

As I mentioned, photography labs that specialize in working with pro photographers generally accept work from any photographer, amateur or professional, and are excellent for high-quality prints that you really want to treat well. They hand-print every image, ensure color correction, and can make other adjustments. Of course, you end up paying more for this service and treatment; however, if you have an extra-special photograph, this is a better choice.

Labs very often will request a specific file type; high-end labs typically want TIFF files, which tend to be larger than JPEGs. Labs like Costco take JPEGs without any problem. TIFF files are a "lossless" format that, while bigger and bulkier, preserve image quality over many iterations of saving and editing.

Also, if you're using a large consumer service lab (like Costco or Wal-Mart), you want to make sure that your files are sized exactly correctly. Attempting to print a 5-x-7 photo from an 8-x-10 image, or vice versa, may not turn out very well!

Online lab services

Using big labs in other parts of the country can save you lots of money, and the quality can be superb. It also takes longer, and if you don't use a reliable or good lab, it can be a big headache. If your print isn't what you expected, or the quality isn't what you wanted, then you have to send it back and wait for several days.

Online labs come in basically three varieties. Most offer a variety of prints and prices, with add-on services for color-profiling, touchup, and custom sizes.

Big labs process your photos from files you send them, via e-mail, FTP, or on CD. Some let you upload images to their system as well; Costco and Wal-Mart both offer this service.

Sports Photography Services

If you or your child has ever had a photo taken for a sports team, it may have been by a photographer who established himself with a professional sports photo service. There are many services around the country, some of them quite big operations. Many also are regionally exclusive, meaning that they only work with a specific photographer or photographers in a given region and don't take on other clients.

These photographers and services may limit the photos that you can take at a local sports event — especially if you plan to sell your photos to anyone. You should be aware that they are there, and make sure you have permission to take photos.

Most of the services supporting the photographers offer a variety of packages to support their work, including team and player products like posters and prints, trading cards, key chains and pennants, and other common photo-oriented items. You establish an account with these services, and they support you with large-order printing, including sales tools (like the order envelopes kids take home to their parents), print packaging, and other things you need to market your photography services to a team.

These services also offer custom templates and design products for you to provide to your clients so that they have team-specific print folders, posters, and other personalized items that make athletes more likely to buy. Some of the online services, like Printroom.com, also offer these types of products, and many photographers use them for this type of work as well.

If you are interested in doing this kind of sales-oriented photography and you find a sport along with a region that doesn't already have this available, you can look for a specialized sports photography service.

Some services let you upload galleries of images and then select images you want to print; Kodak EasyShare Gallery, Shutterfly, and Snapfish are three such services. Other people can see these images as well, including your family members and friends. They can choose the images they want from those you upload and have them printed and delivered for a small fee per print.

Services specializing in photographers who want to sell their images let you establish a gallery storefront, where you can display your images and print them for yourself, but primarily it is meant to display the images for clients to select and purchase them. Printroom.com, for example, has several thousand photographers that present and sell their images online. Printroom.com fulfills the prints — meaning they print and ship the orders, and handle the payment transactions — and send you a check each month for your sales, minus a small commission. And now they even let you sell high-resolution digital images online in addition to prints and products.

For online galleries, all the services need is a thumbnail to post your images; some, like Printroom.com, offer utilities that automatically configure your images for this. Then, when an image is ordered, you upload a full-sized image (sending all your full-sized images gets really unwieldy); Printroom even offers a configurable image agent that automatically does this for you if you're not at your computer or out of town. For others services, such as those you are using only to for printing images, you need to send the full-sized images right away. It is often faster and better to just send your images on a CD, especially if you have many of them.

Tip

GoDaddy.com, a major Web-hosting service, offers a place where you can easily upload and share really large files online without having to use an FTP server or client. Check out their "Online File Folder" service www.GoDaddy.com to find out more about it and to sign up for an account. However, you pay for how much space you have, which can be very large if you aren't careful. I use this service to easily deliver large image files to various clients around the world; I simply send a secure link via a special e-mail to clients, and they can click the link and download the files. It times-out after a period I specify, and I can tell whether they've downloaded the files. This is also a great way to send big images to a lab without having to send CDs or use an FTP server.

Don't hesitate to ask any lab — online or local — to give you samples of their work and quality. Any good lab will let you provide one of your images for testing; they will provide you with a sample print. I suggest you try this before settling on any one lab; you may be surprised at the difference in quality among them. Also look at how they ship your prints. Even the best prints can suffer from poor packaging if they get bent when inserted into a mailing tube, or shipped with inadequate protection from mail handling.

Also, scrutinize the breadth of services the labs offer. Most should offer a wide range of images, ranging from wallet photos to rather large, poster-sized prints. Printroom.com, for example, includes prints up to 40-x-60 inches (which is larger than most). Many services also offer other types of printing products, such as coffee mugs, T-shirts, mouse pads, trading cards, and other items with your photos imprinted on them.

Online Photos for Sharing and Profit

Millions of photos populate the Web today, nearly all of them tiny little 72 ppi images that appear bigger-than-life when displayed on computers screens everywhere in the world. How can you get your images online where others can look at them?

Your images can be uploaded to an online service for presentation, sharing, and printing. You can share your photos with friends, family, teammates, and fellow fans.

Services like Yahoo! Photos or Kodak EasyShare Gallery allow you to post photos that others can purchase (or just look at for fun). Those services charge everyone competitive rates for all kinds of printing options. People (including you!) can order posters, coffee mugs, and a variety of photo sizes and frame options.

If you want to sell your photos, several online services let you sell images to clients, and then they print and fulfill them. Or, if you have a Web site, you can share your photos with the world that way.

Creating your own Web site

You may be ambitious enough to have your own Web site that you maintain and where you present images. This requires that you either hire someone to build a Web site for you, or you use a program like Microsoft FrontPage or another consumer Web-building tool to create a site.

You need your own URL (Uniform Resource Locator, which is a Web address, like www.smithfamily.com, www.bigvalleysoccer.com, or something like that) that you purchase from a Web service; www.register.com offers the chance to look for names and buy them, as does www.GoDaddy.com and many others. I like GoDaddy very much and think they have the best service, prices, and products available on the Web for acquiring, creating, and maintaining Web sites.

You don't need to know HTML, or even how to use FrontPage, Dreamweaver, or another Web-design software to create your own Web site. You can display sports photos on Web sites generated by easy, interactive online tools at Yahoo's Geocities (www.geocities.com), although annoying pop-up ads

plague this program. Also, for Web galleries of images, Photoshop and other applications include automatic gallery and slide show capabilities that can be formatted into HTML and added into a Web site relatively easily. Some word processing and publishing programs, such as Microsoft Word, allow you to save files as Web pages, as well.

Note For a complete and highly accessible guide to creating your own Web site, check out *Build Your Own Web Site* by David Karlins. The companion Web site — www.buildyourownwebsite.us — has articles and tools that will get your sports photos online in an hour or less. Also take a look at *HTML Complete Course* by Donna L. Baker; it teaches you how to create an entire Web site with simple HTML and free tools.

Using online photo galleries

For some people, however, building their own Web site is a bit intimidating, and even building a simple one takes some technical skills. Some photographers using professional online photography fulfillment services use the template provided by the services as their sole Web site, where they can show galleries and include contact information; for other photographers, this isn't enough. For example, as you can see in Figures 11-2 and 11-3, I use my own Web site for fencing photos — www.fencingphotos.com.

Figure 11-2: The main FencingPhotos.com site, where I present key images and provide a front-end to my photo galleries

Figure 11-3: The Printroom.com-hosted galleries section of FencingPhotos.com, which presents all the different menus of image galleries for people to find shots of their clubs, individuals, teams, events, competitions, fine art photography, and so on

A gallery of images, shown in Figure 11-4, is presented for people to review and select shots they'd like to buy; they can also glance over the shots and even zoom in, shown in Figure 11-5, to a large image view to see an image better and to make various selections for purchase (such as converting it to black and white). Most people never know or notice that they've technically left the www.fencingphotos.com site; the effect of transition to the Printroom.com-hosted site is seamless.

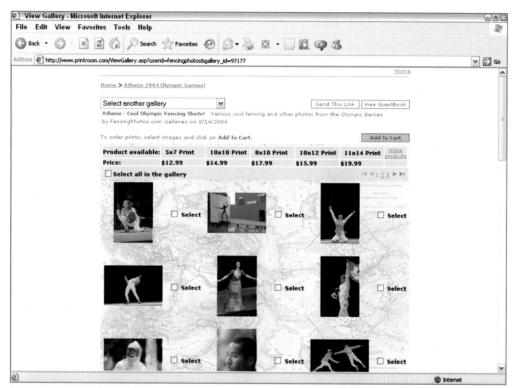

Figure 11-4: A gallery of images from FencingPhotos.com, hosted by Printroom.com but seamless to the Web surfer

If you don't intend to sell your images right away, then you may be satisfied using Yahoo! Photos, Kodak EasyShare Gallery, Snapfish, DotPhoto, or Shutterfly. These services allow you to upload, share, and buy prints easily, and they provide a quick, fast way to get your images online for others to see.

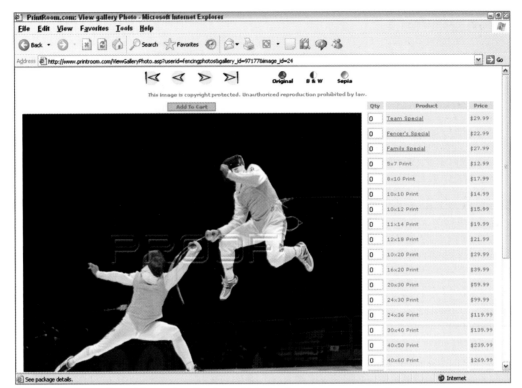

Figure 11-5: An enlarged image for viewing, which also includes a watermark to deter copying

Figures 11-6, 11-7, 11-8, 11-9, and 11-10 show photos on display at various Web services.

Figure 11-6: Yahoo! Photos is one of the easiest photo-sharing services on the Web, and it includes very visual and easy-to-follow directions for setting up an online photo gallery.

Figure 11-7: Buying prints online is a primary use of photo-sharing services, and the prices are very competitive. Kodak EasyShare Gallery, provides high-quality photos printed on, of course, Kodak paper.

Figure 11-8: Most services provide free or inexpensive software utilities that allow you to easily upload thumbnail and full-size images, such as Snapfish Photoshow.

Figure 11-9: Another way many of the services get you to sign up is by offering free prints—which is a great way to try them out, such as this offer from Shutterfly.

Figure 11-10: DotPhoto features various photographers' galleries on a showcase page, which is a nice way to get your work seen.

Virtually all these services offer a way for you to upload your images to their site easily, without having to change them significantly yourself. If you have your own Web site, you have to resize images so that they are physically small enough that they don't take up lots of size on your Web site and so that they don't take too long to load when people visit your site — typically images are about two or three inches at 72 ppi resolution. (72 pixels per inch is known as *screen resolution,* and it's the most a computer screen can display, so it's useless to have images with resolutions any higher than that on the Web.)

The services, instead, offer utility software — either online or something you install on your computer — that automatically converts your large image files into small thumbnails and uploads them to their Web site for display. It's better for you to do it on your computer using their software, because uploading the big images would take forever! Figures 11-11 and 11-12 show utility software screenshots from Kodak's Ofoto Now (PC) and Ofoto Express (Mac) that is part of the EasyShare Gallery and Printroom.com's Pro Studio Manager.

Some of the utilities, especially those from sales-oriented services intended for selling photos like Printroom.com, are pretty elaborate, providing additional capabilities such as gallery management and organizational tools and even a way for the software to automatically check for orders and upload full-sized images even if you're not there to check the system.

Note Preparing images for the Web generally means they need to be much smaller than in print and lower resolution. For galleries, thumbnails are rarely larger than an inch or two wide and tall with a resolution of 72 dpi. Enlarged images may be several more inches wide and tall, but are still 72 dpi. You can resize a digital image to these dimensions using an image-editing package like Photoshop Elements; however, you'll want to save them as separate files. Once a file has been saved in a smaller size, if you try to enlarge it the results will be poor and jaggy (highly digitized due to low resolution). Many online photo services' utility software will create thumbnails automatically for you.

Figure 11-11: Kodak EasyShare Gallery contains simple, step-by-step instructions for using its proprietary image-uploading tool for PCs (Ofoto Now) or Macs (Ofoto Express).

Figure 11-12: Printroom's Pro Studio Manager, in addition to providing uploading and management capabilities, provides a way for the system to check orders automatically at specified intervals. This way, photographers selling images have their orders fulfilled even when they're not there to manage the studio.

Displaying and Distributing Sports Photos

One of the factors often differentiating photographers in it for a living from those doing it just for fun is the way they present their images. If you are intent on selling your images, or even if you just want to present your images nicely, it's worth going to the trouble of putting together proof books or albums. You have these display choices:

✦ You can present your images in a live slide show, complete with sound and projection for a big group.

✦ You can create a slide show that you send people as an e-mail attachment or place on a CD or DVD for distribution, complete with music and other fun multimedia components.

✦ You can create screen savers to give to friends and family.

For any of the various things that can happen to your image(s), you're going to have to figure out whether your digital photo needs to be prepared for the specific use. Depending on the end product, you need to make sure it's the right size and resolution. For example, if it's going to be displayed on the Web, you may need to downsize the image so it's ready to be display and won't choke a Web site because it's too big. The rest of this section looks at these various display choices and how you can make your images look their very best.

Proof books are the mini-albums that allow you to place a large number — 25, 50, or more — of small prints (4 x 6 or 5 x 7s) into slip-covers. Customers or friends can look at the many images and decide on which they may want as larger prints. Typically, you won't have spent much time with these proof images because there are so many of them, and you're counting on people selecting a few images to be enlarged that you'll work on in more detail. Online and local labs all offer proof book services that help to automate the printing of a large number of shots.

Another method for presenting images is to produce *contact sheets*. In the days of film, photographers would place negatives directly in contact with photographic paper and then expose the paper; this would create a sheet with many images, all the exact size of the negatives, for people to review and compare. Various image-editing packages, such as ACDSee, allow you to create virtual contact sheets; you simply tell the software to place any number of image files into a contact sheet, and it automates the creation of it. It's a nice and remarkably easy way to let people select images, and you can often store one contact sheet as a single image file that lets them review the images as thumbnails in a print instead of online. Figure 11-13 shows a contact sheet created with ACDSee of shots that I took at a regional soccer championship.

Creating a virtual contact sheet

You may want to be able to look at your photos and compare them in a print, without having to use a computer or have large prints produced. Or you may want an easy way to compare images on the Web without having to page from photo to photo. You can use contact sheets either to print, to save as a file to send to someone, or even to put into HTML format so you can place the sheet on a Web site. Here's how to create a virtual contact sheet using ACDSee.

1. **In your ACDSee file/image browser, select the images you want to put into the contact sheet.** You can either select images one by one (hold down the Ctrl button as you do so) or create a special folder with all the files you want to use.

2. **With the images selected, choose Create ➪ Create Contact Sheet.** The Contact Sheet dialog box opens, where you have a variety of selections and options from which to choose.

3. **Format the contact sheet (by adding drop-shadows or other effects to the thumbnails, for example).** You can also choose your output options, you can change the size of the thumbnails, and you can create captions, headers, and footers.

4. **Click OK, and a single file is generated with the images placed and sized correctly with all of your images organized for display at 72 dpi.** You can print this file, or you can create a contact sheet for print more automatically by following the next set of steps.

Figure 11-13: You can use ACDSee to create a contact sheet of images. Note the various options available for presenting the sheet.

To create a contact sheet to be printed, follow these steps:

1. **In your ACDSee file/image browser, select the images you want to put into the contact sheet.** You can either select images one by one (hold down the Ctrl button as you do so) or create a special folder with all the files you want to use.

2. **With the images selected, choose Create ➪ Print.** A Print Options dialog box appears, with the option of your print layout as a full page (one image per page) or a contact sheet.

3. **Select your format options for your printed contact sheet.** Choose from items such as captions, drop shadows, and so on).

4. **Assuming you've properly set your printer (there's a dialog box to do this), clicking OK prints the contact sheet.**

LCD projection

Another way to present images so that they look very professional is to project them using an LCD projector onto a screen. Many photographers believe that showing photos in a large format — such as projected onto a big screen — makes for bigger sales and more impressed clients, and I have to agree with them that it is an impressive way to show photographs. In addition to the hardware required — a computer along with an LCD projector (and these devices are not inexpensive, costing at least $1,500 for one that's reasonably good) — you need software to present the images. You may also want to have music with your presentation, so you need speakers. We get into these products a little later in this chapter.

The bottom line is that image presentation is as important as shooting the pictures well. It's as important in photography as it is for a culinary creation to be properly presented by a chef who's worked hard to make it taste incredible — how it looks can have a direct effect on how it's perceived by the diner. Likewise, you're undoubtedly working hard to produce great photos, and they deserve to be presented in their best light.

If you're planning to present and project images, you'll want to consider a few tips:

✦ Fewer is better: No one wants to sit through hundreds of images.

✦ Show the best shots of different images, not multiple shots of the same thing.

✦ Mix-up your images unless you have a specific reason for being chronological.

✦ Use a software package that lets you use some fun transitions, but don't go too wild — even a plain, smooth fade often will suffice for all images. Too many transitions gets tiring and distracting.

✦ Some software applications, such as Photodex's ProShow Gold, allow you to add motion effects to your images. By moving the images in and out and turning them slightly, your audience stays engaged to a greater degree.

✦ Don't let slides linger too long, or display them too quickly. Allow you audience to view them, but if they stay too long it gets tedious. About two to four seconds per slide is about right.

✦ Adding music can enhance your presentation.

Slideshows

Every photographer loves to show his or her work — we're all natural hams when it comes to wanting an audience for the two-dimensional prizes we've captured in the field. In the past, the only ways to present your work was to give a slideshow with a slide projector or have a gallery showing. Today, there are many ways of presenting images to audiences of all sizes, but you should still keep the basic principles outlined in the previous section in mind.

In December 2004, I was asked to present my photographs of the Olympic Games to an audience in Paris of the International Fencing Federation (FIE) annual World Congress meeting, consisting of representatives from about 120 countries around the world. This was a golden opportunity to present my work to a highly appreciative audience anxious for an entertaining break from committee and electoral meetings. Not only did I have the challenge of figuring out what to show that was both exciting and diplomatic, but I also had to choose a software program that would show the work in the most compelling way.

In addition, the FIE asked me to make copies of the presentation and distribute it to each delegation — 120 copies in all. So I had my work cut out. This section I explains what I did and why, and it offers some choices and recommendations for how you can learn and benefit from my experience.

Software considerations

For years, I've been looking hard for the best product I can possibly find that lets me create high-end, slick slideshows. Many products are on the market, ranging from very easy-to-use but rather limited consumer packages to very high-end authoring tools that require lots of effort to learn and use. Very few products are in the middle, being easy to use for the average photographer, but still powerful enough to provide the options and capabilities they need.

To present images to an audience, photographers need software that effectively provides the following features:

✦ An easy way to load photos into a sequence of slides that can be managed and rearranged easily

✦ Good options for adding music from a variety of common formats (MP3, WAV, and WMA, for example)

✦ Lots of options for slide transitions — how the slides move from one to the next (for example, with various effects such as fade, wipe, blinds, and so on)

✦ An easy way to synchronize slides and sound so that they work in tandem, beginning and ending together, as well as being able to have multiple tracks play in order

✦ An easy way to edit and work with images, such as rotating them, moving them around, enlarging/shrinking them, adding text to them, and being able to alter their contrast and other basic attributes

✦ A way to produce an HTML version of the slide show that is Web-ready to load into a personal Web site

✦ The ability to output the slideshow in a variety of ways, including producing them as an executable file, a screen saver, or a slide show on a CD containing all the original photos (or not), and being able to produce a DVD or a CD that runs on a DVD player (known as a VCD, or video CD)

iView MediaPro

I searched in vain for a long time to find a product that met my criteria. I even tried using Microsoft Powerpoint — which is used to give business presentations, and which I use very often for giving workshops — but it handles images miserably in large quantities.

A very powerful archival tool, iView MediaPro, provides one of the more powerful slide show capabilities available on the market today, but it still is primarily an image archival and management product. It's very easy to use for creating a very simple slide show: You simply drag and drop slides into a window, which are automatically rendered as thumbnails and consequently are very easy to manage, and you can add sound or video. The software uses its own special terminology that you need to learn to really get the most out of it. For example, it refers to managing images as cataloging; however, after you understand it, the program becomes the most powerful tool available today for keeping track of your images. For this reason, I recommend it highly.

ProShow Gold: A photographer's dream

For slideshows, the magic solution I finally discovered was a product called ProShow Gold, from a Texas-based company called Photodex Corporation. They produce a consumer version of it, called ProShow, which is also great, but the ProShow Gold was the answer to my prayers, literally: It features all the criteria listed a few sections back in addition to a number of other capabilities, which are especially helpful in protecting my work.

✦ You can set a slideshow to time out, so that it stops running after a matter of weeks or number of presentations, which is invaluable for protecting your work.

✦ You can add a registration number to shows, which the user must have to run it.

✦ You can create a file that runs your slideshow, including the music, transitions, and so on that contains all your images embedded in it so no on can extract them.

✦ Special motion effects, which are highly configurable, allow you to have images move, zooming in and out and around the page from slide to slide, in addition to transitions. This not only looks great and helps keep audiences engaged, but it also protects your work from being videotaped, captured in a screenshot, or otherwise copied.

✦ Remarkably robust image-editing tools let you modify images in the slideshow easily and on-the-fly, which means that you don't have to extract them into a separate image-editing package to adjust them after they're loaded into the show.

✦ It offers easy ways to put multiple shows together, add text, and use a loop option so the show can keep running.

✦ It includes simple tools for synchronizing slides to audio (this feature alone originally sold me on the product), as well as randomizing transitions, motion, and slides.

Maybe I don't even need to tell you that this product was the perfect solution for my presentation in Paris and has now taken a front seat in all my photography workshops to help people easily and quickly display their photos. It let me create a show and screen saver, shown in Figure 11-14, with different transitions from slide to slide (see Figure 11-15) that I could easily copy onto 120 CDs and distribute without having to worry about them being abused, and that gave the delegates a really great gift from the Olympic Games and the fencing federation.

Figure 11-14: I used ProShow Gold to create a slideshow of great sports shots along with music, captions, and lots of special effects.

Unbelievably, ProShow Gold sells for less than $100, and ProShow (the consumer version) sells for even less. For me, this product is as important as Photoshop. Nonetheless, many slideshow packages exist that let you display and present your images to an audience using transitions, sound, and other features.

Now that you have a good idea of what software is out there to help you create a slideshow, you are probably wondering what kind of equipment you need to do this:

✦ A computer loaded with your slideshow package and your images

✦ An LCD or other type of projector (really large venues will have very powerful projectors to which you can attach your computer) that supports a PC connection

✦ A highly reflective screen

✦ Speakers with a subwoofer that attach to your computer

Tip　There are legal issues involved with incorporating music in a presentation. Adding sound to your presentation makes it much more powerful. However, you need to be aware that there are legal limitations to putting on large shows and playing copy-protected music. Most music on CDs or that you have purchased online limit you to playing them just for your own personal use; using them in a public performance is usually prohibited by law. For more on legality of reusing copyrighted music, check out *Music and Video Downloading: Your Guide to Legal, Safe, and Trouble-Free Downloads* by Russell Shaw and Dave Mercer.

Figure 11-15: ProShow Gold offers a large variety of special effects, such as transitions, which move the show from one slide to the next.

Putting on your own show from a big sporting event is lots of fun for you, your family, and your friends. It's a great thing to put on a loop function at a party and just let it run with people getting to enjoy the various images as they happen to look at the screen. Also, giving screen savers or slideshows on a CD or DVD is a wonderful gift.

Another option is to create screensavers, which can be done automatically in ProShow. This makes a nice gift for your friends and for your own computer. ProShow and ACDSee both let you automatically generate a screensaver from your slide show and run it in Windows.

Summary

When it comes to photography, nothing is more satisfying than having an individual, customer, family member, or audience, appreciate your work. Today, this can take place online, in print, or even projected in front of a group—all from the digital images you took at one or several sporting events.

Whether you're displaying gallery-quality prints from your spectacular rock-climbing adventure or just showing a slideshow of your daughter's soccer finals, choosing the right format for their ultimate use makes life much easier. A digital image can take on many sizes, formats, and treatments; for example, preparing an image for print can be very different—and create an image of very different size—than producing the same shot to be displayed on a Web gallery.

Online, you can share, sell, and print images easily with a variety of services that range from simple consumer-friendly Web sites to powerful professional online tools and storefronts. Whatever you plan to do with your photos, looking at how they can be processed online is well worth your time to best manage your digital photography workflow.

Finally, getting images displayed with music, transitions, and other accoutrements for a multimedia slide show can be a wonderful way to treat an audience. You can even put images and everything else onto DVDs, CDs, screen savers, and more. A number of software packages are available to do this, and you will want to look at them to find the one that best suits your purposes.

✦　　✦　　✦

12

Going Pro or Covering Costs: Selling Sports Photos

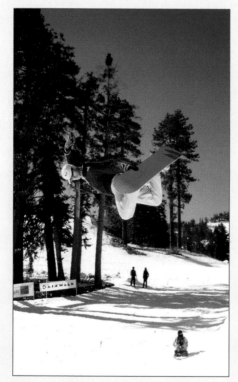

© David Esquire

Digital photography, combined with the proliferation of the very affordable personal computer market, makes for a tremendous growth in interest for selling photography and even going pro. While many pro photographers are grappling with the transition of expensive equipment and new techniques required by a changeover to digital photography workflow, some computer-savvy opportunists

are starting their photography careers from scratch and making impressive progress quickly. The basic point here is that there are many levels of digital sports photography, and you can begin to distribute and even sell your photos now. Maybe you'll continue to improve your technique and upgrade your equipment—or maybe not. But in any case, you can find an audience, and maybe a market, for your digital sports photos.

Professional photography has changed dramatically over the last few years with the advent of a digital world, not the least of which has been the Internet and its amazing capabilities for presenting, transporting, and distributing photography. Some of the traditional areas of professional photography have become less viable as a business, while others are booming. For example, it's much tougher today to make money shooting commercial products for catalogs or even Web sites. Many businesses are satisfied with digital snapshots of their buildings, executives, and even the goods they produce to be used on their Web sites and elsewhere—even though the composition and photographic quality of those images are clearly lacking.

Likewise, in sports, many people today are able to take digital photos of their family members as they compete or participate in various events using cameras that produce good photos. However, for any action sports, most consumers realize quickly that sports photography requires more technique and equipment than they have. Team photos, like the one in Figure 12-1, are in constant demand on many levels, from pro teams to school and community teams.

Figure 12-1: Not every team photo can be planned ahead and shot with optimal lighting, backdrops, and team participation. This photo of the U.S. national fencing team was shot in a hotel lobby in Havana, Cuba, and required some creativity for lighting both at the shoot and later in Photoshop.

Full-time professionals have practiced their skills with photography to the point that they know how to take shots that people want to see in the sport they're shooting. But that doesn't mean you can't also identify shots that people will want to display or purchase. There are important realms of digital sports photography where non-professionals can find space to take distributable, and marketable, photos. For example, regional teams in your area might need team-and-player photographs. Stock photography, meaning the creation of images that can be used generically for advertising and marketing purposes by agencies and companies, is another viable and very specific type of shooting. Yet another type of photography is sports journalism, meaning photographers who shoot for magazines, newspapers, and news agencies. Finally, event photographers such as those shooting races and competitions can do quite well, but it takes some work getting established with race officials and organizations and the old "Catch-22" applies: It's always easier to become involved if you've already been involved.

All these areas are ways in which people today are making a living — some full-time and even more part-time — with their digital cameras. Is it for you? That is what this chapter helps you consider and understand.

Establishing Yourself with Team and Player Photos

One of the most traditional ways to make money in sports photography is to take photos of teams and players in posed shots that are sold ahead of time — much like school photos are done. Photographers offer a variety of packages to the team members, who take home and review the options for the shoot ahead of time and show up to have their photo taken with a check or credit card in hand.

These photographers have put into place a system that allows them to fulfill their shoots, to market and sell them, and to build a repeat business. Most often, they are supported by a specialized lab focused on this type of photography that supplies them with all the marketing and sales materials they need to optimize their sales. And there's a trend today for big companies with literally hundreds of photographers around the country to sell their services to teams of all types.

Although these large photography firms have locked up team photos in some realms, other sports and levels of teams need team photos too. Many photographers set up team and player shoots with some of the sports that aren't quite as mainstream — such as lacrosse, swimming, fencing, martial arts, and so on — and that aren't really of financial interest to the big photo conglomerates. These can be very lucrative if you have a way to pursue the business systematically, and you can offer a reasonable selection of products and services.

If you set up your business properly, you can pitch local sports clubs and teams and begin making money. What do you need? Here are some suggestions:

✦ Write a business plan that covers all the aspects of your business, what you intend to do, how you will do it, how much money you'll make over a given time period and how you'll manage it, how you'll market and sell, and the equipment and resources you'll need. Additionally, you should have an idea of how you'll become part of your target community, whether that's a region, a specific sport, or organization.

✦ Basic marketing materials describing your services, pricing, and information about yourself.

✦ A Web site with information about you and your services, contact numbers and e-mail, and galleries of samples — images you are selling and/or that you've taken.

✦ Equipment suited for the job. This doesn't have to be the highest-end studio camera; in fact, it can be a good-quality consumer model with a relatively simple set of lights and a backdrop. A reasonably powerful and relatively new home computer is likely to be sufficient for getting going. If you're

using lights separate from your camera that need to flash in-synch with your camera, you need to have an SLR-type camera that supports external lights (most do). A point-and-shoot definitely is inadequate for this job.

✦ A way to fulfill your images. In other words, you need a relationship with a lab (local or online); if you're doing more than just a few photos, chances are good that you probably won't want to do this kind of printing yourself.

✦ A way to keep yourself scheduled and managed administratively, including your financial infrastructure for processing sales, forecasting revenue, and managing your taxes.

✦ A name for your business.

It's going to be very hard to sell yourself if you don't have at least a minimal portfolio of your work so you can convince a club or team manager that you're the right person for the job. So, before you begin the job of selling yourself, you want to actually take some photos to build samples of your work. Portraits of individual athletes, as in Figures 12-2 and 12-3, are often easier to organize than teams without experience and help to build your portfolio.

Figure 12-2: A good portfolio shot may be taken with a model, but will always be more believable if the model also participates in the sport he or she is portraying in the image.

You can do it in basically two ways. If you already have a relationship with a team—such as one you or a family member are part of—then you have an "in" and you can let them know what you're doing. They may let you shoot the team *on spec* where you take the photos and either give out free photos in kind, or offer them at a greatly reduced price (which gives them incentive to let you do it in the first place!) as well as a percentage of your gross revenues from the shoot. This last part is essential in winning business—nearly every photography arrangement with a sports team or league involves a percentage (typically somewhere between 15 and 30 percent) of the gross being returned to the organization.

Another way is similar, but meant for a club or team that you don't know; it also creates the foundation for how you ultimately can sell your services to other organizations. You present yourself professionally

but admit freely that you're just starting your business and need to build samples. Then you offer them a deal that they (hopefully) can't refuse: You'll take photos for no charge, offer prints and other products to their members at a cut rate (basically your cost), and give them a team print for the club or office for free. And when you begin to work with them beyond your initial discounted "deal," let them know ahead of time that you'll be offering them a percentage of your gross revenue.

Either of these methods works to get you going. If you haven't got much experience shooting these types of images, you're bound to make some mistakes, but as long as you plan ahead and the mistakes are not too catastrophic, these are good ways of establishing your business — and possibly getting a first client out of it. You can expect that in your first attempts at this you might have some poses that don't end up looking as good as you expected, you might have some blinking subjects, and you may accidentally have some images that are soft (out of focus). These things happen, but fortunately digital photography allows you to do quick checks on-the-fly of at least some factors.

© Francis Baker

Figure 12-3: Alternative sports — such as kickboxing, martial arts, gymnastics, and others — are growing quickly in the United States and present viable opportunities for independent photographers to sell individual and team photos.

The foundation of your sales pitch for other clubs, then, after you establish a portfolio, isn't really much different: You offer your services for free (meaning you don't charge the club or team anything to come and do a shoot of their members), and you offer them a free team print as a thank you. The difference is that the services and products you offer the individuals are then at your normal prices.

One of the most important aspects of making this type of business successful is being able to fulfill people's orders in a timely, efficient, and professional manner. Many photographers who are entirely competent to take a good photograph fall down in the follow-through of getting orders processed. This is why I suggest that you connect yourself with a professional fulfillment service adept in working with you at a deeply integrated level to handle your sports photography business needs at the back end — getting photos printed, packaged, and distributed.

More about Online Fulfillment

Another option, and one that can get you up and running even faster, is to use an online fulfillment service like WebShots.com or Printroom.com. These services allow you to place images online in your own galleries specific to your events. You upload the images and then set prices for your photos. People can then go online and see their photos and purchase them; the service prints them, ships them, and handles all the financial transactions. They then send you checks on a regular basis with for the money you've made from the images people have purchased (minus your cost of the prints plus a small commission).

You can see a gallery photo from WebShots and a page of galleries from Printroom.com with images on display in the following figures. The photographers and/or agencies have set these prices based on cost and a markup to ensure a profit. Companies typically offer innovative sales tools to help photographers sell, as well; Printroom.com, for example, provides a service called PhotoPass, which allows you to print a coupon good for whatever prints you specify and purchase ahead of time. The coupon can then be sold to customers on-site when you do the photo shoot — this gets them to go online and, hopefully, buy even more.

Online services usually require some type of sign-up fee and have various types of fees for their services; some have a monthly fee, others have upload fees, and others charge only their commission when you sell images.

Before making a decision, consider talking to other photographers using the service — you can often just search a site for images posted into galleries by other pros, and then you can call the photographer directly. Because these types of services integrate deeply into your digital photography workflow and essentially become an extension of your business, you want to make a careful decision.

A pro soccer shot as shown on WebShots.com and for sale as a premium purchase. In this case, the image is owned by the stock agency Getty Images.

All of the images in this gallery of basketball images featured by various photographers on Printroom.com are for sale individually.

As discussed in Chapter 11, various options exist for fulfilling images — including producing prints yourself, using a local lab, or using an online service. Although many of the services focus on professional photographers, and some specialize in school and sports photos, few if any focus exclusively on team and individual sports. Also, some of the services are regionally exclusive or big corporate entities, which means that they have professional photographers with whom they've established contractual agreements; they may not work with you, even in a non-related sport.

School Photo Marketing (www.schoolphotoonline.com) is a smaller, but very good, photography service available for first-time as well as highly experienced photographers (see Figure 12-4). They pride themselves in helping independent photographers compete effectively against the big sports and school photography companies. The New Jersey–based service isn't a lab, but rather it supports school and sports photographers with a wide range of products suitable for selling and packaging your prints. The CEO, Rob Klepner, suggests the following if you're interested in getting into the business of team and player photography:

> "The sports [and school] photography market is re-energizing with a whole new level of business due to digital. The independent and new photographer has to have a game plan and be able to sell, know to whom they're selling, be ready to show packages with pricing. And what many photographers don't realize is that half the reason many clients buy is the personality of the photographer, not necessarily the product. They have to knock on doors, put in bids, and earn the business. They need to know their products, their lab, how fast products are going to be turned around, and so on."

Figure 12-4: School Photo Marketing's Web site, with sports services highlighted

School Photo Marketing is one of several companies that works with pro and semi-pro photographers to get their photos produced, packaged, and fulfilled professionally. Here are some of the things companies may offer:

✦ Wallet-sized photos

✦ Framed photos (with customized sports frames such as soccer balls, basketballs, and so on)

✦ Photo plaques

✦ Photo key chains

Tip You can search for more vendors that cater to your needs in this area by searching for "school photos" in Google.

Stock Sports Photography

Stock photography are images created and then sold to a service that markets them to advertising agencies, graphic design firms, and other businesses (primarily) that need *generic* images of various sorts. Until the Internet became a big deal, these used to be managed by stock agencies that published high-quality thumbnail images in large books. The design firms and ad agencies would pick photos they liked and order them, which would be delivered on film or in digital form for use in ads, brochures, and myriad other commercial uses.

Today, most stock photography is managed online and dominated by a few extremely large stock agencies followed by a plethora of smaller ones — many of whom are happy to take photos from amateur and semi-pro photographers, perhaps such as yourself. Corbis and Getty Images are the two large agencies — I shoot fencing for Corbis — and offer hundreds of thousands of images of all types. The same ad agencies and graphic design firms that used to pick from a book can now simply go online, review the available images, purchase them, and download them; the download includes license and usage rights for their various applications. Figures 12-5 and 12-6 illustrate the kinds of photos I've supplied to Corbis.

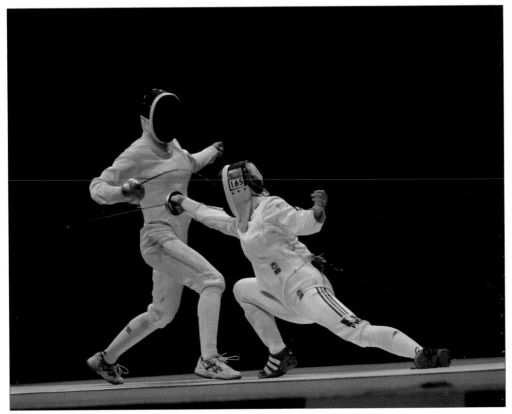

Figure 12-5: A classic fencing shot from the Olympic Games

Photographers of all types shoot these images, and the images are as varied as you can imagine: business, arts, sports, entertainment, abstract, nature, people, places, and conceptual—pretty much anything you can imagine. However, what really distinguishes most stock photography is its generic quality, which means it lacks brand names, logos, and other factors that would be limiting from a copyright standpoint. This also means that virtually anyone who buys the photo(s) can use it — which can be risky for some companies if they have the same image in their ad or publication as a competitor's — but you, as the photographer, will want to sell as many of the same image as possible to make ongoing revenue from your image(s). Furthermore, stock photography often features series of images in a concept. For example, for baseball, you might find numerous photos of balls, bats, and gloves in one series; another series might have batters in a variety of images and poses.

Understanding stock photography no-nos

Stock photography is a specialized area, and it's not the kind of photography you get paid for up front; instead, you shoot stock images, provide them to the agency, and over time hope they will sell—for which you get a specific payment and/or commission. Unless the stock agency specifies otherwise, images must be completely devoid of brand identity. So if you are going to try your hand at taking stock photos, follow these guidelines:

Figure 12-6: An environmental photo of the fencing hall, often useful for news editors needing to "tell a story" about a competition or event

✦ No logos on vehicles, products, clothing, and so on.

✦ No signs or recognizable names anywhere in the photo (for example, a car driving in front of a McDonald's restaurant would be unacceptable).

✦ Logos, branding, names, and so on must not be present on sports equipment; even something like the three stripes on Adidas shoes or an article of clothing would be potentially problematic—even if the name Adidas is not visible.

Stock agencies like series of images, showing many versions of the same image, because buyers want to be able to select just the right image. Greg Choat, a sports editor who acquires various stock images for Corbis, advises photographers to "think in concepts." You should look for ideas that are represented by images. Use the following terms as a start:

✦ Argument

✦ Agreement

✦ Speed

✦ Perfection

✦ Conflict

✦ Determination

The old adage of "a picture is worth a thousand words" applies to stock photography, in spades. Focusing on conceptual image development and thinking of as many angles and ways to portray a subject as possible is essential in this area of photography.

However, one of the biggest problems for photographers—and for stock agencies—is being able to pare down images. Often, and especially in the digital age, they receive far too many photos, and they don't like having to select images. It's up to you, most often, to present your best work.

Knowing what stock agencies want

Images must adhere to the standards of the stock agency, which they will specify for you. They often include specific information about ownership and usage, and how you identify images such as placing captions, descriptions, and keywords into metadata.

Someone may call for sport-specific stock shots, like the kind shown in Figure 12-5, or shots of a specific team, sport, or athlete. For these, you need the permission of the player or team in writing that you can provide to the stock agency, unless you are shooting in an official capacity with a commercial release, meaning the entity has signed an agreement with you as to how the images will be owned, licensed, and used, who owns them and makes money from them, and so on.

Images must also be sized correctly to the agency specifications and must be of very high quality. You should use images that are perfectly exposed and focused (unless the image is intentionally blurry for artistic or metaphoric reasons, such as to show motion in an athlete); nothing less is acceptable in the stock world.

You may want to focus on one sport and really exhaust what you can shoot for it before going to another; alternative sports also are good ideas for stock agencies because they're likely to have many images of football, baseball, and soccer, but perhaps not so many of table tennis, tae kwon do, canoeing, or handball (as seen in Figure 12-7).

Figure 12-7: A search for the term "handball" at Corbis.com resulted in this page being displayed.

You need to have model releases for any non-public events you shoot that include people. The agency may have its own releases for you to use. Just because you're developing images for a stock agency doesn't mean you are one of "its" photographers; this means that you won't necessarily have any special access or credentials just because you're providing them with photos.

Some stock agencies will let you try your hand at this type of photography, so take a look at the following; keep your eyes open for new ones popping up with various business models based primarily on Web innovation:

- ✦ Corbis (www.corbis.com)
- ✦ Getty Images (www.gettyimages.com)
- ✦ The Stock Agency (www.tssphoto.com)
- ✦ iStockphoto.com (www.istockphoto.com)
- ✦ Index Stock Imagery (www.indexstock.com)
- ✦ Fotosearch (www.fotosearch.com)

Assignment Photography

Commercial photographers often shoot images *on assignment*, which means that a company or organization has hired them to take photos of something specific, and a contract and financial agreement have been put into place.

In sports, this can mean any of the following:

✦ Shooting photos of a team or individual for publicity purposes

✦ Taking photos of a sports facility for a team or company to use in marketing, advertising, and so on

✦ Shooting a sporting event for a sports organization such as a federation, association, or even a company sponsoring an event

✦ Shooting on assignment for a stock agency (for example, the agency may need a specific type of sports image, and they know that you can provide it)

Shooting on assignment may occur because you happen to know that a specific event is taking place and you call ahead to the organizers or a sponsor. If they don't have an established or arranged photographer, you may be able to shoot the event; if you lack experience or a good portfolio, you can offer to (and they may want you to anyway) shoot the event on spec. But, you can't count on them purchasing any of your photos.

Larger sporting championships, even such as a regional or state tournament in a sport such as soccer or baseball, often have photographers already established, so you may need to start with smaller events and work your way up. However, under no circumstances should you try to shoot an event and sell photos when there's already a photographer contracted to do so.

If it's for publicity or marketing purposes, you work out a shot list with the organizers or team so that you know specifically what kinds of images they want. They may very well want a mix of poses — both individual and/or team — along with traditional action shots (such as a pitcher on the mound, a quarterback getting ready to throw a pass, and so on). If you've established yourself with one of the fulfillment services described earlier in this chapter, you can produce products that the team can offer to fans, athletes, and families, such as trading cards, prints, products like T-shirts, coffee mugs, and so on. Additionally, you will likely have to offer a small percentage (usually somewhere between 15 and 30 percent) of your profit to the team itself.

Sports Photojournalism

Sports photojournalists are what many people envision when they hear the term "sports photographer." The majority of photography taking place on the sidelines of major sports — in other words, the photographers you see shooting them — are doing so for publications, sports news agencies, and sports Web sites, primarily. Most of the photographers shooting with me at the Olympic Games were photojournalists, and they make up the vast majority of big-event sports shooting.

Becoming a sports photojournalist is a tough job to pursue and land. It's a competitive world; after all, who wouldn't want to shoot giant sporting events and get paid for it? At the same time, many newspapers and magazines, suffering from reduced advertising revenues over the last few years, have begun reducing their staffs, and photographers are among the biggest vocations hit. Furthermore, those lucky enough to get the jobs find that, with the supply of photographers far exceeding the demand, the pay scales are surprisingly low.

That said, sports photojournalism is a rewarding career, and many sports photojournalists augment their often-meager pay with their own photography businesses on the side, ranging from shooting local teams and individual athletes to portrait and commercial work.

One nice perk of being a sports photojournalist on staff at a newspaper is that usually your photography equipment is supplied, and it often includes very high-quality lenses and cameras. On the down side, if the organization happens to favor Canon over Nikon, or vice versa, and you don't, then you still may have to shoot with what they provide.

Breaking into digital sports photojournalism

Getting into sports photojournalism means having lots of experience under your belt and being able to show a sports editor a hefty portfolio of work germane to the kind of events he or she would assign. Versatility, the ability to produce top-level photos on a daily basis, the willingness to work long hours and sometimes to travel, and other demands will be placed on you to be able to get the sports shots required of a busy publication, especially in a larger city.

Education is also a factor; especially today when photojournalist positions have become less available with trimmed-down newspaper staffs. Having a degree in journalism or communications can make the difference between getting a job and being beaten-out by someone who perhaps has less experience.

Beyond education, if you're intent on building a career in sports photojournalism, you need to build a portfolio first and foremost. You may want to begin by working for a smaller local newspaper, shooting things like middle school and high school sports, before approaching the media in larger cities.

The kind of photographs that sell to an editor fall into specific categories. Unlike stock photography, seldom are the photos going to be generic:

✦ Shots of winning moments, like home runs, athletes celebrating, coaches jumping out of their seats, cheering fans, and so on

✦ Images of victory and defeat, filled with passion and sometimes controversy

✦ Key athletes, especially ones that the community wants to see highlighted and often those assigned by an editor

✦ Environmental shots, such as showing a filled-to-capacity stadium, especially if they relate to news stories

✦ Shots of dignitaries, celebrities, or local notables attending a game

✦ Injury shots, such as a player being taken off the field on a stretcher

Freelancing

Another type of photojournalism is called freelance photography. Instead of working on the staff of a newspaper or other media organization, you essentially work on assignment to go to specific events and get photos that you then sell to an editor. This is how many magazines work to get photographs of key events, especially if they lack the resources to hire photographers and send them to lots of events.

A book titled *The Photographers Market* has been informing photographers for years about all the various publications that hire freelancers, how much they pay, what they assign, who to contact, how to contact them, and so on. This is a great starting place, because it lists literally thousands of publications, including many that are sports-related, and it gives you a sense of what's out there and what you can do to pursue this area of photography.

Joining Pro Sports Photography Organizations

Many pro sports photographers turn to professional organizations for support in their trade. The Professional Photographers of America (PPA) and the National Press Photographers Association (NPPA), for example, have a number of sports photographers who rely on them for information, insurance, and other benefits.

Another Web-based organization, SportsShooters.com, has a large number of sports photographers who pay a fee to belong to the site, which features a large amount of information, image exchange, and chat lines, information posts, and the like. However, unlike the NPPA and PPA, SportsShooters.com has been very restrictive in allowing new members and seems to be a rather closed community, even for very accomplished and respected photographers who become interested in joining.

Local chapters of the PPA are good to research and see whether they have any special meetings and/or events for sports photographers. Sometimes, these organizations tend to favor portrait and wedding photographers more than photojournalists or sports photographers; however, if you're doing team and individual shooting, you essentially fall into a portrait photography category anyway so you may very well find benefit in checking into what they offer and the meetings they hold.

Summary

If the essence of professional or commercial photography is making money with your photos, then many ways are available in which almost anyone can go pro. You don't have to be shooting from the sidelines of a pro basketball game or assigned to cover the Olympics to sell your images; in fact, a large number of photographers selling their work are doing it part-time. However, doing this well, consistently, and being able to replicate your good work day-to-day is a differentiating factor that separates pros from amateurs. It's not always fun or what you want to do; instead, it's what you know you must do, and do it well, to maintain your reputation, credibility, and build your business.

What you need to determine is what kind of photography you want to do and of what subjects. In sports, you have opportunities to shoot teams and individuals, to work for newspapers and magazines, or to develop stock photography. Each requires specific skills and a dedication to building your business, whatever type you've chosen.

✦　　✦　　✦

13

Legal Issues: Taking, Displaying, and Distributing Sports Photos

© Joy Absalon

We live in a litigious society, like it or not. People want to protect what they have, and on occasion this goes beyond what is prudent or even reasonable. Nonetheless, photographers must work within the confines of legality and must not only protect their work but also protect to the rights of others. Because a photograph is so potentially revealing, it has a special place in the legal world, and in the wrong hands, it can be very damaging.

Sports photographers must be aware of legal issues in their efforts to ensure that they are protecting the rights of others as well as themselves. In addition, especially because their work takes place almost exclusively in the field, they must be prepared for the legal restrictions placed upon them by the organizations and individuals they encounter and with whom they work.

Understanding the Legal Issues in Sports Photography

Some people love having their photos taken, and others — especially in light of how broadly images can be disseminated on the Web — are highly concerned and suspicious of their images appearing without their permission or knowledge. Every photography situation differs in its legal implications, and this aspect of amateur as well as professional work must be realized and kept in mind.

This said, I'm a photographer and not a lawyer. I do everything I can to protect myself and adhere to the legal restrictions placed on me in various situations and by various organizations. In this chapter, I offer some guidance and advice based on the law and standard practices, as I understand them. You should do the same; the more public your images, the more you should protect yourself as well as your subjects, and if necessary you should consult with an attorney to ensure that you're doing the right thing.

Note For a really great and thorough source of helpful legal information for photographers, check out *Law in Plain English for Photographers* by Leonard D. DuBoff. This covers a wide range of legal issues that you will find useful.

Following the rules, even when you think they're dumb

As part of working on this book, I set out to take some soccer photos. I contacted the state soccer organization, which, as it turned out, was having a state youth championship. I applied to them as a media photographer, telling them I was looking for images for my book on sports photography.

For the championship, the state organization required that I submit a written request to them as a member of the media, to send them a photograph of myself, and to fill out a state patrol document indicating whether I had been convicted of any felony. Further, I had to include my name, address, phone number, social security number, and driver's license number.

Once approved, they sent me a media credential in the mail — a badge to wear at the event — as well as an e-mail confirmation. I also received a card in the mail for my state patrol approval. The state organization was very friendly and seemed pleased that I was attending.

When I went to the event, which perhaps had about 100 spectators, I was the only photographer aside from the company taking professional shots and selling them (which I was not doing). I approached the organizers and let them know I was there. The state commissioner introduced himself and immediately told me that no one had told him I was coming, and he seemed surprised. I explained what I was doing.

We discussed that I wanted to take shots of soccer players (in this case, 17- and 18 year-old girls) playing at this state final to publish in a book. I also indicated that I would probably like to get model releases from individuals who might appear in the book.

The commissioner immediately expressed concern about this, and to make a rather long story a bit shorter, told me that I would have to go through the state organization to contact the teams, and then the teams would have to contact the parents of the athletes, and that it could be a very long, drawn-out process.

In addition, the commissioner told me that he was limiting me to taking images from no closer than wherever the spectators were sitting and standing — at least 30 yards from the field — and that the closer

spots on the huge and wide-open spaces surrounding the field were limited to the commercial photographers shooting the event.

"Your legal limitations here are more rigid than the Olympic Games," I told him. "Yes, we like to keep a very sterile environment," he replied. Figures 13-1 and 13-2 illustrate how I made the most of a restrictive situation by taking shots that show the soccer game from perspectives that do not reveal any specific players personally.

If you decide you want to try to get media credentials for an event, make sure to ask what allowances it gives you and if officials will be notified of your attendance ahead of time. However, even if you do all this, you still aren't guaranteed the best access or great shots.

Every organization is responsible for protecting its youth players while they play in very public places, ranging from their safety on the field to who has access to them. But, you have to protect yourself, so work with your chosen organization as best you can and follow the rules they've set.

Avoiding potential legal pitfalls

Sports photographers must understand legal limitations and what's asked of them in any setting. You may be taking a photograph of an individual skateboarder, a catcher and batter at a Little League baseball game, a parasailer soaring above the trees, or players from two basketball rivals playing against each other on a court. Each of these situations presents different legal scenarios, and you should know what to do for each.

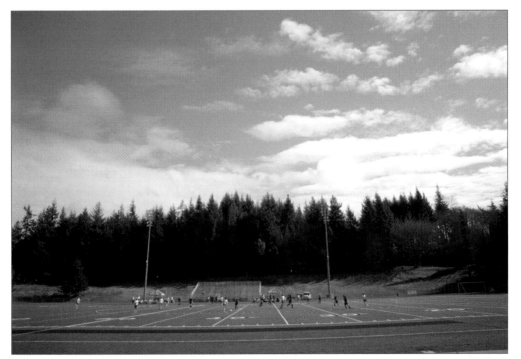

Figure 13-1: To avoid significant hassles in getting permissions, I chose to take some photos that had a larger scope in which no athlete could be recognized.

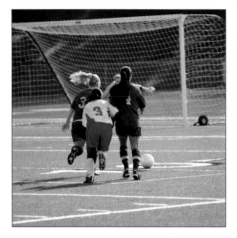

Figure 13-2: Shots of the action going away, where subjects are not facing you, are also a good work around.

Furthermore, each situation differs depending on what you intend to do with the photos. If you're publishing the photos in your personal Web gallery, that's much different than just showing them in a slide show in your living room. If they're going to be published somewhere, or you're going to sell them, you're again dealing with different legal issues.

Let's say that you take a photo of a nice couple sitting in the stands of a hockey game, and you publish the image on your public Web site all about ice hockey. Have you violated the couple's right to privacy?

Most right-to-privacy laws focus on photographs of individuals "in seclusion," not at a public event. However, singling out a non-performing subject at a sports event, such as a screaming fan, and publicizing it may potentially present a case that you've infringed on their right to privacy. If possible, you should get that person's written permission to use his photo for anything other than private use. This applies doubly if the subject is a minor.

Legal issues and youth sports

Our commissioner friend, while making the media photographer's life difficult and preventing his sport from being better publicized, certainly had the protection of young soccer players in mind. Kids represent a special category in the law, and those who come into contact with them — whether as a coach, a parent driving someone else's children, a referee, or a sports photographer — become responsible for protecting and respecting them individually and collectively. Their protection is (or at least should be) more important than anything else. At the same time, everyone has a job to do.

If you're a parent shooting your child while he or she competes on a playing field and other kids are in the photo, especially at an event open to the public, there's no problem if you print these images, give them to friends, and even put them on the Web to share with others on a service like Kodak Image Gallery or Snapfish. You're not publishing the images commercially, and the event was taking place where anyone could come and take photos.

However, this gets a little different if you've singled out a particular player — presumably not your own child — and taken several photos of her and then published the images on your own without a particular reason to do so. Even if that child was the leading scorer in the game, when you're taking kids' photos for any kind of publication, it's best to get written permission in the form of a model release, from someone in authority — at the least, a coach or organizer, but it would be best to have a parent's or guardian's signature. If you plan to use the images on your Web site, or have them displayed publicly (such as in a photo

presented in a gallery), or used commercially — such as in a magazine ad — you must get a release. If the player is being compensated for having his photo taken, then that should also be stated in the release and the amount/type of compensation specified.

If the players are not recognizable — meaning that you can't see their faces or something else that obviously identifies them (like a name on a shirt), then no release is necessary. Figure 13-3, for example, shows some soccer players' feet on the field; even if these players recognize themselves in the image, there is no legal issue with the image because no one will know who they are.

Tip In some cases, players and those responsible for them — their parents, typically — sign a publicity and photo release before an event as part of their registration. If so, the organization can tell you that this is the case if you are working for the organization or if you are going to use the images for media or other purposes. However, this usually does not include commercial usage.

Many sports organizations are very intent upon protecting their images. Typically, in a photo of a large, public sports scene where many players are visible but appear only as a small part of the shot, concern about using the image at the individual player level is minimal. Using it as a fine art image — such as in an art gallery, on a Web gallery, or in a similar fashion — may be acceptable and of little consequence. However, the organization putting on the event or the teams themselves may not approve of the photo being used for *commercial* purposes, which means that you are using it to promote something such as a product or a company; selling the image(s) as fine art or as stock, generic shots are distinguished from this use.

© Alexander A. Timacheff

Figure 13-3: No one can tell who these soccer players are, where they are, or even what team they're on, so there's no legal issue with them being used commercially or publicly. Additionally, this image has been treated creatively with the Photoshop Cutout filter for an interesting effect.

If you've engaged the organization or team to shoot the players and to sell them team and/or player photos, then you're in a different situation. Presumably, everyone coming to have her photo taken knows the images will be printed and probably used on a public Web gallery or in some other way. Some Web services offer the option of having the photos password-protected, which is something you may want to offer parents. You don't need a release for this kind of photography because it's a personal service and everyone is giving you implied permission to take the photos by being there for the shoot. If you decide some of the images from the shoot are ones that you'd like to use to promote your business, however, such as on your Web site or in a brochure, then you should get a parental release. And, obviously, if you intend to sell the image to another entity such as for stock or commercial purposes, then you definitely need a release.

Legal issues and adult sports

With adult athletes, the same general rules apply as with youth sports:

✦ For images where no one is recognizable, you don't need a release.

✦ Know and respect the organization's and the teams' legal restrictions.

✦ If you're taking photos for any purpose other than as a family member or friend, let the organization know you're there and what you're doing.

✦ Images just for your own private use don't require any special permission (usually, unless someone notices you taking photos of them and objects to having photos taken).

✦ Using an image for the media, as fine art, or commercially are legally different, and each situation may require you to do different things, such as obtaining a model release.

✦ If in doubt, get a model release (obviously, the athlete and/or subject can sign it himself).

Model Releases

Model releases are most often meant to protect the photographer. They allow you to do whatever you need to do with a photo and indicate that the subject (as well as the parents or guardians, if the subject is a minor) has given you unrestricted permission to use and own the photos you take of them.

Not everyone, of course, is willing to sign a model release. Every photographer has encountered — or will encounter — situations where a great shot can be or has been taken and the subject refuses to allow it to be used. In these situations, you can do little to get someone to sign a release if he's not happy about his image being displayed somewhere. Furthermore, even if the image could arguably be used without a release, if you know the person may have a problem with it, it's probably not worth the risk.

The bottom line in youth as well as adult sports photography is that getting a release is often desirable and sometimes a necessity. Figure 13-4 shows a typical, simple release that you can use for these purposes.

You should keep signed model releases in a safe and accessible place where you can get to them if it ever becomes an issue. I hope it won't.

As a sports photographer, you probably don't want to use lengthy, jargon-ridden model releases to distribute at sports events. If you're doing a commercial shoot with models for a specific client, that's a different story. But if you want to be able to use images on your Web site, for fine art, or other less commercial endeavors, simple releases work because they are plain, clear, short, and still legally binding. A person in the midst of a sporting event — whether a player or a spectator — is far more likely to sign a short, simple release.

(Simple model release)

Date

I,_____ (adult parent or guardian), declare that I am the parent or legal

guardian of _____ (minor), and that I herby give permission

to _____ (photographer) to photgraph the named minor. I realize that

the images may be published in any form and in all manner, electronically or in print. I assign the

photographer, his legal representatives, licensees, or anyone else he or she assigns or authorizes,

the right to use the name (real or fictional) along with their image for commercial, public, or any

lawful use. I further acknowledge that I am releasing and waive any rights to review or approve

any version of the image.

Witness & Date

Address

Signed (parent or guardian) & Date

Address

Photographer & Date

Compentsation:

The following compensation (money, products, or services) have been or are being provided

to the subject in consideration of their being photographed:

Figure 13-4: Here's a simple and quick youth model release that can be carried to a sports event. You don't want anything where the text is too long or contains too much legalese if you need a quick approval.

Sports Organizations and Photographers

Whether it's a local Little League team or an NFL giant, every structured sports organization has a concern for how its team is portrayed in photographs. Although some large organizations, such as Major League Baseball or the National Hockey League, may, along with various stadiums, limit you just as a spectator in what kinds of photos you may or may not take, you can easily attend most sports events and shoot photos for your own use. You can even share images on Ofoto or another service without concern.

However, if you plan to publish, sell, or use the images in any commercial way, or sell or even give them to a media organization, then most teams require that you get their permission to do so. Fortunately, it's easy to get credentials for the vast majority of sports events other than the big professional ones, because most teams and organizations want as much publicity as possible.

Another limitation that is important to consider is that of the school sports organizations, and, in particular, the NCAA. Responsible for managing collegiate athletics, the NCAA is very restrictive when it comes to maintaining the amateur standing of their athletes. They cannot receive compensation of any kind for photos taken of them, and photographers are discouraged from using the photos unless they're officially sanctioned and credentialed by the NCAA or are members of a recognized media organization.

If you're attending a game and you want some photos of your favorite player, or family member, there's no issue. However, if the photos are used in any other way, then the college will want to apply its limitations in accordance with how it interprets NCAA regulations; not doing so can potentially cost the college as well as individual athletes the eligibility to compete in NCAA events — or to be fined.

For example, you may have heard the story of a college athlete at one U.S. university who was banned from competition for a period of time because he allowed a sorority at his school to use his photograph in a fundraising calendar. Although he received no compensation for the image, it was still considered a violation.

There's a distinction made between how you intend to use the images: to sell them commercially and publicly (such as for stock or specific advertising purposes); to sell them to the media (for publication in a news-oriented newspaper, magazine, or Web site); or for private use (such as fine art and individual ownership of the image). Various sports entities sometimes stipulate how you can use your images based upon these different uses and will give you credentials accordingly.

A tremendous amount of personal photography was shot at the Olympic Games, and a Kodak photo center on-site allowed spectators to develop, process, and print their film and digital photos, but anything commercial was restricted. The International Olympic Committee goes to great lengths to protect its image in many ways, and photography is one of them.

In an official capacity at the Olympics, I was subject to a commercial usage limitation, meaning that my photography was to be used for media and private use only. Also, because official photographers get special access to areas where others cannot enter, they must have special security credentials. Months before the games, I had to apply using a detailed process and set of forms. It doesn't matter if it is the Olympics or the local soccer tournament, some form of credentials may be needed.

Other big sports organizations, such as major-league sports, also greatly limit and usually completely prohibit any commercial photography that they haven't commissioned. Media photographers get special credentials through their publications or news/sports bureaus, and getting a media pass isn't easy. Space is limited on the sidelines (see Figure 13-5) and in the photographer areas, so even the qualified photographers have a pecking order.

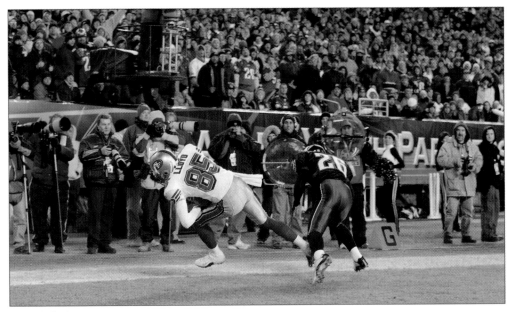

© *Terrell Lloyd*

Figure 13-5: All of the photographers on the sidelines of this pro football game have obtained media credentials well in advance of the game.

For any sports organization beyond a small, local team, and for any photography other than for your own private use, you should contact the organizers ahead of time to get credentials for the event — or, at the very least, to let them know you'll be there and learn about any limitations they may have. By contacting the organization, you may get special access; the organization probably wants to have its event photographed and may go out its way to provide you with the opportunity to take some really great shots.

Protecting Digital Photography

Copying pictures has never been easier. A digital photograph on the Web is vulnerable to being duplicated with a couple of mouse clicks, and it can instantly be sent anywhere in the world to be used in a manner over which the photographer has no control or knowledge. So, you must protect your work.

A photograph I took of a jumping fencer from the Olympic games has become so popular that I often hear that it has been taken and used — even though the only copies that I provided were *watermarked*, meaning that that they have added text and/or graphics displayed as part of the image. At a recent fencing championship in Tokyo, a referee told me that his brother was using the image as a background screen for his mobile phone!

My knowing about it or having no control over what happens doesn't make it any more legal, of course. When you take a photograph, you own it, unless you're doing it on assignment for an organization and you've given permission for the organization to own the photos. You don't have to apply to the federal government to lay claim to owning the image, although there is a way to file images with the U.S. Copyright Office (there is a fee, so it can be pricey if you have lots of images).

You can put your name, a copyright statement, and other personal information into the *metadata* of an individual image (the embedded information in an individual digital image, which shows camera and exposure information automatically as well as information you can add), which at the very least identifies you as the originator of the image. Figure 13-6 shows metadata being added to a photo in Photoshop Elements. If you haven't added your own information to the metadata tag, someone else can put his name in it and claim it for his own—sort of a "finders-keepers" concept of digital photography, but a disturbing one. Many image-editing packages let you add metadata tags to large numbers of photos in a batch process, which is an advisable thing to do if your images are getting passed around digitally. Metadata isn't necessarily permanent, however, other than the camera/exposure information, which you can't easily change. Theoretically, someone could go into a file and change the information — so it's merely a deterrent, not a definitive way of preventing the file from being misused.

Figure 13-6: Adding a metadata copyright statement in Photoshop Elements

To see the metadata, and to add your own, in Photoshop Elements, open a photo, such as a JPEG or TIFF file. Once the image is open, choose File ➪ File Info. The File Info window will appear. From the Section dropdown menu, choose General or EXIF. Selecting General allows you to add your own information, such as your name, a caption, and a copyright notice. This information remains with the file after you save it. Selecting EXIF gives you information about the file, such as the type of camera it is and the settings used to take the photo.

Images that appear in photo-sharing and storefront services are often in danger of being copied as well, unless the company has protected them through software (if you right-click on an image in Printroom.com, for example, instead of seeing a menu with the option to copy, a dialog box appears telling you the image is copy protected, as shown in Figure 13-7).

Another way to protect images is by watermarking them. Removing the watermark would irreparably damage the photo. Some online services offer this as an option. All stock agencies watermark their photos, and various image-editing packages allow it as well. Another way to do it is to add text across an image in your image-editing package — your name, for example — and then save the image as a *flattened* JPEG file. When you flatten an image, you remove the separate layers of text and the image; all the elements are merged as one layer, as demonstrated in Figure 13-8. You can then put this image on your Web site or offer for distribution, unless it's specifically destined for final display.

Figure 13-7: Images are copy-protected in some online services, such as this one at Printroom.com.

Figure 13-8: A watermarked image being produced in Photoshop Elements

Tip If you watermark an image yourself, don't just place the watermark in a small corner of the photo. Someone could still crop out the watermark and use the photo without it!

Yet another way of protecting images has to do with prints. Many professional photographers use *back printing* on prints, which means that their studio and/or personal information is printed on the back of the photograph by the lab. If you're using a lab or an online service, you can ask whether this is an option; usually it's offered for free or for a small fee per image. If someone were to take that print to another lab and ask that it be scanned and copied, most professional labs will refuse to do so if they see a copyright statement or even a photographer's name.

Tip If you're selling your work, many people will want to buy digital photos from you, and not just prints. Some photographers won't sell digital images; if you decide that you will, make sure that you have metadata tags on the images and don't sell the full-sized images unless the customer has paid a price for them that reflects their value — remember, once they have the digital images, chances are you won't be selling them prints of the image! Also, organizations such as the Professional Photographers of America offer small copyright leaflets that you can include with your order.

The very nature of digital photography demands that you do everything you can to prevent your images from being copied; if you're reasonably prolific and you've distributed your photos to others, it's likely that you'll encounter copying at some point. The best defense is a good offense, as they say, so do whatever you can to prevent problems. It's much easier than fixing problems after they happen.

Summary

Sports photographers of all types must understand the legal implications of digital photography. Shooting at sports events often requires letting the organizers know that you're there, and they may require you to have some credentials or be pre-approved to photograph the event. Other photographers may have contractual arrangements allowing them to be there, and if you appear to be a commercial threat to them, you'll hear about it. Getting permission from event organizers is important and may require that you sign documents; however, this may give you access to being able to take photographs from angles you may not otherwise have had.

If you're shooting images that will end up in print or on the Web — especially in any commercial or highly visible way — then you need to get model releases from your subjects. This becomes increasingly important when it involves minors, and then you'll need to involve parents or guardians. The basic rule: If in doubt, get a release.

Protecting your work is the flip side of the legal issue in photography. Your images are your personal property, and you should know how and when to have them watermarked, as well as how to add metadata that helps identify them as yours. Although it's probably impossible to completely protect your work from others taking it — and the more visible and interesting your work is, the more likely it is to be taken — you can take measures to prevent it.

✦ ✦ ✦

A Photography Resources

There are a scads of organizations, retailers, software manufacturers, online services, labs, and resources available to digital sports photographers, whether you want to go pro or just go out and shoot a backlot stickball game. Here are some I think are noteworthy and/or interesting to help get you started:

ACD Systems: Software manufacturer of ACDSee and other applications.

> www.acdsystems.com

Adobe: Software manufacturer of Photoshop and Photoshop Elements.

> www.adobe.com

Adorama: Major photography retailer.

> www.adorama.com

American Society of Media Photographers: Professional society for photojournalists.

> www.asmp.org

B&H Photo: Major photography retailer.

> www.bhphoto.com

Express Digital: Software manufacturer of products for professional and amateur photographers such as Digital Darkroom.

> www.expressdigital.com

Graphic Authority: Electronic educational tools and tutorials for photography.

> www.graphicauthority.com

IAPEP-International Association of Professional Event Photographers: Highly oriented to sports photographers as well as general event shooters.

> www.iapep.com

Kodak EasyShare Gallery: Kodak's online photography lab, formerly called Ofoto.

> www.kodakgallery.com

MorePhotos: Professional online photography fulfillment service.

> www.morephotos.com

National Press Photographers Association: National organization for photojournalism, including sports photographers.

www.nppa.org

Photo.net: Huge online photography community.

www.photo.net

Photodex: Software manufacturer of slideshow software such as ProShow and ProShow Gold.

www.photodex.com

Photographic Society of America: Worldwide, interactive photography organization for all types of photographers.

www.psa-photo.org

Photography-on-the.net: Forums and information, all about digital photography.

http://photography-on-the.net

PhotoLinks: Online photography directory.

www.photolinks.com

PhotoReflect: Professional online photography services.

www.photoreflect.com

Printroom.com: Professional online photography services with many sports and event photographers.

www.printroom.com

Professional Photographers of America: Professional society of photographers.

www.ppa.com

Shutterfly: Online photography lab.

www.shutterfly.com

SportsShooter.com: Online community and resource for sports photographers and other working photojournalists.

www.sportsshooter.com

The Nikon Users Community: User group discussing all aspects of shooting Nikon cameras.

www.nikonians.org

Yahoo! Photography Groups: Many informative groups about all aspects of photography. Search for photography, digital photography, or sports photography.

http://groups.yahoo.com

✦ ✦ ✦

B Contributing Photographers

We would like to wish hearty thanks to the incredibly talented photographers for contributing their diverse and creative work to this book — in both images and words.

Most of the photographers listed below have their own Web sites. Please take a look at them for more examples of great sports photography — as well as many other types of images.

Joy Absalon (www.sportsshooter.com/members.html?id=833)
E-mail: joyabsalon@cox.net

Francis Baker (www.francisbaker.com)
E-mail: francis@francisbaker.com

Craig Chan
E-mail: craigchan_hk@yahoo.com.hk

Marc Chirico (www.seattleparagliding.com)
E-mail: marc@seattleparagliding.com

David Esquire (www.esquirephotography.com)
E-mail: david@esquirephotography.com

Bill Garvin (www.garvinphoto.com and www.marinephoto.com)
E-mail: info@garvinphoto.com

Sharon Green (www.ultimatesailing.com)
E-mail: sail@ultimatesailing.com

Adam Hardtke (www.adamhardtke.com)
E-mail: adamhardtke@hotmail.com

Hollie Hailstone

Harry Haugen (www.keepsakereflections.com)
E-mail: haugenphotopro@aol.com

Nathan Jendrick (www.phoenix-digital.com)
E-mail: nathanjendrick@gmail.com

Wernher Krutein (www.photovault.com)
E-mail: admin@photovault.com

Laura Little (www.shashinya-onna.com)
E-mail: laura@shashinya-onna.com
Management: JP Global, www.ampglobal.com

Terrell Lloyd (www.terrelllloyd.com)
E-mail: terrelllloyd@earthlink.net

Jim McKiernan (www.snoqualmieimages.com)
E-mail: mckiernan@centurytel.net

Amber Palmer (www.amberpalmer.com)
E-mail: amber@amberpalmer.com

John and Terry Reimer (www.legacyartists.com)
E-mail: john@legacyartists.com

Dave Taylor (www.ColoradoPortraits.com)

Neal Thatcher (www.networksphotoandvideo.com)
E-mail: nealth@networksphotoandvideo.com

Amy Alden Timacheff (www.tigermountainphoto.com)
E-mail: mail@tigermountainphoto.com

Alexander A. Timacheff

Will Wissman
E-mail: willwissmanphoto@hotmail.com

✦　　✦　　✦

Glossary

additive color: Monitors add colors together to project light and can produce a larger spectrum of color than is possible to create by mixing colors on a printed page.

archival quality: References to archival quality usually mean a print that will last between 60 and 80 years.

archival quality CDs: Archival quality CDs are made with materials and to standards intended to allow them to last well over 100 to 150 years without degradation of quality.

ASA: Film sensitivity was rated with ASA or, in Europe and some other places, with a DIN rating (DIN stands for Deutsche Industrie Norm, a German standards organization). ASA stands for the American Standards Association, which, like DIN, was replaced by the ISO rating.

backup media: Backup media includes readable and read-write CDs, as well as writable DVDs that store six or seven times the amount of data as a CD. Other backup media include internal or external hard drives, removable media such as Zip disks, and even portable media such as the Apple iPod.

barn doors: An attachment to the front of the modeling light consisting of multiple doors that can be moved to control where light is being cast on a scene.

batch processing: Applies the same types of changes or modifications to all images in a folder (or drive).

calibration: Monitor calibration corrects color display to established (ICC) standards.

card reader: A card reader is a device that reads photo-storage cards and transfers data to a computer.

chrominance noise: Very small, off-colored specks in an image.

CMYK color: Printers create colors by mixing inks — cyan, magenta, yellow, and black — collectively referred to as CMYK (K is used to represent black, to prevent confusion with blue). Current inkjet photo printers enhance the set of printable colors by adding other cartridges like light cyan, light magenta, or red, green, and blue.

colorimeter: A device used to measure a given lighting scene and then adjust your camera's Kelvin degree setting accordingly.

copyright: When you create an image, you automatically own the copyright, which is essentially the legal right to reproduce, publish, and sell your photographs. Do not forget that your photos are intellectual property, and they need to be protected.

CRT (cathode-ray tube) monitors: A CRT moves an electron beam back and forth across the back of the screen of the CRT monitor, lighting up phosphor dots on the inside of the glass tube, illuminating the active portions of the screen. When many lines are drawn from the top to the bottom of the screen, you see an entire image. CRT monitors are favored for soft-proofing by serious digital photographers because of traditionally better calibration results.

digital noise: Refers to grain in images, making them look film-like. Digital noise, which occurs more noticeably when you take photos with a higher ISO setting on your camera, rarely looks attractive.

digital photo processing: Taking the untouched, original digital image from when it first is transferred to the computer and processing it to be stored, archived, optimized, prepared for client needs, edited and enhanced, displayed, and printed.

digital viewfinder: Digital viewfinders, common in less-expensive, point-and-shoot, consumer digital cameras rely on some form of liquid crystal display (LCD). LCDs have many advantages over optical viewfinders in film cameras — they allow you to view other photos, and they provide a sharp, accurate image. LCD viewfinders, however, require substantial battery power, particularly when it's necessary to generate an image bright enough to see in bright light.

DIN (Deutsche Industrie Norm): A German standards organization for film speed. ISO (International Organization for Standardization) is now used worldwide as the prefix to film speed and to refer to speed settings on digital cameras.

dithering: Combining many different ink droplets (in a printer) or pixels (on a monitor) to generate a composite color. These droplets are too small to be distinguished by a human eye, even with a magnifying glass. They blur together to produce colors.

dye-based inks: Dye-based inks are dissolved in the inkjet spray process, and mist in the form of tiny droplets onto photo paper where they are absorbed into and combine with the layers of photo paper to produce color. Traditional (film) photo printing relies on dye-based inks and their ability to react to paper on a molecular level.

dye-sublimation (dye-sub) printing: Dye-sublimation printing combines cyan, magenta, and yellow ink in gaseous form, where gasified droplets of ink combine to form the color range.

EXIF (Exchangeable Image File): An internal file format commonly used by many digital cameras to manage JPEG- and TIFF-processed images. This allows images to be "understood" in various formats and applications. Even when a camera records a JPEG file, for example, it is storing the file in EXIF format and using a JPEG compression algorithm to process the image.

FireWire: A simple, fast form of file transfer that uses a FireWire cable to connect your camera directly to your computer. FireWire devices can be daisy-chained, as well, allowing multiple drives to be connected to the computer via one port.

fixed-lens camera: Typically a less-expensive digital camera without the option of interchanging different types of lenses. Fixed-lens cameras have a single lens permanently attached to the camera; many of them can zoom in or out, both digitally and optically. Images are presented to the photographer via a video LCD or through a mini-viewfinder that approximates where the lens is pointing.

flagging images: Flagging is a technique for selecting, prioritizing, and sorting images.

flash bracket mount: A flash bracket mount, often with cable, allows you to raise the flash higher than if it's just on the hot shoe of the camera (to avoid red-eye and be able to rotate the flash for vertical shots).

flash card: Small storage devices (such as CompactFlash, SmartMedia, and Memory Stick) that store and move or copy photos to a computer using a flash card reading device. Flash cards hold image files that have been transferred from the camera.

gels: Colored transparent sheets of plastic that add spot color to a scene; these are mounted onto a light.

GIF (Graphical Interchange Format): A graphics format supported by the Web. The GIF format is a lossless compression technique that supports 256 colors. GIF is better than JPG for images with only a few distinct colors, such as line drawings, black-and-white images, and small text that is only a few pixels high. GIF supports animation and transparency.

glossy paper: Glossy paper reflects more light than matte or textured paper and, therefore, produces brighter colors.

grid: A honeycombed disk that snaps into the hood in front of the light to control light on a subject and provide lighting depth without highly defined edges. These also come in large, soft styles as a combination of a soft-box light with the grid effect.

grid lighting: Grid lighting disks can be mounted in a light and are available in varying percentages. The percentages refer to the amount of light allowed through.

ICC (International Color Consortium) profiles: The International Color Consortium is an organization that manages the standardization and information about how digital cameras, monitors, printers, and scanners process and manage color. When devices are equipped with ICC profiles, image-editing software, such as Adobe Photoshop, can preview your photo based on your printer and paper using the ICC profile of your printer. Most major printer and scanner manufacturers include ICC profiling information with the printer drivers and software that come with your printer.

image-capture device: Usually a digital camera, but it could also be a scanner or other equipment.

inkjet printing: Inkjet printing provides the widest scope of size, quality, and print media, and dominates studio printing.

ISO (International Organization for Standardization): ISO is now used worldwide as the prefix to film speed and to refer to speed settings on digital cameras.

ISO settings: When you set the ISO on your camera, you're determining how much light you want the camera to allow the CCD or CMOS to absorb for the image. For lower light, you want a more sensitive, or higher, ISO setting. This setting ranges from as low as 50 (for very bright light) to as sensitive as 3200 (for very low light). Higher ISO settings typically generate more digital noise.

JPEG: JPEG files are the most versatile and standardized images today. The format and term, which stands for Joint Photographic Experts Group, has been around for some time and is a good choice — especially for Web photos — because of quality, size, and general support. However, there are better-quality formats; for printing and general lossless file quality use TIFF, and for use on the Web and when simpler, solid colors are involved, use GIF.

LCD (liquid crystal display) monitors: Monitors with convenient flat screens for desktops and all notebook monitor screens.

light temperature: Different types of light have different temperatures that result in the light having different colors. A candle flame, for example, has different colors at its top, middle, and bottom, due to the fire being a different intensity and, therefore, a different temperature in those different areas. Likewise, the light outside in sunlight, inside a room with normal household lamps, inside an office with fluorescent lights, or in a studio with flashes all cast different temperatures and, therefore, appear in different colors when photographed the same way.

lighting kits: Lighting kits are typically more dedicated than stand-alone units and work with specific power supplies and connectors.

lossless formats: These are formats like TIFF, RAW, or JPEG 2000 that do not compress photo files or reduce data during saving.

lossy format: These are image file formats like JPEG, PNG, and GIF that compress digital data to reduce file size. Repeated resaving to lossy formats degrades quality.

loupe: A magnifying lens used specifically to view slides and negatives.

luminance noise: Tiny, dark specs that look like film grain in a digital photo.

mat spacing: Buffer between framed photo and glass.

matte paper: Nonglossy paper. Matte surfaces have the advantage of resisting fingerprints and stand up better to wear and tear.

metadata/metadata tags: The unique sub-file of data about an image recorded by the digital camera. It tells when the image was created, by what type of camera, the exposure and focal settings, and even information such as if the flash fired or not. Metadata is an easy way for a photographer to embed copyright, authorship, and image title information in a file.

mini-slave strobe light: A mini-slave strobe light is a very portable, inexpensive, and handy light that fires when your flash goes off.

model releases: A legal contract signed by photographer and model (and, in some cases, a model's agent and/or representative) that gives you permission to use the image of the individual being photographed.

nanometers: Color tones are measured in wavelength nanometers (nm), which is a billionth of a meter. The spectrum of visible light runs from about 400 nm (purple) to around 700 nm (red).

online storefronts: Online storefronts are essentially Web-based galleries where another company hosts your images in a format optimized for others to view them. You create the gallery, upload images to specific galleries, and set prices and other features such as image optimization, copy protection, and so forth. Customers can go online, see the images, select them, and purchase them. The capabilities of storefronts differ from site to site.

PCMIA card: A PC card adapter that fits into a laptop PC card slot. Can be used for card readers that accept CompactFlash cards for downloading images to the computer.

Photoshop Camera RAW format: The Photoshop Camera RAW format is a flexible file format for transferring images between applications and computer platforms. This format supports CMYK, RGB, and grayscale images with alpha channels, and multi-channel and lab images without alpha channels. Documents saved in the Photoshop Camera RAW format can be any pixel or file size, but cannot contain layers. This is not the same file format as a RAW image file from a digital camera.

picoliter: Ink droplets are measured in picoliters. One picoliter is one millionth of a millionths of a liter. Inkjet droplets generally range is size, depending on resolution, between two or three and 25 picoliters.

pigment-based ink: Pigment-based ink is sprayed onto the page in larger droplets. When Epson introduced pigment-based ink for photo inkjets, like the UltraChrome inks, those pigment-based inks represented a significant development in ink stability.

pixel: The smallest digital dot used to record image data. On-screen resolution is often referred to as ppi, or pixels per inch, while print resolution is usually referred to as dpi, or dots per inch.

PNG (Portable Network Graphics): PNG is a graphics standard supported by the Web (though not supported by all browsers). PNG images are 5 to 25 percent more compressible than GIF files of a comparable size. PNG also allows control over the degree of transparency. Repeated saves of a PNG image do degrade its quality. Animation is not supported.

pocket drives: Portable, pocket external drives are extremely convenient and provide a quick way to stash photos in the field. But their small capacity and relative fragility make them unsuitable as backup media.

profiles: Files that store information that synchronizes the output of color in various devices. Profile standards are set by the Internal Color Consortium (ICC).

proof books: One of the easier ways to show your work to a client or friend for whom you've shot a large number of photos is the tried-and-true film-photographer method of a proof book — with a digital twist. You can take the digital images to any lab to be processed as 4-x-6 or 5-x-7 images and then place your best shots in a presentation flip-style album. With it, you can include a CD of the images in low resolution that the client can see on a PC, or you can even include a simple slide show in a self-running mode.

RAID (redundant array of inexpensive disks) system: A RAID system is a set of drives that work together to create a large amount of storage. The drives automatically back each other up so that they are swappable and work together for optimal efficiency, scalability, and access. RAID systems are very reliable and perhaps the best way to store lots of vital information. They usually require a board that's inserted in your computer, the RAID hardware shell that holds the drives, and the drives themselves. Although a bit pricey for the entire configuration, your images are very secure stored in this manner.

ranking images: Image-management tools offer features that allow you to rank images, prioritizing the best shots. Rate the images that are obvious best shots, as well as those that are good possibilities, and so on. Although not every image needs to be rated, ranking down to second- or third-best can be accomplished quickly.

RAW format: A digital camera's RAW image file is a camera-specific proprietary format that provides the photographer with a digital negative, an image free of any filtering, white-balance adjustments, and other in-camera processing. RAW format provides instantaneous control of the image as the camera and photographer saw it, without any distortion, chemical intervention, or digital alteration. And this is all before images have been filtered in Photoshop or otherwise manipulated.

resolution: The concentration of data recorded by a digital camera, displayed on a monitor, or printed on a page.

RGB color: Monitors mix channels of red, blue, and green to produce millions of different colors. Each pixel on your monitor contains a combination of red, blue, and green. Those combinations are quantified with the RGB color system. For example, an RGB setting of red = 0, blue = 225, green = 0 produces blue.

rule of thirds: A very important, traditional, and yet simple concept for composing a good photograph is the rule of thirds, which involves positioning your subject within something similar to a tick-tack-toe grid.

sharpen: Virtually all image-editing packages offer a sharpen feature of one ilk or another that allows you to simulate the appearance of detail in a photo or section of a photo. Usually the feature allows you to use a slider tool to dynamically change the sharpness of an image, or perhaps you progressively click a button to increase sharpness incrementally.

silver-halide prints: Prints produced by traditional chemical photo development and printing.

sketch filters: Image-editing filters that transform your image into a black-and-white photograph that looks like someone sketched it with a pencil, charcoal, or other instrument.

SLR (single lens reflex): An SLR camera captures an image through a lens that reflects light through a prism and onto the viewfinder. Therefore, the viewfinder shows the real prepixel (nondigital) image that will be captured by the camera. Different from a fixed-lens camera, most SLRs support interchangeable lenses.

snoots: Cone-like attachments to a light that provide a focused spotlight on a scene or subject.

soft-proofing: Viewing a preprint proof in photo-editing software. Unlike traditional photo developing, it's possible to preview and soft-proof on a properly calibrated monitor to see a close approximation of your final print output. Soft-proofing is useful for printing on your own photo-quality inkjet or dye-sub printer and for previewing photos that will be printed by a service bureau.

stock photos: Stock images are photographs that can be purchased and used for commercial purposes, such as in brochures, advertisements, Web sites, and other purposes by advertising agencies, graphic-design firms, magazines, and individuals. They are typically marketed through stock agencies, a market dominated by huge companies such as Getty Images and Corbis. Photographers can also sell their images to these houses.

stylize filters: Perhaps the most wide-ranging artistic filters Photoshop CS2 and other image-editing packages offer, including embossing, solarization, glowing edges, and other effects.

subtractive color: Printers layer inks on top of each other to produce a spectrum of colors. This process is referred to as subtractive because, for example, when cyan is applied on top of yellow, the result is less yellow.

TIFF (Tagged Image File Format): A lossless photo file format. Some digital cameras offer TIFF as a file format in addition to RAW, but this has become less prevalent.

Unsharp mask: A seemingly counterintuitive term for sharpening an image. This type of mask doesn't actually blur anything in the end product, but sharpens it instead.

USB (Universal Serial Bus): The simplest form of transferring data between components like a digital camera or card reader and computer. Drives with USB 2.0 support, providing your computer supports 2.0, is significantly faster than USB 1.1. However, note that flash cards themselves don't download at full USB 2.0 speeds (but they're usually faster than USB 1.1).

UV-protected glass: UV-, or ultraviolet-, protected glass can help prevent ink and paper from degrading. Perfectly clear framing glass is available with up to 98 percent UV protection.

virtual backdrop: Using a virtual backdrop allows you to green-screen subjects onto virtually any background imaginable. Virtual backdrops combine an in-studio subject with a scene of anything you can photograph and create as a background. The result is a photo that looks like the subject was physically part of the background.

watermark: Text imposed on or embedded within an image to protect it against unauthorized use. Photographs can be watermarked with your copyright information using a variety of methods. At a simple level, professional online photography services allow you to watermark an image when it is displayed. If someone used a screen-capture program to copy the image, as long as it's watermarked it will be difficult to use because a word, logo, or other graphic or text is printed on the image, and removing it using an image-editing package like Photoshop would be very difficult.

white-balance: A measure of how the camera sees and records color based on light that's being reflected into the lens or sensor. White is actually a misnomer because cameras are actually calibrated against an 18 percent gray shade, not white. Gray is a midtone and, thus, a better determinant of what the camera is likely to see. You can purchase perfectly colored, 18 percent gray cards from photographic supply stores, take photographs of them in the light where you intend to shoot, and adjust your camera to that color to obtain a perfect exposure.

XMP (extensible metadata platform): Photoshop uses XMP to carry information among various Adobe applications and to manage publishing workflows. The information you append to a file's metadata, such as copyright information or a document name, will then appear as metadata in other applications.

✦　　✦　　✦

Index

A

Absalon, Joy, photographer, 168–171, 339
ACD Systems Web site, 337
ACDSee software, 48–49, 231, 237, 337
action shots
 adapting to the environment, 8–9, 13–15
 anticipating, 7–8
 basic principles, 9
 capturing key moments, 70
 composition, 69–70
 spot focus, 69–70
adapting to the environment, 8–9, 13–15
additive color, 341
Adobe software
 Photoshop Album, 231
 Photoshop CS2, 231–232, 236, 337
 Photoshop Elements, 49, 231–232, 236–237, 337
 Web site address, 337
Adorama photography retailer, 337
adult sports
 legal issues, 330
 model releases, 330–331
adventure sports. *See* extreme and adventure sports
AI Servo setting (digital cameras), 70
American Society of Media Photographers (ASMP), 337
American Standards Association (ASA), 341
angles, 70–72
anticipating action, 7–8
aperture (f-stop), 78–79
applying filters, 276–279
archival quality CDs, 341
archival quality (defined), 341
archiving images, 231, 238
ASA (American Standards Association), 341
ASMP (American Society of Media Photographers), 337
aspect ratio, 248
assignment photography, 320–321
athletes
 effect of photography on performance, 5
 outdoor field and court sports, 106–107
 reactions to photographers, 5
audio annotation, 40–41
auto levels, 264–265
auto-focus, 39

B

back focus, 39, 165
back printing prints, 336
backlighting, 265
backup media, 341
baffles, 121
Baker, Francis, photographer, 339
barn doors, 341
baseball
 positioning, 89–91
 settings, 91–95
basketball
 positioning, 164–166
 settings, 166–167, 171
batch processing (defined), 341
Bates, Patrick, photographer, 226
batteries, 188–189
big glass lenses, 33
black-and-white photos, 272–274
boating, 127–130
Bogen rain covers, 125
boogie-boarding, 216, 218–219
boxing, 179
bracketing, 199
bright sunlight, 133
brightness (photos), 264
buffer rates (digital cameras), 29
bungee jumping, 204
burning discs, 240, 253–254
business opportunities
 assignment photography, 320–321
 freelance photography, 322
 image fulfillment, 312–315
 online storefronts, 344
 player photos, 311–313
 portfolio of work, 312
 professional sports photo service, 289
 spec projects, 312–313
 stock photography, 311, 317–320, 346
 team photos, 311–313
business plan, 311

C

calibration (defined), 341
calibration systems
 monitors, 234–235
 printers, 236
camera bags, 34–36

cameras
 aperture (f-stop), 78–79
 audio annotation, 41
 batteries, 188–189
 buffer rates, 29
 CCD (charge-coupled device), 45
 choosing, 26–27
 CMOS (complementary metal oxide semiconductor), 45
 file formats, 36–37
 fixed-lens, 342
 flash cards
 downloading, 45–47
 image transfer software, 48–49
 removing, 49
 write speed, 45
 focal plane, 44–45
 image stabilization, 125
 ISO settings, 78–79
 memory, 45
 point-and-shoot
 features, 27
 lenses, 62–63
 limitations, 28
 optimizing, 12–13
 resolution (defined), 345
 sensors, 45, 63
 shutter lag, 28
 shutter speed, 78–79
 shutter speed priority, 28
 single lens reflex (SLR)
 back focus, 39
 defined, 345
 features, 27–28
 model comparison, 29
 underwater photography, 214
 USB (Universal Serial Bus), 346
 water resistance, 124–125
 zooming features, 12
candid photography, 64
Canon
 Digital Rebel camera, 29
 dye-sublimation (dye-sub) printers, 287
 inkjet printers, 286
 L series of lenses, 59
 1D Mark II camera, 10–11
 PowerShot camera, 28
car and motorcycle racing, 133–138
card readers, 341
catch lights, 243
cathode-ray tube (CRT) monitor, 341

CCD (charge-coupled device), 45
CD or CD/DVD burner, 230, 234, 253–254
CDs
 archival quality, 341
 CD-R, 239
 CD-RW, 239
Chan, Craig, photographer, 339
charge-coupled device (CCD), 45
Chirico, Marc, photographer, 190–191, 339
choosing
 best camera, 26–27
 best flash card, 239
 best photos, 245–247
chrominance noise, 341
cleaning sensors, 63
climbing, 199–204
cloning (for photo touchups), 268–269
CMOS (complementary metal oxide semiconductor), 45
CMYK color, 285, 341
color
 additive color, 341
 calibration (defined), 341
 calibration devices, 234–235
 CMYK color, 285, 341
 dithering, 342
 ICC (International Color Consortium) profiles, 343
 image editing, 264
 nanometers, 344
 profiles
 creating, 285
 defined, 345
 selecting, 286
 RGB color, 284, 345
 subtractive color, 346
color printing, 285–286
colored gels, 164
colorimeters, 234, 341
ColorVision
 PrintFIX, 235
 SpyderPro2 calibration system, 234–235
CompactFlash cards, 239
competition sports. *See* indoor competition sports; outdoor
 recreation and competition sports
complementary metal oxide semiconductor (CMOS), 45
composition
 action shots, 69–70
 angle, 70–72
 capturing key moments, 70
 exposure, 75, 78
 importance of, 65–68

posed shots, 75–77
rule of thirds, 68–69, 345
style, 73–75
telling a story, 73
computer systems, 230–231, 233–234
contact sheets, 301–302
contrast (photos), 264
copyright, 333–336, 341
Corbis stock photography agency, 317, 320
Corel software
 Paint Shop Pro, 237
 Painter, 237–238
 Photo-Paint, 237
correcting photos, 261–262
Costco lab services, 288
creating
 online photo galleries, 291–292
 profiles, 285
Creative Energy Technologies Web site, 188
Creative's Nomad Jukebox Zen Extra, 244
credentials, 15–16, 326–327
cropping photos, 266–268
cross-country skiing, 148
CRT (cathode-ray tube) monitor, 341
CuteFTP, 287
cycling, 138–140, 145–146

D

damage to equipment, 41–43
deleting photos, 243
depth of field, 38
desiccant, 123, 212
Deutsche Industrie Norm (DIN), 342
diagram of workflow, 31
digital cameras
 aperture (f-stop), 78–79
 audio annotation, 41
 batteries, 188–189
 buffer rates, 29
 Canon 1D Mark II, 10–11
 Canon PowerShot, 28
 CCD (charge-coupled device), 45
 choosing, 26–27
 CMOS (complementary metal oxide semiconductor), 45
 file formats, 36–37
 fixed-lens, 342
 flash cards
 downloading, 45–47
 image transfer software, 48–49
 removing, 49
 write speed, 45

focal plane, 44–45
image stabilization, 125
ISO settings, 78–79
memory, 45
point-and-shoot
 features, 27
 lenses, 62–63
 limitations, 28
 optimizing, 12–13
resolution (defined), 345
sensors, 45, 63
shutter lag, 28
shutter speed, 78–79
shutter speed priority, 28
single lens reflex (SLR)
 back focus, 39
 defined, 345
 features, 27–28
 model comparison, 29
underwater photography, 214
USB (Universal Serial Bus), 346
water resistance, 124–125
zooming features, 12
digital display. See monitors
digital file formats. See file formats
Digital Image Pro (Microsoft), 231, 237
digital noise, 93, 341
Digital Photo Pro magazine, 230
digital photo processing (defined), 342
digital photography workflow. See workflow
digital studio
 advantages over a dark room, 229
 color-calibration devices, 234–235
 computer system, 230–231, 233–234
 disc burners, 230, 234, 240
 external hard drive, 230
 flash cards, 239
 image storage, 239
 image-archiving software, 231, 238
 image-editing software, 231, 236–237
 monitor, 231, 234, 341, 343
 networks, 235
 portable storage device, 230
 printers, 231, 235
 RAID system, 233, 345
 removable storage media, 238
 scanners, 236
 slide show software, 231, 237
 sound system, 234
 Web-based photography services, 231, 238
digital viewfinders, 342

DIN (Deutsche Industrie Norm), 342
disasters, 41–43
disc burners, 230, 234, 240
dithering, 342
DotPhoto online photo gallery, 293, 298
downhill skiing, 148
downloading flash cards, 45–47
DVD discs, 239
dye-based inks, 342
dye-sublimation (dye-sub) printers, 287
dye-sublimation (dye-sub) printing, 287, 342

E

editing photos. *See* photo editing
effects. *See* special effects
Epson inkjet printers, 286
equestrian sports, 206–210
equipment
 backup media, 341
 camera bags, 34–36
 cameras
 aperture (f-stop), 78–79
 audio annotation, 41
 batteries, 188–189
 buffer rates, 29
 CCD (charge-coupled device), 45
 choosing, 26–27
 CMOS (complementary metal oxide semiconductor), 45
 file formats, 36–37
 fixed-lens, 342
 flash cards, 45–49
 focal plane, 44–45
 image stabilization, 125
 ISO settings, 78–79
 memory, 45
 point-and-shoot, 12–13, 27–28, 62–63
 resolution (defined), 345
 sensors, 45, 63
 shutter lag, 28
 shutter speed, 78–79
 shutter speed priority, 28
 single lens reflex (SLR), 27–29, 345
 underwater photography, 214
 USB (Universal Serial Bus), 346
 water resistance, 124–125
 zooming features, 12
 card readers, 341
 CDs (archival quality), 341
 desiccant, 123, 212
 FireWire, 342
 flash bracket mount, 342
 flash card readers, 46–47
 lenses, 33
 packs, 33–34
 portable CD burner, 46
 portable hard drives, 46
 rain covers, 124–125
 rain protection, 104, 123–125
 solar-powered battery charger, 188
 theft, 41–42
equipment checklist, 30, 32–35
equipment damage, 41–43
equipment (specialized)
 car and motorcycle racing, 135–136
 extreme and adventure sports, 188–190
 indoor competition sports, 158–159
 outdoor field and court sports, 87–89
 outdoor recreation and competition, 121–127
 scuba diving, 214–215
 skateboarding, 143–145
 skiing, 152–154
 snowboarding, 152–154
 snowmobiling, 152–154
 water sports, 122–126
Esquire, David, photographer, 339
establishment shots, 87–88
EXIF (Exchangeable Image File), 342
Expodisc Web site, 164
Expodisc White Balance filter, 163
exposures
 bracketing, 199
 composition, 75, 78
 LCD image preview, 55
 overexposure, 53–54
 recommended settings, 53, 55
 underexposure, 53–55
Express Digital Web site, 337
extensible metadata platform (XMP), 346
external hard drive, 230
extreme and adventure sports
 bungee jumping, 204
 climbing, 199–204
 equipment, 188–190
 hang gliding, 190–195
 ice climbing, 204
 paragliding, 190–196
 parasailing, 196, 198
 planning a shoot, 19–20
 skydiving, 196–198

F

fanny packs, 33–34
fast glass lenses, 33, 92
fencing, 182–185
field hockey, 111–113
file formats
 GIF, 342
 JPEG, 36, 77, 343
 lossless, 343
 lossy, 343
 Photoshop Camera Raw, 344
 PNG, 344
 RAW, 37, 77, 232, 345
 RAW+JPEG, 37
 TIFF, 37, 346
file numbers, 249–250
file size, 248–249
File Transfer Protocol (FTP), 287
fill flash, 58
fill flash filter, 266
film scanners, 236
filters
 applying, 276–279
 Expodisc White Balance filter, 163
 fill flash, 266
 sharpen filter, 269, 345
 sketch filters, 345
 stylize filters, 346
FireWire, 342
fixed lenses, 33, 58–59
fixed-lens camera, 342
flagging images, 342
flash
 fill flash, 58
 indoor competition sports, 161
flash bracket mount, 342
flash card readers, 46–47
flash cards
 choosing the best one, 239
 defined, 342
 downloading, 45–47
 image transfer software, 48–49
 PCMIA card, 344
 removing, 49
 write speed, 45
focal plane, 44–45
focus
 AI Servo setting, 70
 auto-focus, 39
 back focus, 39, 165

 soft image, 62
 spot focus, 69–70
 thumb focus, 39, 165
football
 positioning, 95, 99
 settings, 99–101
Fotosearch stock photography agency, 320
frames, 276
framing photos
 mat spacing, 344
 UV-protected glass, 346
freelance photography, 322
f-stop, 78–79
f-stop ratings (lenses), 33, 92
FTP (File Transfer Protocol), 287
FujiFilm FinePix S2 Pro camera, 29
fulfilling image requests, 312–315

G

galleries. *See* online photo galleries
Garvin, Bill, photographer, 216–218, 339
gels, 164, 342
Getty Images stock photography agency, 317, 320
GIF file format, 342
glossy paper, 343
GoDaddy.com Web hosting service, 290
golf, 210–212
grain, 93
Graphic Authority Web site, 337
Green, Sharon, photographer, 215, 339
grid, 343
grid lighting, 343
gymnastics, 179–182

H

Hailstone, Hollie, photographer, 339
hang gliding, 190–195
hard drives
 external, 230
 Microdrive miniature hard drives, 239
 pocket drives, 344
 portable, 46, 230
Hardtke, Adam, photographer, 339
Haugen, Harry, photographer, 339
highlights, 262–263
histograms, 262–264
hockey. *See* ice hockey
HP inkjet printers, 286

I

IAPEP (International Association of Professional Event Photographers), 337
ICC (International Color Consortium) profiles, 343
ice climbing, 204
ice hockey
 positioning, 174–175
 settings, 175–176
 white-balance, 158
ice skating, 174
image archiving software, 231, 238
image capture device (defined), 343
image editing. *See* photo editing
image editing software, 231, 236–237
image fulfillment, 312–315
image prints
 back printing, 336
 silver-halide prints, 345
image stabilization, 125
image storage, 239
image touchups, 268–270
images. *See* photos
ImageTank portable hard drive, 46
Index Stock Imagery stock photography agency, 320
indoor competition sports
 basketball, 164–166, 171
 boxing, 179
 equipment, 158–159
 fencing, 182–185
 flash, 161
 gymnastics, 179–182
 ice hockey, 174–176
 ice skating, 174
 lighting, 156–159
 martial arts, 171–173
 planning a shoot, 18–19
 red-eye reduction, 161–162
 settings, 160–162
 wrestling, 177–178
inkjet printers, 286–287
inkjet printing, 343
inks
 dithering, 342
 dye-based inks, 342
 picoliters, 344
 pigment-based ink, 344
insurance, 42

International Association of Professional Event Photographers (IAPEP), 337
International Color Consortium (ICC) profiles, 343
interpolating, 258
ISO (International Organization for Standardization), 343
ISO settings, 78–79, 343
iStockphoto.com stock photography agency, 320
iView Media2, 231, 238
iView MediaPro, 304
iView MediaPro2, 231, 238

J

Jendrick, Nathan, photographer, 224–225, 339
jet skiing, 130–132
joining professional organizations, 230, 323
journalism, 311, 321–322
JPEG file format, 36, 77, 343

K

Kata rain covers, 124
kayaking, 216, 218–219
Kelvin temperatures for lighting, 163
keywords, 251
Kodak EasyShare Gallery, 293, 296, 337
Krutein, Wernher, photographer, 339

L

lab services, 287–290
lacrosse, 111–113
laser printers, 287
layers, 271–272
LC Technology RescuePRO File Recovery Utility, 244
LCD image preview, 55
LCD monitor, 343
LCD projector, 234, 302–303
Legacy Artists, 272
legal issues
 adult sports, 330
 copyright, 333–336, 341
 media credentials, 326–327
 model releases, 330–331, 344
 music downloads, 306
 right-to-privacy laws, 328
 sports organizations, 332–333
 youth sports, 328–330

lenses
 big glass, 33
 Canon L series, 59
 fast glass, 33, 92
 fixed, 33, 58–59
 f-stop ratings, 33, 92
 image stabilization, 125
 original equipment versus aftermarket, 62
 point-and-shoot digital cameras, 62–63
 portrait, 60–61
 telephoto, 60–61
 wide angle, 60
 zoom, 33, 58–59, 62
Lexar Image Rescue Software, 244
Lexar, John, founder and CEO of Legacy Artists, 272
light temperature, 343
lighting
 barn doors, 341
 bright sunlight, 133
 gels, 164, 342
 grid, 343
 grid lighting, 343
 indoor competition sports, 156–159
 ISO settings, 78–79
 Kelvin temperatures, 163
 mini-slave strobe light, 344
 outdoors, 56–57
 snoots, 345
 tungsten lights, 162
 underwater photography, 215
lighting kits, 343
Little, Laura, photographer, 141–142, 340
live storage, 253
Lloyd, Terrell, photographer, 52, 96–98, 340
lossless file format, 343
lossy file format, 343
loupe, 344
luminance noise, 344

M

marketing plan, 311
martial arts, 171–173
mat spacing, 344
matte paper, 344
McKiernan, Jim, photographer, 340
media credentials, 15–16, 326–327
memory (digital cameras), 45
metadata, 251, 334–335, 344

Microdrive miniature hard drives, 239
Microsoft Digital Image Pro, 231, 237
Microsoft PowerPoint, 237
Microsoft Windows Explorer, 48–49
midtones, 262–263
mini-slave strobe light, 344
model releases, 330–331, 344
Monaco Systems colorimeters, 234
"money" shot, 25
monitor, 231, 234
monitors
 CRT (cathode-ray tube), 341
 LCD, 343
 resolution, 284
MorePhotos Web site, 337
motorcycle racing, 133–138
MP3 players, 244
music (in slideshows), 306

N

nanometers, 344
NAPP (National Association of Photoshop Professionals), 231
narrow depth of field, 38
National Press Photographers' Association (NPPA), 42, 323, 337
Nero Express, 240
networks, 235
night shots, 137–138
Nikon
 D-100 camera, 29
 Nikon Users Community Web site, 338
noise, 93, 341
Nomad Jukebox Zen Extra (Creative), 244
notes (audio annotation), 40–41
NPPA (National Press Photographers' Association), 42, 323, 337

O

ocean sports, 212–216, 218
offshore sailing, 213
Ofoto, 337
Olympics
 credentials, 15–16
 hierarchy of photographers, 6–7
Olympus E-1 camera, 29
on spec projects, 312–313
online fulfillment services, 314–315

online lab services, 288–290
online photo galleries
 creating, 291–292
 DotPhoto, 293, 298
 Kodak EasyShare Gallery, 293, 296
 Printroom.com, 292–294
 Shutterfly, 293, 297
 Snapfish, 293, 297
 utilities, 298–300
 Yahoo! Photos, 293
online storefronts, 344
optimizing point-and-shoot digital cameras, 12–13
outdoor field and court sports
 access levels, 87–88
 baseball, 89–95
 equipment, 87–89
 field hockey, 111–113
 football, 95, 99–101
 lacrosse, 111–113
 personalizing athletes, 106–107
 planning a shoot, 17–18
 positioning (general), 84–86
 soccer, 101–105
 softball, 89–95
 tennis, 57–58, 114–116
 track and field, 107–111
 venue size, 87
 volleyball, 114
 weather, 89
outdoor recreation and competition sports
 boating, 127–128, 130
 car and motorcycle racing, 133–138
 cycling, 138–140, 145–146
 equipment, 121–127
 jet skiing, 130–132
 planning a shoot, 18–19
 positioning (general), 118–121
 skateboarding, 140–146
 skiing, 147–152
 snowboarding, 147, 149–152
 snowmobiling, 148–152
 wakeboarding, 130–132
 water skiing, 130–132
overexposure, 53–54

P
packs, 33–34
Paint Shop Pro (Corel), 237
Painter (Corel), 237–238
Palmer, Amber, photographer, 340
panoramic shots, 130

paper
 glossy, 343
 matte, 344
paragliding, 190–196
parasailing, 196–198
PC Magazine Guide to Printing Great Digital Photos, David
 Karlins, 287
PCMIA card, 344
Pentax *ist D camera, 29
photo editing
 auto levels, 264–265
 backlighting, 265
 brightness, 264
 color, 264
 contrast, 264
 corrections, 261–262
 examples, 256–257
 fill flash, 266
 highlights, 262–263
 histograms, 262–264
 midtones, 262–263
 shadows, 262–263
photo galleries. *See* online photo galleries
photo processing (defined), 342
photo touchups, 268–270
Photodex
 ProShow, 231, 237
 Web site address, 338
photographers' vests, 33
Photographic Society of America (PSA), 338
photography retailers
 Adorama, 337
 B&H Photo, 29, 337
Photography-on-the.net Web site, 338
photojournalism, 311, 321–322
PhotoLinks Web site, 338
Photo.net Web site, 338
Photo-Paint (Corel), 237
PhotoReflect Web site, 338
photos
 aspect ratio, 248
 black-and-white, 272–274
 choosing the best ones, 245–247
 cropping, 266–268
 deleting, 243
 file numbers, 249–250
 file size, 248–249
 keywords, 251
 layers, 271–272
 metadata, 251, 334–335, 344

previewing, 255–256
prioritizing, 248
ranking, 345
recovering, 244
renaming, 249–250, 252
resampling, 259–261
resizing, 258–261
rotating, 271
sorting, 245–246
special effects, 272–279
storing, 239, 252–253
text, 275
transferring, 244–245
viewing, 255–256
Photoshop Album (Adobe), 231
Photoshop Camera RAW file format, 344
Photoshop CS2 (Adobe), 231–232, 236, 337
Photoshop Elements (Adobe), 49, 231–232, 236–237, 337
picoliters, 344
pigment-based ink, 344
planning a shoot
 equipment checklist, 30, 32–35
 extreme and adventure sports, 19–20
 indoor competition sports, 18–19
 outdoor field and court sports, 17–18
 outdoor recreation and competition sports, 18–19
player photos, 311–313
players. *See* athletes
PNG file format, 344
pocket drives, 344
point-and-shoot digital cameras
 features, 27
 lenses, 62–63
 limitations, 28
 optimizing, 12–13
 shutter speed priority, 28
portable CD burner, 46
portable hard drive, 46, 230
portable storage device, 46, 230
portfolio of work, 312
portrait lens, 60–61
posed shots, 64, 75–77
positioning
 baseball, 89–91
 basketball, 165–166
 boating, 128–129
 car and motorcycle racing, 133–134
 climbing, 200–201
 cycling, 138–140
 equestrian sports, 207–208

fencing, 182–184
football, 95, 99
golf, 210–212
gymnastics, 179–180
hang gliding, 190, 192–193
ice hockey, 174–175
jet skiing, 130–131
martial arts, 172
outdoor field and court sports, 84–86
outdoor recreation and competition, 118–121
paragliding, 190, 192–193
parasailing, 197
skateboarding, 141–143
skiing, 147–148
skydiving, 197
snowboarding, 147
snowmobiling, 148
soccer, 101–103
softball, 89–91
tennis, 114–116
wakeboarding, 130–131
water skiing, 130–131
wrestling, 177
post-pixel stage of workflow, 25
PowerPoint (Microsoft), 237
PPA (Professional Photographers of America), 323, 338
pre-pixel stage of workflow, 25
presentations. *See* slideshow software
preventing theft of equipment, 41–42
previewing photos, 255–256
printers
 digital studio setup, 231, 235
 dye-sublimation (dye-sub) printers, 287
 inkjet printers, 286–287
 laser printers, 287
 printing costs, 235
 profiles, 285–286
 resolution, 284
printing
 color, 285–286
 costs, 235
 dye-sublimation (dye-sub), 287, 342
 inkjet, 286–287, 343
 lab services, 287–290
 watermark, 295
Printroom.com
 online photo gallery, 292–294
 print sizes, 290
 Pro Studio Manager, 300
 Web site address, 338

prints
 back printing, 336
 buying online, 296
 silver-halide prints, 345
prioritizing photos, 248
privacy laws, 328
processing
 batch processing (defined), 341
 defined, 342
 file size, 248–249
professional organizations
 American Society of Media Photographers (ASMP), 337
 International Association of Professional Event
 Photographers (IAPEP), 337
 joining, 230, 323
 National Association of Photoshop Professionals (NAPP),
 231
 National Press Photographers' Association (NPPA), 42,
 323, 337
 Photographic Society of America (PSA), 338
 Professional Photographers of America (PPA), 323, 338
 SportsShooters.com, 323
professional photography
 market changes, 310–311
 sports photojournalism, 311, 321–322
professional sports photo service, 289
profiles
 creating, 285
 defined, 345
 selecting, 286
projector, 234
proofs
 contact sheets, 301–302
 proof books, 301, 345
 soft-proofing, 346
ProShow/ProShow Gold (Photodex), 231, 237, 304–306
PSA (Photographic Society of America), 338

R

RAID system, 233, 345
rain covers, 124–125
rain protection equipment, 104, 123–125
ranking images, 345
RAW file format, 37, 77, 232, 345
RAW+JPEG file format, 37
recording sound clips, 40–41
recovering photos, 244
red-eye, 161–162, 268
REI free-standing rock wall, 204
Reimer, John and Terry, photographers, 272, 340

removable storage media, 238
removing flash cards, 49
renaming photos, 249–250, 252
resampling, 259–261
RescuePRO File Recovery Utility (LC Technology), 244
resizing photos, 258–261
resolution
 defined, 345
 monitors, 284
 printers, 284
retailers
 Adorama, 337
 B&H Photo, 29, 337
RGB color, 284, 345
right-to-privacy laws, 328
rock climbing, 199–204
rotating photos, 271
rule of thirds, 68–69, 345

S

sailing, 213
scanners, 236
School Photo Marketing, 315–316
screensavers, 306
scuba diving, 213–215
Seattle Paragliding, 190
selecting profiles, 286
selling photos
 assignment photography, 320–321
 business plan, 311
 freelance photography, 322
 image fulfillment, 312–315
 marketing plan, 311
 online storefronts, 344
 player photos, 311–313
 portfolio of work, 312
 professional sports photo service, 289
 spec projects, 312–313
 stock photography, 311, 317–320, 346
 team photos, 311–313
 Web site, 290–291, 311
sensors, 45, 63
setting up, 37
settings
 baseball, 91–95
 basketball, 166–167, 171
 boating, 129–130
 car and motorcycle racing, 136–138
 climbing, 201–204

cycling, 145–146
equestrian sports, 208–210
fencing, 184–185
football, 99–101
golf, 212
gymnastics, 181–182
hang gliding, 194–195
ice hockey, 175–176
indoor competition sports, 160–162
jet skiing, 131–132
martial arts, 173
paragliding, 194–195
parasailing, 197–198
skateboarding, 145–146
skiing, 149–152
skydiving, 197–198
snowboarding, 149–152
snowmobiling, 149–152
soccer, 103–105
softball, 91–95
tennis, 57–58
wakeboarding, 131–132
water skiing, 131–132
white-balance, 162–164
wrestling, 178
shadows, 262–263
sharpen filter, 269, 345
shutter lag, 28
shutter speed, 78–79
shutter speed priority (digital cameras), 28
Shutterfly online photo gallery, 293, 297, 338
Sigma lenses, 62
silhouette shots, 194–195
silver-halide prints, 345
single lens reflex (SLR) digital cameras
 back focus, 39
 buffer rate, 29
 defined, 345
 features, 27–28
 model comparison, 29
 shutter speed priority, 28
sizing photos, 258–261
skateboarding, 140–146
sketch filters, 345
skiing, 147–154
skydiving, 196–198
slide scanners, 236

slideshow software
 digital studio setup, 231, 237
 features to look for, 303–304
 iView MediaPro, 304
 music, 306
 ProShow/ProShow Gold, 304–306
SLR (single lens reflex) digital cameras
 back focus, 39
 buffer rate, 29
 defined, 345
 features, 27–28
 model comparison, 29
 shutter speed priority, 28
Snapfish online photo gallery, 293, 297
snoots, 345
snowboarding, 147–154
snowmobiling, 147–154
soccer
 positioning, 101–103
 settings, 103–105
soft image, 62
softball
 positioning, 89–91
 settings, 91–94
soft-proofing, 346
solar-powered battery charger, 188
Sony
 Cyber-Shot camera, 63
 dye-sublimation (dye-sub) printers, 287
sorting photos, 245–246
sound clips, 40–41
sound system, 234
SoundBlaster Extigy sound card, 234
spec projects, 312–313
special effects
 black-and-white photos, 272–274
 filters, 276–279
 frames, 276
 text on photos, 275–276
sports organizations, 332–333
sports photojournalism, 311, 321–322
SportsShooters.com Web site, 323, 338
spot focus, 69–70
SpyderPro2 calibration system (ColorVision), 234–235
standards
 American Standards Association (ASA), 341
 Deutsche Industrie Norm (DIN), 342
 International Organization for Standardization (ISO), 343

The Stock Agency stock photography agency, 320
stock photography, 311, 317–320, 346
storing photos, 239, 252–253
studio. *See* digital studio
style, 73–75
stylize filters, 346
subtractive color, 346
surfing, 216, 218–219
swimming, 223–226

T

Tamron lenses, 62
team photos, 310–313
telephoto lens, 60–61
telling a story, 73
Tenba rain covers, 124
tennis
 positioning, 114–116
 settings, 57–58
text on photos, 275–276
Thatcher, Neal, photographer, 220–222, 340
theft of equipment, 41–42
thumb focus, 39, 165
TIFF file format, 37, 346
Timacheff, Alexander A., photographer, 340
Timacheff, Amy, photographer, 206, 340
Toast, 240
touching up photos, 268–270
track and field, 107–111
transferring photos, 244–245
tungsten lights, 162

U

UltimateSailing.com Web site, 215
underexposure, 53–55
underwater photography, 214–215
unsharp mask, 269–270, 346
U.S. Copyright Office, 333
USB (Universal Serial Bus), 346
UV-protected glass, 346

V

vests, 33
viewfinders, 342
viewing photos, 255–256
virtual backdrop, 346
volleyball, 114

W

wakeboarding, 130–132
walk-in lab services, 288
Wal-Mart lab services, 288
water skiing, 130–132
water sports, 122–126
watermark, 295, 336, 346
water-resistant cameras, 124–125
weather
 outdoor field and court sports, 89
 rain protection equipment, 104
Web services, 231, 238
Web site for selling photos, 290–291, 311
Web-based photography services, 231
WebShots.com online fulfillment service, 314–315
white-balance
 defined, 346
 Expodisc White Balance filter, 163
 ice hockey, 158
 settings, 162–164
 snow sports, 149–150
wide-angle lens, 60
wind surfing, 216, 218–219
Windows Explorer (Microsoft), 48–49
Wissman, Will, photographer, 152–153, 340
workflow, 24–25, 30–32
wrestling, 177–178

X

XMP (extensible metadata platform), 346

Y

Yahoo!
 Photography Groups Web site, 338
 Photos Web-based photography service, 238, 293
youth sports
 legal issues, 328–330
 model releases, 330–331

Z

zoom lenses, 33, 58–59, 62
zooming features (digital cameras), 12